HUNTINGTON LIBRARY PUBLICATIONS

Drawings by
Thomas Rowlandson
in the
Huntington Collection

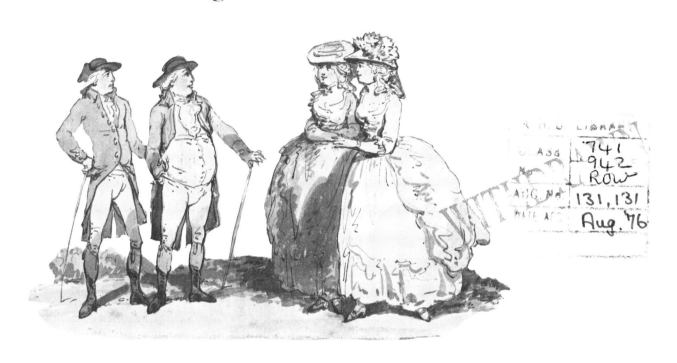

BY ROBERT R. WARK

HUNTINGTON LIBRARY · SAN MARINO, CALIFORNIA

1975

THIS VOLUME HAS BEEN PUBLISHED WITH THE ASSISTANCE OF GRANTS FROM THE
FORD FOUNDATION AND THE NATIONAL ENDOWMENT FOR THE ARTS, A FEDERAL AGENCY

Copyright © 1975
Henry E. Huntington Library and Art Gallery
Library of Congress Catalog Card Number 74-20036
ISBN 0-87328-065-2
Printed in the United States of America
by Anderson, Ritchie & Simon
Designed by Ward Ritchie

CONTENTS

Acknowledgments

THE PREPARATION of this catalog has been proceeding with interruptions and intermissions for the past dozen years. During that period many professional colleagues, students working under my direction, collectors, and art dealers have supplied quantities of helpful information. When this information relates to a specific drawing I have endeavored to acknowledge my indebtedness in the catalog entry concerned, but I am happy to have the opportunity here to express general thanks to these many generous and often very patient people. To one good friend in particular I wish to add a special word of gratitude. Throughout the whole of the time I have been working on the Huntington Rowlandson collection I have had constant help and encouragement from John Hayes. We have exchanged thoughts and information about Rowlandson in so many ways over such a long period that I suspect it is now impossible for us to disentangle our respective thoughts on the artist. Furthermore, the existence of Hayes' admirable introduction to Rowlandson (*Rowlandson, Watercolours and Drawings*, Phaidon Press, 1972) makes unnecessary much general information about the artist that might otherwise be expected in this catalog.

I also wish to thank Ann Ely, Betty Leigh Merrell, and Jane Evans of the Huntington staff for help in preparing the copy for the printer. Publication of the book was made possible by generous grants from the Ford Foundation and the National Endowment for the Arts.

ROBERT R. WARK
San Marino, California
November 1974

A Rowlandson Chronology

The best brief account of Rowlandson's life is in John Hayes, *Rowlandson Watercolours and Drawings* (Phaidon, London, 1972). The reader is referred to that book for a more expanded presentation of the data here listed.

1756 (or 1757) Thomas Rowlandson born on July 14 in Old Jewry, London, son of a textile merchant, William Rowlandson. There is conflicting evidence concerning the year of Rowlandson's birth. The obituary notice in *The Gentleman's Magazine* (XCVII, Pt 1 [1827] 564) gives 1756. This is supported by an inscription in Rowlandson's hand on a portrait drawing of Rowlandson by G. H. Harlow (National Portrait Gallery). When Rowlandson enrolled as a student at the Royal Academy in 1772 he said he was fifteen the previous July 14, making his birthdate 1757. He inscribed his age as seventy on another portrait drawing of him by J. T. Smith made in 1824, suggesting a third possible date, 1754. The weight of evidence favors 1756.

1759 William Rowlandson declared bankrupt. Thomas was placed in the care of his uncle James, a prosperous Spitalfields silk weaver, and of James's wife, Jane.

1764 Death of James Rowlandson. Thomas was henceforth under the care of his aunt, who moved to Soho and sent her nephew to the respected school of Dr. Barvis in Soho Square.

1772 Rowlandson admitted to the Royal Academy Schools on November 6.

1774 Probable date of Rowlandson's first trip to Paris. Evidence from the recollections of his friend Angelo suggests Rowlandson arrived in Paris in July 1774.

1775 Rowlandson's first exhibit at the Royal Academy, *Dalilah payeth Sampson a visit while in prison at Gaza*, the only biblical subject Rowlandson is known to have attempted, and unfortunately now lost.

1776 Rowlandson's earliest surviving dated drawing (Hayes, No. 3).

EARLY 1780s Rowlandson again visited the Continent, and probably was in Italy as well as France.

1784 A peak year in Rowlandson's career. He exhibited two of his mas-

terpieces, *Vauxhall Gardens* and *The Serpentine River*, as well as creating the drawings for *A Tour in a Post Chaise* and the pencil caricatures for the *Westminster Election* in the Huntington Collection.

1786 Rowlandson appears to have been again on the Continent in this and the following year, visiting France.

1787 Last year in which Rowlandson exhibited at the Academy.

1789 Death of Rowlandson's aunt, by whose will he received a substantial legacy, probably close to £2000.
 Traveled with Henry Wigstead to Brighton, and published a series of prints commemorating the trip in 1790.

EARLY Further trips on the Continent, including France, the Low Coun-
1790s tries, and Germany.

MID- Rowlandson began his association with the publisher Rudolph
1790s Ackermann, for whom he executed a great quantity of graphic work throughout the remainder of his career. Also met one of his most consistent patrons, the banker Matthew Michell. Frequent visits to Michell's country house in Cornwall resulted in some of the most attractive of Rowlandson's landscape drawings.

1799 *Loyal Volunteers of London*, Rowlandson's first major production for Ackermann.

1808 *The Microcosm of London* (3 vols.) with colored plates by
-11 Rowlandson and A. C. Pugin, published by Ackermann.

1812 The three Dr. Syntax tours with illustrations by Rowlandson
-21 and text by W. Combe, published by Ackermann.

ABOUT Rowlandson probably visited Paris to see the treasures Napoleon
1814 had gathered in the Louvre.

1815 *The English Dance of Death* with illustrations by Rowlandson
-16 and text by Combe, published by Ackermann.

1822 *The History of Johnny Quae Genus*, Rowlandson's last series of illustrations for Ackermann.

EARLY Rowlandson probably visited Italy. The supporting evidence is
1820s in a scrapbook in the Victoria and Albert Museum.

1825 Rowlandson, on the evidence of the obituary notice in *The Gentleman's Magazine*, became seriously ill and may have suffered a stroke, from which he seems never to have fully recovered.

1827 Rowlandson died on April 21 and was buried in St. Paul's, Covent Garden.

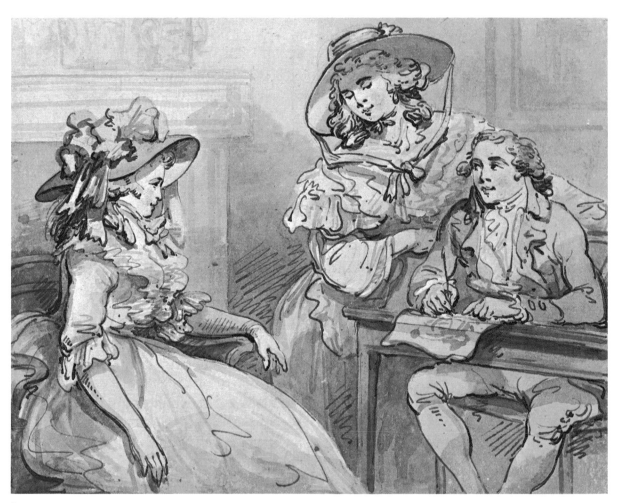

83. ROWLANDSON AND HIS FAIR SITTERS

Introduction

THOMAS ROWLANDSON, among the most popular and immediately appealing of British artists, was also one of the most prolific. No one has ever attempted a count of his drawings, but the number already in public collections, plus the seemingly endless quantities that continue to appear on the market, suggest that the total might well go above ten thousand. Even the most intrepid cataloger capitulates when faced with such incredible productivity. As the thought of anything approaching a complete listing of Rowlandson's drawings is sheer fantasy for the near future, the number of his works reproduced or otherwise available to the public is likely to remain a small fraction of his output. To base our estimate of an artist on such a sampling is a little like charting the contours of an iceberg from the portion above water. In both instances a fair amount about what is not visible may be deduced with reasonable accuracy from what is. But there always remains the possibility that some large, unexpected shelf or prominence may exist below the surface.

Most of the books on Rowlandson contain a selection of his work chosen to show him at his best, or at least to support the particular estimate of the artist which the compiler wishes to advocate.[1] It is probable that we now know as much about the man as this approach will reveal, and if our knowledge of his art is not to remain at a standstill some other, perhaps more pedestrian and plodding, ways of reconnoitering the mountain should be adopted. There have been a few attempts at systematic exploration of a particular facet of Rowlandson's career, or his connection with a special project,[2] and there is certainly more that could be done in this way. A very useful book, although not, it must be admitted, a very inviting one to write, would be a fully illustrated catalog of the prints he designed or executed.[3] Such a publication would provide much needed pegs on which to string garlands of undated and otherwise unassociated drawings. The present book is devoted to a third approach: the publication, with illustrations, of a major Rowlandson collection.

The Huntington collection of drawings by Rowlandson is generally regarded as the largest and most comprehensive at present in a public museum. Parts of the collection have been reproduced and discussed, but at least two thirds of it has been hitherto seen by only a half-dozen students who have visited the gallery specifically for the purpose of going through this material. It covers all known facets of Rowlandson's career (except the pornographic drawings); it ranges chronologically from his earliest to his latest works, and qualitatively from major drawings to minor scraps. The publication of this material places before the public a genuine and generous cross-section of his output as an artist.

The Huntington Rowlandson collection has taken form over the last sixty years. As far as the acquisition of the material is concerned, it can be divided into five parcels: a large album of mounted drawings, about two hundred and forty in number, acquired by Mr. Huntington from the Philadelphia book dealer Charles Sessler about 1910; two important series of drawings, sixty-nine for *A Tour in a Post Chaise* and about one hundred for *The English Dance of Death*, obtained by Mr. Huntington in the mid-1920s, again from Sessler; a group of about fifty drawings purchased by the Huntington trustees from Gilbert Davis in 1959; and a miscellaneous assemblage of another fifty drawings and a sketchbook that have entered the collection at various times by gift, bequest, or purchase.

It is interesting that Mr. Huntington, who generally had little enthusiasm for drawings, should have acquired the first three groups, comprising the bulk of the Rowlandson collection, during his lifetime. A significant factor in explaining this situation is that all three came to him as bound volumes. For some reason he seems to have found drawings that were either literally in books or intimately associated with books more palatable than separate sheets. In this regard it is worth noting that of the British drawings acquired by Mr. Huntington the great group of Blakes all arrived in bindings and are all basically book illustrations;[4] and the large series of drawings by Isaac Cruikshank also came as a book.[5] Only the pencil portraits by Cosway were acquired as separate sheets, but encased in elaborate gold frames and clearly considered as part of the collection of miniatures.

Mr. Huntington's preference for drawings in books is probably no more than a reflection of the fact that he was first and foremost a book collector. But the preference led him, instinctively or otherwise, to the most original and attractive forms of narrative art produced in England at the turn of the eighteenth to the nineteenth century. There can be no

doubt that it is with the watercolors of Blake and Rowlandson, conceived to a great extent with book illustration or prints in mind, rather than with the large-scale paintings of men like James Barry and Benjamin West, that English narrative art of the Georgian period is at its best.

Unfortunately we have no information about the earlier history of the first, large volume of Rowlandson drawings acquired by Mr. Huntington from Sessler. It is a mixed collection, with a sprinkling of items not by Rowlandson (including a good one by Francis Barlow)[6] and a wide range in the dates, thematic material, and general quality of the authentic drawings. All have been carefully inset into elephant folio pages and placed in a handsome, blue, full morocco binding by Riviere. There is no date on the binding, but the book was probably put together about 1900. The job of mounting the drawings was expertly done, leaving the backs of the sheets fully visible. From the backs it is evident that most of the drawings had been previously tipped onto other mounts or pages. As a substantial portion of the drawings must on technical evidence date from late in Rowlandson's career, it appears possible that some of them may have been in a scrapbook similar to the surviving scrapbooks of late Rowlandson drawings in the British Museum, Victoria and Albert Museum, Houghton Library, and one or two private collections. But other groups of drawings in this album, particularly the fine series of Cornish and Devon landscapes, come from earlier in Rowlandson's career and are probably from a totally different source. Insofar as the album appears to have been bound not long before Mr. Huntington acquired it, there is a distinct possibility that it was Sessler himself, knowing his client's preferences in such matters, who placed the drawings in this form. In any event, although they entered the collecton as a unit, this is clearly an artificial coherence given to them at a fairly recent date.

Concerning the other two volumes of drawings purchased from Sessler some fifteen years later, in the 1920s, there is more information. Both came from the great collection of William Henry Bruton dispersed at Sotheby's in June 1921. The drawings for *A Tour in a Post Chaise* had previously belonged to Joseph Grego, and before that to Thomas Capron. The first definite reference to them thus far located is in the Capron sale at Christie's in January 1888.[7] Bruton appears to have acquired the drawings for *The English Dance of Death* from a variety of sources, although most of them had previously belonged to Joseph Parker, who had exhibited them in 1882 at the Burlington Fine Arts Club.[8] Both groups of drawings were placed in bindings, presumably while they were in the

Bruton collection. Those for *The English Dance of Death* form part of an elaborate extra-illustrated book which includes a full set of the colored etchings and aquatints derived from the drawings, the etching proofs before aquatint, and the printed text supplied by William Combe to accompany the designs.

These three major groups of Rowlandson drawings acquired by Mr. Huntington slumbered quietly in his library for thirty years and more until the mid-1950s. During that period they were certainly properly cataloged and available to any interested student who wished to see them, but the fact that they were in California seems to have been unknown to Rowlandson scholars.

In the late 1950s the Huntington trustees decided to embark on a program of acquiring a good, comprehensive collection of British drawings and watercolors as a complement to the gallery's well-known British paintings. Fortunately this program was begun at a time when British drawings were still relatively low in price, and when two or three important private collections were about to come on the market. The bulk of one of the most distinguished of these, formed by Gilbert Davis, was acquired in 1959. Mr. Davis was particularly attracted to Rowlandson and his collection included about three hundred and fifty drawings by that artist—without doubt the finest assemblage of his works then in private hands. Because of the Huntington's existing strength in Rowlandson, only about fifty of these drawings were included in the purchase of the Davis Collection, but these were some of the best in the group. This material was reasonably well known in England before coming to California. An exhibition derived from it had been held at The Arts Council, London, in 1950, and individual Rowlandson watercolors had been lent by Mr. Davis to other shows of British drawings during the 1940s and 50s. Some have also been reproduced in recent books on Rowlandson, particularly those by John Hayes and Ronald Paulson. Nevertheless, a major part of this distinguished group has remained hitherto unknown to the general public.

The final portion of the Huntington Rowlandson collection consists of about fifty drawings, plus a sketchbook with another fifty, that have come from a wide variety of sources. A few date back to Mr. Huntington's day, and, like the *Dance of Death* series, arrived in extra-illustrated books. The interesting group of rare pencil drawings for 1784 political caricatures came in an extra-illustrated copy of *The Westminster Election* acquired in 1920. The series for *Characteristic Sketches of the Lower*

Orders and *Cries of London* likewise came in grangerized volumes purchased by Mr. Huntington himself. A small but distinguished group of seven watercolors was bequeathed by Albert M. Weil in 1970. All of these appear to have been acquired from the Chicago branch of Ackermann's in the 1930s, and some of them came before that from the Desmond Coke Collection. There have also been smaller gifts and bequests from Homer Crotty and Julia Bodman. A fine single drawing, *Disappointed Epicures* (No. 80), was presented by the Friends of the Huntington in 1962. The most important purchases made by the trustees, aside from the items in the Gilbert Davis Collection, are the early Rowlandson sketchbook (No. 1), acquired in 1974, and *The Dissection* (No. 2) acquired in 1968.

It seems unlikely that more major additions will be made to the Huntington Rowlandson holdings, at least by purchase. The collection is now sufficiently comprehensive, and prices sufficiently high, that expenditures in that area could be regarded as extravagant. It is certainly possible, however, that further gifts and bequests may gravitate in the Huntington direction from the very substantial number of Rowlandson drawings still in private hands in America. Although the inevitable drift of this material into public collections means that fewer individuals will enjoy the privilege of being temporary custodians of these drawings, more will become available to interested members of the public at large. Hopefully, more will also be reproduced and cataloged, providing the raw material from which our understanding of this fascinating artist may grow.

The information about Rowlandson that may be derived from his works in the Huntington Collection falls into two more or less distinct although interrelated categories. The drawings provide an excellent guide to his range of interests and thematic materials; they also offer by far the best opportunity now available to explore his technical procedures and evolution as a draftsman. It is on these two factors that our understanding of Rowlandson's artistic personality rests.

It is immediately apparent on turning over the plates in this volume that Rowlandson's thematic range is wider than is often supposed, and that to class him purely as a comic draftsman is a serious oversimplification. A considerable portion of his work consists of picturesque genre, landscapes, and various types of figure drawing in which there are no humorous overtones. But undoubtedly comic drawing remains the dominant and most impressive part of his output.

Rowlandson has a larger repertory of comic devices at his command

and comes closer to exploiting their full potentialities than any other British artist. Unfortunately it is very seldom that his knowledge and skill in this matter come into focus in a single work of art, and this is probably the most disappointing feature of his career. But the fact that he raises expectations he leaves unfulfilled should not make us any less grateful for what he does achieve. *The Registry Office* (No. 135) involves as many forms of humor as Rowlandson is likely to combine in one drawing, and it is a good point of departure for a study of his comic vocabulary. As the sign on the wall tells us, the drawing represents a "Registry Office for the hiring of servants. Masters and mistresses may be accommodated with servants of all descriptions; show days Mondays, Wednesdays, and Fridays." What we see is evidently one of the "show days" when prospective employers have come to survey the market. On the right a lecherous looking old man inspects a young woman, eyeing her through a glass with the practiced air of a gourmet about to savor a tasty morsel. A distinctly older and plumper servant seated on the extreme right looks on with obvious disapproval, aware no doubt that domestic experience is not what the man has in mind in choosing a maid or cook. On the left side of the drawing we see the converse of this situation: an amply endowed matron shows a lively interest in a young male servant, while an older man, who has been passed over, gives a disgruntled sideways glance. In the background another client casts an appreciative eye over a girl seated near the doorway, while one of the proprietors of the office, with over-elegant solicitation, accepts a fee from a servant who wishes to register. The amorous play between the two dogs in the background epitomizes the real theme of the picture.

It must be admitted that there is nothing inherently funny about the situation Rowlandson depicts; it could be regarded as sordid and nasty. That we respond to the drawing as humor is due to a complex intermingling of various factors: caricature, action, pictorial arrangement, verbal labels, and, ultimately, the actual medium in which the drawing is executed. There is nothing unequivocally comic about any of these factors in isolation any more than there is about the situation itself, but they all come together to create an effect that is unmistakably comic. These various components of Rowlandson's comic art have separate histories going back well before his involvement with them, but there are no artists before him who combined so many of them so successfully.

Caricature, the exaggeration of facial or other bodily features for expressive, and particularly for comic, effect, is probably the most imme-

135. THE REGISTRY OFFICE

diately apparent and insistent of the sources of humor in *The Registry Office*. Rowlandson is here heir to a long pictorial tradition stretching back to antiquity, but which became clearly formulated in early eighteenth-century Italy in the work of men like Ghezzi and his English imitator, Thomas Patch. Prints by both of these men were popular in England and surely known to Rowlandson. He would also have found the same ideas fully expressed in the work of an artist he greatly admired, J. H. Mortimer. Rowlandson gives added bite to his caricatures by contrasting figures so treated with others that are not. In *The Registry Office* the young servants are not caricatured, throwing into sharper relief the old employers and prospective employees who are. Deliberately contrived contrasts of this type are one of Rowlandson's most frequently used expressive devices, especially for comic effect.[9]

In Rowlandson's understanding of the potential comedy in action and situation (two additional elements in his comic repertory) he had a brilliant predecessor in Hogarth, whose works he obviously knew well. Hogarth's prints would have taught Rowlandson to capture the eloquent comic pose, such as the subtly observed stance of the man to the right, ogling the girl in *The Registry Office*, or the affected gesture of the clerk in the background receiving a fee from a prospective client. The exploitation of the situation in this drawing, and especially the discrepancy between what ostensibly and what actually is going on, is another important source of humor. The germ of such an idea might again be found in Hogarth, although not so fully developed there as in Rowlandson.[10] Here too the element of contrast is important for the humor.

The notion of presenting us with rather carefully worked out complementary situations on either side of *The Registry Office* is another device that tends to heighten the comedy without, of course, being funny in itself. In using this arrangement there is perhaps an element of parody of pictorial and rhetorical devices that one normally expects to find in more serious artistic exposition. Parody, whether here consciously intended or not, was certainly another comic device which Rowlandson used and had encountered in the work of his older contemporaries. Hogarth used parody sparingly, but his *Charity in the Cellar*[11] is explicitly intended to be taken that way. Reynolds created a witty parody of Raphael's *School of Athens*,[12] and continued to employ elements of parody in portraiture throughout his career. Gillray was very fond of parody in political caricatures, one of the most notable examples being a particularly savage presentation of the Younger Pitt, the Queen, and Lord Thurlow employ-

ing the well-worn pictorial formula of *Satan, Sin, and Death*[13] from *Paradise Lost*. Early in his career Rowlandson created an obvious parody of Fuseli's popular painting *The Nightmare*[14] in a caricature of Charles James Fox. And probably he expected some of the humor of *His Highness the Protector* (No. 4) to come from the mock-heroic stance of Fox's distinctly pudgy figure. On the whole, however, pictorial parody is not a comic device which Rowlandson used frequently, even though he did understand it fully.

It is probable that without the sign in the background of *The Registry Office* most of Rowlandson's contemporaries would still have readily understood the situation represented. But the sign clearly serves to underline the gap between what the people supposedly and actually are doing, a vital source of humor in the drawing. The use of words to give edge to visual humor in this way is a frequent device in Georgian comic art, although the source of this interplay is difficult to discover. Hogarth used words to clarify the meaning of his prints, but seldom with the type of tension and play between the two that was developed later in the century.[15] How sophisticated this interplay can become is beautifully exemplified by *A French Frigate Towing an English Man o' War into Port* (No. 96), where image and caption are interdependent in a highly involved but delightfully comic way, each incomplete without the other. It is worth noting that in this particular instance Rowlandson is developing an idea that appeared in earlier, anonymous prints of the 1780s. The anonymous comic prints were frequently the work of amateurs, ladies and gentlemen who liked to dabble in humorous art, who sometimes engraved the prints themselves, but often were content to do no more than pass an idea to a professional printmaker. This practice was sufficiently widespread that the printseller Darly went so far as to advertise in the early 1770s: "Gentlemen and Ladies may have Copper plates prepared and Varnished for etching. Ladies to whom the fumes of the Aqua Fortis are Noxious may have their Plates carefully Bit, and proved, and may be attended at their own Houses Ladies and Gentlemen sending their Designs may have them neatly etch'd and printed for their own private Amusement at the most reasonable rates, or if for publication, shall have evry grateful return and acknowledgment for any Comic Design, Descriptive hints in writing . . . shall have due Honor shewn 'em & be Immediately Drawn and Executed. . ."[16] Such a statement is strong evidence concerning the participation of amateurs in English comic art. The nimble humor involved in the visual-verbal play between caption and image is something one

9

might expect to come from such a source, although it is not possible to prove this suggestion at present.

One final but highly important component in Rowlandson's comic art is the pen and watercolor medium itself. The cursive, elegant pen work and the charming pastel colors do as much as anything else to dispel any sinister atmosphere about *The Registry Office*; although here again there is contrast and tension, in this instance between the medium and the vulgarity of the theme, which adds a piquant touch to the humor. This bittersweet quality, which runs through much of Rowlandson's art, is one of its most distinctive features. As noted below in the discussion of Rowlandson's technique, he had predecessors in the application of the pen and watercolor medium to comic subjects, but the results are never happier than in his drawings.

Caricature, situation and action, parody, captions, and the pen and watercolor technique: these are the principal means by which Rowlandson obtains a comic effect. He applies these to a fairly wide range of subjects: sex and marriage, fashion, customs and manners, mishaps, personal foibles. He can, especially in the early part of his career, be relatively subtle in his humor. Later he is likely to rely more heavily on gross caricature and exaggerated activity. He is most at home with situations involving the English middle class, and less sure in his touch when dealing with either the top or the bottom of the social ladder. He is also at his best when depicting something connected, even remotely, with his own experience. Imagination is not his strong point, and in this matter he operates within a limited range. When he occasionally exceeds this with a striking image or idea there is often some special explanation, such as the work of another artist from whom he has derived inspiration.

All in all, Rowlandson is probably the most nearly complete master of comic art that England has produced. He controls a much wider repertory of comic devices than does Hogarth, and his thematic range is very much more comprehensive than that of Gillray; and these are his two closest competitors. Both Hogarth and Gillray can be more incisive and arresting than Rowlandson, but for sheer fun and fecundity he leaves them far behind.

Rowlandson's landscapes, like his comic drawings, are an amalgam of various trends in late eighteenth-century art, but less complex in character. His work as a landscapist has not received much attention, but his achievement in that area is of high quality and distinctly personal.[17] He created

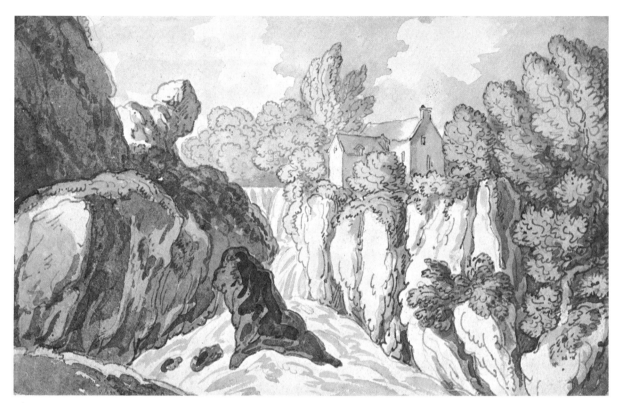

163. HOUSE NEAR A ROCKY GORGE

landscape drawings throughout his career, although they tend to cluster at the beginning and just after 1800. *House Near a Rocky Gorge* (No. 163), on paper watermarked 1808, is a typical mature example, and a good point of departure for discussing this facet of Rowlandson's art. The drawing, like the majority of his landscapes, is charming and decorative. Pen work animates most of the page, but is kept from being fussy and jumbled by the strong, rhythmic, looping motion of the strokes. The watercolor washes are light in key and pretty. The general effect of overall surface activity and the absence of emphasis on mass and depth point up Rowlandson's stylistic affiliations with the rococo, affiliations that run through all phases of his art. It is worth remembering that at the time this drawing was made J. R. Cozens and Girtin were both dead, Turner was already a full academician, and Constable (a slow starter) was beginning to develop his mature style. The effects of light and atmosphere, which are the dominant concerns of English landscapists by 1810, have no interest for Rowlandson; the primary thrust of English landscape at the time had clearly passed him by and left him untouched. But if from the historical standpoint Rowlandson's landscapes are somewhat anachronistic that does not affect their intrinsic quality as works of art.

The basic components from which Rowlandson fashioned his landscape style are the topographical tradition (which is the backbone of English landscape from the mid-seventeenth until the early nineteenth century) and the lyrical, mood landscape of Gainsborough. Judging from the early Huntington sketchbook and the scenes from *A Tour in a Post Chaise* it was the topographical approach that captured his attention first, and he never really abandoned this point of view. These early drawings all appear to be reasonably accurate, if somewhat dry, records of the appearance of particular places, insofar as verification is now possible; but it is clear that Rowlandson was never a pedantic topographer insisting upon accuracy in every detail, and that from the outset he was interested in picturesque landscape motifs (see Nos. 1C, F, G, etc.).

The Gainsboroughesque, the other component of Rowlandson's landscape style, is not apparent in his work until the mid-1780s, although he must have known Gainsborough's drawings from an early age. In the 1780s Rowlandson included prints based on Gainsborough landscapes in his *Imitations of Modern Drawings*. What Rowlandson appears to have admired in Gainsborough's drawings, and increasingly emulated in his own, is the rhythmic, flowing calligraphy with which the older man described foliage and other landscape elements. Rowlandson normally

transcribes this formula into pen, thereby losing much of the atmospheric and chiaroscuro effects which are so important a feature of Gainborough's drawings. Equally important, Rowlandson did not follow Gainsborough in abandoning the topographical component in landscape. Gainsborough's mature landscapes, both paintings and drawings, are imaginary mood pictures created without reference to any particular place. With a few exceptions, Rowlandson's point of departure in evolving a landscape drawing remains an actual view. Also, Gainsborough's gentle lyricism is alien to Rowlandson, whose calligraphy has more bounce and never loses itself in the depiction of landscape elements, and whose compositions become increasingly restless, without the areas of repose so essential for the creation of Gainsborough's moods. Nevertheless the influence of Gainsborough is crucial in the development of Rowlandson's mature landscape style. This style develops as a highly personal blend of topography and the Gainsboroughesque, easily distinguishable from the works of artists who are the sources for the components.

One of the most interesting features of the Huntington Rowlandson collection is the large proportion of drawings (about one-third) which are neither comic nor landscapes, or in which these elements do not play dominant roles. Most noticeable in this catagory is a substantial group of genre scenes, mostly figures and animals in rural settings, in which the comic element, if present at all, is subdued, and landscape is clearly dominated by figures. *Man Herding Sheep* (No. 209) is a good example of this type of drawing. The general theme, of course, is a very popular one in late eighteenth-century British art, associated primarily with Morland, Wheatley, and Ibbetson, as well as the "fancy" pictures of Gainsborough. Rowlandson has no special claims to attention in this area, except that the quality and extent of his activity as a genre artist are less generally recognized than they should be. He certainly did not invent this type of picture, nor does he make any unusual contribution to it. In producing these subjects he reveals an interest in bucolic themes tinged with nostalgia that is sufficiently common at the time to be regarded as characteristic of the late eighteenth century. There is, perhaps, less sentiment in Rowlandson's treatment of this material than there is in the works of Gainsborough and Wheatley; the mood overtones weaken in the face of Rowlandson's strong, cursive calligraphy; more purely decorative qualities come to the fore, once again emphasizing his affiliations with the rococo. Some of Rowlandson's most attractive drawings fall in this genre category, and his

general strength as a draftsman means that he comes off well in comparison with Wheatley and Ibbetson. The oils of Gainsborough and Morland are the most memorable pictures in this vein produced in England. But these masters aside, there are no other late eighteenth-century British artists who stand ahead of Rowlandson in the area of rustic genre, and none that equal him as a draftsman.

It is less easy to be enthusiastic about Rowlandson's occasional essays in heroic, pathetic, and ideal subjects: *The Scots Greys at Waterloo* (No. 237), *The Press Gang* (No. 133), *Working the Guns on Board a Ship* (No. 71), *Apollo and the Muses* (No. 366), etc. There is no reason to doubt that Rowlandson is here attempting a more serious form of narrative art, but the degree of success he achieves is a moot point. Whether by association with Rowlandson's other work, or whether there is something inherently lighthearted about his bouncy calligraphy and pastel washes, it is difficult for us to take entirely seriously drawings executed in this medium. Also working against a serious effect is an innate tendency to caricature that may be part of Rowlandson's personality, or related to his technical means. *The Press Gang*, for instance, comes very close to being the forceful indictment of an injustice which one suspects Rowlandson intended, but misses, primarily because of the unconvincing prostrate figure in the foreground, whose pose reads as a caricature of a faint. There are similar difficulties with *Scots Greys* and *Working Guns*.

Related problems arise in Rowlandson's comparatively rare attempts to present ideal, classical figures (such as *Apollo and the Muses*) and even in the wiry copies after engravings of ancient sculpture and other antiquities that occupied a considerable amount of his time late in life (Nos. 467-74). In these instances the difficulty seems to rest in the very nature of Rowlandson's line, which has an ebullient quality that is at odds with ideal human contours. These studies do serve to remind us, however, that neoclassic linearism was in its heyday during the latter part of Rowlandson's career, and that he was aware of and responsive to this facet of his artistic environment. It is more difficult to explain the purpose of the line copies, not only after antiques but other later works of art as well (Nos. 358-65). Rowlandson makes very little use of such material in his own independent drawings, so his interest does not seem to have been in enlarging his repertory of motifs. Where the antiques are concerned, it is possible that he may have been contemplating some form of publication on ancient sculpture. But as the sources for most of the drawings are

engravings already in books, this suggestion is not very persuasive. It seems equally unlikely that these highly academic exercises were undertaken by Rowlandson merely for his own pleasure. Whatever the purpose of these various copies, they indicate an awareness of earlier European art that would not be suspected from the more familiar facets of his work.

There is a final side of Rowlandson's oeuvre that is revealed in the Huntington collection—although less fully than one would like—his work as a portraitist. Judging from the early (but lost) exhibits at the Academy, portraiture was the art form that most occupied Rowlandson's time at the outset of his career, during the late 1770s and first years of the 1780s.[18] Unfortunately there are no portrait drawings by Rowlandson now known that may be definitely dated to these years, and in view of the different techniques he was employing and the changes in his techniques taking place at that time it would be foolish to speculate on the appearance of these portraits. We are on somewhat firmer—but not really solid—ground in the mid-1780s. The touchstone for this period is usually regarded as the full-length portrait drawing of George Morland in the British Museum, to which the Huntington *Portrait of a Man with a Gun* (No. 86) is related. Assuming that these somewhat problematic drawings are in fact by Rowlandson, he is here working with a type of small full-length watercolor portrait associated primarily with artists like De Wilde, Edridge, Dighton, and (to some extent) Cosway. The origin of this type of portrait is, of course, the Conversation Piece of the second quarter of the eighteenth century—another detail underlining Rowlandson's affiliations with his rococo predecessors. Most of the other men working with this type of watercolor portrait are active in the 1780s and later. If Rowlandson's portraits of the 1770s were in this same manner, then he would be among the early artists to shift this type of portraiture from an oil to a pen and watercolor medium. Further clarification concerning this facet of Rowlandson's career is needed, but must await the appearance of additional related material. He seems to have given up this type of portrait drawing after the mid-1780s. The *Seated Woman* (No. 124), which both on the basis of technique and costume must be close to 1800 in date, is unusual. But it also suggests at least one reason why Rowlandson had less to do with portraiture as his career developed. As his pen work became more settled in its bouncy, cursive manner it became less capable of capturing the eccentricities of a particular face without slipping into caricature.

The *Seated Woman*'s face is so generalized that the question of whether it is a portrait of a specific person is difficult to determine; Rowlandson's mature line does not lend itself readily to portraiture.

In addition to providing insight into Rowlandson's thematic range and interests, the Huntington collection offers probably the most comprehensive and detailed view available anywhere of his technical procedures. In technique Rowlandson is essentially a line draftsman, at his best the most distinguished performer in that medium that England has produced. To many perceptive critics the essence of Rowlandson's appeal lies in his uncanny abilities with his pen, and the themes with which he deals are of interest only insofar as they offer him opportunities for the display of his calligraphic control. This is an oversimplified view, but there can be no doubt that any approach to Rowlandson that ignores his extraordinary gifts as a draftsman misses the most important quality that sets his art so far above that of dozens of his contemporaries with similar interests.

Rowlandson's drawings are normally created in a combination of pen and watercolor with preparatory pencil underneath. It is almost inevitable that, as a professional artist, he must have experimented with oil and pastel, but nothing indubitably from his hand has been identified in these other media. He used pencil constantly, and some remnant of it can be found on nearly all his drawings that did not begin as counterproofs. It is apparent, particularly from the many late, unfinished drawings in the Huntington Collection, that pencil is the normal foundation for a Rowlandson design. But it is only on very rare occasions that he develops a drawing fully in pencil; usually it is merely a guideline to the pen and watercolor, to be obliterated or actually erased as the drawing develops. The group of 1784 political caricatures (Nos. 4-9), which are executed in pencil alone, is unusual. Possibly it was their ephemeral character, dealing with current events, that prompted Rowlandson to leave the drawings in pencil. And it may be for this same reason that so few of his preparatory studies for political cartoons survive. Even more unusual is the fully developed landscape (No. 191) in soft pencil or charcoal. Were it not for the presence in the Ashmolean Museum of another drawing in precisely the same technique with what appears to be an authentic signature, there would be little reason for attributing this study to Rowlandson. It is worth noting, however, that a similar use of pencil shading (although in conjunction with pen outline) appears in *Time, Death, and Eternity* (No. 327) from *The English Dance of Death*. Probably there are more

16

pencil drawings by Rowlandson that have escaped detection because they are, in general appearance, so unlike his normal work in pen and watercolor. But it is unlikely that enough new material will appear to overturn the conclusion that he had little interest in pencil as a medium for itself.

The combination of pen and watercolor in the normal Rowlandson drawing was developed early in his career and then retained with little modification until his death. But the first drawings we have by Rowlandson do not exhibit this combination. His early figure studies, of which *The Dissection* (No. 2) is a good example, are usually in pen alone, or pen with monochrome wash. In these drawings he follows the technique of J. H. Mortimer, whose work enjoyed great popularity during the 1770s and was imitated by several artists. The contours of the figures are constructed with firm, continuous pen lines; modeling is created with hatching and stippling; the backgrounds are filled in with patterns of hatching. The distinctive feature of Rowlandson's technique in relation to Mortimer's is that the contour lines take on greater prominence and develop a highly personal calligraphic flexibility, a swelling and contracting that gives the line intrinsic interest, and is also used by Rowlandson to assist in modeling the forms. Rowlandson's pen work is consistently more robust than Mortimer's, without the latter artist's somewhat finicky delicacy and refinement.

The origins and character of Rowlandson's early use of watercolor are less easy to pinpoint. If the topographical drawings in the early Huntington sketchbook are in fact by Rowlandson, as they certainly appear to be, then he apparently first used watercolor in landscape studies, and was doing so at the same time he executed the early figure drawings in pen alone. The date when Rowlandson combined these two techniques in figure drawings, and the reasons that led him to do so, remain possibly the most interesting unanswered questions in connection with his artistic development. The assumption that this combination, once made, was never abandoned is probably correct, although some wavering might be expected, and it is entirely possible that some figure drawings executed in pen alone or pen and monochrome wash date after Rowlandson's first successes in combining pen and full watercolor. This marriage was certainly achieved by 1784 when Rowlandson produced the drawings for *A Tour in a Post Chaise*, as well as his two exhibition masterpieces for that year, *Vauxhall* and *The Serpentine River*. The complete assurance in handling the pen and watercolor combination that characterizes all these drawings suggests some previous experience. Probably one would not be

far wrong in guessing that it was about 1782 when Rowlandson began experimenting with the mixed technique that he subsequently adopted as the standard one for the rest of his long career.

The tinted pen figure drawing was certainly not Rowlandson's invention. It was common in English art for at least twenty years before Rowlandson used it, and had been applied specifically to comic figure drawing by men such as Collet and Brandoin as early as the beginning of the 1770s.[19] The problem with Rowlandson is less in explaining why he should have adopted this technique than in explaining why he was so slow to do so, especially as he must have encountered pen and watercolor drawings frequently during his student days. One more or less unknown factor that may hold answers to some of the riddles of Rowlandson's early career is his good friend Henry Wigstead. Wigstead has usually been dismissed as an amateur who may have supplied some ideas to Rowlandson but who does not really exist as an independent draftsman. This view needs to be revised. Recently a few drawings have surfaced that bear Wigstead's signature, are very close in technique to Rowlandson's early pen and watercolor sketches, but are patently not by Rowlandson himself. Much the most important of these is *John Gilpin's Return to London*, signed and dated 1785, in the Victoria and Albert Museum.[20] When looking at this drawing one is inclined to assume that Wigstead must have been more or less taking lessons from Rowlandson, and this may well be the truth. But it is worth remembering that Wigstead was certainly older than Rowlandson (by exactly how much we don't know) and that his association with the younger man appears to go back at least to 1774, when his initials appear on a print that is usually attributed to Rowlandson.[21] One would give a good deal to be able to trace the artistic relationships between Wigstead and Rowlandson from the mid-1770s to the mid-1780s. It might well be that nothing of interest would emerge; but there is a possibility that some explanations for Rowlandson's artistic vagaries during this decade would be forthcoming.

Tracing the evolution of Rowlandson's draftsmanship from the first glimpses we get of it in the late 1770s until his death half a century later is not unlike tracing the evolution of someone's handwriting over a comparable period. There are certainly changes and developments, but they operate within the limits of a single, strong, and well-formed personality. The most conspicuous changes, which come in the pen line itself, may be the result of nothing more than different writing equipment, equivalent to the differences between a nib and a ball-point pen. In his early work

23. HEAD AND TAILPIECE

(through much of the 1780s) Rowlandson prefers to use a single pen stroke to define contours and works with an instrument that has marked flexibility. The *Tailpiece* (No. 23) from *Tour in a Post Chaise* is an excellent example of this type of Rowlandson draftsmanship at its best. There are occasional instances of multiple contours in his early work, especially in the portrait drawings (see, for instance, No. 83), where a less flexible instrument has been used, but these are comparatively rare.

As Rowlandson grows older his line becomes more complicated; he works over the contours of his drawings with different instruments and the single, pulsating line of the 1780s disappears. From about 1800 on the secondary pen strokes become much coarser than the basic outlines and are often made in a dull red ink. These coarse strokes normally are used to strengthen shadowed areas of the contour, and may occasionally be used for modeling within the basic outlines. *'Tis Time to Jump Out* (No. 139) is a typical example of this more sophisticated type of pen work characteristic of Rowlandson at mid-career, about 1800.

In the last decade or so of Rowlandson's life the initial pen outlines become very thin and spidery. Usually this line is reinforced with others in the finished drawing. An excellent example of this late manner is *The Band* (No. 478), an unfinished drawing without watercolor or the additional reinforcing lines normally present in a completed picture. Rowlandson's late, thin, wiry line is troublesome to students. It normally occurs where a tracing from another drawing is involved. It is very impersonal and mechanical, and frequently clumsy and inapt in defining the forms. From the standpoint of Rowlandson's reputation as a draftsman it would be fortunate if this line could be assigned to the hand of a copyist, someone employed by Rowlandson late in life to make outlines of his drawings which he could then work up himself with watercolor and a little more pen work. This is an appealing and, on the surface, a plausible suggestion which may yet turn out to be true. But at present there is not a shred of hard evidence to support the idea that Rowlandson ever employed assistants, whereas there is ample proof (to be explored below) that he himself was constantly making copies of his own drawings. A suggestion was put forward tentatively by Oppé, on the basis of an inscription on some drawings in the Ashmolean Museum, that copies of Rowlandson's drawings were made during his lifetime by a Miss Howitt.[22] But this suggestion has been shown to rest on a misinterpretation of a notation in an account book by Francis Douce, who gave the drawings to the Ashmolean.[23] The problem would, of course, take on a different com-

plexion entirely if a group of drawings in this technique should be found on paper watermarked after Rowlandson's death. Several drawings (including *The Band*) are known on paper watermarked 1826, Rowlandson's next to last year, but nothing later has appeared.

The evolution in Rowlandson's pen work is probably no more difficult to explain than changes in the handwriting of any normal person over a fifty-year period. But there are various external factors that may have exerted some influence. One of these is the great popularity of neoclassic linearism in the early part of the nineteenth century. The type of impersonal, clean outline associated with Flaxman, for instance, is very similar in character to Rowlandson's late line. The great popularity of outline drawings of the Flaxman type may have encouraged Rowlandson to adopt a similar technique. The more impersonal type of line is also readily reproduced in etching and engraving. Much of Rowlandson's late work was undertaken with commercial prints in mind, and this may have been a factor in determining his late technique.

There is less variation in Rowlandson's use of watercolor than in his pen work, but the watercolor washes also tend to become more sophisticated in later years. The early washes are broadly applied and seldom worked over. In later drawings Rowlandson occasionally uses color for modeling, applying washes on top of each other to create a much more complicated surface. The face of the recently ennobled breeches maker (No. 140) is a good example of this tendency in his work of the early nineteenth century. Rowlandson's color is consistently on the pretty and decorative side, although he is more likely to use primary reds and blues early in his career and mixed pastel shades later. But on the whole one is more impressed by how consistent he is in his use of watercolor over a forty-five year period than by changes and developments.

There can be no simple answer to the question of the order in which Rowlandson used pen and watercolor in the creation of a drawing. Unfinished sketches in the Huntington Collection may be produced to support the suggestion that watercolor sometimes preceded pen (No. 79), that pen sometimes preceded watercolor (No. 491), and that pen and watercolor were occasionally being used almost simultaneously (No. 232). The evidence suggests that in the early part of his career the application of watercolor was more likely to precede pen. By the end of his life the wiry pen line normally was completed before watercolor was added. But even at this stage it seems probable that the reinforcing pen lines were the last stage in the creation of a drawing.

21

139. 'TIS TIME TO JUMP OUT

Rowlandson was not a great master of composition, although he is competent in this matter, and usually creates a satisfactory effect, especially in the grouping of his figures. He has a limited repertory of devices which he develops early and then uses throughout his career. He is quite capable of organizing a composition in depth, but his normal preference is for a frieze-like arrangement of figures across the picture area, an arrangement that offers maximum opportunity for the development of narrative incident. Rowlandson also likes to animate the whole area of a picture with squiggles of one kind or another to interest the eye and lead it a "wanton kind of chace"—a tendency he inherits from his rococo predecessors and which increases in his later work. Indeed Rowlandson's principles of composition are very much in the rococo tradition of overall, surface animation. In this matter he swims with the interesting undercurrent of rococo art that continues to flow through the late eighteenth century, to surface in the "painterly picturesque" paintings and drawings of about 1800.

There are a few instances in which Rowlandson's pictorial composition clearly strengthens the mood of the picture. Among the Huntington drawings *The Scots Greys at Waterloo* (No. 237) is a good example, with the thrust of the foreground figure's sword reinforced by the charge of cavalry down the crest of the hill. The symmetrical organization of figures in *The Registry Office* (No. 135) is an important factor in enhancing the humor of that drawing. But this type of clear relation between composition and expression is rare, except, of course, for the fact that the overall animation of the normal Rowlandson composition is in complete accord with the type of general confusion he often depicts.

Reference has already been made to Rowlandson's repetitions of his drawings. This is a problem of great importance when considering his technical procedures, and one that can be studied in detail in the Huntington Collection. It is only in recent years that the nature and full extent of Rowlandson's repetitions have become known. The evidence, both documentary and internal, has always been there but was neglected until systematic investigation of particular Rowlandson projects was undertaken. The title page of the sale of his effects, which took place at Sotheby's in 1828, states that the drawings included are "many of them the originals from which he made duplicate drawings," indicating clearly enough that his contemporaries knew that he made repetitions. We now recognize that any Rowlandson drawing of importance is likely to exist in more than one version, and, although this situation is more prevalent for his late work,

it clearly exists throughout his career. The repetitions are of many types. Comparatively few are free variants in which Rowlandson drew a subject again without recourse to any copying aids. Most of the repetitions began as tracings, a connection which can be readily verified in the Huntington Collection by holding up to a window two superimposed sheets with the same subject. Rowlandson was also adept at reducing or enlarging his drawings by means of a pencil grid. Many of the *Dance of Death* drawings in the Huntington Collection bear remnants of pencil squares that correspond precisely in position on repetitions of drawings at different scale. In these instances the repetitions are almost certainly reductions to the size required for the prints.

The most distinctive and interesting of Rowlandson's methods of duplicating his drawings was counterproofing. Here again, the *Dance of Death* drawings and others in the Huntington Collection provide very explicit evidence concerning how he proceeded. Counterproofing was widely practiced by eighteenth- and nineteenth-century artists, but usually the drawings involved were executed in pencil or some medium that left a similar granular deposit on the paper. The artist placed a piece of soft paper on top of his drawing and then, by rubbing the back of the top sheet, obtained an impression from the original. Frequently the counterproof would be worked over in the medium of the original. The counterproof would, of course, be a reverse image. Rowlandson knew how to make a counterproof of a pencil drawing, as is clearly indicated by the 1784 political caricatures in the Huntington Collection (Nos. 6 and 7 *verso*). But most of his counterproofs were made from his inked outlines. This seems to have been a personal variant in counterproofing which Rowlandson developed himself, and it has not yet been detected in the work of other artists. Although the internal evidence indicates conclusively that Rowlandson must have made these counterproofs himself, there is also documentary support for this contention in an account printed in *Notes and Queries* (Ser. 4, Vol. IV, p. 89) for 1869. The article is signed W.P., who may be identified with reasonable certainty as Wyatt Papworth, the younger son of J. B. Papworth, closely associated with Rowlandson's publisher, Ackermann, and consequently in a position to know what he was talking about.[24] This account has been reprinted a couple of times in recent Rowlandson literature and need not be quoted again here.[25] It states unequivocally that Rowlandson made the counterproofs himself, that he considered them "originals," and that he frequently drew several counterproofs from the same drawing while the ink was still wet. He

would then "reline the replicas and . . . tint them according to the fancy of the moment."

The evidence from the drawings in the Huntington Collection enables us to make a few refinements in this account. The idea that Rowlandson would be able to pull more than one counterproof from an ink drawing seems improbable, and no evidence has yet appeared that he did in fact do so. While it is logical to assume that the counterproof was pulled while the ink was still wet, this supposes that the original pen drawing must have been executed with unbelievable rapidity. There is also clear evidence in the Huntington Collection that counterproofs were occasionally pulled from drawings to which watercolor had already been applied (No. 206, for instance). The only explanation seems to be that a counterproof could be taken at almost any time by using a damp paper which would partially reactivate the ink. But it is equally evident that counterproofs were frequently pulled while work on the original drawing was in progress, as several of the originals have lines added after the counterproof was taken (Nos. 267 and 268).

All these mechanical and semimechanical methods of duplicating drawings grate against our current idea of the creative process and the freedom and spontaneity that we normally think of as embodied in drawings. It is to Rowlandson's credit that even in these repetitions much of the verve and vigor of his line are retained. The creation of the repetitions reminds us forcefully that the drawings were Rowlandson's principal source of income. The idea of a drawing as a private, informal notation made by an artist for his own personal use and pleasure does not apply to Rowlandson's vast output. His drawings were articles of commerce. It is significant that although there are hundreds of unfinished Rowlandson drawings there are very few that may be classed as preparatory working sketches. One certainly hopes that Rowlandson derived personal pleasure from drawing; considering his incredible productivity his life would otherwise have been misery. But there is very little evidence that he drew primarily for his own pleasure and satisfaction. Rather, he had in mind the pleasure of others, and his pocket book.

There is so much to enjoy in Rowlandson's work, he is so productive and versatile, that it may seem he should have nothing but praise from a critic. At his best he is a brilliant draftsman, a delightful humorist, an attractive landscapist, a charming genre artist; and he also operates, although less successfully, in portraiture and more serious forms of narra-

tive art. As a line draftsman and humorist he is probably the finest that England has produced, and he occupies a respectable place both as a genre artist and a landscapist. Perhaps it is the very fact that he is so talented and versatile that makes us a little dissatisfied with his work in the aggregate, sensing great potentialities that are never fully realized. As a draftsman his early work is his best. There are brilliant passages in his drawings at any point in his career, but there is much sloppy and inferior work as he grows older. The control and economy in drawing which one usually regards as the result of a lifetime of practice he acquired very early; as a draftsman he never did anything better than his work in 1784, and from this standpoint the remaining forty years of his career are an uninterrupted and steady decline. There is no other British artist with a wider understanding and command of the sources of humor in art; but this knowledge is rarely integrated into a forceful and memorable picture. The problem here may be a lack of conviction and commitment on Rowlandson's part. He seldom uses humor for a satirical purpose, and when he does it is never with the bite of Hogarth or Gillray. One is left with the impression that Rowlandson does not feel, or think, very deeply. The sheer quantity of his work is in the end rather depressing. What seems at first glance an almost incredibly rich and fertile array becomes frequently repetitious on closer examination; the great quantity of Rowlandson's copies of his own works is not in accord with our idea of creative artistic activity. For these reasons one hesitates to class Rowlandson as a great artist. But he certainly holds an honorable position on the fringes of that select company, and with so many valid claims to our respect and admiration it is most unlikely he will ever be dislodged.

96. A FRENCH FRIGATE TOWING AN ENGLISH MAN O' WAR INTO PORT

References

[1]The fullest Rowlandson bibliography is a typescript compiled by Catherine Nicholson, of which copies are on deposit in the Print Room of the Boston Public Library, the Art Reference Library of the Henry E. Huntington Library and Art Gallery, and the Princeton University Library. For a briefer but more readily accessible note on Rowlandson bibliography see John Hayes, *Rowlandson Watercolors and Drawings* (London, 1972), p. 209.

[2]Edward C. J. Wolf, *Rowlandson and his illustrations of eighteenth century English literature* (Copenhagen, 1945). *Rowlandson's Drawings for a Tour in a Post Chaise*, with an Introduction and Notes by Robert R. Wark (San Marino, Calif., 1964). *Rowlandson's Drawings for the English Dance of Death*, with an Introduction and Notes by Robert R. Wark (San Marino, Calif., 1966).

[3]Joseph Grego's two-volume *Rowlandson the Caricaturist* (London, 1880), comes close to being a catalog raisonné of Rowlandson's prints, but the book needs to be thoroughly revised and enlarged.

[4]C. H. Collins Baker, *Catalogue of William Blake's Drawings and Paintings in the Huntington Library*, rev. and enl. by R. R. Wark (San Marino, Calif., 1957).

[5]*Isaac Cruikshank's Drawings for Drolls*, with an Introduction and Notes by Robert R. Wark (San Marino, Calif., 1968).

[6]See Robert R. Wark, *Early British Drawings in the Huntington Collection 1600-1750* (San Marino, Calif., 1969), p. 17, B.

[7]Wark, *Tour*, p. 6.

[8]Wark, *Dance of Death*, p. 14.

[9]Rowlandson's exploitation of contrasts is one of the principal themes developed by Ronald Paulson in *Rowlandson: A new interpretation*, (New York, 1972).

[10]In *The Lady's Last Stake*, for instance, there is a nicely contrived contrast between the elegant interior, the young man's courtly deportment, and the proposition he is making to the lady. Also, the two dogs chained together in Scene I of *Marriage à la Mode* comment on the scene depicted in much the same way as the two dogs in the background of *The Registry Office*.

[11]For an illustration see Ronald Paulson, *Hogarth: His Life, Art, and Times* (New Haven, 1971), Vol. II, Fig. 268.

[12]For an illustration see Ellis Waterhouse, *Reynolds* (London, 1973), Fig. 12.

[13]For an illustration see *The Works of James Gillray* (London, 1968, rep.), Fig. 86.

[14]For an illustration see M. Dorothy George, *English Political Caricature to 1792* (Oxford, 1959), Pl. 75.

[15]Paulson, *Rowlandson*, p. 19, suggests a similar tension between title and image in Hogarth's *Midnight Modern Conversation*, but the humor there seems less explicit than in Rowlandson.

[16]Quoted from Mary Dorothy George, *Catalogue of Political and Personal Satires . . . in the British Museum* (London, 1935), V, xxxiv.

[17]A doctoral dissertation on Rowlandson's landscapes was submitted to Tübingen University by Idis Birgit Hartmann in 1971, *Thomas Rowlandson: Stilphasen in seinen Landschaftsdarstellungen.*

[18]Of the eight works exhibited by Rowlandson at the Royal Academy before 1784, five are clearly designated as portraits.

[19]See Robert R. Wark, *Ten British Pictures 1740-1840* (San Marino, Calif., 1971), p. 73.

[20]Reproduced in Hayes, op. cit., Fig. 41. See also Wark, *Tour*, pp. 17-18 and Fig. 3.

[21]Grego, op. cit., I, 96-97.

[22]A. P. Oppé, *Thomas Rowlandson his Drawings and Water-colours* (London, 1923), p. 27.

[23]Wark, *Dance of Death*, pp. 19-25.

[24]Ibid. p. 18.

[25]Ibid. p. 18; Hayes, pp. 41-42.

Catalog

THE GENERAL ARRANGEMENT of the Catalog is chronological; but it is not possible to be precise in this matter. Fortunately a substantial number of the drawings are dated, or datable on various types of internal and other evidence. These provide pegs on which the rest of the drawings have been hung, primarily on the basis of technique. Drawings that are closely related thematically have usually been grouped together even if (as is the case with the copies after earlier pictures, or the landscapes, for instance) there is reason to believe they were executed over several years. Watermarks have been recorded only when dated.

Abbreviations used in the Catalog

Arts Council (1950)
: *Watercolours & Drawings by Thomas Rowlandson,* The Arts Council, London, 1950

Bury
: Adrian Bury, *Rowlandson Drawings,* London, 1949

Falk
: Bernard Falk, *Thomas Rowlandson: His Life and Art, London,* n.d. [1949?]

George
: Mary Dorothy George, *Catalogue of Political and Personal Satires . . . in . . . the British Museum,* London, Vol. VI, 1938; Vol. VII, 1942; Vol. VIII, 1947; Vol. IX, 1949

Grego
: Joseph Grego, *Rowlandson the Caricaturist,* London, 1880

Gully
: Anthony L. Gully, "Thomas Rowlandson's Doctor Syntax," (Ph.D. diss., Stanford University, 1972)

Hayes
: John Hayes, *Rowlandson Watercolours and Drawings,* London, 1972

Oppé
: A. P. Oppé, *Thomas Rowlandson his Drawings and Water-colours,* London, 1923

Paulson
: Ronald Paulson, *Rowlandson: A new interpretation,* New York, 1972

Roe, F. Gordon
: *Rowlandson: The Life and Art of a British Genius,* Leigh on Sea, 1947

Sabin (1933)
: V. P. Sabin *A Catalogue of Watercolour Drawings by Thomas Rowlandson,* Frank T. Sabin, London, 1933

Sabin (1938)
: *Catalogue of an Exhibition . . . of Drawings by T. Rowlandson,* Frank T. Sabin, London, 1938

Sabin (1939)
: *Drawings by Thomas Rowlandson,* Frank T. Sabin, London, 1939

Sabin (1948)
: Philip Sabin, *A Catalogue of Watercolour Drawings by Thomas Rowlandson,* Frank T. Sabin, London, 1948

Wark *Dance of Death*
: *Rowlandson's Drawings for the English Dance of Death,* with an Introduction and Notes by Robert R. Wark, San Marino, California 1966

Wark *Ten British Pictures*
: Robert R. Wark, *Ten British Pictures 1740-1840,* San Marino, California, 1971

Wark *Tour*
: *Rowlandson's Drawings for a Tour in a Post Chaise,* with an Introduction and Notes by Robert R. Wark, San Marino, California, 1964

1. SKETCHBOOK

Half contemporary brown calf, boards covered with English marbled paper, back cover detached, 8¾″ x 14″, thirty-two leaves

Paper label on spine inscribed in early script: Sketches by Rowlandson

Collections: The book was in the "Various Properties" section of a Sotheby sale, 19 July, 1973, lot 64, cataloged as "a volume of landscape and caricature studies by, or attributed to, F. Grose, T. Rowlandson, and other hands." It was acquired at that time by the London dealer, Andrew Edmunds, who seems to have been the one person on the spot to recognize the true nature of the book. The sketchbook was purchased by the Huntington Art Gallery from Mr. Edmunds, who also generously made available his own notes on the book.

Acquired: 1974
Accession Number: 74.11

Notes on the Sketchbook as a whole
(a) Physical composition of the sketchbook

It is obvious that the sketchbook is a made-up affair, and also that about half the pages originally in it have been cut out. There can, however, be no doubt that it was bound during Rowlandson's lifetime, and that some of the sheets in it were used by him both before and after they were bound.

Torn stubs and the numbering on the sheets indicate that the book when first bound probably consisted of seventy-two leaves. The initial twenty-four (of which twenty now remain) were tipped onto stubs of the sheets which comprised the bulk of the book. These first twenty-four are on paper with varying watermarks: English, Dutch for the English market, and Continental (The Chateau de Madrid sheet). None of the watermarks is precisely datable; all belong to the late eighteenth century. These sheets appear to have been numbered before binding, as in three instances the numbers are on the verso or upside down.

One may surmise that Rowlandson gave these twenty-four sheets to a binder who then made up the volume, adding forty-eight leaves of blank paper (watermark C. Taylor). But it is evident Rowlandson continued to work on these early sheets after they were bound because in several instances washes cross from the sheet onto the stub. The sequence of pen sketches of a man in a carriage that occurs on the versos of the early sheets reinforces the suggestion that Rowlandson continued to work on these sheets after they were bound.

The facts that the first of the bound-in—as distinct from the tipped-on—sheets (Lady Pelham's, sheet U) carries a drawing that continues the architectural sequence on the tipped-on sheets, and that the drawing, on internal evidence, probably dates not later than 1780, suggest that the book was bound at least by that time, and that the tipped-on sheets precede that date.

(b) Thematic material of the sketchbook

There are two primary sequences of drawings; one running from the front (as the pages have been numbered), the other from the back. The first sequence is a series of views of buildings, principally, insofar as they can be identified, houses in and around London and in southern Hertfordshire. The one clearly non-English building is the Chateau de Madrid, Paris. These drawings represent a hitherto unknown but not entirely unsuspected facet of Rowlandson's early career. Topographical interests continue sufficiently strong in later work (such as the *Tour in a Post Chaise*, 1784, and the "Environs of London" drawings ca. 1820) that evidence of early training in this genre should not cause much surprise.

The drawings in the second sequence, running from the back of the book forward, are figure subjects. They are generally less fully worked out than the landscape drawings. Several are concerned with the theater; a whole sequence is devoted to studies of a man driving a carriage.

(c) The techniques used in the sketchbook

The figure studies are in techniques that are normal for early Rowlandson drawings. All, except the studies of a man driving a carriage, began in pencil. Those that are carried on further are worked out either in pen or a combination of pen and monochrome wash. The topographical drawings also all began in pencil. Some have then been worked out in pure pen with hatchings of parallel lines of the type Rowlandson used in early figure drawings. Others have wash added without pen. A few are in pen and wash. The wash stays within a very limited color range and is usually monochrome. The characteristic looping, rhythmic

brushwork which Rowlandson had developed for landscape backgrounds by 1784 is not in evidence. The one drawing in the book that uses full water-color is the one drawing that looks as if it may have been tampered with by a later hand (V verso).

(d) Inscriptions in the sketchbook

With one exception all the inscriptions are in pencil. The handwriting appears to be identical with samples of Rowlandson's writing in pencil and pen on other early drawings in the Huntington collection (particularly the *Tour in a Post Chaise* and the 1784 political caricatures). One very tantalizing inscription, largely erased and illegible, appears to contain the date August 1776 (N verso).

(e) The date of the sketchbook

It appears that the sketchbook was used over several years, and that the two principal sequences of drawings are some distance apart in time. Internal evidence connected with some of the topographical sketches (M, O, U) suggests that these were done before 1780. It is not clear how much weight should be attached to the undecipherable inscription that appears to contain the date 1776.

The figure drawings appear to be slightly later in date than the topographical studies; the costumes and coiffures suggest ca. 1780. The one dated drawing in the book (U verso, 1787) is the only sheet that obviously has been tipped in after the book was bound, and the date is thus of no significance for the rest of the sketches.

The outside extremes in date for the sketchbook are probably 1774 (if the *Chateau de Madrid* drawing was made on Rowlandson's first trip to Paris) and 1784 (by which time Rowlandson's technique in both figure and landscape drawing had matured beyond the level of work in the sketchbook). After assessing all the fragments of evidence it appears probable that the topographical drawings date from the mid-1770s and the figure studies from ca. 1780.

(f) Attribution of the sketchbook

Although there is much in the sketchbook that is not characteristic of Rowlandson's early work as hitherto known, there seems no reason to doubt that all the sketches are by him. The figure studies are within the range of his accepted early work. The topographical studies are more problematic, but there is nothing about any of them that precludes Rowlandson's authorship, and much that supports it. The inscriptions all appear to be in his handwriting; the pen work relates closely to at least one accepted early Rowlandson drawing (Hayes, Pl. 2); the drawings suggest a tour of a type which we know Rowlandson enjoyed.

(g) Conclusion

The sketchbook contains the only substantial cache of Rowlandson's early work (pre-1784) now known. It enlarges our knowledge of the artist's beginnings, suggesting in particular strong early interests in topography and in the theater. The book also suggests that Rowlandson was prepared to experiment with various techniques early in his career. Generally the book indicates that Rowlandson's beginnings were more complicated and varied in character than has hitherto been supposed.

CATALOG OF THE DRAWINGS IN THE SKETCHBOOK

A. A Country House with Three Horses Grazing in the Right Foreground

Gray wash over pencil, 7⅞" x 11⅞", tipped onto a stub

Inscribed: 2

Verso: slight pencil sketch of a building with stooks in the foreground

Verso inscribed: A View of Whores Palace

B. A House by a River

Gray and yellow wash over pencil, unfinished, 7⅞" x 12½", tipped onto a stub

Inscribed: 3

Verso: three pen sketches of a man driving a carriage; some trees sketched in pencil

C. Farmhouse with Three Dormers and Stables to Right

Gray wash over pencil, 7⅞" x 12¾", tipped onto a stub

Verso: pencil sketch of a manor house and tree

Verso inscribed: 6/ Duke of Brigewaters [sic] in Herts

NOTES: The view on the verso is the north front of Ashridge, Little Gaddesden, a seat of the Duke of Bridgewater in the eighteenth century.

D. Fulham Palace

Brown wash over pencil, 7⅞" x 12½", tipped onto

a stub, the wash continuing onto the stub
Inscribed: Bishop of London/ at Fulham/ 7
Verso: two pen sketches of a man driving a carriage

E. A Wall and Wrought Iron Gate
Gray wash over pencil, 7¾″ x 13″, tipped onto a stub, the wash continuing onto the stub
Inscribed: Near Acton/ 9
Verso: pen sketch of a man driving a carriage

F. A Farmhouse with a Wooden Fence in the Foreground
Gray, brown, and yellow wash over pencil, 7¾″ x 12⅞″, tipped onto a stub
Inscribed: Near Acton/ 10
Verso: pen sketch of a man driving a carriage

G. A Cart in a Shed under Trees
Pen over pencil, 7⅞″ x 11⅝″, tipped onto a stub
Verso: pen sketch of a man driving a carriage

NOTES: Compare the technique in the recto drawing with that in Hayes Pl. 2.

H. A House behind a Wrought Iron Fence and Gate
Pen and gray wash over pencil, 7⅞″ x 13″, tipped onto a stub
Inscribed: near Highgate
Verso: pen sketch of a man with a whip

I. Gabled Cottage near a Tree
Pencil, 7⅞″ x 13″, tipped onto a stub
Inscribed upside down, lower left corner: 13
Verso: slight pencil sketch of trees by a gatepost

J. Darly Church
Gray wash over pencil, 7⅝″ x 12¼″, tipped onto a stub, the wash continuing onto the stub
Inscribed: Darly Church/ Derbyshire/ 14
Verso: slight pen sketch of a man with a whip

NOTES: The church is St. Helen, Darley Dale. I am indebted to John Harris for this information.

K. Thatched Farm Buildings
Gray wash over pencil, 8″ x 12⅞″, tipped onto a stub, the wash continuing onto the stub
Inscribed: 15

L. Lady Essex's House
Gray wash over pencil, 8″ x 12⅞″, tipped onto a stub
Inscribed: Lady Essexs near/ Kings Langley Herts/ 16
Verso: pencil drawing of garden front of Moor Park [see O and Q]

NOTES: No information on "Lady Essex's House" has been located. The Dowager Lady Essex lived at Kings Langley until her death in 1784.

M. A Country House near Northchurch
Gray, brown, and yellow wash over pencil, 8″ x 12⅞″, tipped onto a stub
Inscribed: near Northchurch Herts
Verso: Lord Clarendon's House
Pen over pencil
Verso inscribed: Lord Clarendons near Watford in Hertfordshire/ 17

NOTES: Thomas Villiers (1709-1786) was created Earl of Clarendon 14 June 1776. The house is The Grove, Watford, and the drawing shows it before the addition of a third story and another wing. Nikolaus Pevsner, *The Buildings of England, Hertfordshire* (London, 1953), p. 268, indicates that additions were made ca. 1780 and again ca. 1850, but does not state what was added when.

N. A Country House with Four Corner Pavilions; Probably Not English
Gray wash over pencil, 8″ x 12⅝″, tipped onto a stub
Inscribed: 18
Verso: pencil sketch of a street scene with carts
Verso inscribed in pencil with four lines almost obliterated. The first, and only readable line is: £ 13.13 N 359 [undecipherable] Bank 8[?] Aug. 76

NOTES: The inscription is of great interest in suggesting a possible date when the sketchbook was being used.

O. Front of Moor Park, Herts
Pencil, 8″ x 12⅞″, tipped onto a stub
Inscribed: Front of Sir Lawrence Dundas /19
Verso: pencil sketch of a gate, and pencil and wash sketch of a farmhouse. The gate appears to be

that to Moor Park. I am indebted to John Harris for this suggestion.

NOTES: Moor Park is generally regarded as the grandest of the eighteenth-century mansions in Hertfordshire (see Pevsner, op. cit., pp. 170-71). Rowlandson's sketch shows the side wings added 1763-64 and demolished 1785. Sir Lawrence Dundas died in 1781.

P. Canons Park, Stanmore, Middlesex[?]
Gray wash over pencil, 7⅞″ x 12⅞″, tipped onto a stub
Inscribed: 20
Verso: slight architectural pencil sketch

NOTES: I owe the suggestion that the house may be Canons Park to Luke Herrmann. No view of the house corresponding to the drawing has been located, but the identification seems probable. Canons Park was erected by the cabinet maker Hallett, partly with materials from the Duke of Chandos' Canons.

Q. Garden Front of Moor Park
Gray wash over pencil, 8″ x 12⅞″, tipped onto a stub, the washes continuing onto the stub
Inscribed: Back View of Sir Lawrence Dundass/ at Moor Park. Herts /21
Verso: slight architectural pencil sketch

NOTES: See under (O)

R. Farmyard Buildings
Pen over pencil, 7¾″ x 11⅞″, tipped onto a stub
Inscribed: 22

S. Porch of a Parish Church
Pencil, 8″ x 12⅞″, tipped onto a stub
Inscribed: 23
Verso: pencil sketch of a barn with trees

T. Chateau de Madrid
Pen and watercolor over pencil, 8⅛″ x 13″, tipped onto a stub
Inscribed: Chateau De Madrid dans le Bois de Boulogne a Paris /24
Verso: vague pencil scribble

NOTES: This famous building from the reign of Francis I was ordered demolished in 1778, but was not actually pulled down until 1795.

This is the only unequivocally Continental subject in the sketchbook. Rowlandson was in Paris as a student, probably in 1774, and was apparently there again in 1782. If the sketch is from the first trip it is the earliest drawing by Rowlandson known. Unfortunately there is no definite evidence to determine to which trip the drawing belongs, or (for that matter) to prove that the sketch was done on the spot.

U. The Queen's House, Greenwich
Pencil, 8¼″ x 13½″ (from this point on the drawings are on sheets bound into the volume)
Inscribed: Lady Pelhams in Greenwich Park/ 25
Verso: Pencil drawing of a seated girl, on sheet 9⅛″ x 7¼″, tipped on. Signed and dated: Rowlandson 1787

NOTES: Lady Catherine Pelham occupied the Queen's House from 1743 until her death in 1780. See George H. Chettle, *The Queen's House, Greenwich* (the fourteenth monograph of the London Survey Committee), pp. 86-87.

V. Greenwich from the River
Pencil, 8¼″ x 13½″
Inscribed: 26
Verso: sketch of three women and a man (in a theater box?), pencil and watercolor

NOTES: The watercolor used on the verso is the one instance of full watercolor in the book (as opposed to monochrome or slightly tinted washes). The face is rather delicately treated for Rowlandson, and it is possible that the watercolor is a later addition. The pencil work, however, is fully characteristic of Rowlandson.

W. Main Gates, Chelsea Hospital
Gray wash over pencil, 8¼″ x 13½″
Inscribed: 30
Verso: three figure studies in pencil

NOTES: I am indebted to John Harris for the identification.

X. An Architectural Capriccio in the Manner of Clérisseau

Pencil, 8¼″ x 13½″

Verso: pencil sketch of a highway robbery

NOTES: This sheet is the last of the architectural drawings. The remaining pages are devoted to figure studies. For these studies the book was used from the other end and upside down, but the pages continue to be numbered in the same place and in the same sequence as the earlier sheets.

Although the architectural capriccio is unlike anything else in the book, it seems clearly in Rowlandson's hand. Clérisseau was in England from about 1771 to about 1778.

Y. Sketches, Including a Man and Performing Animals

Pencil, 8¼″ x 13½″

Inscribed: 50

Verso: Pen sketch of figures in a theater box; standing man

NOTES: The verso drawing is a typical Rowlandson pen sketch of the type usually dated ca. 1780

Z. Sketches, Including a Female Figure, and Possibly a Stage Set

Pencil, 8¼″ x 13½″

Inscribed: 57

Verso: pencil sketch of two figures in costume. Probably related to the scenes on AA verso and BB verso.

AA. Sketch with Figures in Front of a Doorway

Pencil, 8¼″ x 13½″

Inscribed: 58

Verso: Falstaff and two companions, possibly 1 Henry IV, Act II Scene IV

BB. Sketch of a Man and Two Women

Pencil, 8¼″ x 13½″

Inscribed: 59

Verso: Falstaff and companions; 1 Henry IV Act II Scene IV?
Pen and gray wash over pencil

CC. A Horse Race

Pen and gray wash over pencil, unfinished, 8¼″ x 13½″

Inscribed: 60

Verso: pencil sketch of two male figures

DD. Figure Studies

Pen over pencil, unfinished, 8¼″ x 13½″

Inscribed: 64

Verso: slight pencil sketches of a building and a figure subject

EE. Fragment of a Page with Figure Studies Recto and Verso

Pencil, 8¼″ x 7″ (irregular, and torn)

FF. Seated Man and Woman (slight)

Pencil, 8¼″ x 13½″

Verso: miscellaneous slight pencil sketches

2. THE DISSECTION

Pen over pencil, unfinished, 14″ x 19″

Literature: Wark, *Ten British Pictures*, p. 70, Fig. 50; Paulson, pp. 17 and 89 and Pl. 10; Hayes, p. 29, Fig. 14, and Pl. 1

Acquired: 1968

Accession Number: 68.21

NOTES: In technique and subject matter the drawing shows strong affiliations with Mortimer and belongs with the small group of Rowlandson studies assigned to the late 1770s and early 1780s (see Hayes, Pls. 1-10). It must be admitted, however, that there are not many firm dates that can be attached to these early drawings. The assumption that Rowlandson ceased to use the elaborate pen cross-hatching found in these drawings when he adopted watercolor in the early 1780s is probably correct, but some overlapping of the two techniques is possible. Hayes dates the drawing 1775-80, Paulson ca. 1776. The range might be extended to include the first two years of the 1780s.

The drawing has been mounted on Whatman paper watermarked 1830.

3. A BILLIARD MATCH

Pen and gray wash, 6″ x 7¾″

Collections: Desmond Coke, Albert M. Weil

Acquired: 1970, bequest of Albert M. Weil

Accession Number: 70.35

NOTES: An early drawing, ca. 1780, freer and sketchier in technique than most of the known drawings of that period.

The men are playing with maces rather than

38

normal billiard cues. A mace, which had a head at the end, continued to be used in English billiards until the late eighteenth century, but was already being replaced by the Continental cue at the time this drawing was made.

4. HIS HIGHNESS THE PROTECTOR

Pencil, 12⅞″ x 9″

Inscribed in Rowlandson's hand: [on the door] Treasury / [at bottom] His Highness the Protector

Verso: tracing in pencil of the principal outlines of the composition on the recto, the outlines scored, presumably for transfer to the plate. Also on the verso a small, characteristic Rowlandson pen sketch of figures in an interior. Two undecipherable words are written below the sketch.

Engraved: 1784 (George 6379, Grego I, 114)

Literature: for the political background see George 6373 ff.

Acquired: 1920 (in an extra-illustrated copy of *History of the Westminster Election* [1784])

Accession Number: 71.2A

NOTES: Charles James Fox, not really caricatured, stands in a protective attitude before the door of the Treasury. Lord North, in the form of a bulldog, also stands guard.

Rowlandson's preliminary drawings for political cartoons are comparatively rare. Six of the seven in the Huntington Collection are in pencil only and not executed with any of the careful elaboration Rowlandson gives to his pen and watercolor drawings. Political drawings seem to have been regarded by the artist as ephemeral, and this probably explains why so few of them survive. In many instances the subjects and even the visual images for the cartoons were probably suggested to Rowlandson by others. One such preliminary sketch for *The Parody—or Mother Cole and Loader* (George 6514) is in the Huntington collection and appears to be by an amateur draftsman.

5. LORDS OF THE BEDCHAMBER

Pencil, 10½″ x 14⅛″

Inscribed: p. 128 [also see Notes]

Verso: Slight pencil sketch of two men, possibly related to Fox and House on recto

Engraved in reverse: 1784 (George 6529, Grego I, 128-29)

Literature: for the print see George 6529

Acquired: 1920 (in an extra-illustrated set of *The Westminster Election* [1784])

Accession Number: 71.2 D

NOTES: See under No. 4

The Duchess of Devonshire in morning cap and gown makes tea for Charles James Fox and Sam House, a publican who kept open house for Fox's supporters.

The drawing contains long inscriptions in balloons issuing from the three figures. Unfortunately the inscriptions are badly blurred, and they do not appear on the print. The balloon issuing from Sam House is the only one that is more or less readable: "Open House Charly for ever with me. Do bring Madame Perdita [presumably Perdita Robinson] to Night. We'l be damned jolly over a Pot of —"

6. MADAME BLUBBER ON HER CANVASS

Pencil (counterproof), scored for transfer to the plate, 9½″ x 14″

Inscribed, in reverse, in balloon coming from seated butcher to right: I am engaged

Verso: a blurred counterproof, pulled from the same drawing as the counterproof on the recto

Engraved: 1784, in reverse (George 6544, Grego I, 129-30)

Literature: for the political situation see references to George and Grego above.

Acquired: 1920 (in an extra-illustrated copy of *The Westminster Election* [1784])

Accession Number: 71.2E

NOTES: See under No. 4

The lady is Mrs. Hobart, who canvassed for Hood and Wray in opposition to Fox, during the Westminster Election of 1784. In the print the balloon reads: "I am engaged to the Dutchess," meaning that the Duchess of Devonshire had been successful in securing the butcher's vote for Fox.

This scored counterproof is presumably the immediate source for the engraving.

7. DARK LANTHERN BUSINESS OR MRS HOB AND NOB ON A NIGHT CANVASS WITH A BOSOM FRIEND

Pencil, 9 7/16″ x 14″

Inscribed in Rowlandson's hand above door to right: Haddock

Verso: a faint counterproof of *The Devonshire or most approved Method of Securing Votes* (George 6520). The print is the reverse of the counterproof, which has been scored for transfer to the plate.

Engraved: 1784 (George 6554 b)

Literature: for the print see George 6554b

Acquired: 1920 (in the extra-illustrated set of *The Westminster Election* [1784])

Accession Number: 71.2C

NOTES: See under No. 4

George suggests that the stout woman with the lantern is the Duchess of Devonshire. In other drawings Rowlandson does not represent the Duchess as fat. Possibly the lady with the lantern is Mrs. Hobart (who is always presented as fat) with her "bosom friend" in the background. The Duchess of Devonshire might be the lady with a partner going through the door to Haddocks, a well-known bagnio. This interpretation accords better with the title, which is taken from the print. I am indebted to Diana Wilson for this suggestion.

8. THE DEPARTURE

Pencil, 10″ x 14⅛″

Inscribed in Rowlandson's hand: The Departure/[balloon from Duchess of Devonshire] Farewell my Charlye/[in a later hand] p. 140/The Departure

Engraved, with changes: 1784 (George 6563, Grego I, 140)

Literature: for the print see George 6563

Acquired: 1920 (in an extra-illustrated set of *The Westminster Election* [1784])

Accession Number: 71.2F

NOTES: See under No. 4

Charles James Fox is seated on an ass, taking leave of the Duchess of Devonshire, standing on his left, and Lady Duncannon, on his right. The figure on

the extreme left is Burke as a postboy or jackboots. The figure looking from the window is the Prince of Wales. The man standing to the right holding the ass's tail is Lord North. In early versions of the print he appears seated, and is omitted entirely from later impressions.

9. SECRET INFLUENCE DIRECTING THE NEW PARLIAMENT

Pencil, 9⅝″ x 15⅜″

Inscribed in Rowlandson's hand: [in balloon issuing from the king] Go to my Faithful Subjects/[in a balloon issuing from the man to the right] Thieves, Thieves, Madam

Engraved: 1784 (George 6587, Grego I, 140)

Literature: for the print see George 6587

Acquired: 1920 (in an extra-illustrated set of *The Westminster Election* [1784])

Accession Number: 71.2G

NOTES: See under No. 4

The new parliament met on May 18, 1784.

The king is seated on a throne with Lord Thurlow on his right in the form of a bird of prey, Lord Bute behind the throne in Highland dress, the Younger Pitt to the king's left with the body of a serpent. Britannia sits asleep, and is being roused by a man, possibly the Prince of Wales.

10. MR. ROWLANDSON HIRING THE FIRST POST-CHAISE

Pen and watercolor, 4⅞″ x 7⅞″

Inscribed in Rowlandson's hand on a sign in the background: Neat Post Chaises Saddle Horses/Hearses Glass Coaches/Phaetons Whiskeys Gigs/to lett. Horses stand at/ Livery . . .

Literature: J. G. [Joseph Grego], "Rowlandson's Tour in a Post Chaise 1782," in *The Graphic Summer Number*, London, 1891; Oppé, pp. 14-15; Falk, pp. 64-66; Wark, *Tour*; Paulson, pp. 15-16, 17, 86; Hayes, pp. 14, 18, 35, 54, 74, 103, 143, 147; Figs. 2, 4; Pls. 18-21

Collections: Thomas Capron, Joseph Grego, William Henry Bruton

Acquired: 1925

Accession Number: Tour 1

NOTES: This and the following sixty-seven draw-
ings come from a dismembered sketchbook of a
tour made by Rowlandson and Henry Wigstead
to the New Forest and Isle of Wight, probably in
the early autumn of 1784. The evidence concern-
ing date is summarized under No. 74. For a full dis-
cussion of the drawings and circumstances related
to the tour see Wark, *Tour.*

The drawings constitute the only travel sketch-
book by Rowlandson that has come down to us
more or less complete. One drawing, of Stone-
henge, that originally belonged with the series has
become separated and is now in the Salisbury,
South Wilts and Blackmore Museum, Salisbury.

The sketches are brilliant examples dating from
the most attractive moment in Rowlandson's ca-
reer, when his pen work still retains its early flexi-
bility and calligraphic elegance but has begun to
be enriched with watercolor. Taken as a unit the
drawings for *A Tour in a Post-Chaise* constitute
one of Rowlandson's finest works.

The titles here given follow the captions cur-
rently on the mounts of the drawings. The source
for these captions is not clear; they may follow
inscriptions that have been trimmed from the
drawings. In any event, the information in the cap-
tions has proved, on investigation, to be precise and
accurate in many details, and it should be respected.
There are, however, one or two instances in which
the captions on the mounts are clearly wrong.
These have been corrected.

The drawings appear to have been mounted and
titled while in the Bruton collection. The fact that
the drawings have been firmly glued to the mounts
makes direct examination of the backs impossible,
but the information on the backs has been recorded
insofar as it is decipherable.

11. BUYING LEATHER BREECHES—PRE-
VIOUS TO OUR JOURNEY

Pen and watercolor, 4 15/16″ x 7⅞″
Inscribed in Rowlandson's hand on a sign in the
background: Fitch Breeches maker to his
Higness [sic] the Pr . . .
Verso inscribed in Rowlandson's hand, only
partly decipherable: Mimento 7th Septr sorely
troubled with Gripes Windy Cholic & was
obliged to stop frequently on my way to

Kensington—the heat past bearing dipt in the
Serpentine in my . . . home . . . practise not
. . . the Art of Swimming
Literature: as for No. 10
Collections: as for No. 10
Acquired: 1925
Accession Number: Tour 2

NOTES: See under No. 10
The verso inscription is one of the scraps of
evidence concerning date. The only warm Septem-
ber 7 within the range of years possible for the
Tour was in 1784.
The Universal British Directory of Trade and
Commerce (London, 1790), p. 145, lists John Fitch,
Breeches-maker and Glover, 195 Piccadilly.

12. TRUNK SHOP—MR WIGSTEAD
BARGAINING

Pen and watercolor, 5″ x 7¾″
Inscribed in Rowlandson's hand: Trunk Shop—
Mr. W. bargaining/[on trunks and signs in
the background] Capt Helfire 56 Regt/
Major Blunderbuss 49 Regt/ Drivenn Trunk
Maker
Verso inscribed in Rowlandson's hand: [the
only decipherable words are] . . . having cast
an eye upon our . . . her recommendation . . .
Literature: as for No. 10
Collections: as for No. 10
Accession Number: Tour 3

NOTES: See under No. 10
The Universal British Directory of Trade and
Commerce (London, 1790), p. 131, lists Messrs
Drivers, Trunkmakers, 70 Charing Cross and 10
Strand.

13. MYSELF AT DINNER

Pen and watercolor over pencil, 5″ x 7 13/16″
Inscribed in pencil, lower right: 13
Literature: as for No. 10
Collections: as for No. 10
Acquired: 1925
Accession Number: Tour 4

NOTES: See under No. 10

This drawing is in a technique slightly different from the rest of the drawings for the *Tour*. The subject is not clearly connected with the *Tour*. There is a possibility that this drawing was not part of the original sketchbook, although it has been associated with the *Tour* drawings since at least the early years of this century. In any event, it is a characteristic Rowlandson drawing of the mid-1780s.

14. MR. ROWLANDSON'S OLD HOUSE-KEEPER CALLING HIM UP ON THE MORNING WE SET OFF

Pen and watercolor, 5" x 7 13/16"
Inscribed in Rowlandson's hand: Sir. Sir. Sir. its past 4 O Clock
Literature: as for No. 10
Collections: as for No. 10
Acquired: 1925
Accession Number: Tour 5

NOTES: See under No. 10

15. MR. WIGSTEAD TAKING LEAVE OF HIS HOME AND FAMILY—THE START

Pen and watercolor, 5" x 7⅞"
Inscribed in Rowlandson's hand: You may expect to see me again Sunday Sennight—
Literature: as for No. 10
Collections: as for No. 10
Acquired: 1925
Accession Number: Tour 6

NOTES: See under No. 10

As far as is known, Wigstead was at this time living in Gerrard Street, Soho, within a few blocks of Rowlandson's residence in Wardour Street.

The inscription is of interest as an indication of the duration of the tour, something between one and two weeks.

16. CHAISE AT THE DOOR, SETTING OUT FROM ROWLANDSON'S HOUSE IN WARDOUR STREET

Pen and watercolor, 5 15/16" x 7¾"

Inscribed in Rowlandson's hand: Chaise at the Door
Literature: as for No. 10
Collections: as for No. 10
Acquired: 1925
Accession Number: Tour 7

NOTES: See under No. 10

Rowlandson lived at 103 Wardour Street, Soho, from 1777 through 1786.

17. THE FIRST STAGE FROM LONDON—"KING'S HEAD INN YARD," HOUNS-LOW, ARRIVED AT 7 O'CLOCK

Pen and watercolor, 4 15/16" x 7⅞"
Inscribed in Rowlandson's hand: Kings Head Inn Yard. Hounslow arrived at 7 O Clock
Verso inscribed, only partially decipherable: A curious piece of French poetry/F . . . moi de . . ., F . . . de toute que vois nous sommes des . . . nous faire . . .
Literature: as for No. 10
Collections: as for No. 10
Acquired: 1925
Accession Number: Tour 8

NOTES: See under No. 10

John Cary's *New Itinerary* (London, 1798) records the King's Head as one of the principal coaching inns at Hounslow (p. 39).

18. BREAKFAST AT EGHAM

Pen and watercolor over pencil, 4 15/17" x 7½"
Inscribed in Rowlandson's hand: Please your Honours Remember your Post Boy
Verso: an undecipherable inscription
Literature: as for No. 10
Collections: as for No. 10
Acquired: 1925
Accession Number: Tour 9

NOTES: See under No. 10

19. THE WHITE HART INN, BAGSHOT

Pen and watercolor over pencil, 4⅞" x 7¾"
Verso: an undecipherable inscription

Literature: as for No. 10
Collections: as for No. 10
Acquired: 1925
Accession Number: Tour 10

NOTES: See under No. 10
 John Cary's *New Itinerary* (London, 1798) records the White Hart as a coaching inn at Bagshot (p. 39).

20. THE SPREAD EAGLE AT HOOK
Pen and watercolor, 5″ x 8″
Inscribed in Rowlandson's hand: Hook a Village 43 Miles from London. stopt at the Spread Eagle
Literature: as for No. 10
Collections: as for No. 10
Acquired: 1925
Accession Number: Tour 11

NOTES: See under No. 10
 The inn still stands at Hook, with little change. It is now called the White Hart.

21. THE DELAY AT POPHAM LANE
Pen and watercolor, 5″ x 8″
Inscribed in Rowlandson's hand: The Delay or Accident Popham Lane 1 O Clock
Verso: drawing of a building
Verso inscribed in Rowlandson's hand: Stockbridge arrived with a tolerable appetite at three, dined at the White Hart 68 miles from London
Literature: as for No. 10
Collections: as for No. 10
Acquired: 1925
Accession Number: Tour 12

NOTES: See under No. 10

22. THE CONTEST FOR PRECEDENCE OVER THE DOWNS BETWEEN STOCKBRIDGE AND SALISBURY
Pen and watercolor over pencil, 5″ x 8″
Inscribed in Rowlandson's hand: The Contest
Literature: as for No. 10

Collections: as for No. 10
Acquired: 1925
Accession Number: Tour 13

NOTES: See under No. 10

23. HEAD AND TAILPIECE
Pen and watercolor over pencil, 4½″ x 7 5/16″
Literature: as for No. 10
Collections: as for No. 10
Acquired: 1925
Accession Number: Tour 14

NOTES: See under No. 10
 Grego mentions this drawing in connection with *The Contest for Precedence over the Downs*, where it probably belongs, although, as he also points out, it makes an effective tailpiece.

24. COFFEE HOUSE IN SALISBURY MARKET PLACE
Pen and watercolor, 5″ x 7⅞″
Inscribed in Rowlandson's hand: Coffee House in Market Place/at Salisbury/[newspaper inscribed]: Morning Chronicle
Verso: a sketch of No. 26, *Monument in Salisbury Cathedral*
Verso inscribed: Buchamp monument in Salisbury . . .
Literature: as for No. 10
Collections: as for No. 10
Acquired: 1925
Accession Number: Tour 15

NOTES: See under No. 10
 The interior represented may be the Parade Coffee House on the Blue Boar Row.

25. SALISBURY MARKET PLACE
Pen and watercolor, 4⅞″ x 7⅞″
Inscribed in Rowlandson's hand: Salisbury—Markett Place
Verso inscribed: . . . at the White Hart, Salisbury
Literature: as for No. 10
Collections: as for No. 10

Acquired: 1925
Accession Number: Tour 16

NOTES: See under No. 10

The Council House is shown after the fire of 1780, which destroyed part of the top story. The old Bishop's Guildhall, standing behind, was pulled down about 1788.

26. A MONUMENT IN SALISBURY CA-THEDRAL

Pen and watercolor over pencil, 4⅞″ x 7 15/16″
Literature: as for No. 10
Collections: as for No. 10
Acquired: 1925
Accession Number: Tour 17

NOTES: See under No. 10

The evidence on the verso of No. 24 suggests that the monument may have been one in Bishop Richard Beauchamp's Chantry Chapel, which was demolished by Wyatt in 1789.

27. THE YARD OF AN INN

Pen and watercolor, 5″ x 8″
Inscribed in Rowlandson's hand, on coach: Exeter Post Coach
Verso: sketch of Stonehenge
Literature: as for No. 10
Collections: as for No. 10
Acquired: 1925
Accession Number: Tour 18

NOTES: See under No. 10

The sketch on the verso is closely related to the left half of the drawing of Stonehenge that has become separated from the rest of the series and is now in the Salisbury, South Wilts and Blackmore Museum, Salisbury. For an illustration of the latter see Wark, *Tour*, No. 19.

28. THE GRAND ROOM IN WILTON HOUSE

Pen and watercolor, 4 13/16″ x 7¾″
Verso inscribed, only partially legible: . . . Romsey 96 miles from . . . Memorandum Washing Chamber maids, Post boys, hostlers . . . minding the departure . . . difficult to get . . .

Literature: as for No. 10
Collections: as for No. 10
Acquired: 1925
Accession Number: Tour 20 [Tour 19 is the drawing of Stonehenge, see No. 27 above.]

NOTES: See under No. 10

This is a free recollection of the Double Cube Room at Wilton. Rowlandson is pointing at the large Van Dyck group portrait of the Pembroke family.

The inscription on the verso may refer to No. 29.

29. THE DEPARTURE FROM THE WHITE HART, SALISBURY

Pen and watercolor over pencil, 5″ x 7⅞″
Inscribed in Rowlandson's hand: The Departure from White Hart Salisbury
Verso: slight sketch and inscription of which the only decipherable words are: . . . little Gibson . . .
Literature: as for No. 10
Collections: as for No. 10
Acquired: 1925
Accession Number: Tour 21

NOTES: See under No. 10

The drawing shows the inn before the addition of the portico, which now projects in front of the arch.

30. ARRIVAL AT AN INN

Pen and watercolor, 4 15/16″ x 7 15/16″
Inscribed in pencil upper left, not definitely in Rowlandson's hand: Actor [?]
Literature: as for No. 10
Collections: as for No. 10
Acquired: 1925
Accession Number: Tour 22

NOTES: See under No. 10

31. THE BAR, SOUTHAMPTON

Pen and watercolor, 5″ x 8″
Literature: as for No. 10
Collections: as for No. 10

Acquired: 1925
Accession Number: Tour 23

NOTES: See under No. 10
A free rendering of the Bargate, seen from the north.

32. VIEW ON SOUTHAMPTON RIVER
Pen and watercolor over pencil, 5″ x 8″
Verso: sketch of a rocky bank
Literature: as for No. 10
Collections: as for No. 10
Acquired: 1925
Accession Number: Tour 24

NOTES: See under No. 10

33. THE CHAISE WAITING TO CARRY US TO LYMINGTON
Pen and watercolor over pencil, 5″ x 7 15/16″
Literature: as for No. 10
Collections: as for No. 10
Acquired: 1925
Accession Number: Tour 25

NOTES: See under No. 10

34. THE CHURCH, THE CROWN INN, AND THE DUKE OF GLOUCESTER'S STABLES AT LYNDHURST
Pen and watercolor, 4⅞″ x 15¾″, two sheets glued together
Verso: sketch for *A Barber's Shop,* No. 35
Literature: as for No. 10
Collections: as for No. 10
Acquired: 1925
Accession Number: Tour 26

NOTES: See under No. 10
The church and the Crown Inn were rebuilt in the nineteenth century. The stables have been demolished.

35. A BARBER'S SHOP
Pen and watercolor, 5″ x 8″
Literature: as for No. 10

Collections: as for No. 10
Acquired: 1925
Accession Number: Tour 27

NOTES: See under No. 10

36. FIRST INTERVIEW WITH TWO FE-MALE FRIENDS ON OUR ARRIVAL AT LYMINGTON
Pen and watercolor, 5″ x 7⅞″
Inscribed in pencil, probably in Rowlandson's hand: The Rendezvous [?]
Literature: as for No. 10
Collections: as for No. 10
Acquired: 1925
Accession Number: Tour 28

NOTES: See under No. 10

37. THE YARD OF THE ANGEL INN, LYMINGTON
Pen and watercolor over pencil, 4 15/16″ x 16″, on two sheets glued together
Verso left hand sheet: a sketch of *First Inter-view with a friend at Lymington,* No. 42
Literature: as for No. 10
Collections: as for No. 10
Acquired: 1925
Accession Number: Tour 29

NOTES: See under No. 10
Grego called the drawing "High Street, South-ampton," but this is surely an error. Edward King reproduced the drawing in *Old Times Re-visited in the Borough and Parish of Lymington* (London, 1900), facing p. 260, calling it the yard of the Angel Inn, Lymington. The area has now changed con-siderably but is still sufficiently similar to make the identification plausible.

38. FRUIT SHOP AT LYMINGTON—MR WIGSTEAD MAKING FRIENDS
Pen and watercolor over pencil, 4 15/16″ x 8 1/16″
Inscribed in pencil: Fruit Shop
Literature: as for No. 10

Collections: as for No. 10
Acquired: 1925
Accession Number: Tour 30

NOTES: See under No. 10

39. INSIDE OF A SALTERN AT LYMINGTON, WITH THE MANNER OF MAKING SALT
Pen and watercolor over pencil, 5 15/16″ x 8″
Inscribed in Rowlandson's hand: Salt Pans Mode of making
Verso: sketch of a cottage with figures leaning on a fence
Literature: as for No. 10
Collections: as for No. 10
Acquired: 1925
Accession Number: Tour 31

NOTES: See under No. 10
Lymington's salt industry was already on the decline at the time of Rowlandson's visit. See Richard Warner, Jr., *A Companion in a Tour round Lymington* (Southampton, 1789), p. 11.

40. MRS BEESTON'S BATHS AT LYMINGTON
Pen and watercolor over pencil, 4 15/16″ x 16⅛″, on two sheets glued together
Verso: sea sketches
Literature: as for No. 10
Collections: as for No. 10
Acquired: 1925
Accession Number: Tour 32

NOTES: See under No. 10
According to information in the *Hampshire Chronicle* for May 2, 1783, and May 26, 1783, Mrs Beeston took over the operation of the Sea Baths following the death of her husband in November of 1782. The information is of interest in helping to establish the date of Rowlandson's tour.

41. A COTTAGE AT LYMINGTON
Pen and watercolor over pencil, 4⅞″ x 15 11/16″, on two sheets glued together

Literature: as for No. 10
Collections: as for No. 10
Acquired: 1925
Accession Number: Tour 33

NOTES: See under No. 10

42. FIRST INTERVIEW WITH A FRIEND AT LYMINGTON
Pen and watercolor, 4⅜″ x 7 15/16″
Literature: as for No. 10
Collections: as for No. 10
Acquired: 1925
Accession Number: Tour 34

NOTES: See under No. 10
It is tempting to suppose that the clerical gentleman in this and *Wigstead's Parting Interview with his Lymington Friend*, No. 51, may be William Gilpin, the writer on the Picturesque, who was vicar of Boldre at the time. Lymington lay within the parish of Boldre.

43. THE LANDLORD WHERE WE LODGED AT LYMINGTON COMPLAINING OF HIS MISFORTUNES
Pen and watercolor over pencil, 4 15/16″ x 8 1/16″
Literature: as for No. 10
Collections: as for No. 10
Acquired: 1925
Accession Number: Tour 35

NOTES: See under No. 10

44. THE ANGEL INN AT LYMINGTON
Pen and watercolor over pencil, 4⅞″ x 7 15/16″
Inscribed by Rowlandson on the sign: Haniford/[*over the door to right*] The Angel
Literature: as for No. 10
Collections: as for No. 10
Acquired: 1925
Accession Number: Tour 36

NOTES: See under No. 10
Haniford was the proprietor of The Angel. The name was usually spelled "Hannaford." According

to local rate books the inn appears to have passed to the possession of a James Baughan in 1787. The fact is of some interest in establishing the date for Rowlandson's tour.

45. KITCHEN AT THE INN AT LYMING-TON, ON ROAD TO PILESWELL
Pen and watercolor over pencil, 4 15/16″ x 8″
Verso: a sketch for *Lymington River, near the Quay*, No. 54
Verso inscribed, only partially decipherable: Capt Dobson [?] . . . Alum Bay . . . Cliffs/ fatigued ourselves . . .
Literature: as for No. 10. The drawing is reproduced in A. E. Richardson and H. Donaldson Eberlein, *The English Inn Past and Present* (London, 1925), p. 185.
Collections: as for No. 10
Acquired: 1925
Accession Number: Tour 37

NOTES: See under No. 10

46. PILESWELL, NEAR LYMINGTON IN HAMPSHIRE—THE SEAT OF ASCAN-IUS WILLIAM SENIOR, ESQ^re
Pen and watercolor, 4 15/16″ x 15⅞″, on two sheets glued together
Verso left hand sheet: sketch of *The Angel Inn Lymington*, No. 44
Literature: as for No. 10
Collections: as for No. 10
Acquired: 1925
Accession Number: Tour 38

NOTES: See under No. 10

The house, now called "Pylewell," is on the Solent, a short distance to the north and east of Lymington. It has been considerably altered since the eighteenth century; another story has been added and the terminal pavilions removed.

According to *The Victoria History of Hampshire and the Isle of Wight*, IV (London, 1911), p. 617, the house was purchased by Ascanius Williams, Sr., in 1781 and sold in 1787. There is some indication that the surname may have been "Senior" (as given in the caption), not "Williams." See the list of county sheriffs in William White, *History, Gaz-*

eteer and Directory of Hampshire and the Isle of Wight, 2nd ed. (Sheffield, 1878), p. 36.

The figures on the lawn appear to be watching and waving towards a balloon. The first balloon ascent in England was that of Lunardi in September 1784. On October 16, 1784, Jean Pierre Blanchard made an ascent that landed near Romsey, about fifteen miles from Pylewell. The details are of interest in suggesting a possible date for the tour.

47. THE OLD WHISKEY, LYMINGTON
Pen and watercolor over pencil, 4 15/16″ x 7 15/16″
Inscribed in Rowlandson's hand: The Old Whiskey/Lymington
Verso: sketch for *Pitt's Deep*, No. 49
Verso inscribed: On the sea coast Pitt's Deep . . .
Literature: as for No. 10
Collections: as for No. 10
Acquired: 1925
Accession Number: Tour 39

NOTES: See under No. 10

48. ROWLANDSON TALKING WITH A LADY OUTSIDE THE ANGEL, LYM-INGTON
Pen and watercolor, 5″ x 8 1/16″
Literature: as for No. 10
Collections: as for No. 10
Acquired: 1925
Accession Number: Tour 40

NOTES: See under No. 10

49. PITT'S DEEP, NEAR HURST CASTLE, A LITTLE ALE HOUSE FAMOUS FOR SELLING GOOD BRANDY
Pen and watercolor over pencil, 4⅞″ x 16″, on two sheets glued together
Verso right hand sheet: a sketch of *Mrs. Beeston's Baths*, No. 40
Literature: as for No. 10
Collections: as for No. 10
Acquired: 1925
Accession Number: Tour 41

NOTES: See under No. 10

The caption is inexact. Pitt's Deep is actually close to Pylewell, to the northeast of Lymington. Hurst Castle is on the other side of the town.

Pitt's Deep has changed very little since Rowlandson's day, and his drawing is an accurate record of the appearance of the two buildings.

50. SHIPPING OXEN ON BOARD THE ISLE OF WIGHT PACKET

Pen and watercolor, 4 ⅞″ x 8¼″
Literature: as for No. 10
Collections: as for No. 10
Acquired: 1925
Accession Number: Tour 42

NOTES: See under No. 10

The drawing is closely related to the left half of *Lymington Quay*, No. 52.

51. WIGSTEAD'S PARTING INTERVIEW WITH HIS LYMINGTON FRIEND

Pen and watercolor over pencil, 5″ x 7 15/16″
Literature: as for No. 10
Collections: as for No. 10
Acquired: 1925
Accession Number: Tour 43

NOTES: See under No. 10 and also under No. 42

If the identification of the friend as William Gilpin is correct, then the house would be Gilpin's residence, Vicar's Hill.

52. LYMINGTON QUAY WITH THE METHOD OF SHIPPING CATTLE FOR THE ISLE OF WIGHT

Pen and watercolor over pencil, 4 15/16″ x 16″, on two sheets glued together
Verso left-hand sheet: sketch for *Shipping Oxen,* No. 50
Literature: as for No. 10
Collections: as for No. 10
Acquired: 1925
Accession Number: Tour 44

NOTES: See under No. 10

53. THE PRETTY HOSTESS AND ROWLANDSON—WITH THE EXTRAVAGANT BILL, AND WIGSTEAD

Pen and watercolor, 5″ x 7¾″
Literature: as for No. 10
Collections: as for No. 10
Acquired: 1925
Accession Number: Tour 45

NOTES: See under No. 10

54. LYMINGTON RIVER, NEAR THE QUAY—GOING ON BOARD THE VESSEL TO CARRY US TO THE ISLE OF WIGHT

Pen and watercolor, 4 15/16″ x 15⅞″, on two sheets glued together
Inscribed in Rowlandson's hand: Lymington River
Literature: as for No. 10
Collections: as for No. 10
Acquired: 1925
Accession Number: Tour 46

NOTES: See under No. 10

55. LYMINGTON TO THE NEEDLES—ON BOARD THE PACKET

Pen and watercolor over pencil, 4⅞″ x 8⅛″
Literature: as for No. 10
Collections: as for No. 10
Acquired: 1925
Accession Number: Tour 47

NOTES: See under No. 10

56. THE QUARTER-DECK OF THE VESSEL WHICH CARRIED US TO THE NEEDLES—THE WIND BLOWING HARD

Pen and watercolor over pencil, 5″ x 8″
Literature: as for No. 10
Collections: as for No. 10
Acquired: 1925
Accession Number: Tour 48

NOTES: See under No. 10

57. SIX MILES FROM YARMOUTH— ALUM BAY
Pen and watercolor over pencil, 5″ x 16⅛″, on two sheets glued together
Verso: coastal sketch
Literature: as for No. 10
Collections: as for No. 10
Acquired: 1925
Accession Number: Tour 49

NOTES: See under No. 10

The quantity of drawings in the series devoted to the small area around the western tip of the Isle of Wight attests to Rowlandson's interest in landscape at this time. The drawings are generally accurate topographically.

58. PART OF THE ROCKS IN ALUM BAY
Pen and watercolor over pencil, 4 13/16″ x 15 15/16″, on two sheets glued together
Verso: a sketch of *St. Christopher's Rock*, No. 61
Literature: as for No. 10
Collections: as for No. 10
Acquired: 1925
Accession Number: Tour 50

NOTES: See under No. 10

59. THE NEEDLE ROCKS FROM THE SEA
Watercolor over pencil, 4 15/16″ x 8″
Verso: another view of the Needles
Literature: as for No. 10
Collections: as for No. 10
Acquired: 1925
Accession Number: Tour 51

NOTES: See under No. 10

60. THE NEEDLE ROCKS
Pen and watercolor over pencil, 4⅞″ x 16″, on two sheets glued together
Literature: as for No. 10
Collections: as for No. 10
Acquired: 1925
Accession Number: Tour 52

NOTES: See under No. 10

61. ST. CHRISTOPHER'S ROCK
Watercolor over pencil, 4⅞″ x 16⅛″, on two sheets glued together
Literature: as for No. 10
Collections: as for No. 10
Acquired: 1925
Accession Number: Tour 53

NOTES: See under No. 10

The cliff on the southern side of the western peninsula of the Isle of Wight leading to the Needles was called St. Christopher's Cliff in the eighteenth century.

62. THE WESTERN END OF THE ISLE OF WIGHT FROM THE SOLENT
Watercolor over pencil, 4¾″ x 16″, on two sheets glued together
Literature: as for No. 10
Collections: as for No. 10
Acquired: 1925
Accession Number: Tour 54

NOTES: See under No. 10

The caption on the mount reads "Rocks near Freshwater, in the Isle of Wight." The view, however, is not taken from Freshwater, but from the vicinity of Alum Bay.

63. THE ISLE OF WIGHT AS SEEN FROM THE BLUFFS ABOVE THE NEEDLES
Watercolor over pencil, 4⅞″ x 15⅝″, on two sheets glued together
Verso of right-hand sheet: sketch for *Lymington to the Needles*, No. 55; also an illegible inscription
Literature: as for No. 10
Collections: as for No. 10
Acquired: 1925
Accession Number: Tour 55

NOTES: See under No. 10

The caption on the mount reads "Freshwater Bay." In fact, when Rowlandson made this drawing he was standing looking east on the bluffs at the western tip of the island just above the Needles. Alum Bay is to the lower left with the Solent and Hurst Castle in the left distance. St. Christopher's Rock is to the right with Scratchell's Bay below.

64. A GENERAL VIEW OF THE ISLE OF WIGHT

Pen and watercolor over pencil, 4 15/16″ x 15 ⅞″, on two sheets glued together
Literature: as for No. 10
Collections: as for No. 10
Acquired: 1925
Accession Number: Tour 56

NOTES: See under No. 10
The view is probably of the mouth of the Medina River at Cowes.

65. COWES HARBOUR IN THE ISLE OF WIGHT

Pen and watercolor over pencil, 4 15/16″ x 15 ⅞″, on two sheets glued together
Verso inscribed: We have now travelled . . . hundred and sixty one miles
Literature: as for No. 10
Collections: as for No. 10
Acquired: 1925
Accession Number: Tour 57

NOTES: See under No. 10
A repetition of the right half of this drawing was with Sabin (1948), No. 31.

66. COWES HARBOUR IN THE ISLE OF WIGHT

Pen and watercolor over pencil, 4 15/16″ x 8″
Literature: as for No. 10
Collections: as for No. 10
Acquired: 1925
Accession Number: Tour 58

NOTES: See under No. 10

67. THE BOAT WHICH WE HIRED FROM COWES TO PORTSMOUTH

Pen and watercolor over pencil, 4 15/16″ x 7 15/16″
Literature: as for No. 10
Collections: as for No. 10
Acquired: 1925
Accession Number: Tour 59

NOTES: See under No. 10

68. AT SUPPER IN PORTSMOUTH ON OUR ARRIVAL FROM COWES, ALL VERY MUCH FATIGUED

Pen and watercolor over pencil, 4⅞″ x 7 15/16″
Inscribed faintly in pencil, top: Supper . . .
Literature: as for No. 10
Collections: as for No. 10
Acquired: 1925
Accession Number: Tour 60

NOTES: See under No. 10

69. GOING ON BOARD THE "HECTOR" OF 74 GUNS, LYING IN PORTSMOUTH HARBOUR

Pen and watercolor over pencil, 5″ x 8″
Literature: as for No. 10
Collections: as for No. 10
Acquired: 1925
Accession Number: Tour 61

NOTES: See under No. 10
The *Hector* was built in 1773, served in the Channel and in the West Indies, 1777-82, and was commissioned as a guardship at Spithead in April 1783. Thereafter she remained at various moorings in Portsmouth Harbor for several years. The information is of interest in determining the date of the Tour.

70. MIDDLE DECK OF THE "HECTOR"

Pen and watercolor, 4 15/16″ x 16″, on two sheets glued together
Verso: landscape and seascape drawings
Literature: as for No. 10
Collections: as for No. 10
Acquired: 1925
Accession Number: Tour 62

NOTES: See under No. 10

71. THE MANNER OF WORKING THE GUNS ON BOARD A SHIP IN TIME OF ACTION

Pen and watercolor over pencil, 5″ x 8″
Literature: as for No. 10
Collections: as for No. 10
Acquired: 1925

Accession Number: Tour 63

NOTES: See under No. 10

This is a vigorous drawing, but presumably an imagined subject.

72. CUSTOM HOUSE CORNER, PORTSMOUTH, WITH A SMUGGLING VESSEL CUT IN TWO

Pen and watercolor, 4 15/16″ x 15⅞″, on two sheets glued together

Inscribed in Rowlandson's hand: [left] Custom House Corner/[right] A smuggler cutt in two this mode has been lately adopted formerly when/condemned they were burnt. The present Method unfits the Vessel for future Service/at the same time saving of Timber.

Verso: a sketch for the *Royal George,* No. 74

Literature: as for No. 10

Collections: as for No. 10

Acquired: 1925

Accession Number: Tour 64

NOTES: See under No. 10

Rowlandson is probably referring to the statute 19 Geo III, cap. 69 (1779). By the terms of this act officers of customs were empowered to seize and arrest any ship forfeited by the act and to secure its prosecution and condemnation. Upon legal condemnation, any such ship had hitherto been liable to be burnt or destroyed or to be used in H.M. service. Section 6 of the new act made it lawful for the commissioners of customs "after condemnation, to direct the hull of every such ship, vessel, or boat to be broken up, and the materials of every such hull to be sold to the best advantage." A condemned ship was not considered "broken up" until she was at least sawn across at about amidships. I am indebted to Mr. Rupert Jarvis of the Library, H.M. Customs and Excise for this information.

73. PORTSMOUTH POINT WITH A DISTANT VIEW OF GOSPORT

Pen and watercolor, 4¾″ x 16⅛″, on two sheets glued together

Literature: as for No. 10

Collections: as for No. 10

Acquired: 1925

Accession Number: Tour 65

NOTES: See under No. 10

74. SPITHEAD, WITH THE EXACT SITUATION AND APPEARANCE OF THE "ROYAL GEORGE," WRECKED AUGUST 29, 1782

Pen and watercolor over pencil, 4 15/16″ x 15⅞″, on two sheets glued together

Literature: as for No. 10

Collections: as for No. 10

Acquired: 1925

Accession Number: Tour 66

NOTES: See under No. 10

The *Royal George* capsized while riding at anchor at Spithead on August 29, 1782. According to Julian Slight, *A Narrative of the Loss of the Royal George,* 6th ed. (Portsea, 1843), about nine hundred people lost their lives in the disaster, many being women, children, and merchants who were visiting the vessel. The same brief account also relates (p. 29): "The masts of the Royal George remained standing out of the water for several years afterwards, one of which so late as the year 1794, when it was unfortunately run down in the night by an English frigate."

This information is of interest in connection with the date of Rowlandson's Tour. Grego, Oppé, and others regarded the Tour as made in late 1782 specifically to see the wreck. But it is clear that the wreck was visible for many years following. Other circumstances: the warm September 7 (No. 11), the presence of the *Hector* at Portsmouth (No. 69), Mrs Beeston's sea baths (No. 40), the balloon ascent seen from Pylewell (No. 46), all suggest a later date, probably September-October 1784. For a full presentation of the evidence concerning date see Wark, *Tour,* p. 10.

75. COTTAGES, FARNHAM, SURREY

Pen and watercolor over pencil, 5″ x 8″

Verso: coastal sketch

Literature: as for No. 10

Collections: as for No. 10

Acquired: 1925

Accession Number: Tour 67

NOTES: See under No. 10

76. AN EARTHENWARE SHOP AT FARNHAM, SURREY

Pen and watercolor over pencil, 4 15/16″ x 7 15/16″

Inscribed in pencil in Rowlandson's hand: Farnham

Literature: as for No. 10

Collections: as for No. 10

Acquired: 1925

Accession Number: Tour 68

NOTES: See under No. 10

77. THE TUMBLE-DOWN DICK

Pen and watercolor over pencil, 5″ x 7 15/16″

Inscribed on sign in Rowlandson's hand: Tumble Down/Dick

Inscribed verso in Rowlandson's hand: Mild Children Make Parents Hearts Glad/M C M P H G/. . .

Literature: as for No. 10

Collections: as for No. 10

Acquired: 1925

Accession Number: Tour 69

NOTES: See under No. 10

The caption for this drawing reads, "The Post House, Tumble Down Dick at Alton in Hampshire." I have not found any record of a Tumble Down Dick at Alton. However, according to *The Torrington Diaries* (London, 1934), I, 73, there was in 1782 an inn with this unusual name along the same road, closer to London, at Farnborough. Rowlandson may have confused the two towns.

78. A CULLY PILLAGED

Pen and watercolor, 8″ x 11″

Signed and dated: Rowlandson 1785

Inscribed in Rowlandson's hand: Cully Pillaged

Engraved in reverse: 1785 (Grego I, 167; George 6867)

Collections: Albert M. Weil

Acquired: 1970, bequest of Albert M. Weil

Accession Number: 70.33

NOTES: The print is dated 1784 on the plate, although it was not published until November 30, 1785. The technique of the drawing is typical of Rowlandson's work in the mid-1780s.

79. THE PANTING LOVER

Pen and watercolor over pencil, 13″ x 10⅜″

Engraved: 1786 (Grego II, 391)

Exhibited: Arts Council (1950) No. 104

Collections: Arthur N. Gilbey, Gilbert Davis

Acquired: 1959

Accession Number: 59.55.1124

NOTES: As an indication of Rowlandson's technical procedure at this stage of his career it is interesting that the lute and chair to the right have been worked out only in watercolor over pencil with no pen work. If these areas are regarded as incomplete, then the pen work was the last stage in the development of the drawing.

80. THE DISAPPOINTED EPICURES

Pen and watercolor over pencil, 13¼″ x 19½″

Engraved: 1787

Literature: Hayes, Pl. 45

Collections: Edward Peter Jones

Acquired: 1962, gift of the Friends

Accession Number: 62.5

NOTES: The 1787 print, etched by Rowlandson and published on June 2 by J. Harris, is not listed by Grego or George, although Grego (II, 131) records a later issue of 1809. An impression of the early print is in the Huntington collection, and is signed and dated on the plate: "Rowlandson. 1787"

A drawing entitled *Disappointed Epicures*, 13¼″ x 19½″, is listed in Frank T. Sabin's 1938 catalog, number 45. This may be the Huntington drawing. A smaller version, 8 9/16″ x 13 3/16″, is listed and illustrated in Sabin's 1948 catalog, No. 12.

81. THE BETTING POST

Pen and watercolor over pencil, 10⅞″ x 16″

Signed and dated in Rowlandson's hand: Rowlandson. 1787

Inscribed in Rowlandson's hand on the sign: Betting/Post

Collections: Gilbert Davis

Acquired: 1959
Accession Number: 59.55.1092

NOTES: The very coarse pen work in the foreground figures is reminiscent of G. M. Woodward, although this drawing predates by several years the period of collaboration between Rowlandson and Woodward.

There is a Rowlandson print entitled *The Betting Post* assigned by Grego to 1789 (Grego I, 259, illus.), but it is not closely related to the Huntington drawing.

82. THE LIFE CLASS

Pen and gray wash over pencil; slight touches of color on the female figure and the faces, 7 7/16″ x 11¼″

Literature: Oppé, Pl. 50; Paulson, pp. 27-28, 74, 84, 85, 88, 122, Pl. 18

Exhibited: Whitechapel Art Gallery, London, 1953

Collections: Henry Harris, Gilbert Davis

Acquired: 1959

Accession Number: 59.55.1098

NOTES: This theme interested Rowlandson over a long period. His earliest dated drawing (1776) is of a group of students sketching (Hayes, Pl. 3) and he returned to the subject many times. Another version of the Huntington drawing was sold at the Georges Petit Gallery, Paris, June 3, 1932, lot 97. That drawing (7⅞″ x 11½″) was inscribed: Given to my old friend [J. T.] Smith/Th. Rowlandson (see Grego II, 16).

A modified and distinctly later version of the drawing, entitled *The French Academy*, is in the Widener Memorial Collection, Harvard. Two variants on the theme, entitled "A Dutch Academy," are in the Widener and Morris Saffron collections. A print based on these drawings was issued in 1792 (see Grego I, 306-07). Other variants on the theme appeared in 1801 (George 9785) and as the first plate in the *Microcosm of London* (1808), in both of which the place is specifically identified as the life class of the Royal Academy. Finally in 1824 (George 14953 and Grego II, 378) Rowlandson produced a last variant on the design entitled "R.A.'s of genius reflecting on the true line of beauty at the Life Academy, Somerset House."

The flexible pen line in the Huntington drawing

and the very slight use of color indicate that it comes early in Rowlandson's treatment of the theme. The traditional, and probably correct, identification of the young man in the center as Rowlandson himself reinforces the suggestion of an early date. But the other men are clearly not students, and there is no doubt the drawing postdates Rowlandson's own student days. According to the Royal Academy Minutes for 17 March 1769 no student under the age of twenty was permitted to draw after the female model "unless he be a married man." Probably the drawing dates from the mid-1780s.

It is interesting and revealing that Rowlandson's own face is the only one among the artists that is not caricatured.

83. ROWLANDSON AND HIS FAIR SITTERS

Pen and watercolor over pencil, 6¼″ x 8″

Literature: Hayes, Pl. 14

Exhibited: Drawings by Old Masters (London, Royal Academy, 1953), No. 484

Collections: Mrs. P. Flanders, Gilbert Davis, Homer Crotty

Acquired: 1968, gift of Homer Crotty

Accession Number: 68.11

NOTES: An attractive and important drawing which, by the costume, pen technique, and Rowlandson's apparent age, must date from the mid-1780s.

Although there is no documentary support for the suggestion that the man is Rowlandson, all the circumstances indicate that this identification is correct.

84. YOUNG WOMAN SEATED

Pen and gray wash over pencil, 6⅜″ x 5⅛″ (corners clipped)

Acquired: ca. 1910

Accession Number: Sessler 146

NOTES: The drawing is typical of those of fashionable young women done by Rowlandson in the mid-1780s. Both the pen work and the lady's coiffure support this date. Two subjects of this general type are illustrated in Grego I 220-21, dated 1787?, and entitled "Modish" and "Prudent."

85. A MORNING VISIT

Pen and watercolor over pencil, 6⅝″ x 9 1/16″
Inscribed in a later hand: Rowlandson
Literature: Sabin (1948), No. 19
Exhibited: English Manners and Humor (Paris, 1938); Arts Council (1950), No. 91; *Drawings by Old Masters* (London, Royal Academy, 1953), No. 459
Collections: Randall Davies, Gilbert Davis
Acquired: 1959, gift of the Friends
Accession Number: 59.55.1134

NOTES: An excellent example of Rowlandson's fluid and flexible early pen work of the mid-1780s. Unfortunately the watercolor washes are much faded.

Attributed to Rowlandson
86. PORTRAIT OF A MAN WITH A GUN

Pen and watercolor over pencil, 11⅝″ x 9⅛″ (oval)
Collections: Gilbert Davis
Acquired: 1959
Accession Number: 59.55.27

NOTES: This drawing raises an interesting problem in attribution which cannot be fully solved at present. The Huntington sheet brings to mind the well-known standing portrait of George Morland by Rowlandson in the British Museum and another portrait of a man seated under a tree that is in the Mellon collection. Of the three, there can be no doubt that the British Museum drawing is the strongest and most attractive. But, on more objective stylistic and technical grounds, all three appear to be by the same hand. Associated with the Mellon drawing is an old label which reads: "P. Wilkinson Esq. sitting under the shade of an oak learning to whistle. Drawn on the spot by S. Alken." The reference is presumably to Samuel Alken the elder, a printmaker and publisher who etched some of Rowlandson's designs in the 1780s. Alken is not otherwise known to have been active as a draftsman.

One hesitates to give much weight to an inscription that is only attached to a drawing and is patently inaccurate in describing what the man is doing. On the other hand it must be admitted that none of the drawings (including the one in the

British Museum) is fully characteristic of Rowlandson's work. In particular, the rather fussy multiple pen-line contour is unlike that of most Rowlandson drawings of the 1780s, although it does occur (Nos. 11 and 83). If the three portrait drawings should prove to be by the elder Alken, then there is clearly an artist working in the 1780s who is very close indeed to Rowlandson. But until more evidence comes to light, an attribution to Rowlandson for all three seems justified.

87. MRS. SIDDONS REHEARSING

Pen and watercolor over pencil, 12¼″ x 9″
Inscribed on verso in an old hand, not Rowlandson's: Mrs Siddons Rehearsing in the Green Room/ Mrs. Siddons, her father the elder Kemble/ and Henderson the actor/ by T. Rowlandson
Literature: George 7591; Wark, *Ten British Pictures*, Chapter VI
Exhibited: Arts Council (1950), No. 111
Collections: Joseph Grego (according to a clipping in the Witt Library); Gilbert Davis
Acquired: 1959
Accession Number: 59.55.1126

NOTES: There is uncertainty about the identity of the actor rehearsing before the mirror in the background. The old inscription says he is John Henderson, who died in 1785. A date of 1784 or 85, while not impossible, is earlier than the technique of the drawing implies. Gilbert Davis suggested, when the drawing was exhibited in 1950, that the third actor might be a man called Hudson, and this allows a little more leeway in dating. Dorothy George suggests 1789 with a question mark. A date in the late 1780s seems probable.

88. A LADY IN A PHAETON DRAWN BY SIX HORSES

Pen and gray wash, 6⅛″ x 10″, right corners torn
Acquired: ca. 1910
Accession Number: Sessler 29

NOTES: The pen technique and the lady's costume both suggest a date in the late 1780s.

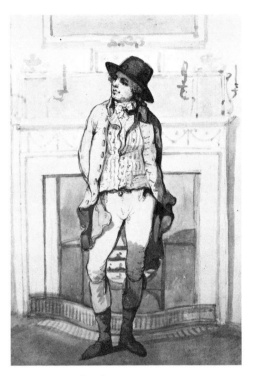

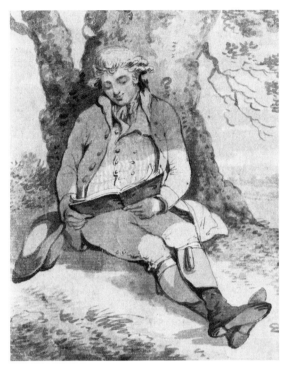

George Morland BY THOMAS ROWLANDSON
(BRITISH MUSEUM)

P. Wilkinson, Esq., HERE ATTRIBUTED TO
THOMAS ROWLANDSON
(MR. AND MRS. PAUL MELLON)

89. A FRENCH HUNT

Pen and gray wash over pencil, unfinished, 4¾"
x 8"
Acquired: ca. 1910
Accession Number: Sessler 99 a

NOTES: The boots, hats, and facial types all indicate that Rowlandson intended to depict Frenchmen. A similar subject, fully worked out, signed and dated 1792, is in the British Museum (Hayes, Pl. 93). The pen work suggests a date also about 1790 for the Huntington drawing.

90. A COVERED WAGON, TWO HORSES, AND TWO FIGURES

Pen and gray wash, 4¾" x 6"
Acquired: ca. 1910
Accession Number: Sessler 10

NOTES: The pen technique suggests a date about 1790.

91. TWO FIGURES ON HORSEBACK AND A DOG

Pen and gray wash over pencil, 5⅞" x 5¼"
Acquired: ca. 1910
Accession Number: Sessler 17 a

NOTES: Probably from the 1790s.

92. A TEAM OF HORSES

Pen and gray wash over pencil, 5½" x 7⅛",
corners torn
Verso: pencil sketch of a coach, possibly a Continental diligence
Acquired: ca. 1910
Accession Number: Sessler 17 b

NOTES: There is another version of this drawing in the Vassar College Art Gallery. The pen work of the Huntington drawing suggests a date about 1790.

93. A LOADED HAY CART

Pen and gray wash over pencil, 4¾" x 5¾"
Acquired: ca. 1910
Accession Number: Sessler 75 a

94. A FARMER STANDING ON HAY; TWO HORSES

Pen and pencil, unfinished, 5⅝" x 3½", top
corners trimmed
Acquired: ca. 1910
Accession Number: Sessler 129 a

NOTES: The pen work suggests a date around 1790. A building is lightly sketched in the background, suggesting that the subject is a farmer loading hay into a barn.

95. LOVE AND WAR

Pen and watercolor, 9⅝" x 14½"
Collections: Albert M. Weil
Acquired: 1970, bequest of Albert M. Weil
Accession Number: 70.30

NOTES: The significance of the title, which was given to the drawing before it entered the Weil Collection, is not entirely clear. In a version of the drawing in the Princeton Art Museum the sign in the background is inscribed, "Man Traps in These Grounds," confirming that the theme is two prostitutes soliciting business. This does not, however, fully explain the title, nor what it is that the two men are holding. A drawing that repeats the group on the left is in one of the British Museum Rowlandson scrapbooks (201 A 12).

96. A FRENCH FRIGATE TOWING AN ENGLISH MAN O' WAR INTO PORT

Pen and watercolor over pencil, 10⅝" x 8½"
Inscribed in pencil on old mount, probably in a later hand: A French frigate towing an English Man of War into Port
Literature: Apollo 10 (July, 1929), p. 17; Sabin (1948), No. 25; Wark, *Ten British Pictures*, p. 77, Fig. 58; Paulson, pp. 130 n. 2, 132 n. 29
Exhibited: Royal Naval Exhibition (1891) (?); *Art Treasures*, Wrexham (no date); *Thomas Rowlandson* (Ellis and Smith, London, 1948); Arts Council (1950), No. 123
Collections: H. Reveley (Lugt 1356), Joseph Grego (?), Madan, Gilbert Davis
Acquired: 1959
Accession Number: 59.55.1105

NOTES: Joseph Grego exhibited a drawing of the title and size of the Huntington drawing in the Royal Naval Exhibition of 1891.

The general theme of this drawing appears in a series of anonymous prints issued by Carrington Bowles in 1781 (George 5951, 52, 54), and illustrated in Charles Napier Robinson, *The British Tar in Fact and Fiction* (London, 1909), pp. 166, 172, 296. The precise title of the Huntington drawing does not appear in this earlier series, but the general idea of encounters between sailors and prostitutes under the names of British and French ships is clearly there. I am indebted to Shelley Bennett for pointing out this connection.

The pen work suggests a date about 1790.

97. FALSTAFF AND DOLL TEARSHEET
Pen and watercolor over pencil, 11" x 13"
Inscribed in Rowlandson's hand: Falstaff and Doll Tear Sheet
Literature: Paulson, pp. 45, 127
Exhibited: Arts Council (1950), No. 109
Collections: Gilbert Davis
Acquired: 1959
Accession Number: 59.55.1104

NOTES: The scene is presumably *The Second Part of King Henry IV*, Act II, Scene iv, the Boar's-head Tavern.

The drawing is unusually coarse technically, but appears to be authentic. Another sheet related stylistically and thematically (but a different composition) is in the Widener Memorial Collection at Harvard.

98. HOUSE BREAKERS
Pen (black and red ink) and watercolor over pencil, 8⅜" x 11 11/16"
Inscribed on the mount in a later hand: Aquatinted by Malton. Pubd by S. W. Fores 1788/ An alarm of Thieves/ House Breakers
Engraved: 1788 (Grego I, 233-34)
Collections: Col. Humphrey Sibthorp, Albert M. Weil
Acquired: 1970, bequest of Albert M. Weil
Accession Number: 70.36

NOTES: The Huntington drawing is closely related to the print. Another version of the drawing, signed and dated 1788, is illustrated in Hayes, Pl. 57.

99. CONCERTO SPIRITUALE
Pen and watercolor over pencil, 7⅞" x 6⅝"
Inscribed in Rowlandson's hand: Concerto Spirituale/ Messrs. Boch & Abel
Literature: Wark, *Ten British Pictures*, p. 75 Fig. 57
Exhibited: Arts Council (1950), No. 114
Collections: Gilbert Davis
Acquired: 1959, gift of the Friends
Accession Number: 59.55.1099

NOTES: Rowlandson alludes to Johann Christian Bach (1735-1782), the eleventh son of Johann Sebastian, and Karl Friedrich Abel (1725-1787). Bach and Abel gave highly successful and fashionable concerts together from 1765 to the early 1780s. Gainsborough's superb full-length portrait of Abel, his close friend, is in the Huntington Collection.

The drawing poses problems because a date as early as 1782, when Bach died, is impossible on stylistic grounds, and a date even as early as 1787, when Abel died, is most unlikely. It seems probable, however, that Rowlandson's drawing is not based on first-hand experience but on a print of this same name engraved by Bretherton after Bunbury and published March 23, 1773. This print contains three musicians rather than two, and differs in many other ways from Rowlandson's drawing, but it could easily be his source. Dorothy George, *Catalogue of Political and Personal Satires . . . in the British Museum*, No. 5417, suggests that Abel is the fat man playing the viola da gamba in Bunbury's design.

Another version of Rowlandson's drawing is illustrated in *Art News*, March 6, 1937, as at the Gernsheim Gallery, London. Yet another version, possibly the same one, is in the Olivia Shaler Swann Collection at the Art Institute of Chicago. A print based on Rowlandson's design is in the Dyson Perrins Rowlandson collection at the Metropolitan Museum. The print, clearly not by Rowlandson himself, is entitled "A Duet," with no artist or publication date given.

100. WEST COWES, LAUNCHING A CUTTER
Pen and watercolor over pencil, 8½" x 21" (on two pieces of paper glued together, presumably pages from a sketchbook)

*Inscribed in pencil in what appears to be Row-
landson's hand:* West Cowes Launching a
Cutter
Literature: Sabin (1933), No. 85 (illus.)
Exhibited: Arts Council (1950), No. 48
Collections: Gilbert Davis
Acquired: 1959
Accession Number: 59.55.1102

NOTES: Cowes is on the north coast of the Isle of
Wight at the mouth of the River Medina. Rowland-
son must have visited the Isle of Wight on several
occasions, judging from the number of drawings
of that area that survive and the way they are
spaced through his career (on evidence of style).
This drawing is certainly later in date than the 1784
Tour in a Post-Chaise; a time closer to 1800 appears
likely.

The drawing is technically interesting in that
many of the background buildings are executed in
pencil and watercolor only without pen reinforce-
ment, supporting the suggestion that (at least on
occasion) pen follows rather than precedes work
in watercolor.

101. CRUMPETS AND MUFFINS, ALL HOT!

Pen and watercolor over pencil, 10½" x 8¼"
Inscribed on the mount in a later hand: Crumpets
and Muffins, All Hot/ Unpublished drawing
by Rowlandson "Cries of London"
Acquired: 1902, in a bound volume of Rowland-
son's *Cries of London*
Accession Number: 73.13B

NOTES: This drawing, like the following, appears
to be an unused design for *Cries of London,* most
of which were issued in 1799.

102. EELS, ALL ALIVE!

Pen and watercolor over pencil, 11½" x 9⅛"
Signed: Rowlandson del.
Inscribed on the mount in a later hand: Eels! all
alive!/ Skinning Eels/ "Cries of London" un-
published Drawing.
Acquired: 1902, in a bound volume of Rowland-
son's *Cries of London*
Accession Number: 73.13A

NOTES: As the inscription states, this appears to be
an unused design for *Cries of London,* most of
which were issued in 1799. The technique of the
drawing is consistent with that date.

103. TWO DETAILS FROM HIGHLAND BROAD SWORD

Pen and watercolor over pencil, 2¼" x 2⅞";
3⅛" x 2⅜"
Inscribed in Rowlandson's hand: Cut at Belly/
Inside half Hang[?]/ Slip/ Cut at Leg
Verso: each sheet has a pencil tracing on the
verso of the figures on the recto
Engraved in reverse: 1799, as parts of *Hungarian
and Highland Broadsword Exercise. Etched
under the direction of H. Angelo and Son*
Acquired: ca. 1910
Accession Number: Sessler 21

104. SLOANE'S VOLUNTEERS, CHELSEA

Watercolor over pencil with touches of pen;
pencil sketches in background, 9½" x 7¼"
*Inscribed in pencil in what appears to be Row-
landson's hand:* Hans Sloane Volunteers/
Chelsea
Acquired: ca. 1910
Accession Number: Sessler 11

NOTES: The drawing, with its rather heavy water-
color washes and light pen work, does not look
much like Rowlandson's work at first glance. But
it follows exactly the form and style of the illustra-
tions in *Loyal Volunteers of London and Environs*
(London, 1798-99), although this particular figure
is not included in any of the copies examined. The
figures in the background, which appear to be
based on works by other artists, are executed in a
pencil technique that is more characteristic of
Rowlandson.

105. A GROUP OF TRAVELERS WITH TWO DONKEYS

Pen and watercolor, 2¼" x 4⅛"
Verso: Pen and wash sketch of figures in front
of a cottage
Acquired: ca. 1910
Accession Number: Sessler 24 a

106. THREE FIGURES ON HORSEBACK AND TWO IN A CARRIAGE
Pen and watercolor over pencil, 3 ⅜″ x 5 ⅝″
Acquired: ca. 1910
Accession Number: Sessler 24 b

107. A COACH AND FOUR AT REST
Pen and watercolor, 3″ x 4 ⅞″
Verso: pencil sketch of trees
Acquired: ca. 1910
Accession Number: Sessler 24 c

108. TWO SKETCHES WITH FIGURES AND HORSES
Pen and gray wash, 4″ x 2 ¼″
Acquired: ca. 1910
Accession Number: Sessler 125 a

NOTES: The drawings are slight, and small in scale, so dating is difficult. They are probably from the 1790s.

109. FOUR HORSES IN A PADDOCK
Pen and gray wash over pencil, 5 ¾″ x 3 ⅞″, bottom corners clipped
Verso: pencil sketch of a man and ducks
Acquired: ca. 1910
Accession Number: Sessler 125 b

NOTES: Probably about 1800

110. A CLERIC WITH AN UNRULY HORSE
Pen and watercolor over pencil, 3 ⅜″ x 5 ⅝″
Acquired: ca. 1910
Accession Number: Sessler 113 a

NOTES: The pen work describing the cleric suggests a date ca. 1800.

111. FORDING A STREAM
Pen and gray wash over pencil, 3 ⅜″ x 5 ¼″, lower left corner torn
Inscribed in Rowlandson's hand: [?] ol your Courage
Acquired: ca. 1910
Accession Number: Sessler 23 a

112. A COUPLE EMBRACING OUTSIDE A FARMHOUSE
Pen and watercolor, 3 ⅝″ x 5 ⅜″
Acquired: ca. 1910
Accession Number: Sessler 108 a

113. FIGURES IN A STABLE INTERIOR
Pen and gray wash over pencil, 5 ¼″ x 9″
Acquired: ca. 1910
Accession Number: Sessler 108 b

114. SEVEN COWS IN A LANDSCAPE
Pen over pencil, 4 ¼″ x 7 ¼″ (corners torn)
Watermark: [18]12
Acquired: ca. 1910
Accession Number: Sessler 52 b

115. DICK NIGHT LEAPING FROM A HEIGHT
Pen (black and red ink) over pencil, unfinished, 6 ½″ x 8 ⅝″
Acquired: ca. 1910
Accession Number: Sessler 14 b

NOTES: Another version of this drawing in the collection of Augustus Loring is inscribed in Rowlandson's hand: Dick Night leaping from a Height from a Wall on to flat Stones about [not clear] feet high at the entrance to Gilsborough Town.

Rowlandson uses a similar composition as Plate 3 of *The English Dance of Death* (see Nos. 247-49), but the technique of the Huntington's *Dick Night* drawing suggests an earlier date, not long after 1800.

116. AN AFFAIR OF HONOUR
Pen and watercolor over pencil, 4 ½″ x 7 3/16″
Inscribed on the mount at a later date: Smollet? / The Duel
Collections: Albert M. Weil
Acquired: 1970, bequest of Albert M. Weil
Accession Number: 70.31

NOTES: The design is not connected with Rowlandson's known illustrations to Smollett.

Dueling was prevalent in England during the

eighteenth century, but was vigorously discouraged in the early nineteenth. In 1808 the survivor of a duel was sentenced to death and executed; in 1813 the survivor and seconds were also all convicted of murder, although a royal pardon was granted.

117. CONNOISSEURS IN THE STUDIO
Pen and watercolor over pencil, 5¾″ x 9¼″
Literature: Paulson, p. 135 n. 31
Exhibited: (?) Burlington Fine Arts Club, London, 1931-32, No. 194; Arts Council (1950), No. 96
Collections: De Bathe (Dame Charlotte?), A. P. Charles, Gilbert Davis
Acquired: 1959
Accession Number: 59.55.1100

NOTES: A related drawing is in the collection of Mr. and Mrs. Paul Mellon (reproduced Paulson, Pl. 48), but differs in too many respects from the Huntington design for the two to be classed as versions of each other. On stylistic grounds the Mellon drawing appears earlier in date. The Huntington drawing probably was made about 1800.

118. SOLDIERS RESTING
Pen and watercolor, 5″ x 7″
Exhibited: Arts Council (1950), No. 72
Collections: Gilbert Davis
Acquired: 1959
Accession Number: 59.55.1109

NOTES: The drawing clearly began as a counterproof, but has been fully reworked. Another version of the drawing, in reverse, is illustrated in Hayes, (Pl. 124) but that does not appear to be the drawing from which the Huntington counterproof was pulled. Hayes's date, ca. 1800-05, for the version he illustrates, is also plausible for the Huntington drawing.

Various titles have been given to the two versions. When the Huntington drawing was exhibited at the Arts Council it was entitled *Soldiers Resting in Hyde Park.* When the other version was with Frank Sabin it was entitled *Soldiers' Bivouac on the Isle of Wight.* There is no evidence to support (or deny) either suggestion.

119. DEATH IN THE RING
Pen and blue and gray wash over pencil, 7¾″ x 10¾″, lower right corner torn
Signed, not in Rowlandson's hand: Rowlandson
Inscribed on papers in the foreground: 100 Guineas/ 100—
Collections: William Henry Bruton
Acquired: ca. 1925
Accession Number: Rare Book 144954 f 197

NOTES: This drawing entered the Huntington collection with the Bruton extra-illustrated set of *The English Dance of Death.* The subject is similar to *The Death Blow,* No. 280 (Wark, *Dance of Death,* No. 25) but the style and physical size of this drawing indicate clearly that it was not originally conceived as part of the Dance of Death series. The technique suggests a date close to 1800.

Attributed to Rowlandson
120. DISTURBERS OF DOMESTIC HAPPINESS
Unretouched counterproof, 8⅝″ x 12⅛″, upper right corner torn
Engraved in reverse: ca. 1815 (Grego II, 297)
Acquired: ca. 1910
Accession Number: Sessler 44

NOTES: There are two prints of this design (both in reverse) in the Rowlandson collection at the Metropolitan Museum. Neither is dated; one is labeled *Disturbers of Domestic Happiness* and carries Rowlandson's name. Both the draftsmanship and the facial types of the robbers are outside Rowlandson's normal range. The woman and child are closer to Rowlandson in style, but were it not for the print there would not be much justification for attributing this sheet to Rowlandson. Certainly if the drawing is by Rowlandson it is closer in date to 1800 than to 1815.

121. A GHOST IN A WINE CELLAR
Pencil, unfinished, 4¾″ x 6⅞″
Engraved: 1800 (Grego II, 6), reissued 1811 (Grego II, 208)
Acquired: ca. 1910
Accession Number: Sessler 147

NOTES: A finished version of the drawing is in the Wiggin Collection of the Boston Public Library.

122. A DRUNKEN MIDSHIPMAN
Pen and watercolor over pencil, 9½" x 6⅜"
Signed: T. Rowlandson
Collections: Henry Reitlinger, Gilbert Davis
Acquired: 1959
Accession Number: 59.55.1114

NOTES: A spirited and somewhat unusual drawing in that it appears to be an on-the-spot sketch rather than a developed, studio composition. The pen work suggests a date before 1800.

123. BAD NEWS
Pen and watercolor over pencil, 8⅜" x 5¾"
Watermark: 1801
Inscribed in Rowlandson's hand: [top, pencil] Bad News [bottom, pen] Bad News
Acquired: ca. 1910
Accession Number: Sessler 92

124. SEATED WOMAN
Pen and wash, 9⅛" x 8¾"
Exhibited: British Water-colours and Drawings from the Gilbert Davis Collection (Arts Council, London, 1949), No. 22
Collections: Gilbert Davis
Acquired: 1959, gift of the Friends
Accession Number: 59.55.1136

NOTES: A recent inscription on the verso identifies the sitter as Lady Hamilton. The face is too generalized to give much support to any such identification, although the general pose, the simplicity of the costume, and the proportions of the head are reminiscent of Lady Hamilton. The drawing, which probably dates around 1800, is a relatively late example of a Rowlandson portrait study with no comic or satiric overtones.

125. A BOXING MATCH
Pen and gray wash over pencil, 4¾" x 6¾"
Watermark: 1802
Acquired: ca. 1910
Accession Number: Sessler 91 a

NOTES: The subject was treated by Rowlandson on many occasions (see for instance, Nos. 119, 143, 280), but no other version of this particular drawing has been located.

126. STUDIES OF DOGS AND A RABBIT
Pen over pencil, 7⅞" x 5¼"
Verso: pencil sketch of a cottage
Acquired: ca. 1910
Accession Number: Sessler 135

127. LORD CARDIGAN AT HOME
Pen and watercolor over pencil, 5¼" x 8⅜"
Inscribed in Rowlandson's hand: Lord Cardigan making Preparations to attend his Majesty's Levee
Verso, inscribed in a later hand: James Brudenell Cardigan/ 5th Earl/ Governor of Windsor Castle/ & Keeper of the Privy Purse/ 1725-1811
Literature: Paulson, p. 72
Exhibited: Arts Council (1950), No. 86
Collections: Gilbert Davis
Acquired: 1959
Accession Number: 59.55.1094

NOTES: Lord Cardigan was Keeper of the Privy Purse to the Prince of Wales and also to the King. He was Constable of Windsor Castle from 1791 until his death, and High Steward of Windsor, 1802. The drawing probably dates from the first decade of the nineteenth century.

128. CHELSEA PENSIONERS
Pen and watercolors over pencil, 4½" x 7⅛"
Inscribed on mount in an early hand: Chelsea Pensioners
Exhibited: Arts Council (1950), No. 81
Collections: L. Deglatigny (Lugt 1768a), Gilbert Davis
Acquired: 1959
Accession Number: 59.55.1097

NOTES: Another version of this drawing (6" x 8½") was with Agnew ca. 1971.
The building in the background is no doubt Chelsea Hospital, but not drawn with any precision.

129. A NOBLEMAN IMPROVING HIS ESTATE

Pen and watercolor over pencil, 7¾″ x 11⅛″
Watermark on old mount: 1802
Inscribed in pencil on old mount probably in a later hand: A Nobleman improving his Estate
Literature: Paulson, p. 88, Fig. 52
Exhibited: Arts Council (1950), No. 87
Collections: Gilbert Davis
Acquired: 1959, gift of the Friends
Accession Number: 59.55.1117

NOTES: Another version of the drawing is in the collection of Edward Croft-Murray. A similar idea, the composition in reverse and with many modifications, is used by Rowlandson as Plate 10 of *The Dance of Life* (1817). The Huntington drawing, however, is probably close to the date of the watermark on the mount.

130. A TABLE D'HOTE, OR FRENCH ORDINARY IN PARIS

Pen and watercolor over pencil, 8¼″ x 13⅜″
Watermark: 1802 [?]
Engraved: 1810 (Grego II, 188; George 11625)
Literature: Grego II, 188; Falk, facing p. 53; Paulson, pp. 19, 76, 119 n. 26
Exhibited: Humorous Art (Royal Society of Arts, London 1949); Arts Council (1950), No. 143; *Three Centuries of British Watercolours and Drawings* (London, Arts Council, 1951), No. 152; *Drawings by Old Masters* (Royal Academy, London, 1953), No. 464.
Collections: Gilbert Davis
Acquired: 1959
Accession Number: 59.55.1106

NOTES: The "ordinary" was more-or-less the equivalent of a modern restaurant.

Another version of this drawing, signed and dated 1804, was formerly in the Deglatigny Collection.

131. A MEETING OF COGNOSCENTI

Pen and watercolor, 5⅝″ x 9¼″
Literature: Sabin (1933), No. 45

Collections: Dame Charlotte de Bathe, Dr. and Mrs. Edward W. Bodman
Acquired: 1960, gift of Mrs. Edward Bodman
Accession Number: 60.1

NOTES: Versions reading in the same direction as the Huntington drawing are in the Metropolitan Museum (D.D.17.97.7 [3]) and the Augustus Loring Collection. A version in reverse, apparently a counterproof retouched by another hand, is in the Achenbach Collection, San Francisco Palace of the Legion of Honor.

Rowlandson used a very similar composition for one of the plates in *The English Dance of Death* (see No. 326 of this catalog). The Dance of Death print was issued March 1, 1816.

132. THE LORD OF THE MANOR RECEIVING HIS RENTS

Pen and watercolor over pencil, 6¾″ x 9½″
Inscribed in Rowlandson's hand: The Lord of the Manor receiving his rents
Inscribed in Rowlandson's hand on various signs in the background, left to right: Plan of Estate/ Rent Roll/ Almanac/ Lives fell in/ Leases grants/ Game Laws
Exhibited: Arts Council (1950), No. 85
Collections: Gilbert Davis, Homer Crotty
Acquired: 1969, gift of Homer Crotty
Accession Number: 69.74

NOTES: Another version of this drawing, signed and dated 1802, is in the Field Collection at the Houghton Library, Harvard University. There is a third version in the Wiggin Collection at the Boston Public Library, No. 42.

133. THE PRESS GANG

Pen and watercolor over pencil, 7 3/16″ x 10½″
Inscribed in Rowlandson's hand on a sign in the background: Bounty/ for Able/ Bodied/ Seamen
Exhibited: Arts Council (1950), No. 83
Collections: Gilbert Davis
Acquired: 1959, gift of the Friends
Accession Number: 59.55.1120

NOTES: Impressment was the normal method of obtaining men for the navy through much of the

eighteenth century. For a good, brief account of impressment and the operation of the press gang in the late eighteenth century see G. J. Marcus, *A Naval History of England*, Vol. I (1961), pp. 373-75.

This is a fine, vigorous drawing in which Rowlandson drops humor and comes close to indignation at a form of injustice. Another version of the drawing (incomplete) was illustrated in *Country Life*, December 5, 1963.

There was a version of the drawing in the Royal Naval Exhibition of 1891, illustrated in Joseph Grego's brochure, p. 30. This drawing apparently carried the rather improbable date, 1820.

134. ROAD TO RUIN
Pen and watercolor, 5⅜″ x 9 1/16″
Engraved: 1803 (Grego II, 397)
Literature: Wark, *Dance of Death*, No. 85
Collections: William Henry Bruton
Acquired: ca. 1925
Accession Number: Rare Book 144594 f 561

NOTES: This drawing was previously regarded as an unpublished design for *The English Dance of Death*. It follows the general format for those designs, but it was in fact published about a decade before Rowlandson began work on the large project.

135. THE REGISTRY OFFICE
Pen and watercolor over pencil, 8⅞″ x 13¾″
Signed and dated: Rowlandson 180[3?]
Inscribed in Rowlandson's hand on several signs in the background, left to right: To be/ disposed/ of/ Terms/ of this/ office/ Wanted/ a Country/ House/ The Only Reputable/ Office in London; Register Office/ for the Hiring of Servants/ Masters and mistresses may be/ accomodated [sic] with servants of/ all descriptions/ Shew Days Monday/ Wenesdays [sic] & Fridays/ [beneath the signature] A Register Office
Literature: Bury, Pl. 29; Falk, facing p. 61; Paulson, pp. 81, 118 n. 3
Exhibited: Arts Council (1950), No. 97
Collections: Gilbert Davis

Acquired: 1959
Accession Number: 59.55.1123

NOTES: See Introduction, pp. 6-10. Another version of the drawing, in the collection of Mr. and Mrs. Paul Mellon, appears to be the version formerly in the Deglatigny Collection, dispersed in Paris in 1964.

136. PROVIDENCE CHAPEL
Pen and watercolor, 9⅜″ x 15″
Inscribed in Rowlandson's hand above the entrance in the background: Providence Chapel/ erected by Wᵐ Huntington
Literature: Falk, facing p. 61; Paulson, pp. 28, 122 n. 20
Exhibited: *Thomas Rowlandson* (Ellis and Smith, London, 1948) No. 8; *Humorous Art* (Royal Society of Arts, London, 1949); Arts Council (1950), No. 36
Collections: Gilbert Davis
Acquired: 1959
Accession Number: 59.55.1122

NOTES: The Arts Council (1950) catalog provides the following information: "Providence Chapel, in Great Titchfield Street, Tottenham Court Road, was a place of worship for the 'Independents', and was under the ministry of an eccentric preacher, William Huntington, a converted coal-heaver who was nick-named 'Sinner-saved Huntington.' The fabric was burnt down in 1810, and on the minister being spoken to respecting its rebuilding, he is said to have observed that 'Providence having allowed the chapel to be destroyed, Providence might rebuild it, for he would not'; in consequence the site was afterwards occupied by a timber-yard."

There are many repetitions and variants of this drawing. Interestingly enough, the name of the chapel changes frequently. A version in the Ashmolean Museum is labeled as *Huntington's Providence Chapel*, but a version at one time with the Leger Gallery is identified as Jones Chapel, Islington; another in the Field Collection at the Houghton Library, Harvard, is inscribed "Zion Chapel," and yet another in the Victoria and Albert Museum (E 507-1931) is called "Rowland Hill's Surrey Chapel."

137. SCENE OFF SPITHEAD
Pen and watercolor over pencil, 10⅝″ x 15″
Inscribed, not in Rowlandson's hand: T. Rowlandson
Literature: Paulson, p. 75
Collections: Gilbert Davis
Acquired: 1959
Accession Number: 59.55.1128

NOTES: Another, more finished version is illustrated in *Connoisseur*, December 1946, p. 87, then in the Bruce Ingram Collection, now in the Ashmolean Museum.

138. THE MOUNTEBANKS
Pen and watercolor, 7¾″ x 10⅞″
Signed and dated: Rowlandson 1804
Inscribed in pencil on old mount in a later hand: The Mountebank
Collections: Deglatigny (Lugt 1786a), Gilbert Davis
Acquired: 1959
Accession Number: 59.55.1116

NOTES: There is a photograph in the Witt Library of another version of this drawing entitled *Musicians at a Fair*. No other information is attached to the photograph.

139. 'TIS TIME TO JUMP OUT
Pen and watercolor over pencil, 11⅞″ x 16¾″
Watermark: 1799
Signed and dated: Rowlandson 1805
Inscribed in Rowlandson's hand: Tis Time to Jump out—
Collections: Gilbert Davis
Acquired: 1959, gift of the Friends
Accession Number: 59.55.1111

NOTES: The basic pen work is extensively reinforced by strokes in sanguine, presumably applied with a coarse reed pen. This is a technique Rowlandson used frequently in the first two decades of the nineteenth century but which is rare in his early or latest work.

140. RECOVERY OF A DORMANT TITLE
Pen, with black and red ink, and watercolor over pencil, 12″ x 8¾″
Signed and dated, almost trimmed off: Rowlandson 180[7?]
Inscribed in Rowlandson's hand on signs in the background: Breeches Cleaned/Lined & Repaired Hunchback . . ./. . . Maker to his/. . . Serene High . . . To be sold the good/will of this Shop/Removed to/Grovesnor [sic] Place
Engraved: 1805 (Grego II, 51; George 10483)
Exhibited: Arts Council (1950), No. 88
Collections: Gilbert Davis
Acquired: 1959
Accession Number: 59.55.1091

NOTES: The title on the print is: *Recovery of a dormant title, or a Breeches Maker become a Lord.* The print was reissued in 1812 with the title: *Taylor Turned Lord.* The drawing entered the Huntington Collection with the title: *The Duke of Beaufort and his Creditors*, but no support for this suggestion has been discovered.

141. TWO HORSEMEN SEEN FROM THE REAR
Pen, 5⅝″ x 7⅛″
Watermark: 1805
Acquired: ca. 1910
Accession Number: Sessler 27 b

NOTES: This was a popular motif with Rowlandson, and several versions and variants of the design are known. One is illustrated in Bury, Pl. 82. Another is in the collection of Mr. and Mrs. Paul Mellon. A variant on the idea, with only one horseman, appears as the frontispiece for William Combe's *Third Tour of Dr. Syntax.*

142. THE SERVANTS' DINNER
Pen and watercolor over pencil, 11 1/16″ x 16 15/16″
Signed and dated: Rowlandson 1806
Literature: Paulson, pp. 35, 125 n. 16, Pl. 24
Exhibited: Arts Council (1950), No. 141; *British Life* (The Arts Council, London, 1953), No. 77
Collections: Gilbert Davis
Acquired: 1959
Accession Number: 51.55.1125

NOTES: Another version of the drawing is in the Metropolitan Museum (see Bury, Pl. 30).

Although it would be unwise to expect absolute accuracy in such matters from Rowlandson, it is worth noting as an indication of social customs that the dinner for the master and mistress is apparently going on at the same time as that for the servants, and that the time is 3:30.

143. A PRIZE FIGHT

Pen and watercolor over pencil, 11¼" x 9" (uneven)

Inscribed in pencil in Rowlandson's hand: Raw Beef

Engraved: 1806 (Grego II, 62-63)

Collections: Desmond Coke, Albert M. Weil

Acquired: 1970, bequest of Albert M. Weil

Accession Number: 70.34

NOTES: Another version of this drawing, signed and dated 1806, is in the Augustus Loring Collection.

144. THE GERMAN WALTZ (1)

Pen and watercolor over pencil, 5⅝" x 7⅞"

Verso: Pencil tracing of the design on the front, inscribed in what appears to be Rowlandson's hand: Vauxhall

Engraved: 1806 (Grego II, 57 and 398)

Acquired: ca. 1910

Accession Number: Sessler 117 a

NOTES: Grego quotes a passage from *The Sorrows of Werther*, Letter X, "The Waltz with Charlotte."

145. THE GERMAN WALTZ (2)

Pen and watercolor over pencil, 5⅞" x 8"

Watermark: 1804

Verso: Pencil sketch of a dancing couple

Acquired: ca. 1910

Accession Number: Sessler 117 b

NOTES: The drawing is closely related to No. 144 (note in particular the group to the right in this drawing and the group to the left in the preceding), but the two compositions are certainly not identical. The preceding drawing is the one that is closer to the print.

146. CHASING YOUR HAT

Pen and watercolor over pencil, 4¼" x 6⅜"

Inscribed in Rowlandson's hand: Miseries of London/Chasing you Hat (just blown off in a high wind) through a muddy street—a fresh gust/always whisking it away at the moment of seizing it. when you have at last caught it/deliberately putting it on, with all its sins upon your head, amidst the jeers of the populace [the last few words are partially trimmed off]

Engraved in reverse: Miseries of Human Life, 1808. This particular print first appeared separately January 1, 1807 (Grego II, 121)

Acquired: ca. 1910

Accession Number: Sessler 81 a

147. BEATING THE CARPET

Pen and watercolor over pencil, 4⅛" x 6¾"

Inscribed in Rowlandson's hand: Turning a corner. being smothered by a gristy cloud following the first/lusty strokes bestowed on a filthy Carpet—

Acquired: ca. 1910

Accession Number: Sessler 81 b

NOTES: The drawing clearly belongs to the "Miseries" series (see Nos. 146, 148-51), but does not appear to have been engraved. Another version of this drawing, inscribed only "Miseries of London," is in one of the British Museum Rowlandson scrapbooks (201 A 11).

148. FOLLOWING ON HORSEBACK A SLOW CART

Pen and brown wash over pencil, 4½" x 5⅛", torn along left margin

Inscribed in Rowlandson's hand: Following on horseback a slow cart through an endless narrow lane at sunset/[when you] are already too late and want all the help of your own eyes as well as/[your horses's feet] to carry you safe through the rest of your unknown way/[Miseries of] the Country

Engraved in reverse: Miseries of Human Life, a collection of plates issued singly 1806-08 and

brought out by R. Ackermann as a group in 1808 (Grego II, 119)

Acquired: ca. 1910

Accession Number: Sessler 84 a

149. MISERY IN A BOAT

Pen over pencil, 5½″ x 6⅞″

Inscribed in Rowlandson's hand: Miseries Miscellaneous—In going out to sea in a fishing boat with a/delightful party. continuing desperately sick the whole time—the rest of the/company quite gay and well—[There are also some numerical notations in pencil to the right]

Acquired: ca. 1910

Accession Number: Sessler 84 b

NOTES: The subject is clearly connected with the various series of "Miseries" created by Rowlandson during the first decade of the nineteenth century (see also Nos. 146-51). This particular subject has not been located amongst the various engravings of the "Miseries" available for consultation.

150. FABRICIOUS'S DESCRIPTION OF THE POETS (1)

Pen and gray wash, 3¼″ x 5⅞″

Engraved in reverse: in *Miseries of Human Life* (1808), this plate first issued individually in 1807 (Grego II, 119)

Acquired: ca. 1910

Accession Number: Sessler 145 b

NOTES: The print carries the following inscription: Vide 'Gil Blas'—'People think that we often dine with Democritus, and there they are mistaken. There is not one of my fraternity, not even excepting the makers of Almanacs, who is not welcome to some good table. As for my own part, there are two families where I am received with pleasure. I have two covers laid for me every day, one at the house of a fat director of the farms, to whom I have dedicated a romance, and the other at the house of a rich citizen, who has the disease of being thought to entertain wits every day at his table; luckily he is not very delicate in his choice, and the city furnishes him with great plenty.'

It is not immediately clear why Rowlandson included this subject in the *Miseries of Human Life.* The inscription doesn't follow the form of other "Misery" plates, and the misery involved (listening to boring conversation in order to obtain a good meal) is much less acute than most of the others. See also No. 151.

151. FABRICIOUS'S DESCRIPTION OF THE POETS (2)

Pen, 4″ x 7″

Engraved in reverse: in *Miseries of Human Life* (1808); this plate first issued individually in 1807 (Grego II, 119)

Acquired: ca. 1910

Accession Number: Sessler 134 b

NOTES: See under No. 150

This drawing is later in technique than No. 150, and must date from about 1820, well after the print was issued. There are many variations between the two Huntington versions of the subject. No. 150 is much closer to the print. No. 151 is a later variant on the theme.

152. CURIOSITY CURED

Pen and watercolor over pencil, 7¼″ x 5⅜″

Inscribed in Rowlandson's hand: Curiosity Cured

Verso inscribed in Rowlandson's hand: A prying old maid caught peeping/To be eternally watched by the prying/eyes of an old maid —/Curiosity Cured

Acquired: ca. 1910

Accession Number: Sessler 102

NOTES: The phrasing of one of the inscriptions on the verso, "To be eternally watched . . . ," follows the formula used by Rowlandson for his captions to *Miseries of Human Life* (1808), and it is possible the drawing may be an unused design for that series.

153. INTERIOR OF AN EATING HOUSE

Pen and gray wash over pencil, 4⅛″ x 6½″

Verso inscribed in Rowlandson's hand: [pencil] had the presence of mind to open/Window

—the Cats immediately made/a retreat—it being on a market day/the Country People's surprise was/great—too [sic] see such a shooting of Cats/who run back each to their respe[ctive]/Dwellings/[ink] Tis done—but yesterday a King/

And arm'd with Kings to strive/
And now thou art a nameless thing/
To abject—yet alive/
Is this the man of thousand thrones/
Who strew'd our Earth with hostile bones/
And can he thus survive?

Acquired: ca. 1910
Accession Number: Sessler 134 a

NOTES: A related, but not closely related, print, the composition in reverse, is reproduced in Grego II, 296, assigned by him to 1815?. A reproduction of the print in the Witt Library is inscribed: Wheatsheaf Eating House.

The source for the poetry quotation has not been located. Clearly the inscriptions on the verso are unrelated to the drawing on the recto.

154. FOUR HORSES
Pen over pencil, 3⅝″ x 5″
Verso: slight pencil sketch of three men seated at a table
Acquired: ca. 1910
Accession Number: Sessler 129 b

NOTES: A similar group, but not the same, occurs in Rowlandson's *Outlines* (1790-92), a collection of picturesque figures, landscapes, and cattle for the use of amateur draftsmen. The technique of the Huntington drawing suggests a later date, probably after 1800.

Attributed to Rowlandson
155. THE LETTER
Pen and watercolor, 6⅜″ x 8⅛″
Inscribed, probably not in Rowlandson's hand: Rowlandson 1797
Acquired: ca. 1910
Accession Number: Sessler 103 b

NOTES: The draftsmanship, especially in the two principal figures, is stiff and gauche; the watercolor

washes are rather muddy. There is, however, nothing in the drawing that definitely precludes Rowlandson's authorship. If the drawing is by Rowlandson, the technique suggests a date closer to 1810 than 1797.

156. SUTTON, NORTHAMPTONSHIRE
Pen and watercolor over pencil, 7⅛″ x 9½″
Inscribed in Rowlandson's hand: Sutton Northamptonshire
Acquired: ca. 1910
Accession Number: Sessler 65

NOTES: A larger version of this drawing, with more buildings shown to the left, was illustrated in *Connoisseur*, Feb. 1928, as then in the Desmond Coke Collection.

157. COASTAL SCENE WITH SHIPWRECK AND RUNNING FIGURES
Pen and watercolor over pencil, 6½″ x 9¾″
Acquired: ca. 1910
Accession Number: Sessler 71

NOTES: Another drawing with the same composition, but without the shipwreck or running figures, was with F. T. Sabin in 1948 (No. 10).

158. COASTAL VIEW FROM A BLUFF, A HOUSE IN CENTER FOREGROUND, BRIDGE AND HOUSE TO RIGHT
Pen and watercolor over pencil, 5¾″ x 9¼″, top left corner torn
Watermark: [18]11?
Acquired: ca. 1910
Accession Number: Sessler 56 a

159. COAST SCENE WITH NATURAL ROCK BRIDGE (1)
Pencil and gray wash, 6″ x 9¼″
Acquired: ca. 1910
Accession Number: Sessler 56 b

NOTES: Apparently a preliminary drawing for No. 160. It is unusual to find Rowlandson drawings that are clearly preliminary or preparatory in nature. Such preparation usually exists underneath a watercolor rather than on a separate sheet.

160. COAST SCENE WITH NATURAL
 ROCK BRIDGE (2)
Pen and watercolor over pencil, 6¾″ x 10⅛″
Acquired: ca. 1910
Accession Number: Sessler 60

NOTES: The watercolor is a worked-up version of
the pencil and wash drawing of the same subject
(No. 159).

161. DARTMOUTH CASTLE FROM
 KINGSWEAR
Pen and watercolor over pencil, 5⅝″ x 9″
Watermark: [18]11
Inscribed in Rowlandson's hand: [top] Dart-
 mouth Castle/[bottom] Dartmouth Castle
 from Kingsweare
Acquired: ca. 1910
Accession Number: Sessler 55 a

162. DARTMOUTH HARBOR
Pen and watercolor over pencil, 5⅝″ x 9¼″
Inscribed in Rowlandson's hand: Dartmouth
 Harbour
Acquired: ca. 1910
Accession Number: Sessler 55 b

163. HOUSE NEAR A ROCKY GORGE
Pen and watercolor over pencil, 5¾″ x 9¼″
Watermark: [1]808
Acquired: ca. 1910
Accession Number: Sessler 54 b

164. RURAL LANDSCAPE WITH A
 CHURCH ON A HILL
Pen and watercolor over pencil, 5½″ x 9⅛″
Inscribed in Rowlandson's hand: Colum[..?]
Acquired: ca. 1910
Accession Number: Sessler 54 a

NOTES: The undecipherable inscription probably is
an indication of the place represented, but no town
has been located that fits the requirements.

165. TWO SAILBOATS ON A LAKE,
 ROCKY BANK TO LEFT
Pen and watercolor over pencil, 5½″ x 9″

Acquired: ca. 1910
Accession Number: Sessler 50 a

NOTES: It is interesting, in connection with Row-
landson's technique, that there is no pen used in the
background.

166. TWO SHIPS IN A STORM
Pen and watercolor over pencil, 5¾″ x 9¼″
Acquired: ca. 1910
Accession Number: Sessler 50 b

167. COUNTRY COTTAGE WITH GATE
 AND STONE FENCE
Pen and watercolor over pencil, 5⅛″ x 8¼″
Watermark: [...]8
*Signed in pencil, not certainly in Rowlandson's
 hand:* Rowlandson
Acquired: ca. 1910
Accession Number: Sessler 64 a

168. RUINS OF A CONVENT IN WILT-
 SHIRE
Pen and watercolor over pencil, 5¾″ x 9¼″
Inscribed in what appears to be a later hand:
 Ruins of a Convent in Wiltshire
Acquired: ca. 1910
Accession Number: Sessler 64 b

NOTES: Another version of this drawing, without
the inscription, is in the Wiggin Collection of the
Boston Public Library (No. 171).

169. STREAM IN A HILLY LANDSCAPE
Pen and watercolor over pencil, 5⅝″ x 9¼″
Acquired: ca. 1910
Accession Number: Sessler 68

NOTES: The background has some buildings and
figures (?) lightly indicated in pencil. Probably
the drawing is unfinished.

170. THE LOGAN ROCK, CORNWALL
Pen and watercolor over pencil, 5¾″ x 9¼″
Inscribed in Rowlandson's hand: Loggan Rock/
 Coast Cornwall
Acquired: ca. 1910
Accession Number: Sessler 61 a

NOTES: There is another version of this drawing in the Leeds Art Gallery (illus. Hayes, Pl. 134) on paper watermarked 1808. In that version there are no figures on the stone itself, and no house on the hill to the right.

Logan Rock, near Land's End, is a massive rocking stone weighing sixty-six tons.

171. NORTH COAST OF CORNWALL
Pen and watercolor over pencil, 5¾″ x 9¼″
Inscribed in Rowlandson's hand: North Coast of Cornwall
Acquired: ca. 1910
Accession Number: Sessler 61 b

172. FARM IN A HILLY LANDSCAPE
Pen and watercolor over pencil, 5⅛″ x 7⅞″, two prominent stains
Inscribed verso, probably not in Rowlandson's hand: H E [possibly an unidentified collector's mark]/Rowlandson
Acquired: ca. 1910
Accession Number: Sessler 66 a

173. COTTAGE NEAR A BRIDGE
Pen and watercolor over pencil, 5¼″ x 8¼″
Acquired: ca. 1910
Accession Number: Sessler 66 b

174. A COVE ON A ROCKY SHORELINE
Watercolor over pencil, 5½″ x 9¼″
Acquired: ca. 1910
Accession Number: Sessler 59 b

175. A RUINED TOWER ON A SEA COAST
Pen and watercolor over pencil, 5¼″ x 8⅞″
Acquired: ca. 1910
Accession Number: Sessler 59 a

NOTES: Another version of this drawing is in the Widener Collection at Harvard.

176. DEER BENEATH A LARGE TREE
Pen over pencil, unfinished, 5½″ x 7¾″
Acquired: ca. 1910
Accession Number: Sessler 58 a

NOTES: A drawing similar in theme but different in composition is in the Metropolitan Museum (D.P.59.533.563).

177. A HUNTER WITH THREE DOGS WALKING THROUGH WOODS
Pen (black and red ink) and gray wash over pencil, 6″ x 9¼″
Acquired: ca. 1910
Accession Number: Sessler 58 b

NOTES: The pen work in the trees suggests a date in the first decade of the nineteenth century.

178. COASTAL SCENE WITH CASTLE, HULK, AND MEN FISHING
Pen and watercolor over pencil, 6½″ x 9⅞″
Acquired: ca. 1910
Accession Number: Sessler 57

179. THAMES [?] DOCKYARD
Pen and watercolor over pencil, 5⅞″ x 9⅞″
Inscribed in Rowlandson's hand on building to left: Ship Chandler
Acquired: ca. 1910
Accession Number: Sessler 53 b

NOTES: Although there is nothing that clearly establishes the identity of the port, London is certainly the most likely possibility.

180. RIVER SCENE (GREENWICH?)
Pen and brown wash over pencil, unfinished, 6″ x 10″
Acquired: ca. 1910
Accession Number: Sessler 53 a

NOTES: The building lightly sketched in pencil on the far side of the river has two domes with hills behind, and appears to be Greenwich Hospital.

181. HARBOR SCENE WITH MANY FIGURES IN BOATS; MAN O' WAR TO LEFT
Pen and watercolor over pencil, unfinished, 7⅛″ x 10⅛″

Verso: slight pencil sketch of houses
Acquired: ca. 1910
Accession Number: Sessler 63

NOTES: Probably first decade of the nineteenth century.

182. BRENT TOR, DEVON
Pen and watercolor over pencil, 5 9/16″ x 9¼″
Verso inscribed in a later hand: Brent Tor, Cornwall [sic]
Literature: Sabin (1948), No. 46
Collections: Gilbert Davis, Homer Crotty
Acquired: 1971, gift of Homer Crotty
Accession Number: 71.5

NOTES: The drawing is too generalized in character to offer much support for the identification as Brent Tor (on the western edge of Dartmoor Forest), but certainly the scene derives from Rowlandson's numerous excursions to Devon and Cornwall.

183. CORNISH CASCADE
Pen and watercolor over pencil, 7 5/16″ x 10¾″
Exhibited: Arts Council (1950), No. 54
Collections: Gilbert Davis
Acquired: 1959, gift of the Friends
Accession Number: 59.55.1101

NOTES: In the Witt Library there is a photograph of a drawing related to the left half of this one. There is no information concerning the source of the photograph.

184. CARCLAZE TIN MINE
Pen and watercolor, 8″ x 12⅝″
Signed: T. Rowlandson
Inscribed in Rowlandson's hand: View of Curclaze [sic] Tin Mine/Cornwall
Collections: Gilbert Davis
Acquired: 1959, gift of the Friends
Accession Number: 59.55.1131

NOTES: R. Symons, *A Geographical Dictionary or Gazetteer of the County of Cornwall* (Penzance, 1884), p. 18: "Carclaze, St. Austell, a large excavation 2 miles north of the town, about 120 feet deep, containing 13 acres of ground and nearly a mile in circumference. It is supposed to have been worked more than 400 years—until 1851—for tin only. Now chiefly for China clay."

185. FIGURES ON HORSEBACK; A BOY ADJUSTING A LADY'S SADDLE
Pen and brown wash, 7″ x 9⅝″
Acquired: ca. 1910
Accession Number: Sessler 69

186. A FISHING PARTY
Pen and watercolor over pencil, 6¾″ x 9¾″
Acquired: ca. 1910
Accession Number: Sessler 73

NOTES: A closely related version of this drawing is in the Achenbach Collection, San Francisco (1963.24.485).

187. THE COTTAGE DOOR
Pen and watercolor over pencil, 7⅛″ x 8⅛″
Acquired: ca. 1910
Accession Number: Sessler 51

NOTES: The motif is certainly Gainsboroughesque, but the drawing probably dates from the early nineteenth century, twenty years after Gainsborough's preoccupation with the "Cottage Door" theme.

Another version of the drawing was at one time in the Lasson Collection (photograph in the archive of Frank Sabin).

188. CATTLE WITH MOUNTED HERDSMAN AND A GIRL
Pen and watercolor over pencil, varnished, 7⅜″ x 9⅝″
Acquired: ca. 1910
Accession Number: Sessler 67

NOTES: It is unusual to find varnished Rowlandson drawings, although the practice was widespread among his contemporaries, and frequently used by Gainsborough. The pen work suggests this drawing may date about 1800.

189. VILLAGE STREET SCENE
Pen and watercolor over pencil, 5⅝″ x 8¾″
Watermark: [18]05
Acquired: ca. 1910
Accession Number: Sessler 75 b

190. A MAN AND WOMAN ON HORSE-BACK PASSING A COTTAGE
Pen over pencil, 4″ x 6⅜″
Watermark: [18]02
Verso: pencil sketch of a gate and some trees
Acquired: ca. 1910
Accession Number: Sessler 156 b

Attributed to Rowlandson
191. RIVER LANDSCAPE WITH FIGURES
Soft pencil, 9⅛″ x 12 3/16″
Collections: Leonard Duke, Gilbert Davis
Acquired: 1959
Accession Number: 59.55.1113

NOTES: This is a puzzling drawing in a technique uncharacteristic of Rowlandson, as well as being tighter and more careful in handling than is usual for him. A drawing very similar technically that carries an authentic looking Rowlandson signature is in the Ashmolean Museum. A similar technique is used in the drawing for the last print in *The English Dance of Death* (No. 327).

192. THE TUILERIES GARDENS
Pen and watercolor over pencil, unfinished, 10¾″ x 15¾″
Inscribed in Rowlandson's hand: The Gardens of the Thuilleries [sic] at Paris
Exhibited: Arts Council (1950), No. 60
Collections: Gilbert Davis
Acquired: 1959
Accession Number: 59.55.1133

NOTES: Another, more finished version, 10⅝″ x 16⅝″, is illustrated in Roe, Pl. 2. Yet another version was in a Christie sale, June 4, 1974, lot 184.

Rowlandson was in Paris on several occasions, from student days in the 1770s onwards. We are not well informed about the date of his various Continental tours; more information on this score may emerge from inscribed and dated drawings. The costumes in the Huntington drawing suggest a date around 1800. Grego II, 7, lists a drawing of "The Tuileries Gardens" as 1800.

From a technical point of view it is worth noting that in this drawing Rowlandson's pen work clearly preceded the watercolor washes.

193. A JUDGE SEATED IN DOCTORS' COMMONS
Pen and watercolor over pencil, 4¾″ x 3⅞″
Inscribed in Rowlandson's hand: Judge seated in/Doctors Commons/ July 7ᵗʰ 1808—/[also in pencil, pointing at the judge's robe]: Scarlet/[also some undecipherable pen scribbles, upper left]
Acquired: ca. 1910
Accession Number: Sessler 148

NOTES: "Doctors' Commons" was the name formerly applied to a society of ecclesiastical lawyers in London, forming a distinct profession for the practice of the civil and canon laws. See *The Encyclopaedia Britannica*, 11th ed., VIII, 367.

194. A LECTURE ON HEADS
Pencil, 5⅝″ x 7⅜″
Engraved in reverse: 1808, as the frontispiece to George Alexander Stevens, *A Lecture on Heads*
Acquired: ca. 1910
Accession Number: Sessler 153 b

NOTES: The book relates to the intense interest in physiognomy which was prevalent through much of Europe in the late eighteenth and early nineteenth centuries, and which occupied so much of Rowlandson's time later in his career.

195. LOVE AND WIND
Pen and gray wash over pencil, 3⅞″ x 5⅞″, tears along top margin
Watermark: [1] 805
Inscribed in Rowlandson's hand: Love and Wind/ 9

Verso: the design has been traced through in pencil

Engraved: 1808 as an illustration to "Letter the Seventh" in *Annals of Horsemanship*, printed and bound with [Henry W. Bunbury], *Academy for Grown Horsemen*

Acquired: ca. 1910

Accession Number: Sessler 16 a

NOTES: The print carries the subscription: H Bunbury Del/ Rowlandson Sculp/ London, Pub. by T. Tegg May 4, 1808. Here, as in the drawings for *Academy for Grown Horsemen*, Rowlandson is reworking Bunbury's ideas, but transforming them into his own idiom in the process.

196. GEOFFREY GAMBADO, ESQ.

Pen over pencil, 4⅛" x 2¾"

Inscribed in Rowlandson's hand: Geoffrey Gambado, Esq^re

Engraved: 1808 for the frontispiece to *An Academy for Grown Horsemen*

Acquired: ca. 1910

Accession Number: Sessler 27 a

NOTES: Rowlandson prepared two sets of prints after Bunbury's popular *Academy for Grown Horsemen.* The first was for a folio edition published in 1798; the second for a small octavo edition in 1809. The Huntington drawing is related to the left half of the frontispiece of the later edition.

There is a photograph of another version of this drawing (4" x 2½") in the Witt Library.

197. HOW TO TRAVEL UPON TWO LEGS IN A FROST

Pen and watercolor, reinforced counterproof: 2⅞" x 3⅞", corners torn

Inscribed in Rowlandson's hand: [How to] travel upon two legs in a Frost/ [Part of the inscription in reverse, a counterproof, is also legible]

Engraved in reverse: 1808, as part of the illustration to "Letter the Eighteenth" in *Annals of Horsemanship*

Acquired: ca. 1910

Accession Number: Sessler 19 c

NOTES: See under No. 196

198. MR. GAMBADO SEEING THE WORLD

Pen (reinforced counterproof), 2¼" x 3⅞", corners clipped

Inscribed in reverse (counterproof): not legible

Engraved in reverse: 1808 as "Mr Gambado seeing the World" in *Annals of Horsemanship*

Acquired: ca. 1910

Accession Number: Sessler 19 a

NOTES: See under No. 196. This drawing and No. 197 are very tight and mechanical, but appear to be authentic. A much freer group of drawings related to the *Academy for Grown Horsemen* and *Annals of Horsemanship* is in the collection of Mr. and Mrs. Paul Mellon.

199. FIRE AT ALBION MILLS, BLACK-FRIARS BRIDGE

Pen over pencil, unfinished, 7" x 8¾"

Inscribed, probably in Rowlandson's hand: Albion Mills

Engraved: 1808 in *Microcosm of London*

Acquired: ca. 1910

Accession Number: Sessler 150

NOTES: The plates for the *Microcosm of London* were executed jointly by A. S. Pugin (who supplied much of the architectural detail) and Rowlandson (who supplied the figures). The print related to the Huntington drawing appeared under the title "Fire in London." The explanatory text adds, "the print is intended to represent the dreadful fire which took place on 3rd March 1791 at the Albion Mills on the Surrey side of Blackfriars Bridge" (II, 36).

A full set of drawings for the *Microcosm* by Pugin and Rowlandson is in the Art Institute of Chicago.

200. PASS ROOM, BRIDEWELL

Pen and watercolor over pencil, 7 5/16" x 10⅞"

Inscribed in Rowlandson's hand on the sign on the right wall: Whoever dirts/ her Bed will/ be punished

Engraved: 1808 in *Microcosm of London*, Vol. I, Pl. 12

Collections: Gilbert Davis

Acquired: 1959
Accession Number: 59.55.1093

NOTES: "The annexed print gives an accurate and interesting view of this abode of wretchedness, the Pass-Room. It was provided by a late act of Parliament, that *paupers*, claiming settlements in distant parts of the kingdom, should be confined for seven days previous to their being sent off to their respective parishes; and this is the room appointed by the magistracy of the city for one class of miserable females" (*The Microcosm of London* [London 1808-10], Vol. I, p. 92).

Another version of this drawing (7½" x 11") is in the collection of Mr. and Mrs. Paul Mellon.

201. INNOCENCE IN DANGER

Pen and watercolor over pencil, 11¾" x 9¼"
Watermark: the old mount is watermarked 1808
Signed: Rowlandson
Verso inscribed in a later hand: Innocence in Danger
Collections: Dr. and Mrs. Edward W. Bodman
Acquired: 1961, gift of Mrs. Bodman
Accession Number: 61.08

NOTES: A recurring theme with Rowlandson, although often without the "Madam" as intermediary. Probably about 1800.

202. FIGURES WALKING BY A RIVER

Unretouched counterproof, 4¾" x 7"
Acquired: ca. 1910
Accession Number: Sessler 128 a

NOTES: From the standpoint of Rowlandson's counterproofing technique, it is interesting to note that the drawing from which this counterproof was pulled had watercolor washes as well as pen lines.

203. STREET SCENE

Unretouched counterproof, 4⅞" x 6⅞"
Acquired: ca. 1910
Accession Number: 128 b

204. PLEASURE BOATS, A HOUSE IN THE BACKGROUND

Unretouched counterproof, 4⅝" x 6⅞"
Acquired: ca. 1910
Accession Number: Sessler 70 a

NOTES: The right half of the counterproof was blurred in the pull, which may explain why it was never reworked.

205. A LARGE BOATING PARTY WITH WATER MUSIC

Unretouched counterproof, 5⅜" x 8¼"
Acquired: ca. 1910
Accession Number: Sessler 70 b

206. THE PUBLIC LIBRARY, CAMBRIDGE

Counterproof, partially reworked in pen, 7½" x 10¾"
Engraved in reverse: 1809 (Grego II, 401 and 184)
Acquired: ca. 1910
Accession Number: Sessler 107

NOTES: The print was first issued on November 1, 1809, and then reissued on May 1, 1810.

A drawing of this subject reading in the opposite direction, but apparently not the original from which this counterproof was pulled, is in the Fitzwilliam Museum, Cambridge. It is worth noting, in connection with Rowlandson's counterproofing technique, that watercolor had been applied to the original drawing before the counterproof was pulled.

207. TO THE DEVIL WE'LL BOLDLY KICK NAP AND HIS PARTNER JOE

Pen over pencil, 5¼" x 7⅜"
Watermark: 1809
Inscribed, probably in Rowlandson's hand: To the Devil we'll boldly Kick Boney [crossed out] Nap & his Partner Joe
Verso: pen sketch of a male head [Napoleon?]
Engraved: see Notes
Acquired: ca. 1910
Accession Number: Sessler 131

NOTES: A print with an inscription embodying the words on this drawing was issued September 29, 1808 (Grego II, 99; George 11036), but the composition does not correspond closely to the Huntington drawing. In the print two Spanish dons with right legs raised high have just kicked Napoleon and his brother Joseph toward the Devil. The drawing presumably represents an idea related to the print, although the watermark indicates that it postdates the print.

208. A VILLAGE MARKET
Pen and watercolor, 8⅛" x 10⅝"
Acquired: ca. 1910
Accession Number: Sessler 76

209. A MAN HERDING SHEEP; FIGURES TO THE LEFT; FARMBUILDINGS IN THE BACKGROUND
Pen and watercolor over pencil, 9¼" x 11¾"
Acquired: ca. 1910
Accession Number: Sessler 49

NOTES: An ambitious drawing in physical size, but not particularly strong in execution. Probably ca. 1810.

210. A SINGLE STICK MATCH
Pen and watercolor over pencil (unfinished); 14" x 21½"
Literature: Sabin (1933), No. 66
Exhibited: Drawings by Old Masters (London, Royal Academy, 1953), No. 462
Collections: Gilbert Davis
Acquired: 1959
Accession Number: 59.55.1127

NOTES: Single sticking, a type of fencing with cudgels, was very popular in England from the sixteenth to the mid-nineteenth century. By the end of the eighteenth century the rules usually required that the opponents must not move their feet. Blows to any part of the body were allowed, but the bout was decided by the first blow to the head that drew blood. (See *The Encyclopaedia Britannica,* 11th ed., s.v. "Single Stick").

The inn outside which Rowlandson's match is taking place has a sign with three horseshoes. This seems to have been a fairly common sign for inns. There were inns of that name at Colchester and Great Mongeham (see A. E. Richardson and H. Donald Eberlein, *The English Inn Past and Present* [London, 1925]).

There is another version of this drawing in the Museum of Fine Arts, Boston (Accession Number 48.117) measuring 13 11/16" x 20 ⅞". There are differences in the foliage between the two versions; very much less of the sky is blank in the Boston drawing. Neither drawing is dated, but both probably come from the second decade of the nineteenth century. "The Single Stick Match" is an unusually large and complex drawing for the latter part of Rowlandson's career.

211. THE JOCKEY CLUB, NEWMARKET
Pen and watercolor over pencil, 7⅞" x 10⅞"
Inscribed in Rowlandson's hand on signs in the background, left to right: Newmarket; Stallion to cover; Rules and Orders to be/ observed by every Member/ of the Jockey Club; Racing/ Callendar; Sweepstakes; Pocket/ book/ lost; Wanted a/ Pack of/ Hounds; To be sold/ a Freehold/ Estate
Inscribed on mount in a later hand: Meeting of the Jockey Club at Newmarket Betting Room
Exhibited: Drawings by Old Masters (Royal Academy, London, 1953), No. 460
Collections: Deglatigny, Gilbert Davis
Acquired: 1959, gift of the Friends
Accession Number: 59.55.1110

NOTES: Another version of the drawing (Oppé, Pl. 93) is now in the National Gallery of Canada. A generally related print (Grego II, 214) is inscribed 1811 on the plate, but the publication date is not known.

The Jockey Club was formed about 1750 and first met at the Star and Garter Coffee House, Pall Mall. By 1752 the club had established its rooms at Newmarket. The club was founded to regulate racing and eliminate abuses at Newmarket, and it soon became the ruling authority on racing throughout the country.

212. KEW BRIDGE
Pen and watercolor over pencil, 11″ x 17″
Literature: Paulson, pp. 30, 123 n. 27
Exhibited: Arts Council (1950), No. 43
Collections: Gilbert Davis
Acquired: 1959
Accession Number: 59.55.1112

NOTES: The design exists in several versions or copies. Two passed through Sotheby's (November 20, 1928; December 4, 1957); a third is in The London Museum (see John Hayes, *A Catalogue of the Watercolour Drawings by Thomas Rowlandson in the London Museum* [London, 1960], No. 43).

The Inn in the background is The Star and Garter. Kew Bridge, designed by James Paine, was begun in 1783 and opened for traffic in 1789. It replaces a mid-eighteenth-century wooden bridge.

213. THE HUNT BREAKFAST
Pen and watercolor over pencil, 7¾″ x 11⅛″
Engraved: 1789 by S. W. Fores, with several variations
Acquired: ca. 1910
Accession Number: Sessler 26

NOTES: The pen work in the Huntington drawing is certainly much later than 1789, and is probably after the turn of the century. Another version of this drawing was sold at Sotheby's December 4, 1957, ex coll. Lord Radcliffe and Bernard Landau.

214. MADAME CATSQUALANI
Pen and watercolor over pencil, 9⅛″ x 7⅜″
Inscribed in Rowlandson's hand: Catalani Mouth in full Stretch/ Madame Catsqualani
Inscribed probably in a later hand: T. Rowlandson
Literature: Oppé, Pl. 72; Wark, *Ten British Pictures,* p. 75, Fig. 56
Exhibited: Three Centuries of British Watercolours and Drawings (London, Arts Council, 1951), No. 151
Collections: Archibald Russell (Lugt 2770a); Desmond Coke; Gilbert Davis
Acquired: 1959
Accession Number: 59.55.1095

NOTES: Angelica Catalani (1780-1849) was an Italian soprano. She first appeared in London in 1806 at the King's Theatre and remained in England for seven years. It is said that she received as much as two hundred guineas for singing "God Save the King" and "Rule Britannia," and two thousand pounds for a single concert. She revisited London in 1824 and again in 1828.

Rowlandson created a six-part cartoon in 1809 (Grego II, 165; George 11414) entitled "This is the House that Jack Built," concerned with the riots at Covent Garden Theatre occasioned by a change in admission prices and procedures. One part of the cartoon represents Catalani and is inscribed: "This is the *Cat* engaged to squall. . . ." The Huntington drawing probably dates from the same time.

215. THREE MEN AT TABLE AND A COOK
Pen and watercolor over pencil, 5¾″ x 9¼″
Inscribed in pencil in Rowlandson's hand, only one word decipherable: Dolly
Acquired: ca. 1910
Accession Number: Sessler 95 b

NOTES: Another version of the drawing is in the Metropolitan Museum D.D. 17.97.7(24).

216. VIRTUE IN DANGER OR SYMPTOMS OF [?]
Pen over pencil, 5⅜″ x 7¼″
Inscribed in Rowlandson's hand: Virtue in Danger or Symptoms of [?]
Verso: some arithmetic notations
Acquired: ca. 1910
Accession Number: Sessler 126 b

217. TESTING CAPACITY
Pen and watercolor over pencil, 6″ x 8½″
Acquired: ca. 1910
Accession Number: Sessler 106 b

NOTES: There is the remnant of a pencil inscription along the lower margin, trimmed and illegible.

218. A COACH AND FOUR
Pen and gray wash over pencil, 4¾″ x 8⅜″,
 upper left corner torn
Acquired: ca. 1910
Accession Number: Sessler 19 b

219. THE DOCTOR GREETS DEATH
Pen and watercolor over pencil, 7½″ x 5⅞″,
 lower left corner trimmed
Signed in Rowlandson's hand: Rowlandson
Collections: William Henry Bruton
Acquired: ca. 1925
Accession Number: Rare Book 144954 f. 562

NOTES: The drawing was acquired with the Bruton
extra-illustrated set of *The English Dance of Death.*
It is evident, however, from the format of the sheet
that the design was not intended as part of that
series. The technique of the drawing also suggests
a date shortly after 1800, before the time of the
Dance of Death series.

220. THREE MEN SEATED AROUND A TABLE
Pen and watercolor over pencil, 6⅜″ x 8½″
Acquired: ca. 1910
Accession Number: Sessler 101 b

221. A BRACE OF FELLOWS OF BRAZEN NOSE COLLEGE
Pen and watercolor over pencil, 4⅛″ x 6¾″
Inscribed in Rowlandson's hand: A Brace of
 Fellows of Brazen Nose --- Coll ---
Verso inscribed in Rowlandson's hand: Ever
 Greens/ Hot House Plants
Acquired: ca. 1910
Accession Number: Sessler 101 a

NOTES: For another drawing of *Brazen Nose Fellows* (not related to the Huntington sheet except
in title) see Hayes, Pl. 118.

222. A COACH PASSING A HOUSE IN THE COUNTRY
Pen and watercolor over pencil, 5¾″ x 9⅛″

Acquired: ca. 1910
Accession Number: Sessler 20 b

NOTES: From the pen work, probably about 1815.

223. A YOUNG SOLDIER TAKING LEAVE OF HIS FAMILY
Pen and brown wash over pencil, 4¼″ x 7″
Verso, slight pencil sketch, inscribed: Doctor
 Wins at Nine Pins
Literature for the verso: Gully, p. 10, Fig. 3,
 and Cat. No. 115
Acquired: ca. 1910
Accession Number: Sessler 20 a

NOTES: The drawing on the recto is a good, characteristic pen sketch that, from the pen work, appears to date from ca. 1810. Gully regards the pencil sketch on the verso as preliminary to No. 398
in this catalog, which is a Syntax drawing that
was not used in any of the Syntax books. This conclusion is probably correct, although the sketch is
not worked out very far.

224. DUKE OF NORFOLK
Pen over pencil, 7⅞″ x 5⅛″
Watermark: 1808
Inscribed in Rowlandson's hand: Duke of Norfolk 1811
Acquired: ca. 1910
Accession Number: Sessler 118

NOTES: Presumably Charles, 11th Duke of Norfolk
(1746-1815) described in the *Dictionary of National Biography* as "large, muscular, and clumsy,
though active." He was a friend of the Prince of
Wales and President of the Society of Arts from
1794 until his death.

225. STOWE GARDENS (?)
Pen and watercolor over pencil, 10⅞″ x 16¾″
Literature: R. H. Wilenski, *English Painting*
 (London, 1933), p. 169 and Pl. 92; Sabin
 (1933), No. 69 (illus.); Paulson, p. 86 and
 Pl. 51
Exhibited: Arts Council (1950), No. 58

Collections: Alexander Keith Wyllie, Gilbert Davis
Acquired: 1959
Accession Number: 59.55.1129

NOTES: There does not seem to be much support for the traditional identification of the subject as Stowe Gardens. None of the well-known temples or other features of Stowe is shown. The central element is clearly a version of the familiar antique *Dancing Faun.* Henry Rumsey Forster in *The Stowe Catalogue* (London, 1848) lists a plaster of "the dancing faun" in the Orangery Garden (p. 269), but the other sculpture mentioned as in that location has no relation to the pieces depicted by Rowlandson. It is probable, however, that the source of inspiration behind the drawing is a specific garden. A drawing entitled *Stowe Garden,* 11″ x 17″, signed and dated 1809, was in Sabin (1938), No. 19, not illustrated. This was apparently not the Huntington drawing, although the latter also probably dates from about 1809.

226. FOUR MEN STANDING
Pen, 4¾″ x 3″
Acquired: ca. 1910
Accession Number: Sessler 136 a

227. SHIP DRIVEN BY A WHIRLWIND
Pen and watercolor, 3⅜″ x 5⅜″ (three corners torn off)
Inscribed in Rowlandson's hand: [Acc]idental Visit to the Moon—The Ship driven by a Whirlwind/ [a thousa]nd Leagues above the surface of the water
Engraved in reverse: Surprising Adventures of Baron Munchausen (London, 1811)
Acquired: ca. 1910
Accession Number: Sessler 157b

NOTES: The engraving is entitled *The Ship driven by a Whirlwind a thousand leagues above the surface of the water.* A dolphin, present in the print, does not appear in the drawing.

228. MOCK TURTLE
Pen over pencil, unfinished, 7¾″ x 8⅝″

Engraved: 1785, re-engraved and reissued 1810, in reverse (Grego I, 153; II, 237, George 11639)
Acquired: ca. 1910
Accession Number: Sessler 5

NOTES: The drawing is closer to the 1810 than the 1785 version of the print. The technique of the drawing rules out a date as early as 1785, and reinforces the connections with the 1810 version.

229. PORTSMOUTH AND THE ISLE OF WIGHT
Pen and watercolor over pencil, 4⅜″ x 7⅛″
Watermark: fragment 181[?]
Exhibited: Arts Council (1950), No. 47
Collections: Gilbert Davis
Acquired: 1959
Accession Number: 59.55.1119

NOTES: Another version of this drawing, 4⅝″ x 7¾″, signed and dated 1803, is in the National Gallery of Canada.

Both drawings are too generalized to permit any firm opinions about the identification of the place represented, but there is nothing to preclude the possibility that the title, which has apparently been associated with the Huntington drawing for some time, is correct.

230. LONDON JOCKEY GOING TO NEWMARKET
Pen and watercolor over pencil, 8⅝″ x 7″
Watermark: 1811
Engraved: 1831 in *The Humorist* I, facing p. 18, as "Uncle Timothy"
Literature: Paulson, p. 48 and Pl. 35
Acquired: ca. 1910
Accession Number: Sessler 25

NOTES: The origin of this composition appears to be a print by M. Darly, published in 1771, entitled *The London Jockies going to Newmarket.* The print has the composition in reverse and an additional figure. The subject was engraved again by Francis Grose, ca. 1788. Grose's print reverses Darly's composition, omits the additional figure, and

is close to Rowlandson's drawing. I am indebted to Dudley Snelgrove for this information. Grose's drawing, inscribed "Dr. Slop Mounting," is in Mr. Snelgrove's collection.

231. CONVERSATION AT A GATE
Pen and watercolor over pencil, 7¾″ x 5¼″
Acquired: ca. 1910
Accession Number: Sessler 109

232. TREE STUDY
Pen and watercolor over pencil, unfinished, 9″ x 12 5/16″
Watermark: 1811
Exhibited: Arts Council (1950), No. 134 c
Collections: Gilbert Davis
Acquired: 1959
Accession Number: 59.55.1132

Notes: There are some figures sketched in pencil in the lower right.

The drawing is interesting as evidence concerning Rowlandson's technique. In this instance it appears that pen and watercolor proceeded simultaneously.

233. HUNTING SCENE
Pen and watercolor over pencil, 8⅛″ x 10⅞″
Literature: Walter Shaw Sparrow, *British Sporting Artists* (London, 1922), facing p. 152
Exhibited: Thomas Rowlandson (London, Ellis and Smith, 1948); Arts Council (1950), No. 64
Collections: Gilbert Davis
Acquired: 1959
Accession Number: 59.55.1108

234. ARRIVAL OF THE COACH AT BATH
Pen and watercolor over pencil, 5¾″ x 9¼″
Exhibited: Victoria Art Gallery, Bath [information from an old sticker; no information concerning date]; Arts Council, (1950) No. 5
Collections: Harcourt Johnstone, Gilbert Davis
Acquired: 1959
Accession Number: 59.55.1090

235. TATTERSALL'S
Pen and watercolor over pencil, 6″ x 9½″
Inscribed in Rowlandson's hand on a sign in the background: Repository
Collections: Gilbert Davis
Acquired: 1959, gift of the Friends
Accession Number: 59.55.1130

Notes: Tattersall's, the famous firm of horse auctioneers, was founded by Richard Tattersall in 1766. During the late eighteenth and early nineteenth centuries the business was established at Hyde Park Corner, but moved to Knightsbridge in 1865.

A drawing entitled *Tattersall's*, no size or other information given, was exhibited at The Leicester Galleries, *Water-colour Drawings by Thomas Rowlandson* (London, 1903), No. 63. A print of Tattersall's was included in Rowlandson's *Microcosm of London*, but that composition is quite unrelated to the Huntington drawing except in subject.

The pen work suggests a date ca. 1815.

236. PIC-A-BACK MUSICIANS
Pen and watercolor, 5⅜″ x 8⅞″
Signed and dated, possibly by a later hand: Rowlandson 1800
Acquired: ca. 1910
Accession Number: Sessler 97 b

Notes: A version, not signed or dated, with the young man to the right replaced by an older don, was at one time with the Leger Galleries (stock no. 222842). Another version is in the collection of Augustus Loring.

Technically the Huntington drawing appears later than the date inscribed on it. Probably it comes from the second decade of the nineteenth century.

237. SCOTS GREYS AT WATERLOO
Pen and watercolor over pencil, 9 7/16″ x 14¾″
Literature: Hayes, Pl. 139
Exhibited: Arts Council (1950), No. 76
Collections: T. E. Lowinsky (Lugt 2420a); Gilbert Davis
Acquired: 1959
Accession Number: 59.55.1135

NOTES: Another drawing of a cavalry battle, signed and dated 1816, unrelated to the Huntington sheet except in subject and style, was sold at Christie's, November 12, 1968.

There is no evidence to support or deny the traditional identification, but the Scots Greys did make a notable charge at Waterloo (see Dorsey Gardner, *Quatre Bras, Ligny and Waterloo* [Boston, 1882], pp. 260-66).

238. A WATERLOO CELEBRATION
Pen and watercolor over pencil, 8⅛" x 11½"
Signed and dated: Rowlandson 1815
Literature: Paulson, p. 123 n. 24 and Fig. 25
Exhibited: British Life (Arts Council, London, 1953), No. 75
Collections: Gilbert Davis
Acquired: 1959
Accession Number: 59.55.1107

NOTES: The drawing has been called *The Harvest Supper*. When it was exhibited in 1953 it was then entitled *A Waterloo Celebration*. This suggestion seems probable, although the formal Thanksgiving Day was not until January 18, 1816, six months after Waterloo.

239. A BULL LOOSE IN A CROWD
Pen and watercolor over pencil, 5" x 8⅜"
Verso inscribed in Rowlandson's hand: A Bull between two Buttocks of Beef/ A Dead hit at the Bulls eye
Acquired: ca. 1910
Accession Number: Sessler 28 a

240. MOLL FLACKETT
Pen and watercolor over pencil, 5⅝" x 9"
Inscribed in Rowlandson's hand: Moll Flackett hard run to save her Ass (also two undecipherable words in pencil)
Acquired: ca. 1910
Accession Number: Sessler 28 b

NOTES: There was another version of this drawing in the Reitlinger Collection (photo in the Witt Library), entitled *The Donkey Race*.

241. A HORSERACE WITH MALE AND FEMALE RIDERS
Pen and gray wash over pencil, unfinished, 5⅜" x 7⅞"
Verso: slight pencil sketch of women beside a gibbet
Acquired: ca. 1910
Accession Number: Sessler 16 b

NOTES: The unusual subject suggests that this may be a specific event, but no other more fully identified versions of the drawing have been located.

242. A BACCHANALIAN SCENE AT DON LUIGI'S BALL
Pen and some wash, unfinished, 5" x 8"
Engraved in reverse: 1815 in *Naples and the Campagna Felice in a Series of Letters;* originally published 1809-13 in Ackermann's *Repository of Arts* as *Letters from Italy*
Acquired: ca. 1910
Accession Number: Sessler 144

NOTES: Several of the outlines on the drawing have been scored, suggesting that a tracing was made, or that the design was transferred to a plate for engraving.

243. DEATH SEATED ON THE GLOBE
Pen and watercolor over pencil, 7⅛" x 4¼"
Inscribed in Rowlandson's hand on bottles and books: Phisic/ Gin/ Deaths Dance/ Gunpowder/ Opium / Arsnic
Engraved: 1816, as the frontispiece for the two-volume edition of *The English Dance of Death*
Literature: Wark, *Dance of Death*, p. 135; Paulson, *passim* and pp. 93-116; Hayes, pp. 43, 200-02, Figs. 36 and 37
Collections: Joseph Parker (?); William Henry Bruton
Acquired: ca. 1925
Accession Number: Rare Book 144954 f. 1

NOTES: This and the following ninety-nine drawings are all connected with Rowlandson's large project, *The English Dance of Death*, with text by

William Combe, published by Rudolph Acker-mann. The book appeared first in serial form, three prints issued each month with accompanying text, from April 1, 1814 until March 1, 1816. The numbers were reissued as two volumes in 1816. For a full discussion of this project and the Huntington drawings connected with it see Wark, *Dance of Death*.

The group of drawings in the Huntington collection for *The English Dance of Death* is much the largest known, but there are certainly many others elsewhere. Substantial groups are in the Spencer Collection at the New York Public Library and the Harry Elkins Widener Collection at Harvard. Others are noted in the catalog in Wark, *Dance of Death*. In the interval since that publication, more drawings for the project have appeared or been located: for the frontispiece and title page, in one of the British Museum Rowlandson scrapbooks; for the title page, in the Boston Athenaeum; for *The Maiden Ladies*, in the Achenbach Collection, San Francisco; for *The Father of the Family*, Christies March 31, 1971, lot 198; for *The Honey Moon*, in the Art Institute of Chicago; for *Death and the Butcher*, in the collection of Augustus Loring. More will certainly continue to appear.

The English Dance of Death is among the last and the most ambitious of Rowlandson's large publication projects, and nowhere else is the nature and range of his imagination more clearly evident. The drawings, particularly those in the Huntington Collection, also provide clear insight into Rowlandson's working methods in the latter part of his career. For an exploration of this problem see Wark, *Dance of Death*, pp. 13-27, and above, pp. 24-25.

244. TIME AND DEATH

Pen and watercolor over pencil, squared off in pencil, 5 13/16″ x 9⅜″
Inscribed in Rowlandson's hand: Time and Death outwitted by the Historian and Painter/ [also, on a pot to right] Medals/ coins
Engraved: 1814, reissued 1816
Literature: as for No. 243; Wark, *Dance of Death*, No. 1
Collections: as for No. 243
Acquired: ca. 1925
Accession Number: Rare Book 144954 f. 10

NOTES: See under No. 243

There are other versions of this drawing in the New York Public Library and the Glasgow Art Gallery.

The subject does not appear in other treatments of the Dance of Death theme; Rowlandson's use of it in this context appears to be original. The fact that Rowlandson both begins and ends his series with designs depicting the defeat of Death and Time helps to lighten the effect and make the humor with which he treats the sinister theme more palatable.

245. THE ANTIQUARY'S LAST WILL AND TESTAMENT (1)

Pen and watercolor over pencil, squared off in pencil, 5 11/16″ x 9 5/16″
Inscribed in Rowlandson's hand: [on various objects] Almanack/ Algebra/ Maps Charts/ [on a separate sheet mounted with the drawing] The Antiquarian and Death/ Fungus at length contrives to get/ Deaths Dart into his Cabinet—
Engraved: 1814, reissued 1816
Literature: as for No. 243; Wark, *Dance of Death*, No. 2
Collections: as for No. 243
Acquired: ca. 1925
Accession Number: Rare Book 144954 f. 21

NOTES: See under No. 243

Other versions of this drawing are in the Achenbach Collection, San Francisco, and the Widener Collection, Harvard University.

246. THE ANTIQUARY'S LAST WILL AND TESTAMENT (2)

Pen and watercolor over pencil, squared off in pencil, 4 13/16″ x 8 9/16″
Signed in Rowlandson's hand: Rowlandson
Engraved: 1814, reissued in 1816
Literature: as for Nos. 243 and 245
Collections: as for No. 243
Acquired: ca. 1925
Accession Number: Rare Book 144954 f. 20

NOTES: See under Nos. 243 and 245

The positions of the pencil lines made for tran-

scribing the drawing correspond to those on the preceding drawing.

247. THE LAST CHASE (1)
Pen and watercolor over pencil, 5 11/16″ x 9¼″
Engraved: 1814, reissued 1816
Literature: as for No. 243; Wark, *Dance of Death*, No. 3
Collections: as for No. 243
Acquired: ca. 1925
Accession Number: Rare Book 144954 f. 28

NOTES: See under No. 243
In addition to the three versions of this drawing in the Huntington Collection, there is one in the Widener Collection, Harvard University.
A similar composition appears in *Dick Night Leaping from a Height*, No. 115.

248. THE LAST CHASE (2)
Pen and watercolor over pencil, squared off in pencil, 5¾″ x 9 5/16″
Engraved: 1814, reissued 1816
Literature: as for Nos. 243 and 247
Collections: as for No. 243
Acquired: ca. 1925
Accession Number: Rare Book 144954 f. 29

NOTES: See under Nos. 243 and 247
The drawing probably began as a tracing from the preceding.

249. THE LAST CHASE (3)
Pen and watercolor, squared off in pencil, 4¾″ x 8 7/16″
Signed in Rowlandson's hand: Rowlandson
Inscribed in Rowlandson's hand on a separate sheet mounted with the drawing: The Last Chace [sic]/ Such mortal Sport the Chace attends,/ At Break-Neck Hill, the Hunting ends
Engraved: 1814, reissued 1816
Literature: as for Nos. 243 and 247
Collections: as for No. 243
Acquired: ca. 1925
Accession Number: Rare Book 144954 f. 30

NOTES: See under Nos. 243 and 247
The positions of the pencil lines made for transcribing the drawing correspond to those on the preceding drawing.

250. THE STATESMAN (1)
Pen and watercolor over pencil, squared off in pencil, 5 13/16″ x 9 5/16″
Inscribed in Rowlandson's hand: [at bottom] This Man sold his Country for Gold/ [below bust on bookcase] Midas/ [on a sign on the wall] Sinecures/ Promotions/ Patronage/ Presenta/tions/ [on a scroll on the wall] Cornish Burrows bought/ and Sold/ Grampound/ Camelford/ St. Austle/ St. Michael/ . . . [on a box in the foreground] Secure/ Votes/ Box of/ Bribery/ and/ Corruption/ [on a separate sheet mounted with the drawing] The Statesman/ Not all the Statesman's power or Art/ Can turn aside Death's certain Dart
Engraved: 1814, reissued 1816
Literature: as for No. 243, Wark, *Dance of Death*, No. 4
Collections: as for No. 243
Acquired: ca. 1925
Accession Number: Rare Book 144954 f.38

NOTES: See under No. 243
The references to Cornish rotten boroughs (omitted in the print and Combe's verses) are of topical interest. Grampound, Camelford, and Bodmin were notorious rotten boroughs. The towns of St. Austell and St. Michael in Cornwall did not actually return members. There was an investigation of Cornish elections resulting in an important trial at Bodmin in August 1808, fully reported by William Cobbett in his *Weekly Political Register*. It is just possible that Rowlandson may have in mind Andrew James Cochrane Johnstone, who represented Grampound at the time, having expended enormous bribes for his seat. He was involved in shady stock speculations in February of 1814 and was tried for conspiracy in June but managed to escape from the country. See W. P. Courtney, *The Parliamentary Representation of Cornwall to 1832* (London, 1889), p. 198, and the article

on Johnstone in the *Dictionary of National Biography*.

In addition to the three versions of this drawing in the Huntington Collection there is one in the Spencer Collection at the New York Public Library.

251. THE STATESMAN (2)

Pen and watercolor over pencil, squared off in pencil, 5″ x 8 7/16″

Inscribed in Rowlandson's hand on signs in the background: Game/Laws/Canal Shares

Engraved: 1814, reissued 1816

Literature: as for Nos. 243 and 250

Collections: as for No. 243

Acquired: ca. 1925

Accession Number: Rare Book 144954 f. 37

NOTES: See under Nos. 243 and 250

The positions of the pencil lines made for transcribing the drawing correspond to those on the preceding drawing.

252. THE STATESMAN (3)

Pen and watercolor over pencil, 4 15/16″ x 8½″

Signed in Rowlandson's hand: Rowlandson

Inscribed in Rowlandson's hand on signs in background: Bribery/Corruption/Plunder/County of Cornwall/Grampound/Rotton Bouroughs/Bodmin/Camelford

Engraved: 1814, reissued 1816

Literature: as for Nos. 243 and 250

Collections: as for No. 243

Acquired: ca. 1925

Accession Number: Rare Book 144954 f. 36

NOTES: See under Nos. 243 and 250

253. TOM HIGGINS

Pen and watercolor, squared off in pencil, 5 11/16″ x 9¼″

Inscribed on verso in Combe's hand: (6) a man asleep could [illegible] change/[illegible] red cap for a wig & his slippers/for shoes, it would suit me better./If he were a little better dressed/and more as if he were an Esquire/I should be glad

Engraved: 1814, reissued 1816

Literature: as for No. 243; Wark, *Dance of Death*, No. 5

Collections: as for No. 243

Acquired: ca. 1925

Accession Number: Rare Book 144954 f. 45

NOTES: See under No. 243

The pencil inscription on the verso is the only explicit indication of Combe's requesting a modification in a drawing for the sake of his story. The changes asked for were made in the print.

Two other versions of the drawing are known, one in the collection of Philip Hofer (still with cap and slippers) and one in the Spencer Collection, New York Public Library, with the changes requested by Combe.

254. THE SHIPWRECK

Pen and watercolor over pencil, 5⅝″ x 9¼″

Engraved: 1814, reissued 1816

Literature: as for No. 243; Wark, *Dance of Death*, No. 6

Collections: as for No. 243

Acquired: ca. 1925

Accession Number: Rare Book 144954 f. 53

NOTES: See under No. 243

Another version (which apparently began as a counterproof, but not derived from the Huntington drawing) is in the Spencer Collection, New York Public Library.

255. THE VIRAGO (1)

Pen and watercolor over pencil, squared off in pencil, 5¾″ x 9 7/16″

Inscribed in Rowlandson's hand, partially trimmed: The Happy Release or Tranquility Restored

Engraved: 1814, reissued 1816

Literature: as for No. 243; Wark, *Dance of Death*, No. 7

Collections: as for No. 243

Acquired: ca. 1925

Accession Number: Rare Book 144954 f. 62

NOTES: See under No. 243

256. THE VIRAGO (2)

Pen and watercolor, squared off in pencil, 4 7/16″ x 8″

Inscribed in Rowlandson's hand on a separate sheet mounted with the drawing: The Virago/Her Tongue, and Temper to subdue;/ Can only be perform'd by you...

Engraved: 1814, reissued 1816

Literature: as for Nos. 243 and 255

Collections: as for No. 243

Acquired: ca. 1925

Accession Number: Rare Book 144954 f. 63

NOTES: See under Nos. 243 and 255

The positions of the pencil lines made for transcribing the drawing correspond to those on the preceding drawing.

257. THE GLUTTON

Pen and watercolor, squared off in pencil, 5 5/8″ x 9¼″

Engraved: 1814, reissued 1816

Literature: as for No. 243, Wark, *Dance of Death,* No. 8

Collections: as for No. 243

Acquired: ca. 1925

Accession Number: Rare Book 144954 f. 72

NOTES: See under No. 243

Four other versions of this drawing are known: two in the collection of Philip Hofer, one of which is in reverse, and probably began as a counterproof; one in the Widener Collection, Harvard University; one in the Spencer Collection, New York Public Library.

258. THE RECRUIT (1)

Pen and watercolor, squared off in pencil, 5 11/16″ x 9½″

Engraved: 1814, reissued 1816

Literature: as for No. 243; Wark, *Dance of Death,* No. 9

Collections: as for No. 243

Acquired: ca. 1925

Accession Number: Rare Book 144954 f. 77

NOTES: See under No. 243

The print appeared while Europe was briefly at peace during Napoleon's exile on Elba.

259. THE RECRUIT (2)

Pen and watercolor, reinforced counterproof, 4 7/16″ x 7 9/16″

Signed in Rowlandson's hand: Rowlandson

Inscribed in Rowlandson's hand on a separate piece of paper mounted with the drawing: The Recruit/I list you and you'll soon be found,/One of my Regiment. under Ground

Engraved (in reverse): 1814, reissued 1816

Literature: as for Nos. 243 and 258

Collections: as for No. 243

Acquired: ca. 1925

Accession Number: Rare Book 144954 f. 78

NOTES: See under Nos. 243 and 258

260. THE MAIDEN LADIES (1)

Pen and watercolor, squared off in pencil, 5 11/16″ x 9¼″

Verso: squared off in pencil, the positions of the lines corresponding to those on the front. Several of the squares are numbered.

Engraved: 1814, reissued 1816

Literature: as for No. 243; Wark, *Dance of Death,* No. 10

Collections: as for No. 243

Acquired: ca. 1925

Accession Number: Rare Book 144954 f. 83

NOTES: See under No. 243

In addition to the two versions of this subject in the Huntington Collection, there is one in the Achenbach Collection, San Francisco.

261. THE MAIDEN LADIES (2)

Pen and watercolor over pencil, 5¾″ x 9 5/16″

Engraved: 1814, reissued 1816

Literature: as for Nos. 243 and 260

Collections: as for No. 243

Acquired: ca. 1925

Accession Number: Rare Book 144954 f. 84

NOTES: See under Nos. 243 and 260

The two Huntington versions of this subject are related by tracing, but the sequence is not clear.

262. THE QUACK DOCTOR

Pen and watercolor, 5 5/8" x 9 1/4"

Inscribed in Rowlandson's hand: [on a sign in the left background] Apothecaries/Hall/ [on a sign, partially trimmed, to the right] Grea/allow/to/deale/in/Qual/Med

Engraved: 1814, reissued 1816. In the print the sign to the right is replaced by a mirror reflecting Death.

Literature: as for No. 243; Wark, *Dance of Death*, No. 11

Collections: as for No. 243

Acquired: ca. 1925

Accession Number: Rare Book 144954 f. 91

NOTES: See under No. 243

Three other versions of this drawing are known, one in the Widener Collection at Harvard, and two in the collection of Philip Hofer.

The subject of Death and the Doctor was popular with authors of Dances of Death. Rowlandson has more than one drawing involving the theme. For a discussion of this topic see Aldred Scott Warthin, *The Physician of the Dance of Death* (New York, 1931).

263. THE SOT (1)

Pen and watercolor over pencil, squared off in pencil, 5 11/16" x 9 5/16"

Engraved: 1814, reissued 1816

Literature: as for No. 243; Wark, *Dance of Death*, No. 12

Collections: as for No. 243

Acquired: ca. 1925

Accession Number: Rare Book 144954 f. 100

NOTES: See under No. 243

The design is close (in reverse) to a print by Rowlandson issued on November 30, 1810: *Doctor Drainbarrel conveyed Home in a Wheelbarrow, in order to take his trial for Neglect of Family Duty.*

264. THE SOT (2)

Pen and watercolor over pencil, 5 11/16" x 9 1/4"

Verso inscribed in what appears to be Rowlandson's hand: This is to be a drunken Exiseman/ instead of minding the Kings Interest/gets drunk & lets the Country &/Revenue be cheated

Engraved: 1814, reissued in 1816

Literature: as for Nos. 243 and 263

Collections: as for No. 243

Acquired: ca. 1925

Accession Number: Rare Book 144954 f. 101

NOTES: See under Nos. 243 and 263

Combe's verses do not relate in any way to the inscription on the verso.

265. THE HONEY MOON

Pen and watercolor over pencil, squared off in pencil, 4 3/4" x 8 1/8"

Engraved: 1814, reissued 1816

Literature: as for No. 243; Wark, *Dance of Death*, No. 13

Collections: as for No. 243

Acquired: ca. 1925

Accession Number: Rare Book 144954 f. 109

NOTES: See under No. 243

There are other versions of this drawing in the Ashmolean Museum and The Art Institute of Chicago. Concerning the theory that the Ashmolean drawing is a copy by a Miss Howitt see Introduction, p. 20, and Wark, *Dance of Death*, pp. 19-25.

266. THE HUNTER UNKENNELLED

Pen and watercolor over pencil, squared off in pencil 5 3/4" x 9 3/8"

Inscribed in Rowlandson's hand: Nothing certain in this Life

Verso: slight pencil sketch

Literature: as for No. 243; Wark, *Dance of Death*, No. 14

Collections: as for No. 243

Acquired: ca. 1925

Accession Number: Rare Book 144954 f. 118

NOTES: See under No. 243

267. THE GOOD MAN, DEATH, AND THE DOCTOR (1)
Pen and watercolor, 4¾″ x 8 1/16″
Watermark: [18]09
Engraved: 1814, reissued in 1816
Literature: as for No. 243; Wark, *Dance of Death*, No. 15
Collections: as for No. 243
Acquired: ca. 1925
Accession Number: Rare Book 144954 f. 123

NOTES: See under No. 243
In addition to the two versions of this drawing in the Huntington Collection, there is one in the Ashmolean Museum and one in the Widener Collection, Harvard. Concerning the theory that the Ashmolean drawing is a copy by a Miss Howitt see Introduction, p. 20, and Wark, *Dance of Death*, pp. 19-25.

268. THE GOOD MAN, DEATH, AND THE DOCTOR (2)
Pen and watercolor, unfinished, partially reworked counterproof, 4¾″ x 8″
Engraved: 1814, reissued in 1816
Literature: as for Nos. 243 and 267
Collections: as for No. 243
Acquired: ca. 1925
Accession Number: Rare Book 144954 f. 122

NOTES: See under Nos. 243 and 267
This drawing clearly began as a counterproof derived from the preceding. It is interesting, however, that many flexible, coarse lines in sanguine were added to the earlier drawing after the counterproof was pulled.

269. DEATH AND THE PORTRAIT
Pen and watercolor over pencil, unfinished, 5⅝″ x 9¼″
Inscribed in Rowlandson's hand: A Hasty Sketch or the Finishing Touch
Engraved: 1814, reissued in 1816
Literature: as for No. 243; Wark, *Dance of Death*, No. 16
Collections: as for No. 243

Acquired: ca. 1925
Accession Number: Rare Book 144954 f. 130

NOTES: See under No. 243
The drawing differs from the print in several details; the most important is that in the drawing Death gives the old man horns in his portrait and represents himself in the painting as kissing the old man's cheek.
There is another version of this drawing in the Spencer Collection of the New York Public Library.
The theme of infidelity, which was clearly Rowlandson's first thought, makes no appearance in the final design or in Combe's verses. Rowlandson had used a similar design (but without any reference to Death) in *Comforts of Bath* (1798), Pl. 6.

270. THE GENEALOGIST
Pen and watercolor, 4¾″ x 8⅛″
Inscribed on the scroll in Rowlandson's hand: Genealogical/Table
Engraved in reverse: 1814, reissued 1816
Literature: as for No. 243; Wark, *Dance of Death*, No. 17
Collections: as for No. 243
Acquired: ca. 1925
Accession Number: Rare Book 144954 f. 137

NOTES: See under No. 243
The outlines of the figures have been carefully traced by some sort of pencil that has left a silvery deposit visible in raking light. Although the drawing is the reverse of the print there are none of the customary indications that the drawing began as a counterproof.
Another version of the drawing, reading in the same direction as the print, is in the Achenbach Collection, San Francisco.

271. THE CATCHPOLE
Pen and watercolor over pencil, 5⅝″ x 9¼″
Inscribed in Rowlandson's hand on sign to right: Cathpo[le]/Sherriffs Officer
Engraved: 1814, reissued in 1816
Literature: as for No. 243; Wark, *Dance of Death*, No. 18

Collections: as for No. 243
Acquired: ca. 1925
Accession Number: Rare Book 144954 f. 145

NOTES: See under No. 243
The woman pumping water to the right does not appear in the print.

272. THE INSURANCE OFFICE (1)
Pen and watercolor over pencil, squared off in pencil, 5 11/16″ x 9 5/16″
Verso: squared off in pencil, the positions of the lines corresponding to those on the front
Engraved: 1814, reissued in 1816
Literature: as for No. 243; Wark, *Dance of Death,* No. 19
Collections: as for No. 243
Acquired: ca. 1925
Accession Number: Rare Book 144954 f. 153

NOTES: See under No. 243
In addition to the two versions of this drawing in the Huntington Collection there is one in the Spencer Collection, New York Public Library.

273. THE INSURANCE OFFICE (2)
Pen and watercolor, fully reworked counterproof, 4 13/16″ x 8 3/16″
Watermark: 1809
Signed in Rowlandson's hand: Rowlandson
Inscribed in Rowlandson's hand on a separate piece of paper glued to the mount: The Insurance Officer/Insure his Life—But to your Sorrow/You'll pay a good, round Sum to morrow
Engraved in reverse: 1814, reissued 1816
Literature: as for Nos. 243 and 272
Collections: as for No. 243
Acquired: ca. 1925
Accession Number: Rare Book 144954 f. 154

NOTES: See under Nos. 243 and 272
This drawing appears to have begun as a counterproof pulled from one in the Spencer Collection, New York Public Library.

274. THE SCHOOLMASTER
Pen and watercolor over pencil, 5″ x 7 15/16″

Inscribed in Rowlandson's hand: [on left globe] Africa/Terrestrial Globe/Asia/America/Europe/ [on right globe] celestial/ [on book] Compleat Atlas
Engraved: 1814, reissued 1816
Literature: as for No. 243; Wark, *Dance of Death,* No. 20
Collections: as for No. 243
Acquired: ca. 1925
Accession Number: Rare Book 144954 f. 163

NOTES: See under No. 243

275. THE COQUETTE (1)
Pen and watercolor, unfinished, squared off in pencil, 5 ¾″ x 9 ¼″
Engraved: 1814, reissued in 1816
Literature: as for No. 243; Wark, *Dance of Death,* No. 21
Collections: as for No. 243
Acquired: ca. 1925
Accession Number: Rare Book 144954 f. 169

NOTES: See under No. 243

276. THE COQUETTE (2)
Pen and watercolor, squared off in pencil, 4⅞″ x 8 3/16″
Signed in Rowlandson's hand: Rowlandson
Inscribed on a separate sheet mounted with the drawing: The Coquette/I'll lead you to the splendid Crowd/But your next Dress will be a Shroud
Literature: as for Nos. 243 and 275
Collections: as for No. 243
Acquired: ca. 1925
Accession Number: Rare Book 144954 f. 170

NOTES: See under No. 243
The positions of the pencil lines made for transcribing the drawing correspond to those on the preceding drawing.

277. TIME & DEATH, AND GOODY BARTON
Pen and watercolor over pencil, 4⅞″ x 8 7/16″

Signed in Rowlandson's hand: Rowlandson

Inscribed in Rowlandson's hand on a separate piece of paper mounted with the drawing: Time & Death, and Goody Barton / On with your dead & I'll contrive, / To bury this old Fool alive

Engraved with variations: 1814, reissued in 1816

Literature: as for No. 243; Wark, *Dance of Death*, No. 22

Collections: as for No. 243

Acquired: ca. 1925

Accession Number: Rare Book 144954 f. 176

NOTES: See under No. 243

In the print, Time drives the cart and Death hoists up Goody Barton.

A version of the drawing which began as a counterproof pulled from No. 277 is in the Spencer Collection, New York Public Library; another version, closer to the print, is in the collection of Mr. and Mrs. Paul Mellon.

278. THE UNDERTAKER & THE QUACK (1)

Pen and watercolor over pencil, 4 13/16" x 8 5/16"

Inscribed in Rowlandson's hand on signs in the background: [left] Peter Screwtight/appraiser and/Undertaker/Funerals furnished/ [left center] Real Home/Brewed/Bob Quashi/ [right] Deadus Best/Cordial Gin

Engraved: 1814, reissued in 1816

Literature: as for No. 243; Wark, *Dance of Death*, No. 23

Collections: as for No. 243

Acquired: ca. 1925

Accession Number: Rare Book 144954 f. 181

NOTES: See under No. 243

In addition to the two versions of this drawing in the Huntington Collection there is one in the Spencer Collection, New York Public Library.

279. THE UNDERTAKER & THE QUACK (2)

Pen and watercolor, reinforced counterproof, 4¾" x 8¼"

Signed in Rowlandson's hand: Rowlandson

Inscribed: [the signs in the background are in reverse, as one would expect in a counterproof. The "Deadus Best" sign does not appear, and must have been added to No. 278 after the counterproof was pulled.]

Inscribed in Rowlandson's hand on a separate sheet mounted with the drawing: The Undertaker & The Quack/The Doctors sickening toil to close/"Recipe Coffin," is the Dose

Engraved: 1814, reissued in 1816

Literature: as for Nos. 243 and 278

Collections: as for No. 243

Acquired: ca. 1925

Accession Number: Rare Book 144954 f. 182

NOTES: See under Nos. 243 and 278

This drawing clearly began as a counterproof pulled from the preceding. It is interesting that Rowlandson allowed the lettering on the signs to remain in reverse.

280. THE DEATH BLOW

Pen and watercolor over pencil, 4 7/16" x 7 13/16"

Inscribed in Rowlandson's hand: A Rum Customer

Engraved in reverse: 1814, reissued in 1816

Literature: as for No. 243; Wark, *Dance of Death*, No. 25

Collections: as for No. 243

Acquired: ca. 1925

Accession Number: Rare Book 144954 f. 198

NOTES: See under No. 243

281. THE VISION OF SKULLS

Pen and watercolor over pencil, 4 13/16" x 8⅝"

Engraved: 1814, reissued in 1816

Literature: as for No. 243; Wark, *Dance of Death*, No. 26

Collections: as for No. 243

Acquired: ca. 1925

Accession Number: Rare Book 144954 f. 207

NOTES: See under No. 243

Two other versions of this drawing are known.

One, in the Spencer Collection, New York Public Library, appears to have begun as a counterproof pulled from the Huntington drawing, the other was formerly in the collection of John Rickett.

Rowlandson's source of inspiration for this drawing may have been the Paris catacombs at "la Tombe-Issoire."

282. THE PORTER'S CHAIR

Pen and watercolor over pencil, 5¼″ x 8¾″
Engraved: 1814, reissued in 1816
Watermark: 1813
Inscribed in Rowlandson's hand: The Warning or Death's Watch
Literature: as for No. 243; Wark, *Dance of Death,* No. 27
Collections: as for No. 243
Acquired: ca. 1925
Accession Number: Rare Book 144954 f. 216

NOTES: See under No. 243
Another version of this drawing, which apparently began as a counterproof pulled from the Huntington sheet, is in the Spencer Collection, New York Public Library.

283. THE PANTOMIME (1)

Pen and watercolor, 5⅝″ x 9⅛″
Engraved: 1815, reissued 1816
Literature: as for No. 243; Wark, *Dance of Death,* No. 28
Collections: as for No. 243
Acquired: ca. 1925
Accession Number: Rare Book 144954 f. 224

NOTES: See under No. 243

284. THE PANTOMIME (2)

Pen and watercolor, 4¾″ x 8¼″
Engraved: 1815, reissued 1816
Literature: as for Nos. 243 and 283
Collections: as for No. 243
Acquired: ca. 1925
Accession Number: Rare Book 144954 f. 225

NOTES: See under No. 243
Another version of this drawing, which appears

to have begun as a counterproof pulled from the Huntington sheet, is in the Spencer Collection, New York Public Library.

285. THE HORSE RACE

Pen and watercolor over pencil, 5⅛″ x 8½″
Engraved: 1815, reissued 1816
Literature: as for No. 243; Wark, *Dance of Death,* No. 29
Collections: as for No. 243
Acquired: ca. 1925
Accession Number: 144954 f. 231

NOTES: See under No. 243

286. THE DRAM SHOP

Pen and watercolor over pencil, 5¼″ x 8⅝″
Inscribed in Rowlandson's hand: [at top, in pencil] Gin Shop [another word undecipherable] / [on containers to left] Vitriol/Old Tom/11/Comp/ound
Engraved in reverse: 1815, reissued 1816
Literature: as for No. 243; Wark, *Dance of Death,* No. 30
Collections: as for No. 243
Acquired: ca. 1925
Accession Number: Rare Book 144954 f. 238

NOTES: See under No. 243

287. THE GAMING TABLE

Pen and watercolor over pencil, 5¼″ x 8⅝″
Engraved in reverse: 1815, reissued 1816
Literature: as for No. 243; Wark, *Dance of Death,* No. 31
Collections: as for No. 243
Acquired: ca. 1925
Accession Number: Rare Book 144954 f. 244

NOTES: See under No. 243

288. THE BATTLE

Pen and watercolor, 5 1/16″ x 8 7/16″
Watermark: 1813

Engraved with minor variations: 1815, reissued
 1816
Literature: as for No. 243; Wark, *Dance of
 Death*, No. 32
Collections: as for No. 243
Acquired: ca. 1925
Accession Number: Rare Book 144954 f. 250

NOTES: See under No. 243
 The print was issued on February 1, 1815 while
Napoleon was still on Elba and no major military
campaign was in progress.

289. THE SKATERS (1)
Pen and watercolor over pencil, 4 ¾″ x 8 3/16″
Signed in Rowlandson's hand: Rowlandson
Engraved: 1815, reissued 1816
Literature: as for No. 243; Wark, *Dance of
 Death*, No. 34
Collections: as for No. 243
Acquired: ca. 1925
Accession Number: Rare Book 144954 f. 264

NOTES: See under No. 243

290. THE SKATERS (2)
Pen and watercolor, reworked counterproof,
 4 ¾″ x 8″
*Inscribed in Rowlandson's hand on a paper
 mounted with the drawing:* The Skaiters/
 On the frail Ice the whirring Skate/Becomes
 an Instrument of Fate
Engraved in reverse: 1815, reissued 1816
Literature: as for Nos. 243 and 289
Collections: as for No. 243
Acquired: ca. 1925
Accession Number: Rare Book 144954 f. 265

NOTES: See under No. 243
 This drawing appears to have begun as a coun-
terproof pulled from another version of the sub-
ject in the Spencer Collection, New York Public
Library.

291. THE DUEL
Pen and watercolor over pencil, 4 13/16″ x
 8 7/16″

Watermark: 1813
Engraved: 1815, reissued 1816
Literature: as for No. 243; Wark, *Dance of
 Death*, No. 35
Collections: as for No. 243
Acquired: ca. 1925
Accession Number: Rare Book 144954 f. 269

NOTES: See under No. 243 and (for a comment on
dueling) under No. 116

292. THE BISHOP AND DEATH
Pen and watercolor over pencil, 5 ¼″ x 8 3/16″
Signed in Rowlandson's hand: Rowlandson
*Inscribed in Rowlandson's hand on a separate
 sheet mounted with the drawing:* The Bishop
 and Death/Though I may yield my forfeit
 Breath/The Word of Life defies thee, Death
Engraved: 1815, reissued 1816
Literature: as for No. 243; Wark, *Dance of
 Death*, No. 36
Collections: as for No. 243
Acquired: ca. 1925
Accession Number: Rare Book 144954 f. 275

NOTES: See under No. 243
 Two other versions of this drawing are known,
one in the Spencer Collection, New York Public
Library, the other passed through Sotheby's No-
vember 20, 1928, lot 70.

293. THE SUICIDE
Pen and watercolor over pencil, 5 ⅜″ x 9 3/16″
Inscribed in Rowlandson's hand: She died for
 love and he for glory
Engraved in reverse: 1815, reissued in 1816
Literature: as for No. 243; Wark, *Dance of
 Death*, No. 37
Collections: as for No. 243
Acquired: ca. 1925
Accession Number: Rare Book 144954 f. 284

NOTES: See under No. 243
 Another version of this drawing, likewise in re-
verse to the print, is in the Spencer Collection, New
York Public Library.

294. CHAMPAGNE, SHERRY, AND WA-
TER GRUEL (1)

Pen and watercolor over pencil, 5 3/16" x 8½"
Inscribed in Rowlandson's hand left to right:
The Bon Vivant/The Moderate Man/The
Abstemious Man
Engraved: 1815, reissued 1816
Literature: as for No. 243; Wark, *Dance of
Death*, No. 38
Collections: as for No. 243
Acquired: ca. 1925
Accession Number: Rare Book 144954 f. 297

NOTES: See under No. 243

295. CHAMPAGNE, SHERRY, AND WA-
TER GRUEL (2)

Pen and watercolor over pencil, 4 11/16" x 7⅞"
Literature: as for Nos. 243 and 294
Collections: as for No. 243
Acquired: ca. 1925
Accession Number: Rare Book 144954 f. 296

NOTES: See under No. 243
Another version of this drawing, in reverse, and
possibly derived as a counterproof from the Hun-
tington sheet, is in the Spencer Collection, New
York Public Library.

296. THE NURSERY

Pen and watercolor over pencil, 4⅞" x 8⅛"
Watermark: [18]12
Engraved in reverse: 1815, reissued 1816
Literature: as for No. 243; Wark, *Dance of
Death*, No. 39
Collections: as for No. 243
Acquired: ca. 1925
Accession Number: Rare Book 144954 f. 307

NOTES: See under No. 243
Two other versions of this drawing are known:
one (also in reverse) in the Widener Collection at
Harvard, and one in the collection of Dr. Morris
Saffron.

297. THE ASTRONOMER

Pen and watercolor over pencil, 5" x 8⅜"
Signed in Rowlandson's hand: Rowlandson
Inscribed in Rowlandson's hand on a chart:
Planisphere/ [on a globe] Africa
*Inscribed in Rowlandson's hand on a separate
sheet mounted with the drawing:* The Astron-
omer/Why I was looking at the Bear/But
what strange Planet see I there
Engraved: 1815, reissued 1816
Literature: as for No. 243; Wark, *Dance of
Death*, No. 40
Collections: as for No. 243
Acquired: ca. 1925
Accession Number: Rare Book 144954 f. 313

NOTES: See under No. 243
There is another version of this drawing with
several variations in the Widener Collection at
Harvard.

298. THE FATHER OF THE FAMILY

Pen and watercolor over pencil, squared off in
pencil, 5¾" x 9 5/16"
Verso inscribed, not in Rowlandson's hand:
taken in the prime of life
Engraved: 1815, reissued 1816
Literature: as for No. 243; Wark, *Dance of
Death*, No. 41
Collections: as for No. 243
Acquired: ca. 1925
Accession Number: Rare Book 144954 f. 318

NOTES: See under No. 243

299. THE FALL OF THE FOUR IN HAND

Pen and watercolor over pencil, 5" x 8½"
Engraved: 1815, reissued 1816
Literature: as for No. 243; Wark, *Dance of
Death*, No. 42
Collections: as for No. 243
Acquired: ca. 1925
Accession Number: Rare Book 144954 f. 324

NOTES: See under No. 243
Another version of this drawing, in reverse, is in
the Spencer Collection, New York Public Library.

It probably began as a counterproof pulled from the Huntington sheet.

300. GAFFER GOODMAN
Pen and watercolor, reworked counterproof, 4 7/16" x 7 3/16"
Engraved in reverse: 1815, reissued 1816
Literature: as for No. 243; Wark, *Dance of Death*, No. 43
Collections: as for No. 243
Acquired: ca. 1925
Accession Number: Rare Book 144954 f. 334

NOTES: See under No. 243
The drawing clearly began as a counterproof pulled from a version of the drawing in the Spencer Collection, New York Public Library.

301. THE URCHIN ROBBERS
Pen and watercolor, 4¾" x 8"
Watermark: 1813
Engraved in reverse: 1815, reissued 1816
Literature: as for No. 243; Wark, *Dance of Death*, No. 44
Collections: as for No. 243
Acquired: ca. 1925
Accession Number: Rare Book 144954 f. 341

NOTES: See under No. 243
For a similar composition see No. 350.

302. DEATH TURNED PILOT
Pen and watercolor, squared off in pencil, 5¾" x 9 5/16"
Engraved: 1815, reissued 1816
Literature: as for No. 243; Wark, *Dance of Death*, No. 45
Collections: as for No. 243
Acquired: ca. 1925
Accession Number: Rare Book 144954 f. 348

NOTES: See under No. 243
Three other versions of this drawing are known: Spencer Collection, New York Public Library; Mr. and Mrs. Paul Mellon; formerly Fitz Eugene Dixon, American Art Association Jan. 6, 1937, lot 139.

The theme of a lifeboat following shipwreck was treated earlier by Rowlandson in a print issued ca. 1799 (Grego I, 372-74).

303. THE WINDING UP OF THE CLOCK
Pen and watercolor, 4 13/16" x 8 3/16"
Engraved: 1815, reissued 1816
Literature: as for No. 243; Wark, *Dance of Death*, No. 46
Collections: as for No. 243
Acquired: ca. 1925
Accession Number: Rare Book 144954 f. 355

NOTES: See under No. 243
Another version of the drawing, which apparently began as a counterproof pulled from the Huntington sheet, is in the Spencer Collection, New York Public Library.

304. THE FAMILY OF CHILDREN
Pen and watercolor, 4⅞" x 8⅛"
Engraved: 1815, reissued 1816
Literature: as for No. 243; Wark, *Dance of Death*, No. 47
Collections: as for No. 243
Acquired: ca. 1925
Accession Number: Rare Book 144954 f. 362

NOTES: See under No. 243
Another version of this drawing is in the collection of Mr. and Mrs. Paul Mellon.

305. DEATH'S DOOR (1)
Pen and watercolor, reworked counterproof, 6" x 9½"
Engraved in reverse, with variations: 1815, reissued 1816
Literature: as for No. 243; Wark, *Dance of Death*, No. 48
Collections: as for No. 243
Acquired: ca. 1925
Accession Number: Rare Book 144954 f. 368

NOTES: See under No. 243
The drawing which was the source for this counterproof has not been located.

In addition to the two drawings for this subject in the Huntington Collection there is one in the Spencer Collection, New York Public Library.

306. DEATH'S DOOR (2)
Pen and watercolor over pencil, 4¾″ x 8⅛″
Signed in Rowlandson's hand: Rowlandson
Inscribed in Rowlandson's hand on a separate sheet mounted with the drawing: Death's Door/ In this world, all our Comfort's oer/ So let us find it [at] Death's Door
Engraved: 1815, reissued 1816
Literature: as for Nos. 243 and 305
Collections: as for No. 243
Acquired: ca. 1925
Accession Number: Rare Book 144954 f. 369

NOTES: See under Nos. 243 and 305

307. THE MISER'S END
Pen and watercolor, squared off in pencil, 5 13/16″ x 9⅜″
Inscribed in Rowlandson's hand: [on the sign to left] Mortgages/ Leases/ expiring/ Life Annuities/ Scrip/ Omnium/ Loans/ Bank Stock/ South Sea/ [on the bust in the background] Midas/ [on the book to the right] Book of Interest
Engraved with some variations: 1815, reissued 1816
Literature: as for No. 243; Wark, *Dance of Death*, No. 50
Collections: as for No. 243
Acquired: ca. 1925
Accession Number: Rare Book 144954 f. 382

NOTES: See under No. 243

308. GRETNA GREEN
Pen and watercolor, 4 13/16″ x 8″
Inscribed on the signpost: To Scotland
Engraved: 1815, reissued 1816
Literature: as for No. 243; Wark, *Dance of Death*, No. 51
Collections: as for No. 243
Acquired: ca. 1925
Accession Number: Rare Book 144954 f. 390

NOTES: See under No. 243
Another version of this drawing, which began as a counterproof pulled from the Huntington sheet, is in the Spencer Collection, New York Public Library.

Gretna Green, just over the Scottish border, became the popular resort of eloping couples after 1754, when an act abolishing clandestine marriages in England came into force. The traffic died down after 1856 when a law was passed requiring one of the contracting parties to be resident in Scotland for at least three weeks prior to the event.

309. THE WALTZ (1)
Pen and watercolor over pencil, 4 13/16″ x 7⅞″
Engraved: 1815, reissued 1816
Literature: as for No. 243; Wark, *Dance of Death*, No. 52
Collections: as for No. 243
Acquired: ca. 1925
Accession Number: Rare Book 144954 f. 398

NOTES: See under No. 243

310. THE WALTZ (2)
Pen and watercolor, reinforced counterproof, 4 11/16″ x 7¾″, upper left corner torn
Signed in Rowlandson's hand: Rowlandson
Inscribed in Rowlandson's hand on a separate sheet mounted with the drawing: The Waltz/ By Gar that horrid strange Buffoon/ Cannot keep time to any Tune—
Engraved in reverse: 1815, reissued 1816
Literature: as for Nos. 243 and 309
Collections: as for No. 243
Acquired: ca. 1925
Accession Number: Rare Book 144954 f. 399

NOTES: See under No. 243
The drawing began as a counterproof pulled from the preceding.

311. THE KITCHEN (1)
Pen and watercolor, 5¼″ x 8¾″
Engraved: 1815, reissued 1816
Literature: as for No. 243; Wark, *Dance of Death*, No. 54

Collections: as for No. 243
Acquired: ca. 1925
Accession Number: Rare Book 144954 f. 413

NOTES: See under No. 243

312. THE KITCHEN (2)
Pen and watercolor, reworked counterproof, 4¾" x 8¼"
Engraved in reverse: 1815, reissued 1816
Literature: as for Nos. 243 and 311
Collections: as for No. 243
Acquired: ca. 1925
Accession Number: Rare Book 144954 f. 412

NOTES: See under No. 243
The drawing began as a counterproof pulled from the preceding.

313. THE GIG
Pen and watercolor over pencil, 4 15/16" x 8 3/16"
Inscribed in Rowlandson's hand on milestone: 56/ Miles/ from/ London
Engraved: 1815, reissued 1816
Literature: as for No. 243; Wark, Dance of Death, No. 55
Collections: as for No. 243
Acquired: ca. 1925
Accession Number: Rare Book 144954 f. 418

NOTES: See under No. 243

314. THE MAUSOLEUM
Pen and watercolor, reinforced counterproof, 4 13/16" x 8¼"
Inscribed in Rowlandson's hand on the door, in reverse: Mausoleum
Engraved in reverse: 1815, reissued 1816
Literature: as for No. 243; Wark, Dance of Death, No. 56
Collections: as for No. 243
Acquired: ca. 1925
Accession Number: Rare Book 144954 f. 425

NOTES: See under No. 243

The drawing began as a counterproof pulled from a sheet now in the collection of Mr. and Mrs. Paul Mellon.

315. THE COURTSHIP
Pen and watercolor over pencil, 5 11/16" x 9¼"
Inscribed in Rowlandson's hand: A Tottering state, or a Man betwixts Life and Death
Verso inscribed, probably in Rowlandson's hand: Awkward state betwixt Life and Death/ [in another hand] wants explanation/ this to go
Engraved: 1815, reissued 1816
Literature: as for No. 243; Wark, Dance of Death, No. 57
Collections: as for No. 243
Acquired: ca. 1925
Accession Number: Rare Book 144954 f. 431

NOTES: See under No. 243
There is another version of this drawing in the Spencer Collection, New York Public Library. It began as a counterproof, but not pulled from the Huntington sheet.

316. THE TOASTMASTER
Pen and watercolor over pencil, 5⅝" x 9 3/16"
Signed and dated in Rowlandson's hand: Rowlandson 1805
Inscribed in Rowlandson's hand: Sots Hole
Engraved: 1815, reissued 1816
Literature: as for No. 243; Wark, Dance of Death, No. 58
Collections: as for No. 243
Acquired: ca. 1925
Accession Number: Rare Book 144954 f. 447

NOTES: See under No. 243
The technique of the drawing is noticeably different from others in the series. In this respect it appears earlier; the date inscribed on the drawing is probably correct.

317. THE LAW OVERTHROWN
Pen and watercolor with preparatory pencil in the background, 4⅞" x 8⅝"

Engraved in reverse: 1815, reissued 1816
Literature: as for No. 243; Wark, *Dance of Death*, No. 60
Collections: as for No. 243
Acquired: ca. 1925
Accession Number: Rare Book 144954 f. 458

NOTES: See under No. 243
The principal figure group began as a counterproof, probably pulled from another version of the drawing in the collection of Morris Saffron.
The background is probably the entrance front to Westminster Hall.

318. THE FORTUNE TELLER
Pen and watercolor over pencil, unfinished, 5″ x 8 9/16″
Engraved: 1815, reissued 1816
Literature: as for No. 243; Wark, *Dance of Death*, No. 61
Collections: as for No. 243
Acquired: ca. 1925
Accession Number: Rare Book 144954 f. 467

NOTES: See under No. 243
Another version of this drawing, which began as a counterproof pulled from the Huntington sheet, is in the Ashmolean Museum. Concerning the theory that the Ashmolean drawing is a copy by a Miss Howitt see Introduction p. 20, and Wark, *Dance of Death*, pp. 19-25.

319. THE PRISONER DISCHARGED
Pen and watercolor over pencil, 4¾″ x 8 5/16″
Signed in Rowlandson's hand: Rowlandson
Inscribed in Rowlandson's hand on the paper held by the man to the left: Bond/ Judgm/ Execut
Inscribed in Rowlandson's hand on a separate sheet mounted with the drawing: The Prisoner Discharged/ Death without either Bribe or Fee/ Can set the hopeless Pris'ner free . . .
Engraved: 1815, reissued 1816
Literature: as for No. 243; Wark, *Dance of Death*, No. 63
Collections: as for No. 243

Acquired: ca. 1925
Accession Number: Rare Book 144954 f. 479

NOTES: See under No. 243
As Combe points out in the verses accompanying the design, legislation introduced by Lord Redesdale in 1813 and 1814 had done a great deal for the relief of insolvent debtors. The hopeless plight of debtors implied by Rowlandson did not in fact exist at the time the print was issued.

320. THE GALLANT'S DOWNFALL
Pen and watercolor over pencil, 5 7/16″ x 8¾″
Verso: slight pencil sketch of figures and a building
Engraved with variations: 1816
Literature: as for No. 243; Wark, *Dance of Death*, No. 64
Collections: as for No. 243
Acquired: ca. 1925
Accession Number: Rare Book 144954 f. 484

NOTES: See under No. 243

321. THE CHURCHYARD DEBATE
Pen and watercolor over pencil, 5⅝″ x 9 5/16″
Inscribed in Rowlandson's hand: [on the paper held by the lawyer] Last/ Will and/ Testament/ [on the church wall] Dye/ all/ [on the sarcophagus] We Live/ by/ Death
Engraved: 1816
Literature: as for No. 243; Wark, *Dance of Death*, No. 65
Collections: as for No. 243
Acquired: ca. 1925
Accession Number: Rare Book 144954 f. 492

NOTES: See under No. 243
Another version of the drawing is in the Spencer Collection, New York Public Library.

322. THE NEXT HEIR
Pen and blue-gray wash over pencil, 5″ x 8 15/16″
Signed, not in Rowlandson's hand: Rowlandson
Engraved: 1816

Literature: as for No. 243; Wark, *Dance of Death*, No. 67
Collections: as for No. 243
Acquired: ca. 1925
Accession Number: Rare Book 144954 f. 501

NOTES: See under No. 243

323. THE CHAMBER WAR
Pen and watercolor over pencil, unfinished, 4 13/16″ x 8 9/16″
Watermark: 1814
Verso: slight pencil sketch
Engraved: 1816
Literature: as for No. 243; Wark, *Dance of Death*, No. 68
Collections: as for No. 243
Acquired: ca. 1925
Accession Number: Rare Book 144954 f. 508

NOTES: See under No. 243
Another version of this drawing was formerly with Frank T. Sabin. Yet another closely related drawing, but without the figure of Death, belongs to Morris Saffron.
The theme of Death and the doctors is one Rowlandson employs frequently. Five of the published designs for the Dance of Death involve variations on the subject.

324. DEATH AND THE ANTIQUARIES (1)
Pen and watercolor over pencil, 5 11/16″ x 9 3/16″
Verso inscribed in Rowlandson's hand: I doe love these auncient vynes/ We never tread upon them but we set/ Our foote upon some reverend History,/ And questionless here in this open Court/ Which now lies naked to the injuries/ Of stormy weather, some men lye enterred/ Loved the Church so well & gave so largely tot/ They thought it should have canopied their bones/ Till Domesday, but all things have their end./ Churches & Cities (which have diseases like to men)/ Must have like Death that we have/ [also in-

scribed verso in another hand, possibly Combe's] This suppose in Westminster Abbey/ one of them stealing a ring/ & pulls of [sic] the finger at the/ same time
Engraved: 1816. There are several changes in the engraving, the most important being that the background is no longer a ruin.
Literature: as for No. 243; Wark, *Dance of Death*, No. 69
Collections: as for No. 243
Acquired: ca. 1925
Accession Number: Rare Book 144954 f. 513

NOTES: See under No. 243
It is possible that Rowlandson may be alluding to the celebrated opening of the coffin of Charles I in April 1813. The precise whereabouts of the coffin had been a mystery until it was accidentally discovered by some workmen during reconstruction work at St. George's Chapel, Windsor, in 1813. There was some despoliation of the remains, and the royal physician, Henry Halford (who was present when the coffin was opened), obtained a portion of the fourth cervical vertebra, which had been cut by the headsman's axe.

325. DEATH AND THE ANTIQUARIES (2)
Pen and watercolor over pencil, 5″ x 8⅝″
Verso: some arithmetic
Engraved: 1816
Literature: as for Nos. 243 and 324
Collections: as for No. 243
Acquired: ca. 1925
Accession Number: Rare Book 144954 f. 514

NOTES: See under Nos. 243 and 324
This version of the drawing is much closer than the preceding to the print.

326. THE DAINTY DISH
Pen and watercolor over pencil, unfinished, 4⅞″ x 7 15/16″
Engraved: 1816
Literature: as for No. 243; Wark, *Dance of Death*, No. 70

Collections: as for No. 243
Acquired: ca. 1925
Accession Number: Rare Book 144954 f. 519

NOTES: See under No. 243

Rowlandson uses essentially this same composition frequently. See *A Meeting of Cognoscenti*, No. 131 and *Fabricious's Description of the Poets*, Nos. 150 and 151.

327. TIME, DEATH, AND ETERNITY (1)
Pen over pencil (no wash), 4⅞″ x 7⅝″
Engraved: 1816
Literature: as for No. 243; Wark, *Dance of Death*, No. 72
Collections: as for No. 243
Acquired: ca. 1925
Accession Number: Rare Book 144954 f. 532

NOTES: See under No. 243

The drawing is unusual and interesting technically. At this late stage in his career Rowlandson does not normally build shading areas with pencil, or even with pen; he prefers wash. In this respect the drawing is worth comparing with the equally unusual fully developed pencil landscape, No. 191.

While this catalog was in press an article by Allen M. Samuels entitled "Rudolph Ackermann and *The English Dance of Death*" appeared in *The Book Collector XXIII* (1974), pp. 371-80. Mr. Samuels prints two interesting letters, one from William Combe (the author of the verses in *The English Dance of Death*) to Rudolph Ackermann (the publisher of the book) and a second from Ackermann to Richard Cosway. The letters concern the design for *Time, Death and Eternity*, and they indicate clearly that Combe asked Ackermann to approach Cosway for a drawing of this subject. Combe described what he wished the design to contain, and the published print corresponds closely to that description. This is the only instance thus far discovered in the series where there is definite evidence that the idea for a design originated with Combe. The letters do not indicate whether Cosway actually supplied a design.

The two drawings for this subject in the Huntington Collection are certainly unusual for Rowlandson both in general composition and in some details of execution. There is, however, no doubt that the pen work in No. 327, tight and mechanical as it is, is by him. No. 328 is a counterproof derived from the preceding by Rowlandson's normal method and reinforced with pen work that is again unmistakeably by his hand. But there remains the distinct possibility, amounting to a probability, that Rowlandson worked from a design supplied by Cosway. It is even possible that the underlying pencil work in No. 327 is by Cosway rather than Rowlandson.

328. TIME, DEATH, AND ETERNITY (2)
Pen and wash, reinforced counterproof, 4⅞″ x 7⅝″
Engraved in reverse: 1816
Literature: as for Nos. 243 and 327
Collections: as for No. 243
Acquired: ca. 1925
Accession Number: Rare Book 144954 f. 533

NOTES: See under No. 243

This drawing clearly began as a counterproof pulled from the preceding. The color range in the wash, close to monochrome, but with tints of yellow and blue, is unusual for Rowlandson.

329. THE MAN OF FEELING
Pen and watercolor over pencil, 4 15/16″ x 8 3/16″
Signed in Rowlandson's hand: Rowlandson
Inscribed in Rowlandson's hand on a separate sheet mounted with the drawing: The Man of Feeling/ But in the Prison's transient gloom/ May look for better times to come.
Literature: as for No. 243; Wark, *Dance of Death*, No. 73
Collections: as for No. 243
Acquired: ca. 1925
Accession Number: Rare Book 144954 f. 544

NOTES: See under No. 243

The drawing was not engraved in *The English Dance of Death*, but the format, technique, and subject are related to that project. The release from prison and from Death does not properly belong with a Dance of Death, and the design may have been omitted for that reason. A variant on the

subject, in which Death does triumph, was engraved (see No. 319).

330. THE OLD SUITOR REJECTED
Pen and watercolor over pencil, 5 ⅜" x 8 ½"

Literature: as for No. 243; Wark, *Dance of Death*, No. 74

Collections: as for No. 243

Acquired: ca. 1925

Accession Number: Rare Book 144954 f. 545

NOTES: See under No. 243
 The design was not engraved in *The English Dance of Death*, but is almost certainly connected with that project. Rowlandson returns on many occasions to the theme of youth and old age in marriage.

331. DEATH MIXING THE MORTAR
Pen and watercolor over pencil, 5 ¾" x 9 ⅜"

Literature: as for No. 243; Wark, *Dance of Death*, No. 75

Collections: as for No. 243

Acquired: ca. 1925

Accession Number: Rare Book 144954 f. 546

NOTES: See under No. 243
 The drawing was not engraved in *The English Dance of Death*, but was almost certainly intended for the series.

332. DEATH AT THE DOOR
Pen and watercolor over pencil, 5 ⅝" x 9 ⅜"

Literature: as for No. 243; Wark, *Dance of Death*, No. 76

Collections: as for No. 243

Acquired: ca. 1925

Accession Number: Rare Book 144954 f. 547

NOTES: See under No. 243
 The drawing was not engraved for *The English Dance of Death*, but probably was intended for that series.

333. THE SWORD DUEL
Pen and watercolor over pencil, 5 ⅝" x 9 ⅜"

Literature: as for No. 243; Wark, *Dance of Death*, No. 77

Collections: as for No. 243

Acquired: ca. 1925

Accession Number: 144954 f. 548

NOTES: See under No. 243
 The drawing was not engraved for *The English Dance of Death*. It probably is connected with that series, although the costumes are not "English" and the pen work suggests a date closer to 1800.

334. THE YOUNG FAMILY MOURNING IN THE CHURCHYARD
Pen and watercolor over pencil, 5 ⅝" x 9 1/16"

Inscribed in Rowlandson's hand on two tombstones: Loving &/ tender/ husband/ aged 28/ [and] Sacred to the/ Memory of

Literature: as for No. 243; Wark, *Dance of Death*, No. 78

Collections: as for No. 243

Acquired: ca. 1925

Accession Number: Rare Book 144954 f. 549

NOTES: See under No. 243
 The drawing was not engraved for *The English Dance of Death*, but appears intended for that series. Another version of the drawing is in the collection of Philip Hofer.

335. DEATH IN A BALLROOM
Pen and watercolor, 5 ¾" x 9 5/16"

Inscribed in Rowlandson's hand: A Rude intruder rush'd into a private Ballroom/ and disturbed the whole Company

Literature: as for No. 243; Wark, *Dance of Death*, No. 79

Collections: as for No. 243

Acquired: ca. 1925

Accession Number: Rare Book 144954 f. 550

NOTES: See under No. 243
 The drawing was not engraved for *The English Dance of Death*, but the subject is the same as one of the published designs. (Wark, *Dance of Death*, No. 24).

336. DEATH HELPING AN OLD LOVER INTO BED

Pen and watercolor, 5 9/16" x 9 3/16"
Literature: as for No. 243; Wark, *Dance of Death*, No. 80
Collections: as for No. 243
Acquired: ca. 1925
Accession Number: Rare Book 144954 f. 551

NOTES: See under No. 243
Probably intended for *The English Dance of Death* but not engraved. Another version of the drawing is in the Widener Collection, Harvard University.

337. RELEASED FROM DEATH

Pen and watercolor, 5 11/16" x 9¼"
Inscribed in Rowlandson's hand: Released from Death/ [on coffin lid] Come/to/life/again/ [on two chests] Plate/chest [and] Iron ch . . .
Literature: as for No. 243; Wark, *Dance of Death*, No. 81
Collections: as for No. 243
Acquired: ca. 1925
Accession Number: Rare Book 144954 f. 552

NOTES: See under No. 243
Probably intended for *The English Dance of Death* but not engraved. Another version of the drawing is in the Widener Collection, Harvard University.

338. DEATH AND THE BUTCHER

Pen and watercolor over pencil, 5¾" x 9 5/16"
Literature: as for No. 243; Wark, *Dance of Death*, No. 82
Collections: as for No. 243
Acquired: ca. 1925
Accession Number: Rare Book 144954 f. 553

NOTES: See under No. 243
Probably intended for *The English Dance of Death* but not engraved. Another version of the drawing is in the collection of Augustus Loring.

339. DEATH IN THE BARBER SHOP (1)

Pen and watercolor over pencil, 5¾" x 9 5/16"

Verso inscribed in Rowlandson's hand: Smooth chin Death a bad customer to the barber/ The bold Barber or a sworn enemy to Death/ A Struggle Twixt life & Death
Literature: as for No. 243; Wark, *Dance of Death*, No. 83
Collections: as for No. 243
Acquired: ca. 1925
Accession Number: Rare Book 144954 f. 554

NOTES: See under No. 243
Probably intended for *The English Dance of Death* but not engraved. In addition to the two versions of this subject in the Huntington Collection there was another in the Fitz Eugene Dixon Collection, American Art Association, January 6 and 7, 1937, lot 139.

340. THE BARBER SHOP (2)

Pen and watercolor over pencil, 5 11/16" x 9 5/16"
Inscribed in Rowlandson's hand on the lantern: Shaving/Bleeding/Tooth/Draw
Literature: as for Nos. 243 and 339
Collections: as for No. 243
Acquired: ca. 1925
Accession Number: Rare Book 144954 f. 555

NOTES: See under Nos. 243 and 339

341. THE PUMP ROOM DOOR (1)

Pen and watercolor over pencil, 5 11/16" x 9¼"
Inscribed in Rowlandson's hand on various signs in the background: South/Parade Setts off/ every hour/to kingdom/come/Road rather/ Rough &/Dreary Pump Room Places/taken/ here/for/Deat[h's]/Dilly
Literature: as for No. 243; Wark, *Dance. of Death*, No. 84
Collections: as for No. 243
Acquired: ca. 1925
Accession Number: Rare Book 144954 f. 556

NOTES: See under No. 243
Probably intended for *The English Dance of Death* but not engraved. The scene is presumably outside the Pump Room at Bath.

342. THE PUMP ROOM DOOR (2)
Pen and watercolor over pencil, 5⅝" x 9¼"
Inscribed in Rowlandson's hand as on the preceding drawing, with minor differences
Literature: as for Nos. 243 and 341
Collections: as for No. 243
Acquired: ca. 1925
Accession: Rare Book 144954 f. 557

NOTES: See under Nos. 243 and 341
This drawing and the preceding are related by tracing, but the sequence is not clear.

343. THE MAN OF LETTERS
Pen and watercolor over pencil, 9 11/16" x 15"
Inscribed, in pencil, probably by a later hand:
The Man of letters
Literature: Paulson, p. 86
Collections: Kate Fowler Merle-Smith
Acquired: 1951, gift of Sidney Ehrman
Accession Number: 51.12

NOTES: Although the execution of the drawing is indubitably by Rowlandson, both theme and composition are somewhat uncharacteristic. Rowlandson does not normally celebrate the pleasures of a quiet, solitary, scholarly life, and he is not usually content to leave a large, virtually blank space in the foreground of a composition.

344. INTERIOR OF AN INN
Pen and watercolor over pencil, 5¼" x 8⅞"
Collections: Charles Sessler
Acquired: ca. 1910
Accession Number: Sessler 91 b

NOTES: The interior does not look particularly English. The drawing might relate to one of Rowlandson's Continental trips or to some Continental prototype.

345. THE FLOUR MILL
Pen and watercolor, 5 15/16" x 11⅜"
Engraved: 1816 (*The World in Miniature*, No. 5)
Literature: Paulson, p. 123 n. 26

Exhibited: Arts Council (1950) No. 12
Collections: Gilbert Davis
Acquired: 1959, gift of the Friends
Accession Number: 59.55.1115

NOTES: Another version of this drawing, in reverse, is in the Widener Memorial Collection, Harvard University (in a volume of seventy-five drawings from the collection of Sir William Augustus Fraser).

346. MUSICAL CATS
Pen and watercolor, 5¾" x 9¼"
Literature: Paulson, pp. 35, 84, 125, Fig. 39
Collections: Gilbert Davis
Acquired: 1959
Accession Number: 59.55.1096

NOTES: There are other versions of this drawing in the John Witt Collection and the Princeton Art Museum. A third version (Christie's, June 4, 1974 lot 109) is inscribed "Concerto a la Catalani." On Catalani see No. 214.
Subsequent to the publication of his book, Ronald Paulson discovered that the design is closely based on a painting by Teniers, probably known to Rowlandson through the print by J. P. Le Bas. The only significant difference is Rowlandson's addition of the female head in the window.
The technique of the drawing suggests a late date (ca. 1820) which is also the time when Rowlandson seems to have been most interested in this type of fantastic drollery.

347. A YOUNG WOMAN WITH A GROUP OF ADMIRERS
Pen and watercolor over pencil, 4⅜" x 7¼"
Collections: Charles Sessler
Aquired: ca. 1910
Accession Number: Sessler 103 a

348. FORCE OF IMAGINATION (1)
Pen and watercolor over pencil, 5⅛" x 7 5/16"
Collection: Dr. and Mrs. Edward W. Bodman
Acquired: 1960, gift of Mrs. Bodman
Accession Number: 60.2

NOTES: See also No. 349

Two other versions of this composition are in the Dent scrapbook of Rowlandson drawings (photos in the Witt Library). In both of these the soldier proposing is represented as an older and unprepossessing man.

The watercolor washes on the Huntington drawing are blotchy, and may have been reworked by a later hand.

349. FORCE OF IMAGINATION (2)
Pen and watercolor, 4⅜″ x 6″
Acquired: ca. 1910
Accession Number: Sessler 110 a

NOTES: See under No. 348

This version of the drawing, with the soldier as an older man, is closer to the versions of the subject in the Dent scrapbook (photos in the Witt Library) than to the other version in the Huntington Collection.

350. THE MARAUDERS
Pen and watercolor over pencil, 5½″ x 9⅛″
Acquired: ca. 1910
Accession Number: Sessler 72 b

NOTES: This theme appears frequently in Rowlandson's drawings, but no other versions of this particular design have been located. A similar composition appears in the *English Dance of Death* (see No. 301).

351. A MAN AND A WOMAN WATCH-ING SHIPPING
Pen and watercolor over pencil, unfinished, 3¾″ x 5″
Verso: a crude pencil and wash sketch of a boat-house, probably not by Rowlandson
Acquired: ca. 1910
Accession Number: Sessler 157 a

352. THE PROLOGUE
Pen and watercolor over pencil, 6 5/16″ x 9½″
Watermark: 1813
Collections: Gilbert Davis

Acquired: 1959
Accession Number: 59.55.1121

NOTES: The thin, wiry pen line suggests that the drawing may be a few years later than the watermark.

There is no evidence concerning the theater or actor represented.

353. FIGURES ON A BRIDGE IN A PARK
Watercolor over pencil, some pen work in the figures, 6″ x 9⅜″
Acquired: ca. 1910
Accession Number: Sessler 74 a

NOTES: The virtual absence of pen work in a sketch of this type is unusual and almost certainly indicates that the drawing is unfinished.

354. BOATING ON A POND IN A PARK
Pen and watercolor, 5¾″ x 9⅜″
Verso: slight pencil sketch of a woman
Acquired: ca. 1910
Accession Number: Sessler 74 b

NOTES: A design closely related thematically, but not the same composition, was published August 1, 1816 (illus. Grego II, 316) with the title *The Social Day.* The pen work in the Huntington drawing accords with a date around 1816.

355. A MAN TORTURED OVER A FIRE
Pen and pencil, unfinished, 5⅛″ x 8″
Acquired: ca. 1910
Accession Number: Sessler 130 a

NOTES: The drawing is thematically related to No. 356. Another torture scene is in the Achenbach Collection, California Palace of the Legion of Honor, San Francisco. All drawings appear to be intended to represent scenes of the Spanish Inquisition, and suggest that Rowlandson may have had in mind some project on this theme. An item entitled *Spanish Cruelty* was included in the Sotheby sale of the contents of Rowlandson's studio (June 23, 1828, lot 97). All drawings appear to date from the second decade of the nineteenth century.

356. A MAN HAVING HIS TONGUE CUT
Pen, unfinished, 5⅛" x 8"
Acquired: ca. 1910
Accession Number: Sessler 130 b

NOTES: See under No. 355
 The drawing began as a counterproof, and has been only partially reinforced.

357. SCENE OUTSIDE AN INN
Pen and watercolor over pencil, 5⅞" x 8⅝"
Acquired: ca. 1910
Accession Number: Sessler 62 b

NOTES: This is a late drawing with the spidery pen work of Rowlandson's drawings of the early 1820s.

358. COPY AFTER A SEVENTEENTH-CENTURY PORTRAIT
Pen over pencil, unfinished, 8⅝" x 7"⅛
Watermark: 1817
Acquired: ca. 1910
Accession Number: Sessler 120

NOTES: Here Rowlandson is clearly copying a portrait painting or print, probably from the 1630s, but the source has not yet been identified.

359. COPY AFTER HANS SEBALD BEHAM'S WOODCUT "VINE PATTERN WITH SATYR FAMILY"
Pen over pencil, 8½" x 6¾"
Literature: Paulson, pp. 65, 127 n. 7, Pl. 38
Acquired: ca. 1910
Accession Number: Sessler 42

NOTES: I am indebted to Ebria Feinblatt for pointing out that Rowlandson's source for this drawing is Beham's sixteenth-century woodcut. This is an unusual area for Rowlandson to seek inspiration, but he would clearly find both the theme and the ebullient line sympathetic.

360. INTERIOR IN THE MANNER OF OSTADE
Pen (red ink) and grey wash, 8½" x 6 15/16"

Collections: C. R. Rudolf (Lugt 2811b), Gilbert Davis
Acquired: 1959
Accession Number: 59.55.1118

NOTES: The drawing certainly appears to be based on a Dutch seventeenth-century composition by Ostade or one of his followers, but the prototype has not been located. A similar type of drawing, but a different composition, is illustrated in Sabin (1948) No. 2. The technique of the Huntington study suggests a date after 1800.

361. NYMPH AND FAUN WITH CHERUBS
Pen and brown wash over pencil, unfinished, 6⅛" x 7⅜"
Acquired: ca. 1910
Accession Number: Sessler 43 b

NOTES: The composition is outside Rowlandson's normal range. He is probably copying an earlier (seventeenth-century?) work, but the source has not been located.

362. MYTHOLOGICAL SUBJECT
Pen over pencil, 7¾" x 7½"
Acquired: ca. 1910
Accession Number: Sessler 38

NOTES: The composition is outside Rowlandson's normal range; he is probably working from some yet-to-be-identified seventeenth- or eighteenth-century print. The subject is not clear: it might be Diana and Apollo. As both figures appear to be preparing to depart for the hunt, the subject is probably not Venus and Adonis.

363. LE DÉLUGE, AFTER CLODION
Pen and pencil, 5" x 3⅞"
Acquired: ca. 1910
Accession Number: Sessler 34 a

NOTES: The drawing is a close copy of a print based on Clodion's *Le Déluge*, exhibited at the Salon of 1800. For a reproduction of the print see H. Thirion, *Les Adam et Clodion* (Paris, 1885), p. 363. A late drawing, probably from the 1820s.

364. STUDY AFTER GUERIN'S "RETURN OF MARCUS SEXTUS"

Pen and gray wash, 5⅛″ x 7¼″, tears along the top and left margins
Acquired: ca. 1910
Accession Number: Sessler 48 b

NOTES: The painting was exhibited in the Paris Salon of 1799. There is no need to assume that Rowlandson saw the painting itself. It enjoyed great popularity, and the composition could be transmitted to him by intermediary sketches or prints. The technique of the drawing suggests a date in the second or third decade of the nineteenth century. On the whole, Rowlandson exhibits little interest in or awareness of the art of his Continental contemporaries.

365. WINGED FEMALE FIGURE

Pen, 6⅞″ x 5¼″, upper left corner torn
Verso: list of numbers and some washes of watercolor
Acquired: ca. 1910
Accession Number: Sessler 48 a

NOTES: The pen work is characteristic of Rowlandson but the image is outside his range. He is presumably copying some other work not yet identified.

366. APOLLO AND THE MUSES

Pen and watercolor over pencil, 8⅛″ x 14 1/16″
Literature: Oppé, Pl. 54; Paulson, p. 27; Hayes, Pl. 132.
Exhibited: Art Council (1950), No. 148
Collections: Henry Harris, Gilbert Davis
Acquired: 1959
Accession Number: 59.55.1088

NOTES: There appears to be no comic intention in this drawing, but whether through association or the inherent quality of Rowlandson's line, it is difficult to take the drawing seriously. The line suggests a date after 1800.

367. RAPE OF LUCRECE

Pen and watercolor, 10¾″ x 9½″ within ruled borders 8⅝″ x 7¼″ (uneven)
Watermark: 181[6?]
Inscribed, probably not in Rowlandson's hand: T. Rowlandson
Inscribed verso in a later hand: Tarquin and Lucretia/Rowlandson
Collections: Paul Farren
Acquired: 1951
Accession Number: 51.15

NOTES: The drawing reflects the interest in classical themes and motifs that becomes strong in the latter part of Rowlandson's career. It also approaches the area of his numerous pornographic studies.

368. THE PAINTER

Pencil with a few touches of pen, 8 13/16″ x 7″
Inscribed in Rowlandson's hand: [in Greek] Socrates/ [in Latin] Pictura Gravium ostendantur Pondera Rerum. Quae. Latent Magis. haec per mage/aperta Patent
Acquired: ca. 1910
Accession Number: Sessler 35

NOTES: The drawing is unusual for Rowlandson from almost every point of view, but the inscription and the pencil work appear to be in his hand. Probably both the composition and the inscription are derived from other sources not yet located.

369. RUNNING FEMALE NUDE

Pen and watercolor over pencil, 7¼″ x 6¼″
Acquired: ca. 1910
Accession Number: Sessler 4 a

NOTES: The drawing belongs with a substantial number of studies of the female nude, some of which are clearly based on other artists (see Hayes, Fig. 57), some of which equally clearly are Rowlandson's own inventions. *Apollo and the Muses* (No. 366) is the most elaborate and finished drawing of this general type in the Huntington Collection. There are several others in one of the albums in the Widener Memorial Collection, Harvard.

370. LEDA AND THE SWAN
Pen and wash over pencil, unfinished, 5⅝″ x
7⅛″
Acquired: ca. 1910
Accession Number: Sessler 4 b

Notes: This amusing burlesque of a classical sub-
ject is much more successful than Rowlandson's
ostensibly serious treatments of similar themes.

371. DANCING NUDES
Pen over pencil, unfinished, 4⅞″ x 7⅛″
Acquired: ca. 1910
Accession Number: Sessler 45 a

372. THREE CLASSICAL FIGURE STUDIES
Pen and gray wash over pencil, 5½″ x 7½″
Acquired: ca. 1910
Accession Number: Sessler 45 b

Notes: At first glance the drawings appear to be
after ancient sculpture. But the two drawings of a
male figure are clearly not front and back views of
the same piece of sculpture.

373. DIANA AND ACTAEON (?)
Pen and watercolor over pencil, 6¾″ x 9⅛″
Acquired: ca. 1910
Accession Number: Sessler 13

Notes: Another version of the drawing is in the
Wiggin Collection at the Boston Public Library.
 The subject of the drawing is debatable. The
sprouting antlers and hounds that would definitely
establish the subject as Diana and Actaeon are not
present.

374. A NUDE FIGURE, A DAGGER IN THE HEART
Pen and watercolor over pencil, unfinished, 5″ x
7⅝″
Acquired: ca. 1910
Accession Number: Sessler 34 b

Notes: See under No. 369
 A drawing of this figure in combination with
three others is illustrated in Bury, Pl. 72. Although
the source has not been identified, it is probable
that the drawing is derived from a painting or print
and is not Rowlandson's own invention.

375. THE UGLY CLUB
Pen and watercolor over pencil, 9⅛″ x 13⅞″
Literature: Paulson, p. 17, Pl. 9
Acquired: ca. 1910
Accession Number: Sessler 98

Notes: Several other versions of this drawing are
known. One, 9½″ x 13⅞″, is in the collection of
Mr. and Mrs. Paul Mellon; another, possibly the
same one, was in the W. A. Sillence and Randall
Davies collections, 9½″ x 13¾″ (photo in the Witt
Library); yet another was in the Bache Sale, New
York 19-20 April, 1945 lot 451, 9½″ x 14″, there
called *The Ugly Club.*

376. THE CHOIR
Pen and watercolor over pencil, 8⅞″ x 11¼″
Acquired: ca. 1910
Accession Number: Sessler 104

377. TWO PHYSIOGNOMIC STUDIES
Pen and watercolor over pencil, 7⅜″ x 9⅞″
Acquired: ca. 1910
Accession Number: Sessler 100

Notes: Another version of the drawing was sold
at Sotheby's November 2, 1967, lot 85, cataloged
as "a study for the series *Faces in Court.*" No series
of that title is listed in Grego or the other literature
on Rowlandson.

378. A CERTAIN CURE FOR THE HEAD-ACHE
Pen and watercolor over pencil, 7¼″ x 6¼″
Inscribed in Rowlandson's hand: A certain cure
 for the head ache
Verso: Pencil sketch of a man blowing
Acquired: ca. 1910
Accession Number: Sessler 94

NOTES: The drawing on the verso is an interesting conception, outside Rowlandson's normal range of invention. The form of the head is reminiscent of cartographers' decorative devices representing wind, and may have been derived from some such source.

379. AN OLD LADY WITH TWO CATS
Pen and watercolor over pencil, 6⅞″ x 5¼″
Acquired: ca. 1910
Accession Number: Sessler 127

380. TWO PAWN SHOP CHARACTERS
Pen and watercolor over pencil, 4⅞″ x 8¼″
Acquired: ca. 1910
Accession Number: Sessler 99 b

381. HEAD OF A MAN
Pen over pencil, unfinished, 5″ x 5⅜″
Acquired: ca. 1910
Accession Number: Sessler 30 a

NOTES: The subject and the technique (which is from ca. 1820) suggest this drawing may be connected with the large number of physiognomic studies Rowlandson made late in life.

382. 'TIS A COLD, RAINY NIGHT
Pen and brown wash over pencil, 7⅛″ x 8″
Inscribed in Rowlandson's hand: Tis a Cold rainy Night. see I am wet to the Skin/ Do kind Sir have Pity, and pray let me in.
Verso: slight pen and pencil sketch of a seated woman undressing
Collections: Charles Sessler
Acquired: ca. 1910
Accession Number: Sessler 9

383. COSTUME STUDIES
Pen over pencil, 7″ x 6⅞″
Acquired: ca. 1910
Accession Number: Sessler 1

NOTES: There is some evidence to suggest that Rowlandson may have contemplated a project concerned with period and regional costumes. In addition to the Huntington drawing, there are sheets of similar studies in the Achenbach Collection, San Francisco, the Wiggin Collection at the Boston Library, and the Rowlandson scrapbook in the Victoria and Albert Museum. The Achenbach drawing is inscribed in Rowlandson's hand: Habit of a Merchant and his Wife in England in 1640. It bears what appears to be a false signature and date 1773. The latter is clearly impossible; on the basis of technique all the drawings must have been executed after 1800. It is probable that in these drawings Rowlandson is working from some yet-to-be-identified prints by earlier artists.

384. THE NIGHT WATCHMAN
Pen and watercolor, 6⅝″ x 4¾″, tear lower left corner
Acquired: ca. 1910
Accession Number: Sessler 79

385. CREDITORS EXPELLED
Pen and watercolor over pencil, 6⅛″ x 7¾″ within engraved (?) borders 3⅜″ x 5¼″
Acquired: ca. 1910
Accession Number: Sessler 122

NOTES: The borders are a puzzling feature of this drawing. Rowlandson frequently mounted his own drawings and provided ruled and tinted borders. In this instance, however, the borders are on the same sheet as the drawing, and they appear to be engraved.

386. LA MARCHANDE DE COCO
Pen and watercolor over pencil, 7¾″ x 5⅞″
Acquired: ca. 1910
Accession Number: Sessler 105

NOTES: The drawing is based closely on "La Marchande de Coco" by Carle Vernet, engraved by Debucourt in 1815. I am indebted to Lorenz Eitner for pointing out the connection. It is worth noting that Rowlandson has misunderstood the operation of the mechanism carried by the woman. Vernet has her operating a spigot with her right hand, and holding a cup below it with her left.

The technique of the drawing suggests a date about the time the Vernet print was issued, or a little later.

387. THE BUSY COWHERD
Pen and watercolor over pencil, 6⅛″ x 9⅝″
Signed and dated: Rowlandson 1820
Literature: Paulson, p. 123 n. 24; p. 136 n. 47
Exhibited: Arts Council (1950), No. 19
Collections: Gilbert Davis
Acquired: 1959
Accession Number: 59.55.1103

Notes: In technical execution the drawing is certainly late, and accords well with the date inscribed.

388. A GROUP OF DANCERS
Pen over pencil, 6⅜″ x 8″
Acquired: ca. 1910
Accession Number: Sessler 116 a

Notes: The general motif of a round dance occurs frequently in Rowlandson's work, but no other version of this particular design has been located.

389. ROUND DANCE WITH SPECTATORS
Pen and wash over pencil, unfinished, 5⅝″ x 9¼″
Verso: slight pencil sketch, a few touches of pen
Acquired: ca. 1910
Accession Number: Sessler 116 b

Notes: The same general idea occurs in *Rural Happiness at Caverac* from Rowlandson's illustrations to *Journal of Sentimental Travels in the Southern Provinces of France* (1821), but the connection is not close in detail.

390. A COACH AND FOUR AT A STOP
Pen over pencil, unfinished, 5⅛″ x 8¼″
Acquired: ca. 1910
Accession Number: Sessler 14 a

Notes: This is a very popular motif with Rowlandson but no other version of this particular drawing has been located. The pen work suggests

a date in the second decade of the nineteenth century.

391. RIVER SCENE (HAMPTON COURT?)
Pen over pencil, some gray wash, 4½″ x 7⅓″
Verso: pencil sketch of St. Paul's Covent Garden
Acquired: ca. 1910
Accession Number: Sessler 77a

Notes: The small building in the drawing on the recto resembles the Banqueting House at Hampton Court both in shape and in placement beside the river. A fully developed watercolor of St. Paul's Covent Garden, seen from the same angle as the drawing on the verso, is in the Mellon Collection.

392. A BOATING PARTY NEAR AN ISLAND IN A RIVER
Pen over pencil, 5¾″ x 9½″
Acquired: ca. 1910
Accession Number: Sessler 77 b

393. A WOMAN ARRESTED
Pen and watercolor over pencil, 4¾″ x 3⅝″
Inscribed in Rowlandson's hand over the door: Watch House
Acquired: ca. 1910
Accession Number: Sessler 87 a

Notes: Another (doubtful) version of this drawing is in the Witt Collection (No. 3338) labeled *Arrest of a Woman at Night* (photograph in the Witt Library).

394. CANVASSING FOR A BOROUGH
Pen and watercolor, 5⅞″ x 4⅝″
Inscribed in Rowlandson's hand: [top] Canvassing for a Bourough/ [bottom] Electioneering Anecdote
Verso: Some numerical notations, probably in Rowlandson's hand
Acquired: ca. 1910
Accession Number: Sessler 86

395. RETURN FROM THE HUNT (1)
Pen and watercolor over pencil, 4⅜″ x 7⅛″,
 tear in lower right corner
Acquired: ca. 1910
Accession Number: Sessler 72 a

396. RETURN FROM THE HUNT (2)
Pen over pencil, unfinished, 4⅛″ x 6⅝″
Acquired: ca. 1910
Accession Number: Sessler 132 a

NOTES: This drawing and the preceding one are
related by tracing. Presumably the unfinished one
follows the other, but this is not certain.

397. PICNIC BY A STREAM
Pen and watercolor over pencil, 4⅞″ x 7⅞″
Watermark: 1817
Acquired: ca. 1910
Accession Number: Sessler 114 a

NOTES: The bewigged man to the left looks a little
like Dr. Syntax, and this might be an unused Syntax
design. Normally he is represented as older, with
more prominent nose and chin.

398. DR SYNTAX WINS AT NINE PINS
Pen and watercolor over pencil, 5½″ x 8⅝″
*Inscribed in pencil in Rowlandson's hand, par-
 tially obliterated:* . . . and Wins Money at
 Nine Pins
Literature: Gully, p. 10 and catalog number 116
Acquired: ca. 1910
Accession Number: Sessler 114 b

NOTES: This is a sketch not used for any of the
Syntax publications. See also under No. 223.

399. DR SYNTAX KISSING A MULE
Pen over pencil, 4¼″ x 6⅜″
Literature: Gully, catalog number 112
Acquired: ca. 1910
Accession Number: Sessler 112 a

NOTES: An unpublished drawing for a Dr. Syntax
subject.

**400. DR SYNTAX AND THE STRANDED
WHALE**
Pen and watercolor over pencil, 5⅝″ x 9″
Inscribed in Rowlandson's hand: [?] Alarmed
 on his way to Scarborough at a Stranded
 Whale
Literature: Gully, catalog number 108
Acquired: ca. 1910
Accession Number: Sessler 112 b

NOTES: There are several other versions of this un-
published Syntax subject. A large version of fine
quality is in the Wiggin Collection of the Boston
Public Library (No. 71). That version has more
added to the composition on the left. Another ver-
sion is in the collection of Mr. and Mrs. Paul Mel-
lon; a third is recorded in the photograph files of
the Leger Gallery.

**401. DR. SYNTAX IN A BOAT WITH
TWO WOMEN**
Pen over pencil, unfinished, 3½″ x 5¾″
Literature: Gully, catalog number 113
Acquired: ca. 1910
Accession Number: Sessler 111 a

NOTES: This is apparently a Syntax design that was
not used in any of the publications. Another ver-
sion of the drawing, with the woman to the right
holding a basket, is in the Dent scrapbook (photo
in the Witt Library).

402. DR. SYNTAX DINING IN THE LAKE
Pen and watercolor, 4⅞″ x 7⅞″
Watermark: 1815
Literature: Gully, catalog number 109
Acquired: ca. 1910
Accession Number: Sessler 111 b

NOTES: The design was not used in any of the
Syntax publications. The unusual situation cer-
tainly suggests interesting narrative possibilities.

403. DR. SYNTAX ON TOUR
Pen and watercolor over pencil, unfinished, 5″ x
 8¼″
Literature: Gully, catalog number 117

Acquired: ca. 1910
Accession Number: Sessler 110 b

NOTES: This is apparently an unused design for one of the Syntax tours. The presence of two dons suggests that the setting is a picture gallery in a house near Oxford or Cambridge.

404. DR. SYNTAX AND PAT HELPING AN INJURED WOMAN

Pen and watercolor over pencil, 5⅛″ x 8″
Literature: Gully, catalog number 114
Acquired: ca. 1910
Accession Number: Sessler 113 b

NOTES: The drawing was not used in any of the Syntax publications.

405. DR. SYNTAX SKETCHING A WOMAN SPINNING (1)

Pen and watercolor over pencil, unfinished, 4⅛″ x 6¼″
Literature: Gully, catalog number 110
Acquired: ca. 1910
Accession Number: Sessler 111 c

NOTES: This design does not appear in any of the Syntax publications. The pen work suggests a late date, in the 1820s.

406. DR. SYNTAX SKETCHING A LADY SPINNING (2)

Pen over pencil, 5″ x 6¾″
Watermark: [1]825
Literature: Gully, catalog number 111
Acquired: ca. 1910
Accession Number: Sessler 115 b

NOTES: This is a weak but seemingly authentic drawing that probably began as a tracing from No. 405, but has been worked out further in the background.

407. A BAT LOOSE IN A ROOM

Pen over pencil, unfinished, 4¾″ x 6½″

Acquired: ca. 1910
Accession Number: Sessler 115 a

NOTES: This could be an unused design for the Syntax series. Technically a late drawing, probably from the 1820s.

408. DEATH AND THREE FIGURES ON A COUCH

Pen and watercolor over pencil, 4¼″ x 7⅛″
Collections: William Henry Bruton
Accession Number: Rare Book 144954 f. 560
Acquired: ca. 1925

NOTES: The drawing entered the collection with the Bruton extra-illustrated set of *The English Dance of Death*, but it appears not to be directly connected with that project. The half-length presentation of the figures is unlike any of the designs for *The English Dance of Death*.

409. COL. WINDHAM AND HIS BUTCHER

Pen and watercolor, 6″ x 4¼″
Inscribed in Rowlandson's hand: Portraits of Col Windham and his Butcher
Collections: Sir William Augustus Fraser
Acquired: before 1930, loose in a bound series of *Characteristic Sketches of the Lower Orders*
Accession Number: 74.8

NOTES: Another version of this drawing is in the Wiggin Collection. Boston Public Library, No. 153.

410. AN EXCISEMAN WITH A CONSCIENCE

Pen and watercolor over pencil, 5½″ x 3½″
Inscribed, probably not in Rowlandson's hand: An Excisman with a Concience/Wonders! Wonders! Wonders.
Collections: Sir William Augustus Fraser
Acquired: before 1930 in a bound series of *Characteristic Sketches of the Lower Orders*
Accession Number: Rare Book 132503

411. OLD CHAIRS TO MEND
Pen and watercolor, 5¾″ x 4¼″
Inscribed in Rowlandson's hand:

> A Bunch of rushes at his back
> Old Chairs to mend. Tom halloes
> While Dolly in her husband track
> From night to morn still follows
>
> If money in his Pocket flows
> Whos happier than Poor Tom
> Doll with him to the alehouse goes
> And with him staggers home
>
> There was a time when Tom was gay
> And Dolly had a friend
> But flattering fortune fled away
> And left them Chairs to mend/
> Old Chairs to mend

Collections: Sir William Augustus Fraser
Acquired: before 1930 in a bound series of *Characteristic Sketches of the Lower Orders*
Accession Number: Rare Book 132503

NOTES: The drawing is not related to the engraving of this subject.

412. SCRUBBING DOORSTEPS
Pen and watercolor, 5⅛″ x 3⅝″, upper corners clipped
Inscribed in pencil, probably in Rowlandson's hand: Milly quit your old master and come and/scrub my Stones & keep my yard clean
Collections: Sir William Augustus Fraser
Acquired: before 1930 in a bound series of *Characteristic Sketches of the Lower Orders*
Accession Number: Rare Book 132503

NOTES: The drawing is not related to any of the engraved designs in the series.

413. DRAYMAN (1)
Pen and watercolor, 5⅝″ x 4⅜″
Inscribed in pencil, not in Rowlandson's hand: Can this be altered
Collections: Sir William Augustus Fraser

Acquired: before 1930 in a bound series of *Characteristic Sketches of the Lower Orders*
Accession Number: Rare Book 132503

NOTES: The drawing is not related to the engraved design of this subject.
 This and *Drayman* (2) are related by tracing, but the sequence is not clear.

414. DRAYMAN (2)
Pen and watercolor over pencil, 6″ x 4½″
Acquired: ca. 1910
Accession Number: Sessler 88

NOTES: See under No. 413

415. DRAYMAN (3)
Pen and watercolor over pencil, 4¾″ x 3⅛″
Inscribed in Rowlandson's hand on the sign in background: Tap House
Engraved in reverse: 1820 in *Characteristic Sketches of the Lower Orders*
Collections: Sir William Augustus Fraser
Acquired: before 1930 in a bound series of *Characteristic Sketches of the Lower Orders*
Accession Number: Rare Book 132503

416. OLD CHAIRS TO MEND
Pen and watercolor, 6⅜″ x 3⅞″
Inscribed in Rowlandson's hand: Old Chairs to Mend/ [and in a later hand] Cry of London
Engraved in reverse: 1820 in *Characteristic Sketches of the Lower Orders*
Collections: Sir William Augustus Fraser
Acquired: before 1930 in a bound series of *Characteristic Sketches of the Lower Orders*
Accession Number: Rare Book 132503

417. GARDENER
Pen and watercolor over pencil, 4¼″ x 2¾″
Engraved in reverse: 1820 in *Characteristic Sketches of the Lower Orders*
Collections: Sir William Augustus Fraser
Acquired: before 1930 in a bound series of *Characteristic Sketches of the Lower Orders*
Accession Number: Rare Book 132503

418. GREAT NEWS
Pen and watercolor, 4¾" x 2⅞"
Inscribed in Rowlandson's hand: Glorius news
 for Old England
Engraved in reverse: 1820 in *Characteristic
 Sketches of the Lower Orders*
Collections: Sir William Augustus Fraser
Acquired: before 1930 in a bound series of *Char-
 acteristic Sketches of the Lower Orders*
Accession Number: Rare Book 132503

419. BUY MY IMAGE
Pen and watercolor, 4¼" x 3"
Inscribed in Rowlandson's hand: Buy my image
Engraved in reverse: 1820 in *Characteristic
 Sketches of the Lower Orders*
Collections: Sir William Augustus Fraser
Acquired: before 1930 in a bound series of *Char-
 acteristic Sketches of the Lower Orders*
Accession Number: Rare Book 132503

420. MENAGERIE
Pen and watercolor, 4⅝" x 3"
Inscribed: [there is an illegible pencil inscrip-
 tion on the sign in the background]
Engraved in reverse: 1820 in *Characteristic
 Sketches of the Lower Orders*
Collections: Sir William Augustus Fraser
Acquired: before 1930 in a bound series of *Char-
 acteristic Sketches of the Lower Orders*
Accession Number: Rare Book 132503

421. MILK
Pen and watercolor, 4¼" x 2⅞"
Engraved: 1820 in *Characteristic Sketches of the
 Lower Orders*
Collections: Sir Wiilliam Augustus Fraser
Acquired: before 1930 in a bound series of *Char-
 acteristic Sketches of the Lower Orders*
Accession Number: Rare Book 132503

NOTES: In the drawing the male figure is a negro,
but not clearly so in the print.

422. POSTMAN
Pen and watercolor, 4½" x 2¾"
Inscribed in Rowlandson's hand: Postman
Engraved in reverse: 1820 in *Characteristic
 Sketches of the Lower Orders*
Collections: Sir William Augustus Fraser
Acquired: before 1930 in a bound series of *Char-
 acteristic Sketches of the Lower Orders*
Accession Number: Rare Book 132503

423. THE BUTCHER
Pen and watercolor over pencil, unfinished, 5"
 x 3½"
Engraved in reverse: 1820 in *Characteristic
 Sketches of the Lower Orders*
Acquired: ca. 1910
Accession Number: Sessler 140 b

424. THE KNIFE GRINDER
Pen over pencil, 4⅝" x 3½", tear on right
 margin
Watermark: [1]816
Engraved in reverse: 1820 in *Characteristic
 Sketches of the Lower Orders*
Acquired: ca. 1910
Accession Number: Sessler 82 a

425. A MAN WITH DEAD RABBITS (?)
Pen and watercolor over pencil, 6⅞" x 5½"
Acquired: ca. 1910
Accession Number: Sessler 139

NOTES: This and the two following drawings are
thematically and stylistically related. They may
have some connections with *Characteristic Sketches
of the Lower Orders* (1820) although the pen work
of all the drawings appears earlier in date, closer
to 1810.

426. A CANDLE MAKER
Pen, touch of watercolor, over pencil, un-
 finished, 6⅞" x 5⅛"
Acquired: ca. 1910
Accession Number: Sessler 152

NOTES: See under No. 425

427. THE SHEEP SHEARER
Pen and watercolor over pencil, 6⅞″ x 5″
Inscribed in Rowlandson's hand: The Sheep
 Shearer
Acquired: ca. 1910
Accession Number: Sessler 154

NOTES: See under No. 425

428. FIREMEN
Pen and gray wash over pencil, unfinished, 5¾″
 x 4½″
Verso: slight pencil sketch of a woman
Acquired: ca. 1910
Accession Number: Sessler 6 a

NOTES: The same subject, but a different composi-
tion, appears in *Characteristic Sketches of the Low-
er Orders* (1820).

429. BAKERS
Pen with some gray wash over pencil, 8⅜″ x
 8⅛″, lower right corner torn
Verso: pencil sketch for *The Apparition*
Acquired: ca. 1910
Accession Number: Sessler 96

NOTES: The subject is related to *Characteristic
Sketches of the Lower Orders*, but the technique
and format are different from other drawings defi-
nitely for that series.
 The sketch on the verso is closely related to a
drawing called *The Apparition* reproduced in
Grego II, 418 and listed by him as in the collection
of W. T. B. Ashley. Grego gives no date or other
information concerning the drawing.

430. THE WATERMAN (?)
Pen and brown wash, 3¼″ x 5½″
Acquired: ca. 1910
Accession Number: Sessler 133a

431. THE GRINDER
Pen and gray wash, 4⅛″ x 4⅝″
Acquired: ca. 1910
Accession Number: Sessler 133b

NOTES: The sketch has a general relation to No.
424, for *Grinder* in *Characteristic Sketches of the
Lower Orders*, but the connection is not close
enough to call this drawing a version of the other.

432. CARPENTERS
Pen and gray wash over pencil, 3½″ x 5⅝″
Acquired: ca. 1910
Accession Number: Sessler 133 c

433. THE CORONATION PROCESSION
 of GEORGE IV (?)
Pen over pencil, 4⅜″ x 7⅛″, torn along left
 margin and in lower right corner
Verso: slight pencil sketch of buildings
Acquired: ca. 1910
Accession Number: Sessler 121 b

NOTES: The identification suggested is uncertain
but probable. Many pavilions and covered passages
were erected in the vicinity of Westminster Abbey
for the coronation, which took place on July 19,
1821. See George Nayler, *The Coronation of King
George IV* (London, 1837). The technique of the
drawing is in accord with a date about 1820.

434. A PRISONER AT AVIGNON
Pen and watercolor over pencil, 4½″ x 7⅛″
Acquired: ca. 1910
Accession Number: Sessler 95 a

NOTES: The drawing is related to a print entitled
A Prisoner at Avignon published by Ackermann in
*Journal of Sentimental Travels in the Southern
Provinces of France*, 1821. The print is the reverse
of the drawing. There are too many differences in
detail for the drawing to be regarded as immedi-
ately connected with the print, but the subject is
unquestionably the same.

**435. ANGERSTEIN'S HOUSE AT BLACK-
 HEATH**
Pen over pencil, 3¾″ x 6¼″, two corners torn
Watermark: 1819
Inscribed in Rowlandson's hand: [pencil] An-
 gersteen/ [ink] Woodland House Anger-
 steens Greenwich

Verso: slight pencil sketch of two men on horse-back
Acquired: ca. 1910
Accession Number: Sessler 52 a

NOTES: This appears to be one of a large number of more or less topographical drawings which Rowlandson made late in life (ca. 1820) and which are concerned with towns in the environs of London, with emphasis on the area to the east, around Greenwich. The long inscriptions on many of the drawings suggest that the series was intended for publication. Although buildings often are prominent in the drawings, many of the sketches are of figure groups that have no immediately apparent connection with the notes on various towns that are appended to them.

Drawings for this series are scattered. The principal group thus far located is in the Sessler album at the Huntington. There is also a substantial group in the Dent scrapbook (photos in the Witt Library).

John Julius Angerstein (1735-1823) was a merchant, philanthropist, and collector. His picture collection became the nucleus of the National Gallery, London. He owned a villa called Woodlands at Blackheath near Greenwich.

436. A PROCESSION, AND A ROUND, THATCHED BUILDING
Pen over pencil, 5⅞″ x 3⅜″, lower corners torn
Watermark: 1819
Acquired: ca. 1910
Accession Number: Sessler 156a

NOTES: The date, technique, and type of subject suggest that this drawing belongs with the "Environs of London" series (see under No. 435). Another version of the bottom part is in the Dent scrapbook (photo Witt Library), but that is also lacking any identifying inscription.

437. A MAN AND WOMAN LOADING A CART
Pen and watercolor over pencil, 3⅜″ x 4⅛″
Acquired: ca. 1910
Accession Number: Sessler 140 a

NOTES: The drawing is connected with the "Environs of London" series (see No. 435). Another version appears on the verso of No. 449, but that drawing is also lacking any identifying inscription.

438. DOVE HOUSE, CHARLTON
Pen and gray wash over pencil, 6⅛″ x 3⅞″, corners torn
Inscribed in Rowlandson's hand: Lad[...]lson's Dove House Charlton.
[two undecipherable words in pencil at top]
Acquired: ca. 1910
Accession Number: Sessler 82b

NOTES: One of the "Environs of London" drawings (see No. 435). Charlton is a hamlet in southwest Middlesex, three miles southeast of Staines.

Another version of this drawing, without inscription, is in the Dent scrapbook (photo Witt Library).

439. ST ALFEGE'S, GREENWICH
Pen over pencil, 6¼″ x 3¾″
Inscribed in Rowlandson's hand: Rebuilt by the Commissioners for erecting the fifty New Churches/ is dedicated to Alphage, Archbishop of Canterbury, said to have/ been slain on that spot—/ Greenwich Church—
Acquired: ca. 1910
Accession Number: Sessler 82 c

NOTES: One of the "Environs of London" drawings (see No. 435). Another version of this drawing is in the Dent album (photo Witt Library). That drawing has a longer inscription that includes the information on the Huntington drawing and some additional data about the Duke of Norfolk's College and Queen Elizabeth College in Greenwich.

440. A GROUP OF PENSIONERS
Pen, 3⅛″ x 3½″
Watermark: 1819
Verso: pen and watercolor sketch of a woman seated on an ox with side baskets, followed by a man
Acquired: ca. 1910
Accession Number: Sessler 85 a

NOTES: The sketches on both recto and verso may be connected with the "Environs of London" series. See under No. 435. Another version of the recto is in the Dent scrapbook (photo Witt Library). Another version of the verso is in one of the British Museum scrapbooks (201 A 11). Neither drawing has any inscription.

441. HORNSEY
Pen and watercolor, 5⅞″ x 3¾″

Inscribed in Rowlandson's hand: Hornsey. a Village in Middlesex. 5 Miles in the footway/ from this village to Highbury Barn. at Islington is a coppice of/ young Trees called Hornsey Wood. at the entrance of which is a/ public House to which great numbers of persons resort from the/ city. This House being situated on the top of an eminence/ affords a delightful prospect of the neighboring country./ The New River winds beautifully through Hornsey.

Verso: Drawing in pen and watercolor over pencil of a tradesman delivering some produce from a hand wagon. Inscribed: Blackheath/ A fine elevated heath in the parishes of Greenwich/ Lewisham, & Lee. commands some noble prospects/ particularly from that part called 'the point' which/ is a delightful lawn, situated behind a pleasant/ grove at the west end of Chocolate Row—/ On this heath are the villas of Rᵈ. Halse, Esq. the Duke/ of Buccleugh. Lord Latham, the Earl of Dartmouth & Capt. Larkin

Acquired: ca. 1910
Accession Number: Sessler 85 b

NOTES: For "Environs of London" series (see No. 435).

Another version, without inscription, of the drawing on the recto is in the Dent scrapbook (photo Witt Library).

442. VANBRUGH CASTLE
Pen and watercolor over pencil, 6″ x 3¾″
Acquired: ca. 1910
Accession Number: Sessler 142

NOTES: For the "Environs of London" series (see No. 435).

Vanbrugh Castle, built by the architect, Sir John Vanbrugh, overlooks Greenwich Park. Another version of this drawing, horizontal in orientation, is in the Dent scrapbook (photo Witt Library).

443. STREET SCENE
Pen and watercolor over pencil, 5⅜″ x 3⅞″
Acquired: ca. 1910
Accession Number: Sessler 80 a

NOTES: Probably for the "Environs of London" series (see No. 435). What appear to be boats on the left side of the picture suggest the scene is in a dock area.

444. BLACKHEATH AND WOOLWICH DOCK YARD (two scenes on one sheet)
Pen and touches of wash over pencil, 6⅛″ x 3⅞″
Inscribed in Rowlandson's hand: [top] Blakheath [sic]/[bottom] Woolwich Dock Yard
Acquired: ca. 1910
Accession Number: Sessler 80 b

NOTES: For the "Environs of London" series (see No. 435).

Another version of the lower part of the drawing is in the Dent scrapbook (photo Witt Library).

445. VANS FROM GREENWICH
Pen over pencil, 3″ x 3¾″, upper right corner torn
Inscribed in Rowlandson's hand: Vans from Greenwich to Woolwich four Miles set out every half hour Price 6.
Acquired: ca. 1910
Accession Number: Sessler 90 a

NOTES: For the "Environs of London" series (see No. 435). Another version of the drawing, with the same inscription and the buildings in the background more fully developed, is in the Dent scrapbook (photo Witt Library).

446. HAMPSTEAD AND KENSINGTON (two sketches on one sheet)
Pen over pencil, 7⅞″ x 4⅞″

Inscribed in Rowlandson's hand: [top] Hampstead. a Village in Middlesex on the declivity of a fine hill/ 4 Miles from London. on the summit of this hill is a heath adorned/ with many gentlemens houses—and affording an extensive prospect/ over the city. and into the counties around—

[bottom] Kensington. a populous village in Middlesex one Mile & a half/ from Hyde Park Corner. part of which from the palace gate to the Bell is in/ the parish of St. Margaret Westminster—

Acquired: ca. 1910
Accession Number: Sessler 90 b

NOTES: For the "Environs of London" series (see No. 435).

Other versions of both drawings, lacking the inscriptions, are in the Dent scrapbook (photos Witt Library). One of the Dent drawings is on paper watermarked 1823.

Daniel Lysons in *The Environs of London* (London 1811), II 499 also comments on the fact that part of Kensington is in the parish of St. Margaret Westminster: "The palace at Kensington, and about 20 houses on the north side of the road, are in the parish of St. Margaret, Westminster. On the south side, the parish of Kensington extends till after you pass the Gore."

447. GENRE SCENE AND COVERED WAGON (two drawings on one sheet)
Pen over pencil, 5⅞" x 3⅞"
Acquired: ca. 1910
Accession Number: Sessler 151 a

NOTES: For the "Environs of London" series (see No. 435).

Other versions of both drawings are in the Dent scrapbook (photos Witt Library). That related to the top scene has no inscription. That related to the bottom is inscribed: Edmonton a village in Middesex [sic] 7 Miles in the road to Wave— See Bush hill.

448. GREENHITHE
Pen and watercolor over pencil, 6⅛" x 3½", upper corners torn

Inscribed in Rowlandson's hand: Greehithe [sic] [Greenh]ithe in Kent a hamlet of Swanscomb/on the Thames has a horse ferry to West Thurrock in Essex/. Great quantities of lime are conveyed hence to London/ for building & not only the farmers on the Essex coast/ but coasting vessels also from different parts of the/ kingdom frequently take in here a freight of Chalk/. Extraneous fossils are often found imbedded in the chalk

Verso: two pen and watercolor sketches, upper of boating; lower a version of the covered cart on No. 447 (lower)

Acquired: ca. 1910
Accession Number: Sessler 89 a

NOTES: For the "Environs of London" series (see No. 435).

449. DEPTFORD
Pen and watercolor over pencil, 6" x 3⅞"

Inscribed in Rowlandson's hand: Depford [sic] anciently called West Greenwich/ a large town in Kent 3½. It is remarkable for its/ noble Dock in which a great number of hands is employed.

Verso: two pen sketches over pencil: top, a man and two women with a wheel barrow; bottom, a man and woman with a market cart (a version of No. 437)

Acquired: ca. 1910
Accession Number: Sessler 89 b

NOTES: For the "Environs of London" series (see No. 435).

450. BLACKWALL
Pen and watercolor over pencil, 6⅛" x 3¾"

Inscribed: Blackwall/ in Middlesex between Poplar [?] and the mouth of/ the river Lee is remarkable for the Ship yard &/ wet dock of Jms [?] Perry Esq. The Dock, which/ is the most considerable private one in Europe/ contains with the water and embankments/ near 19 acres. It can receive [?] 28 Large East/ Indiamen & from 50 to 60 ships of smaller beam (?).

Acquired: ca. 1910
Accession Number: Sessler 89 c

Notes: One of the "Environs of London" series (see No. 435).

451. CHISLEHURST

Pen and watercolor over pencil, 6⅛″ x 3¾″

Inscribed in Rowlandson's hand: Chislehurst a Village near Bromley in Kent 11¼ Miles/ from London where the celebrated Camden composed the/ principle [sic] part of his Annals of Queen Elizabeth. This was the/ birth place of Sir Nicholas Bacon, Lord Keeper in that reign, and/ father of the great Viscount St Albans, and here also was born/ the famous Sir Francis Walsingham. In this Parish near St Marg[?] is Frognall the seat of Viscount Sydney and opposite/ Bertie Place are the Villa & Park of Mr Twycross.

Acquired: ca. 1910
Accession Number: Sessler 78 a

Notes: Another version of this drawing with the same inscription is in one of the British Museum Rowlandson scrapbooks (201 A 11). Probably for the "Environs of London" series (see No. 435).

452. FARMER GILLETT OF BRIZE-NOR-TON

Pen and watercolor, 3⅝″ x 6½″, lower left corner torn

Acquired: ca. 1910
Accession Number: Sessler 78 b

Notes: Another version of this drawing, differing in some details, is in one of the British Museum Rowlandson scrapbooks (201 A 11). That drawing is inscribed: Farmer Gillett of Brize Norton.

Although the drawing is contemporary with the "Environs of London" series, the fact that Brize-Norton is near Oxford rules out any connection with the series.

453. WATTON WOOD HALL

Pen and brown wash over pencil, 5″ x 3¾″

Inscribed in Rowlandson's hand: Watton Wood Hall an elegant seat 5 Miles from/ Hertford

built by Sir Thos. Rumbold Bart. The Park is/ planted with great taste and a beautiful rivulet/ called the rib[?] which runs through it is formed into a/ spacious canal with islands for the haunts of Swans/ This estate was sold in 1792. to Sir H. G. Calthorpe Bart.

Acquired: ca. 1910
Accession Number: Sessler 83 a

Notes: The place is rather remote for the "Environs of London," but the drawing appears to belong to that series (see No. 435). Another version of the drawing with the same inscription is in the Dent scrapbook (photo Witt Library).

454. RAINHAM

Pen over pencil, 5½″ x 4¾″, right corners torn

Inscribed in Rowlandson's hand: Rainham a village in Essex 15 Miles from London and 1 from the Thames/ where there is a ferry to Erith. the road hence to Purfleet commands an extensive/ View of the Thames & the Marshes—which are uncommonly fine [torn]/ and one covered with a prodigious numbers of cattle.

Acquired: ca. 1910
Accession Number: Sessler 83 b

Notes: Probably connected with the "Environs of London" series (see under No. 435).

455. A SHIPYARD

Pen and watercolor over pencil, 3¼″ x 5¾″
Watermark: 1819
Acquired: ca. 1910
Accession Number: Sessler 137 a

Notes: The date and the motif suggest that the drawing may be connected with the "Environs of London" series (see under No. 435).

456. A WEAVER

Pen over pencil, 5⅛″ x 3¾″, corners torn
Inscribed in what appears to be Rowlandson's hand: A Weaver
Acquired: ca. 1910
Accession Number: Sessler 137 b

NOTES: Apparently from a series Rowlandson was contemplating on oriental craftsmen or occupations (see also No. 457).

457. A MAN STANDING IN FRONT OF ORIENTAL BUILDINGS
Pen over pencil, 4⅞" x 3¾", right corners cut
Acquired: ca. 1910
Accession Number: Sessler 121 a

NOTES: The drawing is related to No. 456, entitled *A Weaver.* A third related drawing, with watercolor, showing a dark-skinned man carrying a net, is in one of the British Museum Rowlandson scrapbooks (201 A 11). All three drawings represent men in loose, vaguely oriental robes in vaguely oriental settings. They suggest that Rowlandson may have had in mind a series of illustrations on oriental (Indian?) crafts and trades.

458. AH ROGER!
Pen and watercolor over pencil, 7 11/16" x 6"
Inscribed in Rowlandson's hand: [top] Ah Roger, you consider only the pleasure/ But I foresee the disagreable consequences. [bottom] You look only at the bait/ Without perceiving the hook.
Collections: Albert M. Weil
Acquired: 1970, bequest of Albert M. Weil
Accession Number: 70.32

NOTES: A weak but seemingly authentic drawing, probably from the 1820s.

459. THE DOCTORS PUZZLED
Pen over pencil, 9¼" x 7½"
Watermark: 182[5?]
Literature: W. H. Harrison, *The Humorist* (London, 1831), facing p. 13, there entitled *The Doctors Puzzled*
Acquired: ca. 1910
Accession Number: Sessler 2

NOTES: The pen work is thicker and more flexible than normal for Rowlandson in the 1820s.

460. A SCHOOLMASTER AND HIS PUPIL STUDYING A TOMB
Pen over pencil, unfinished; 4⅞" x 6⅝"
Watermark: 182[?]
Acquired: ca. 1910
Accession Number: Sessler 158

NOTES: Another version with much freer pen work is illustrated in Hayes, Pl. 117, dated by him ca. 1800-05. A third version is in the Wiggin Collection of the Boston Public Library (No. 213). The draftsmanship in the Huntington drawing is in accord with the watermark date.

461. STREET SCENE IN ITALY
Pen and wash over pencil, unfinished, 5¼" x 8"
Inscribed in pencil in Rowlandson's hand on the cloak of the man in the foreground: Red
Acquired: ca. 1910
Accession Number: Sessler 93 b

NOTES: The men's cloaks and the muff indicate with little doubt that the scene is meant to be in Italy. The dates of Rowlandson's trips to Italy remain uncertain. There is a drawing in the Ashmolean Museum with an inscription that implies Rowlandson was in Italy in 1782 (Hayes, Fig. 3). The scrapbook in the Victoria and Albert Museum indicates that he was probably there again in the 1820s (Hayes, p. 62 n.52). The technique of the Huntington drawing suggests a late date.

462. QUAE GENUS AT OXFORD
Pen and watercolor over pencil, unfinished, 4" x 4⅞"
Engraved: 1822 as *Quae Genus at Oxford* in *The History of Johnny Quae Genus* (this particular print bears the publication date 1821)
Acquired: ca. 1910
Accession Number: Sessler 93 a

463. QUAE GENUS IN SEARCH OF SERVICE
Pen and watercolor over pencil, unfinished, 5⅝" x 8⅞"

Watermark: 1818

Inscribed: [There are numerous inscriptions in pen and pencil on signs attached to the walls. All the signs are "employment wanted" ads appropriate to a Registry Office]

Engraved: 1822 as *Quae Genus in Search of Service* in *The History of Johnny Quae Genus*

Accession Number: Sessler a

NOTES: The provenance and acquisition date of this drawing are not known. It was found loosely inserted in the Sessler album, but was not originally part of it.

464. EIGHT AGES OF WOMEN AND SIX PHYSIOGNOMIC STUDIES

Pen, 8⅞" x 7⅛"

Inscribed in Rowlandson's hand under the six male heads: The Busybody/ The Ostentatious/ The Suspicious/ The Penurious/ The Plausible/ The Detractor

Verso: the skull has been traced through in pencil

Literature: Paulson, p. 94, Pl. 33 (reproduces only *Eight Ages of Women*)

Collections: Gilbert Davis

Acquired: 1959

Accession Number: 59.55.1087

NOTES: The drawing began as a counterproof but has been fully inked over. The inscriptions from the original drawing are still legible in reverse.

The page is part of a series of physiognomic studies that Rowlandson produced in quantity in the early 1820s. The studies are widely scattered in public and private collections, but there are two substantial groups in the British Museum (see Laurence Binyon, *Catalogue of Drawings by British Artists* . . . [London, 1902] III, 260-63) and the Houghton Library, Harvard. The latter group is in an album entitled, *Comparative Anatomy/ Resemblances between the Countenances of Men and Beasts.* Several pages in this album have an 1821 watermark.

The bottom two rows of drawings on the Huntington sheet reappear in both the British Museum

and Houghton Albums, facing in the same direction. There are several sequences of heads in the Houghton album similar to the *Eight Ages of Women*, but none precisely the same.

The sources of inspiration behind these drawings are Giovanni della Porta's *De Humana Physiognomonia* (1586), Charles Lebrun's *Méthode pour apprendre à dessiner les passions* (1667), and the physiognomic theories of J. C. Lavater. The topic was of great interest in Rowlandson's day. See also Rowlandson's drawing for a frontispiece to G. A. Stevens' satiric *Lecture on Heads* (No. 194).

465. COMPARATIVE ANATOMY AND JUG DESIGNS

Pen over pencil, 8½" x 7"

Literature: Paulson, pp. 33-34, 36, 45, 67, Pl. 32 (reproduces top half of sheet only)

Collections: Gilbert Davis

Acquired: 1959

Accession Number: 59.55.1086

NOTES: See under *Eight Ages of Women* (No. 464)

The top row reappears twice in the Houghton album (folios 36 and 46), twice in the British Museum album (folios 38 and 47), at the Princeton Art Museum (48.1667).

No other versions of the jug designs have been located, and indeed these are quite different in character and intention from the physiognomic studies, being more in the nature of grotesque drolleries. They are outside Rowlandson's normal range of invention and it is probable he is taking inspiration from some yet-to-be identified source.

466. THREE PHYSIOGNOMIC STUDIES

Pen over pencil, 8½" x 6"

Watermark: 1822

Acquired: ca. 1910

Accession Number: Sessler 7

NOTES: Both the date and the subject matter indicate that this sheet belongs with the large number of physiognomic studies Rowlandson produced in the early 1820s (see under No. 464). No other versions of the drawings on this sheet have been located.

467. MARCUS AURELIUS, AFTER THE ANTIQUE

Pen over pencil, 6¾″ x 3¾″
Watermark: [18]20
Acquired: ca. 1910
Accession Number: Sessler 36 b

NOTES: This is one of a large number of drawings by Rowlandson after classical antiquities. Several such drawings are in the Rowlandson scrapbooks in the British Museum and Victoria and Albert Museum. The paper of the V and A scrapbook is watermarked 1820. Another volume of similar drawings was sold at Christie's July 25, 1938, lot 45.

Most of the drawings appear to be copied from engravings rather than from the actual objects. A principal source was apparently *Les Monumens Antiques du Musée Napoléon*, with engravings by Thomas Piroli and text by J. C. Schweighauser (1804). Rowlandson's reason for producing these drawings remains a mystery.

The ultimate source for the drawing of Marcus Aurelius is a statue of which a version is illustrated in Salomon Reinach *Répertoire de la Statuaire Grecque et Romaine*, Paris, ed. 1920, I, 592. Another version of this drawing is in one of the British Museum Rowlandson scrapbooks (201 A 14), inscribed in Rowlandson's hand: Roman Emperor.

468. LIVIA, AFTER THE ANTIQUE

Pen over pencil, 6¾″ x 3¾″
Acquired: ca. 1910
Accession Number: Sessler 36 c

NOTES: See under No. 467

The ultimate source for this drawing is a statue of Livia, of which a version is illustrated in Reinach I, 159.

469. PEASANT DISEMBOWELING A DEER, AFTER THE ANTIQUE

Pen over pencil, 6⅛″ x 3⅞″
Inscribed, probably by Rowlandson: Paysan ecorchant un dain
Acquired: ca. 1910
Accession Number: Sessler 43 a

NOTES: See under No. 467

The ultimate source for the design is a sculpture in the Louvre; see Reinach I, 145. The immediate source was probably Pl. 34 in Vol. 4 of *Les Monumens Antiques du Musée Napoléon*.

470. TWO RUNNING FIGURES, AFTER THE ANTIQUE

Pen and gray wash over pencil, 4¼″ x 6½″
Watermark: 18[?]
Acquired: ca. 1910
Accession Number: Sessler 37 a

NOTES: See under No. 467

Another version of this drawing is in the Victoria and Albert Rowlandson scrapbook, p. 7.

The antique source for the motif has not yet been located.

471. THREE CLASSICAL VASES

Pen over pencil, unfinished, 3⅛″ x 5¾″
Collections: Charles Sessler
Acquired: ca. 1910
Accession Number: Sessler 46 a

NOTES: What appears to be a reworked counterproof from this sheet is in the Victoria and Albert Museum Rowlandson scrapbook.

Probably the drawing is derived from a print, but the source has not been located.

472. ELDERLY MAN IN A TOGA

Pen and gray wash over pencil, 6⅞″ x 4⅞″
Verso: pencil sketch of a wheel
Acquired: ca. 1910
Accession Number: Sessler 41 a

NOTES: This drawing is freer than Nos. 467-70, and gives less the impression of a direct copy from a print. No precise source has been located for the design.

473. MAN SEATED WITH HIS HEAD ON HIS ARM

Pen with gray wash over pencil, some color on face and arm, 4½″ x 3⅝″
Acquired: ca. 1910
Accession Number: Sessler 41 b

NOTES: The loose garment suggests that this may be one of Rowlandson's classical studies, although no classical source has been located.

474. ELDERLY MAN SEATED WASHING HIS FEET

Pen and gray wash over pencil, 4½" x 3¾"
Acquired: ca. 1910
Accession Number: Sessler 31 c

NOTES: The costume and general character of the motif suggest that this is one of Rowlandson's studies after the antique, but no definite source has been located.

475. TWO WOMEN CARRYING BAS-KETS

Pen and gray wash over pencil, 6⅛" x 4⅛"
Acquired: ca. 1910
Accession Number: Sessler 138 a

NOTES: Another version of this drawing, likewise without watercolor, is in the British Museum (L.B. 35 a).

476. LEAPING A FIVE-BARRED GATE

Pen and watercolor over pencil, 5⅞" x 9⅝"
Inscribed, not in Rowlandson's hand: Leaping a 5 Barred Gate
Acquired: ca. 1910
Accession Number: Sessler 23 b

NOTES: Another version of this drawing, larger in scale, is in the collection of Augustus Loring (No. 30).

477. DR. SYNTAX AND THE SKIMMING-TON RIDERS

Pen, 2⅞" x 4¼", corners torn
Verso: some arithmetic calculations
Engraved: 1823 (for the miniature edition of the Tours of Dr Syntax)
Literature: Gully, catalogue number 38
Acquired: ca. 1910
Accession Number: Sessler 153 a

NOTES: This design first appeared on August, 1820 in *The Second Tour of Dr. Syntax, In Search of Consolation*, but the scale of the Huntington drawing suggests that it is connected with the later miniature edition of 1823.

478. THE BAND (1)

Pen (gray and red ink) over pencil, 5" x 7"
Watermark: 1826
Literature: Bury, Pl. 56; Wark, *Tour*, p. 20 and Fig. 4; Hayes, p. 26 and Fig. 15
Exhibited: Arts Council (1950) No. 116
Collections: Gilbert Davis
Acquired: 1959, gift of the Friends
Accession Number: 59.55.1089

NOTES: One of several versions of this drawing. There is another in the Huntington collection (No. 479), and a third was in the Hay sale, Sotheby's, November 18, 1953, lot 10.

The drawing is an excellent example, unencumbered by watercolor or reinforcing penwork, of the thin, wiry pen line used by Rowlandson as the foundation for his late drawings.

479. THE BAND (2)

Pen over pencil, unfinished, 4¾" x 6½"
Acquired: ca. 1910
Accession Number: Sessler 6 b

NOTES: See under No. 478

This drawing and the preceding are related as tracings. As No. 478 is more finished, it probably precedes.

480. MME CULLONI AND M. RENAULT, GRAND ASSAULT, PARIS

Pen over pencil, unfinished, 4¾" x 7"
Acquired: ca. 1910
Accession Number: Sessler 136 b

NOTES: Another version of this drawing was with Sabin in 1933 (No. 42). That drawing carries an inscription in Rowlandson's hand: Madame Culloni and Mons. Renault, Grand Assault, Paris. The same subject but a different composition was with Sabin in 1948 (No. 7). It appears probable that the draw-

ings represent an actual contest, but no record of it or the two combatants has been located.

Rowlandson's friendship with the fencing master, Angelo, provides a basis for his interest in fencing.

481. THE CARICATURE PORTFOLIO
Pen and pencil, unfinished, 4¾" x 6⅜"
Acquired: ca. 1910
Accession Number: Sessler 159 a

NOTES: A more fully worked out version of this design is in one of the British Museum Rowlandson scrapbooks (201 A11) and is inscribed: The Caricature Port Folio. The design is an interesting indication of one way in which caricatures were collected and used for entertainment.

The technique of the drawing suggests a date in the early 1820s.

482. TAKING UP NEW LODGINGS
Pen over pencil, unfinished, 4⅞" x 7"
Watermark: 1826
Acquired: ca. 1910
Accession Number: Sessler 159 b

NOTES: The pen line is of the type normally used by Rowlandson in late repetitions of his drawings. No other version of this design has been located as yet.

483. THE DEAD HORSE
Pen over pencil, unfinished, 4⅜" x 6½"
Acquired: ca. 1910
Accession Number: Sessler 12 a

NOTES: A completed version of this drawing entitled *The Dead Horse* was at one time in the Lowinsky Collection (photo in the Witt Library).

The pen work suggests a date about 1820 for the Huntington drawing.

484. THE DEAD DOG
Pen and gray wash over pencil, 4½" x 6½"
Acquired: ca. 1910
Accession Number: Sessler 12 b

NOTES: Another version of this drawing, likewise not fully worked out, is in the Wiggin Collection (No. 109) at the Boston Public Library.

485. A POT MENDER
Pen over pencil, 4¾" x 7"
Acquired: ca. 1910
Accession Number: 151 b

NOTES: Thematically the drawing is related to *Characteristic Sketches of the Lower Orders*, but it follows a different format, and the pen work suggests a late date ca. 1825.

486. TWO MEN WATCHING THREE MEN DIGGING
Pen over pencil, unfinished, 4¼" x 7"
Watermark: [18]25
Acquired: ca. 1910
Accession Number: Sessler 155 a

487. STABLE SCENE WITH EMBRACING COUPLE, TWO HORSES, AND TWO DOGS
Pen over pencil, some gray wash, 4⅛" x 6⅞"
Acquired: ca. 1910
Accession Number: Sessler 132 b

488. THE POACHER ARRESTED
Pen over pencil, unfinished, 4¾" x 6¾"
Watermark: 182[?]
Acquired: ca. 1910
Accession Number: Sessler 141 a

NOTES: A fully worked out version of the drawing is in the Wiggin Collection at the Boston Public Library (No. 152).

489. BAILIFFS OUTWITTED
Pen over pencil, unfinished, 5" x 7"
Acquired: ca. 1910
Accession Number: Sessler 141 b

NOTES: A more fully worked out version, much freer in technique, is in one of the British Museum

Rowlandson scrapbooks (201 A12). Another version is in 201 A11. Both are inscribed: Bailiffs outwitted.

490. HOW TO GET RID OF A TROUBLESOME CUSTOMER
Pen over pencil, unfinished, 4¾″ x 6⅞″
Acquired: ca. 1910
Accession Number: Sessler 126 a

NOTES: A fully worked out pen and watercolor version of this composition is in the Wiggin Collection at the Boston Public Library, No. 106, inscribed in Rowlandson's hand: How to get rid of a troublesome customer.

491. AN OLD HAG WITH A BROOM
Pen and watercolor over pencil, unfinished,
 5¼″ x 8¼″
Acquired: ca. 1910
Accession Number: Sessler 106 a

NOTES: A related subject, in reverse and with many minor variations, is in one of the British Museum Rowlandson scrapbooks (201 A 11).

492. A FAT MAN IN A STUPOR
Pen over pencil, unfinished, 6¼″ x 7½″
Acquired: ca. 1910
Accession Number: Sessler 119 b

NOTES: The unfinished pencil part of the drawing appears to consist of an embracing couple, the woman pouring the contents of a cup into the mouth of the recumbent fat man.

There is a generally related print in the Wilmarth Lewis Collection with the inscription: I shall never overcome the loss of my dear husband/ Pray be comforted Dear Madam

493. A STATUARY YARD
Pen over pencil, unfinished, 4⅜″ x 7″
Acquired: ca. 1910
Accession Number: Sessler 155 b

NOTES: This theme occurs frequently in Rowlandson drawings. There is a similar subject in the

Ashmolean Museum and in one of the plates in *Naples and the Campagna Felice* (1815). But no other version of the Huntington drawing has been located.

494. WINDY DAY AT TEMPLE BAR (1)
Pen and watercolor over pencil, 4″ x 6½″
Watermark: 1818
Acquired: ca. 1910
Accession Number: Sessler 87 b

NOTES: A fully developed drawing of this subject, with many minor changes but basically the same composition, is in the Fitzwilliam Museum, Cambridge, and is there entitled *Windy Day at Temple Bar*.

495. A WINDY DAY AT TEMPLE BAR (2)
Pen and wash over pencil, 4⅜″ x 7″
Acquired: ca. 1910
Accession Number: Sessler 8 b

NOTES: See under No. 494

496. A WINDY DAY AT TEMPLE BAR (3)
Pen and some watercolor over pencil, unfinished, 4¼″ x 6⅜″
Acquired: ca. 1910
Accession Number: Sessler 138 b

NOTES: See under No. 494

497. BLEEDING A FAT WOMAN
Pen and watercolor, unfinished, 4⅜″ x 6⅞″
Acquired: ca. 1910
Accession Number: Sessler 97 a

498. A TERRIFIED MAN
Pen over pencil, unfinished, 3¼″ x 4¾″
Acquired: ca. 1910
Accession Number: Sessler 145 a

NOTES: The figure is close to, but not identical with, that of the Highwayman in *Death and the Highwayman* (see Wark, *Dance of Death*, No. 89). The pen work on the Huntington sheet suggests a date about 1820.

499. A BALLOON ASCENT (?)
Pen over pencil, unfinished, 5⅜″ x 6¾″
Acquired: ca. 1910
Accession Number: Sessler 8 a

NOTES: The subject is not clear, but the confusion appears to be occasioned by a balloon, sketched in pencil in the sky.

The physical size and character of the drawing suggest a connection with some of Rowlandson's book illustrations, but no related print has been located.

500. A COUPLE IN A BOAT
Pen over pencil, 3¼″ x 4⅜″
Inscribed in Rowlandson's hand: Fashionable
 Pursuits
Acquired: ca. 1910
Accession Number: Sessler 124 a

501. A HAPPY COUPLE
Pen over pencil, unfinished, 5⅞″ x 4⅞″
Acquired: ca. 1910
Accession Number: Sessler 124 b

502. COMBING HAIR
Pen over pencil, watercolor on the man's face,
 unfinished, 4¼″ x 6⅝″
Acquired: ca. 1910
Accession Number: Sessler 149 a

NOTES: A more fully worked out watercolor of this composition is in one of the British Museum Rowlandson scrapbooks (201 R12).

503. HERE'S A PRETTY KETTLE OF FISH
Pen over pencil, unfinished, 4⅜″ x 7″
Inscribed in Rowlandson's hand: Here's a pretty
 kettle of fish
Acquired: ca. 1910
Accession Number: Sessler 149 b

504. FIGURE SKETCH
Pen over pencil, unfinished, 4⅝″ x 6⅝″
Acquired: ca. 1910
Accession Number: Sessler 123 a

505. INSPECTING A CABRIOLET
Pen over pencil, unfinished, 4⅞″ x 6⅞″
Acquired: ca. 1910
Accession Number: Sessler 123 b

506. THE MISERIES OF INTRIGUING
Pen over pencil, unfinished, 4⅛″ x 6¾″
Engraved: see Notes
Acquired: ca. 1910
Accession Number: Sessler 143 a

NOTES: A print closely related to this drawing, entitled *The Miseries of Intriguing* and identified as an illustration for Smollett's *Count Fathom*, Ch. 13, p. 61, is included in the volume *Humorous Illustrations to the Works of Fielding and Smollett by Rowlandson*, published by Doig Stirling and Slade, Edinburgh, 1818. It is not clear whether the print also appeared in an edition of *Count Fathom*. The print seems to have been unknown to Edward C. J. Wolf in his *Rowlandson and his illustrations of eighteenth century English literature* (1945).

There are other versions of this drawing at Vassar and in one of the British Museum Rowlandson Scrapbooks.

The Huntington sketch is an awkward affair (note in particular the drawing of the arms and legs of the figure to the left), but it appears to be authentic.

507. ROBBERS CONFRONTED
Pen over pencil, unfinished, 4½″ x 6⅞″
Acquired: ca. 1910
Accession Number: Sessler 143 b

NOTES: A free and lively sketch of this subject with several minor variations from the Huntington drawing is in the Dent scrapbook (photo Witt Library).

508. THE FEAST OF ARISTOTLE
Pen (reinforced counterproof), 3⅞″ x 6⅛″
Inscribed in Rowlandson's hand: The Feast of
 Aristotle [a counterproof of the same inscrip-
 tion is faintly visible underneath]
Acquired: ca. 1910
Accession Number: Sessler 46 b

NOTES: A weak and awkward drawing, but the pen work is fully characteristic of Rowlandson in the 1820s, and the inscription is autograph.

509. A WOMAN AND A MONKEY
Pen (reinforced counterproof), 4″ x 6″
Watermark: [18]2[?]2
Acquired: ca. 1910
Accession Number: Sessler 46 c

NOTES: A weak, but seemingly authentic late drawing. The image is outside Rowlandson's normal range; probably he is copying some unidentified print.

510. DEATH AND THE MISER'S CHEST
Pen and watercolor over pencil, 4½″ x 7¼″
Collections: William Henry Bruton

Acquired: ca. 1925
Accession Number: Rare Book 144954 f. 558

NOTES: This drawing, like No. 511, is clearly later in date than *The English Dance of Death*, and probably has no connection with that series. It is a very weak drawing, but appears to be authentic.

511. DEATH OPENS THE DOOR
Pen over pencil, 4⅝″ x 7″
Collections: William Henry Bruton
Acquired: ca. 1925
Accession Number: Rare Book 144954 f. 559

NOTES: The drawing entered the collections with the Bruton extra-illustrated set of *The English Dance of Death*. But the wiry line and weak draftsmanship are characteristic of Rowlandson's work in the mid-1820s, a decade after the time when the drawings for the *Dance of Death* were produced.

ADDENDA

The following three drawings were given to the Huntington Art Gallery after this catalog had gone to press. For the sake of completeness they are included here, although with only preliminary research.

I. SHOEING: THE VILLAGE FORGE
Pen and gray wash, 5⅛″ x 8 1/16″
Engraved: 1787 (Grego I, 212)
Exhibited: Arts Council (1950), No. 13
Collections: Gilbert Davis, Homer Crotty
Acquired: 1974, gift of Mrs. Homer Crotty
Accession Number: 74.48

NOTES: The print is signed and dated 1787 on the plate. The drawing is interesting technically as an instance of Rowlandson retaining pen and monochrome wash (rather than watercolor) into the late 1780s.

II. ST. JAMES'S DAY
Pen and watercolor over pencil, 11¼″ x 8⅞″
Signed and dated in Rowlandson's hand: Rowlandson 1817
Inscribed in Rowlandson's hand, partially trimmed: St. James's Day
Collections: Gilbert Davis, Homer Crotty
Acquired: 1974, gift of Mrs. Homer Crotty
Accession Number: 74.49

NOTES: St. James's Day is July 25. A shell is an emblem of St. James; presumably the two women are selling shellfish.

III. MARK MY WORD
Pen and watercolor over pencil, 9¼″ x 11½
Collections: Gilbert Davis, Homer Crotty
Acquired: 1974, gift of Mrs. Homer Crotty
Accession Number: 74.50

NOTES: The technique, especially the watercolor on the faces, suggests a date after 1800.

Plates

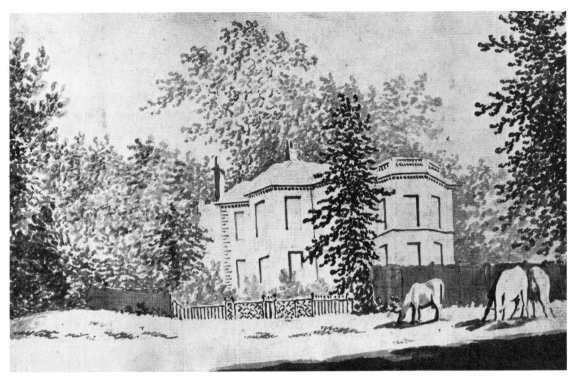

1a. A COUNTRY HOUSE WITH THREE HORSES GRAZING IN THE RIGHT FOREGROUND

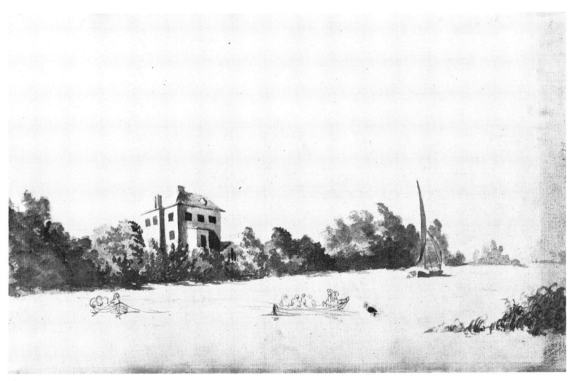

1b. A HOUSE BY A RIVER

1b. [VERSO]

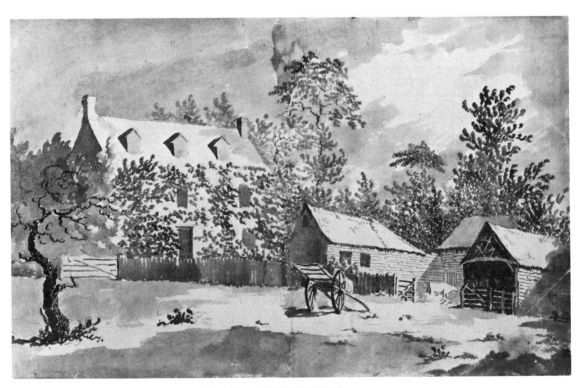

1C. FARMHOUSE WITH THREE DORMERS AND STABLES TO RIGHT

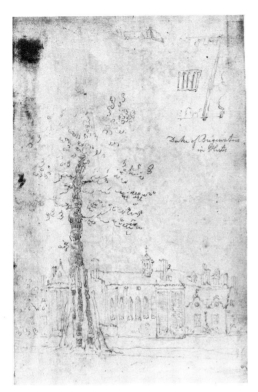

1C. [VERSO]

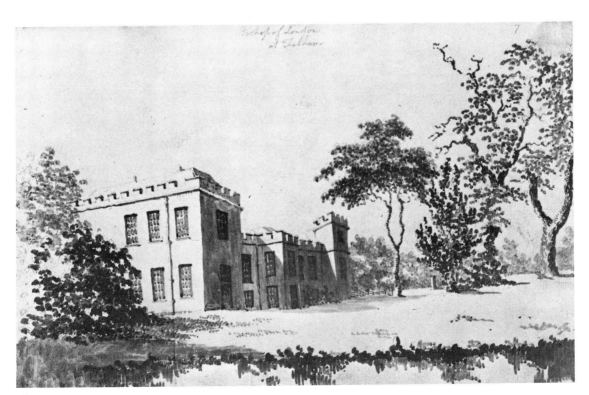

1d. FULHAM PALACE

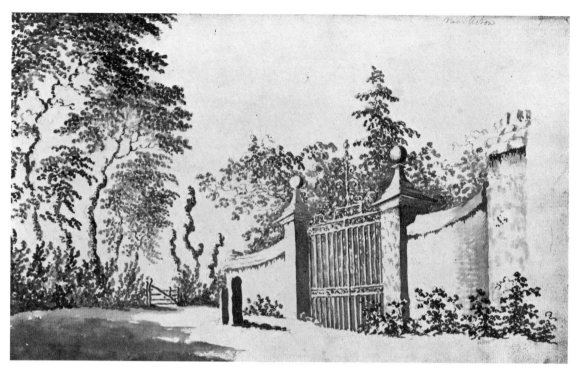

1e. A WALL AND WROUGHT IRON GATE

1e. [VERSO] detail

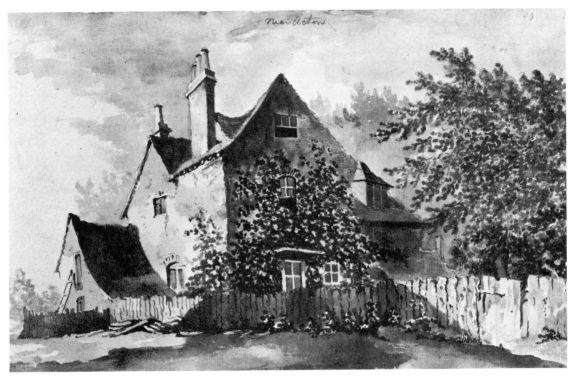

1f. A FARMHOUSE WITH A WOODEN FENCE IN THE FOREGROUND

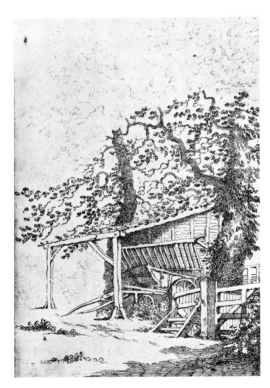

1g. A CART IN A SHED UNDER TREES

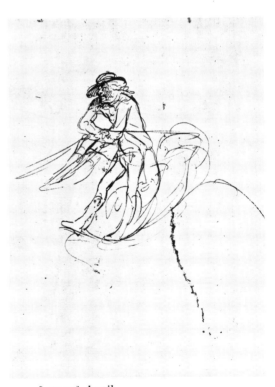

1g. [VERSO] detail

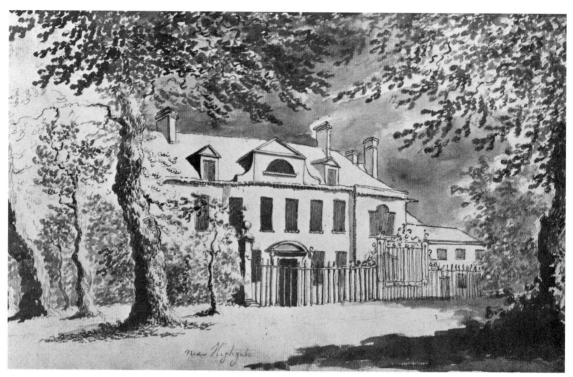

1h. A HOUSE BEHIND A WROUGHT IRON FENCE AND GATE

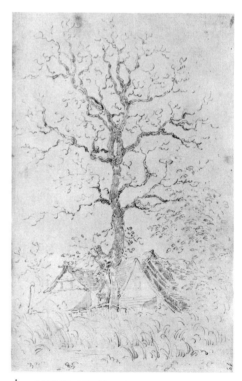

1i. GABLED COTTAGE NEAR A TREE

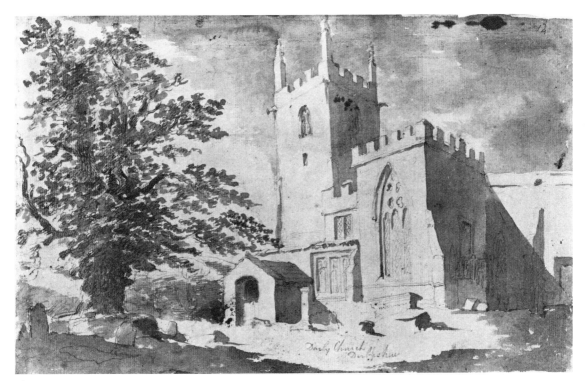

1j. DARLY CHURCH

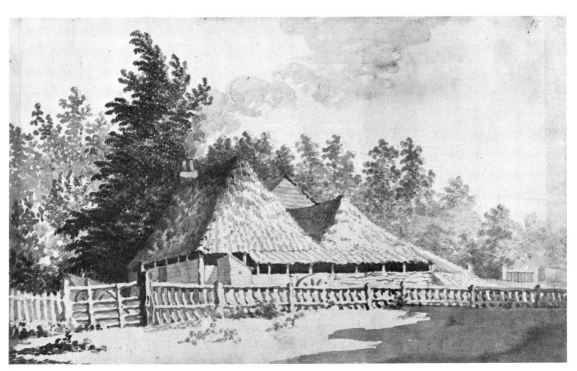

1k. THATCHED FARM BUILDINGS

11. LADY ESSEX'S HOUSE

11. [VERSO]

1m. A COUNTRY HOUSE NEAR NORTHCHURCH

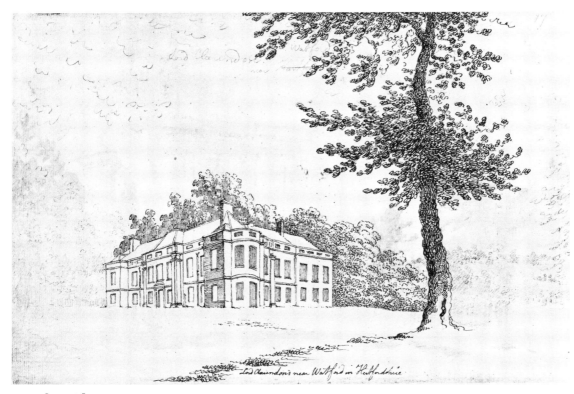

1m. [VERSO]

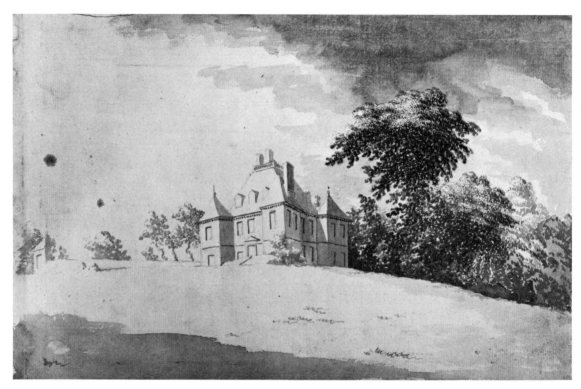

III. A COUNTRY HOUSE WITH FOUR CORNER PAVILIONS; PROBABLY NOT ENGLISH

III. [VERSO]

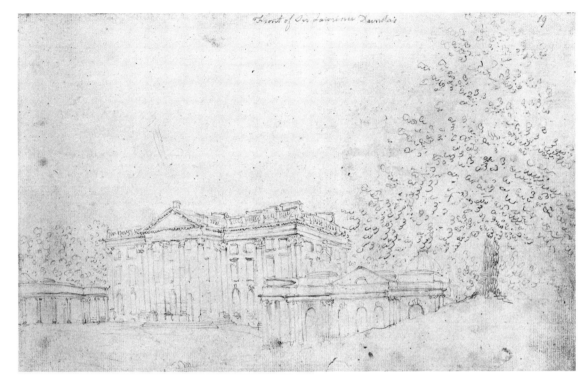

10. FRONT OF MOOR PARK, HERTS

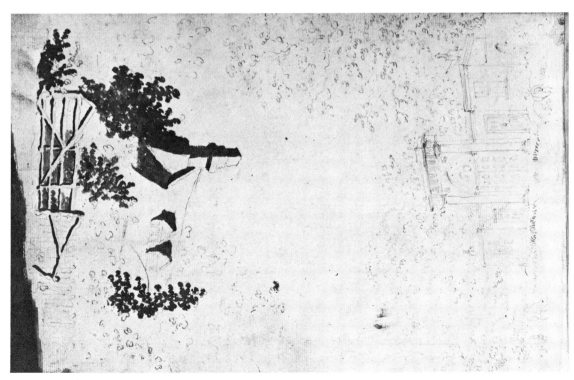

10. [VERSO]

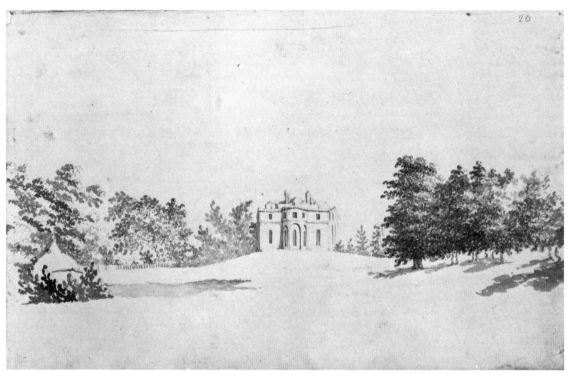

1p. CANONS PARK, STANMORE, MIDDLESEX [?]

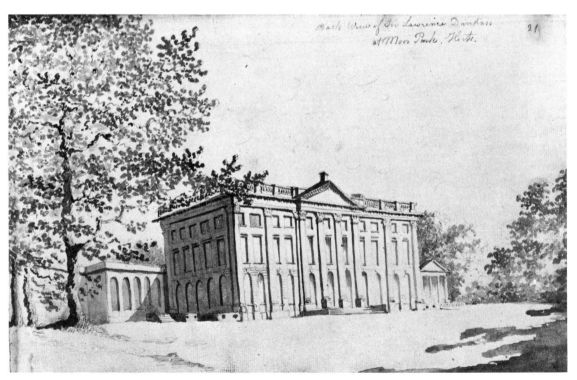

1q. GARDEN FRONT OF MOOR PARK

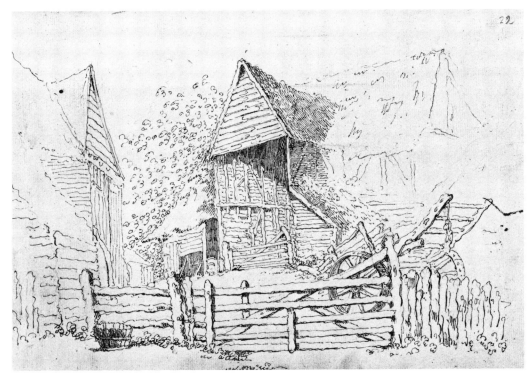

1r. FARMYARD BUILDINGS

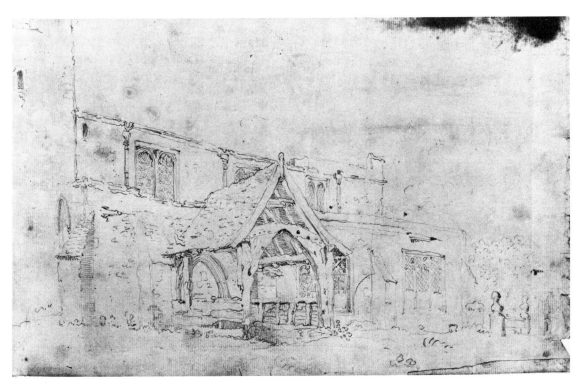

1S. PORCH OF A PARISH CHURCH

IS. [VERSO]

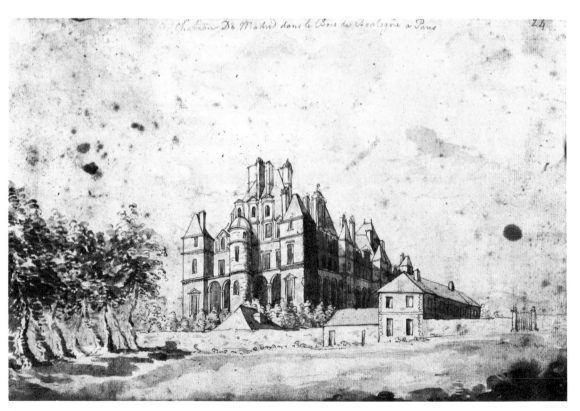

Château De Madrid dans le Bois de Boulogne à Paris

I t. CHATEAU DE MADRID

1u. THE QUEEN'S HOUSE, GREENWICH

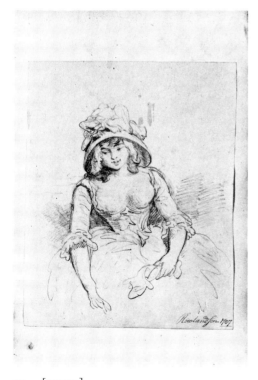

1u. [VERSO]

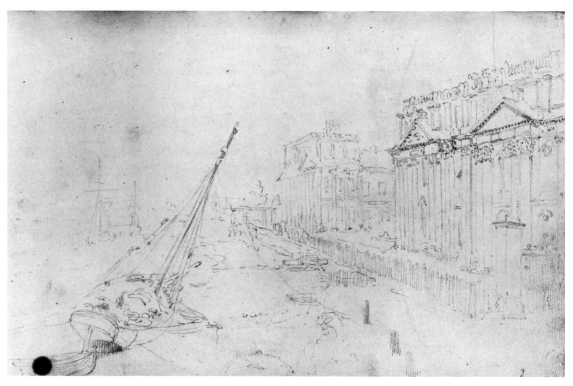

IV. GREENWICH FROM THE RIVER

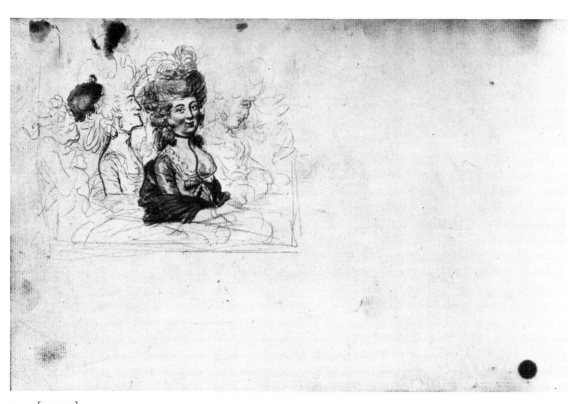

IV. [VERSO]

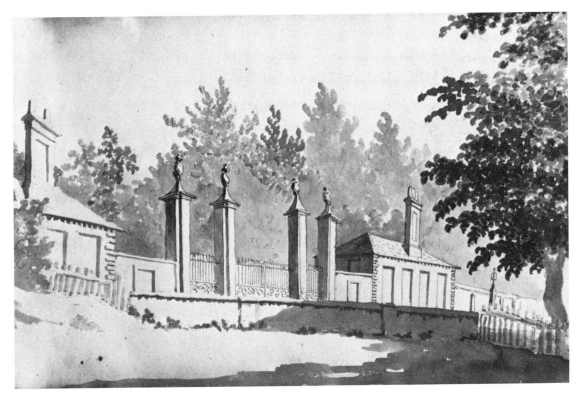

I W. MAIN GATES, CHELSEA HOSPITAL

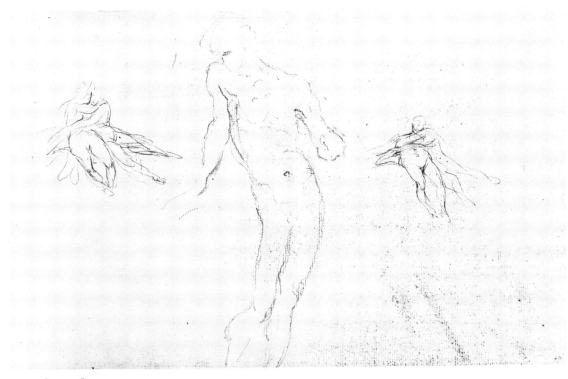

I W. [VERSO]

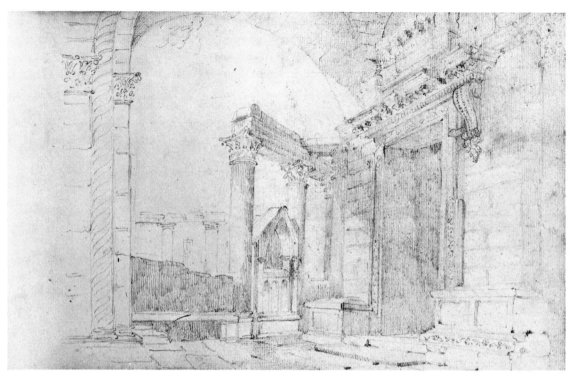

IX. AN ARCHITECTURAL CAPRICCIO IN THE MANNER OF CLÉRISSEAU

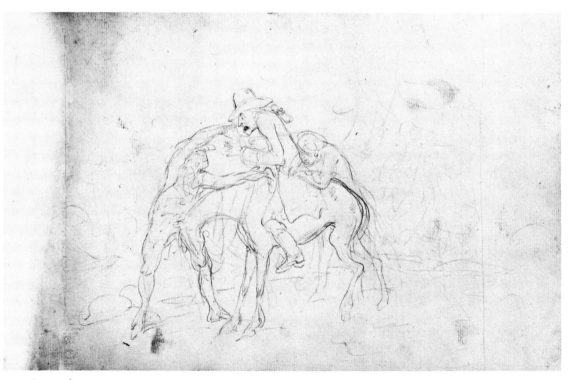

IX. [VERSO]

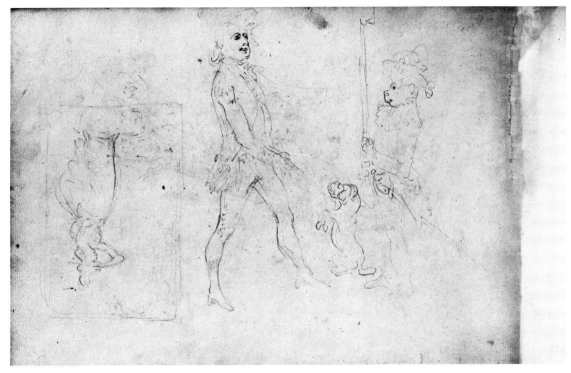

1y. SKETCHES, INCLUDING A MAN AND PERFORMING ANIMALS

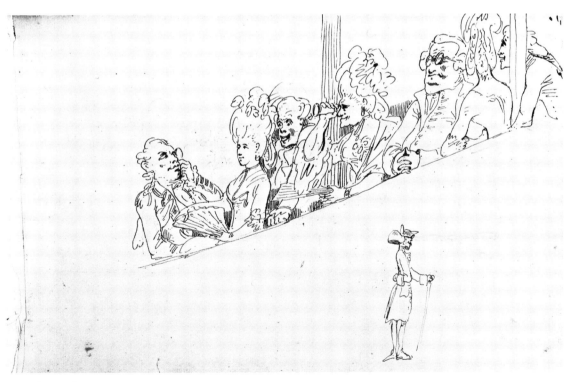

1y. [VERSO]

12. SKETCHES, INCLUDING A FEMALE FIGURE, AND POSSIBLY A STAGE SET

12. [VERSO]

1aa. SKETCH WITH FIGURES IN FRONT OF A DOORWAY

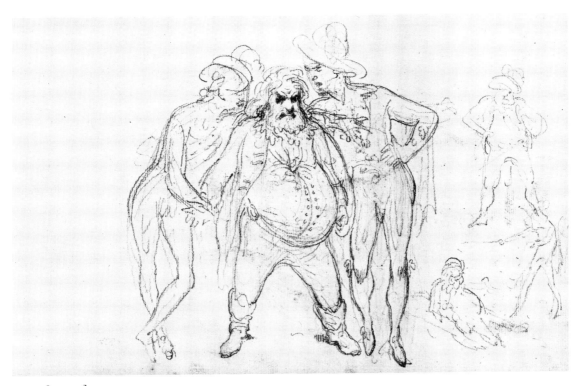

1aa. [VERSO]

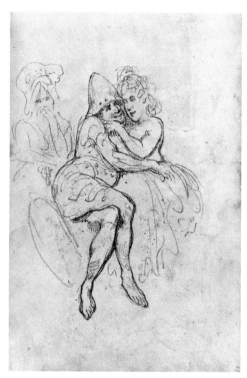

1bb. SKETCH OF A MAN AND TWO WOMEN

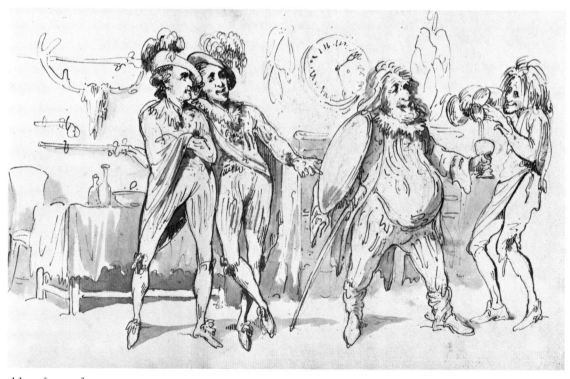

1bb. [VERSO]

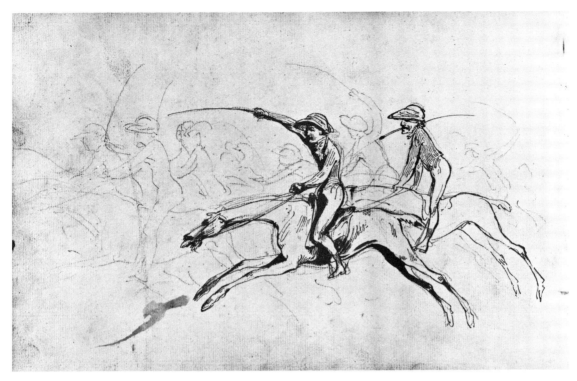

I CC. A HORSE RACE

I CC. [VERSO]

1dd. FIGURE STUDIES

1ee. FRAGMENT OF A PAGE WITH FIGURE STUDIES

1ee. [VERSO]

1 ff. SEATED MAN AND WOMEN

1 ff. [VERSO]

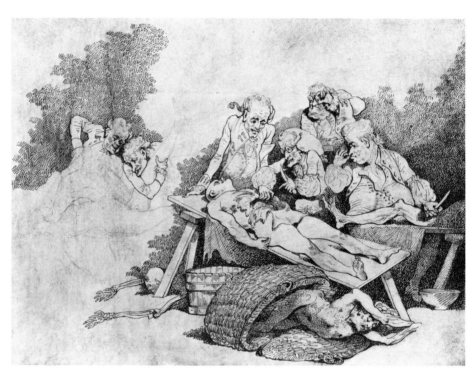

2. THE DISSECTION

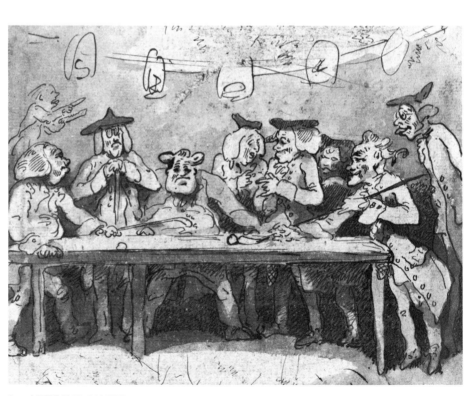

3. A BILLIARD MATCH

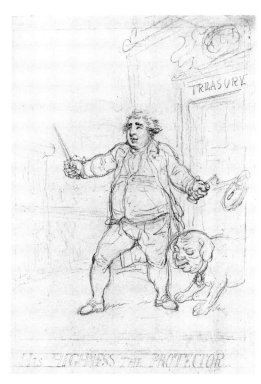

4. HIS HIGHNESS THE PROTECTOR

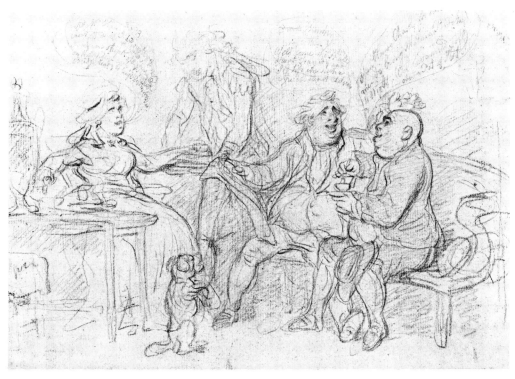

5. LORDS OF THE BEDCHAMBER

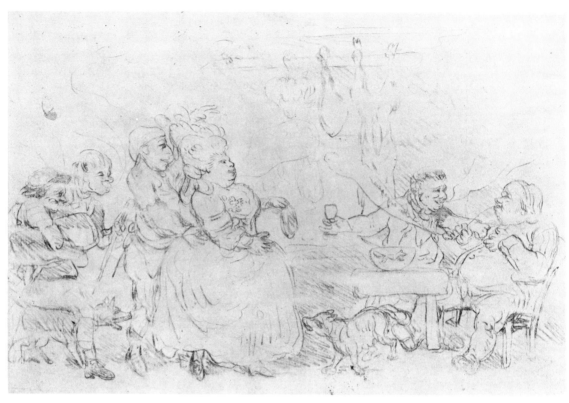

6.　MADAME BLUBBER ON HER CANVASS

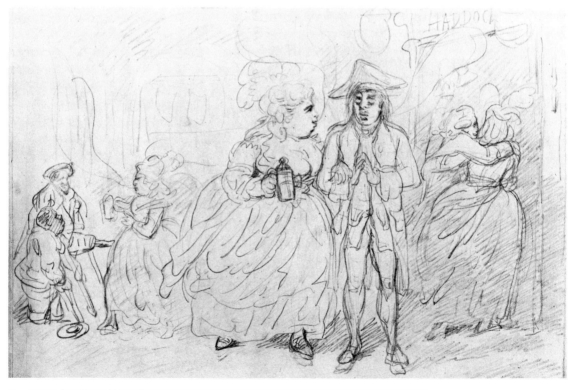

7.　DARK LANTHERN BUSINESS OR MRS HOB AND NOB ON A NIGHT CANVASS WITH A
　　BOSOM FRIEND

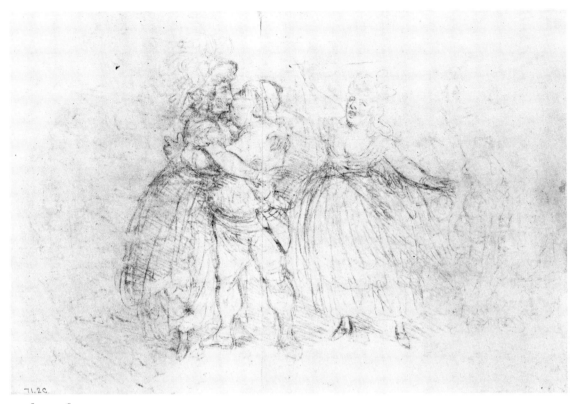

7. [VERSO]

8. THE DEPARTURE

9. SECRET INFLUENCE DIRECTING THE NEW PARLIAMENT

10. MR. ROWLANDSON HIRING THE FIRST POST-CHAISE

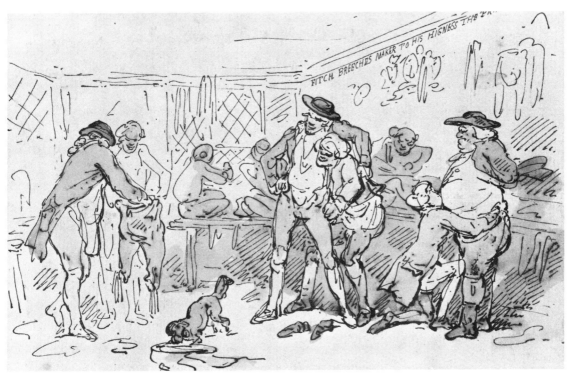

11. BUYING LEATHER BREECHES—PREVIOUS TO OUR JOURNEY

12.　TRUNK SHOP—MR WIGSTEAD BARGAINING

13.　MYSELF AT DINNER

Sir. Sir. Sir. th past 4 o'Clock.

14. MR. ROWLANDSON'S OLD HOUSEKEEPER CALLING HIM UP ON THE MORNING WE SET OFF

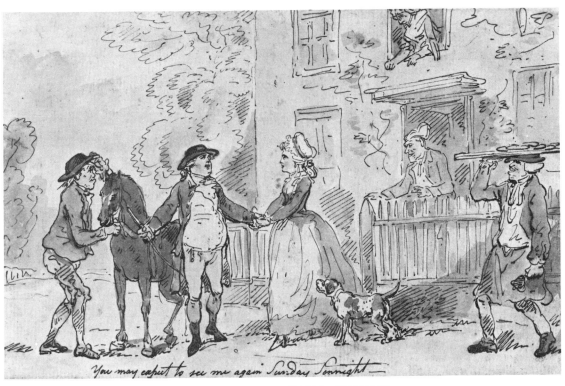

You may expect to see me again Sunday sennight

15. MR. WIGSTEAD TAKING LEAVE OF HIS HOME AND FAMILY—THE START

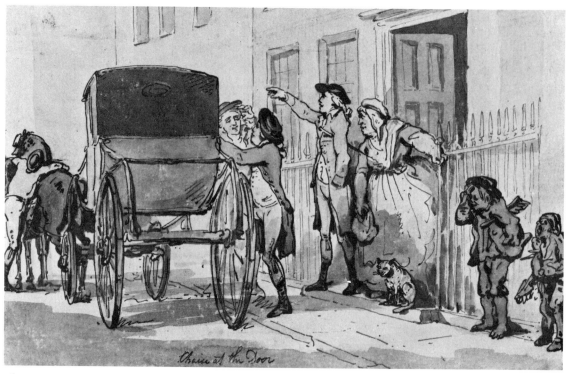

16. CHAISE AT THE DOOR, SETTING OUT FROM ROWLANDSON'S HOUSE IN WARDOUR
STREET

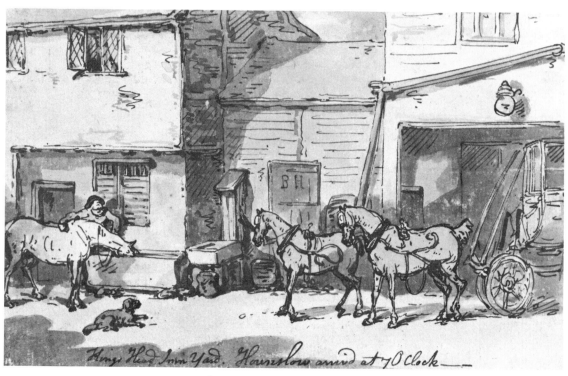

17. THE FIRST STAGE FROM LONDON—"KING'S HEAD INN YARD," HOUNSLOW, ARRIVED
AT 7 O'CLOCK

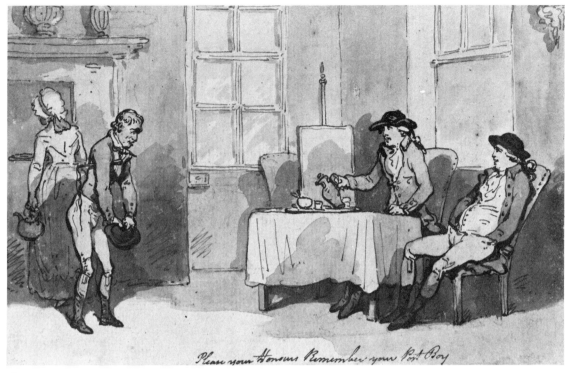

Please your Honours Remember your Port Boy

18. BREAKFAST AT EGHAM

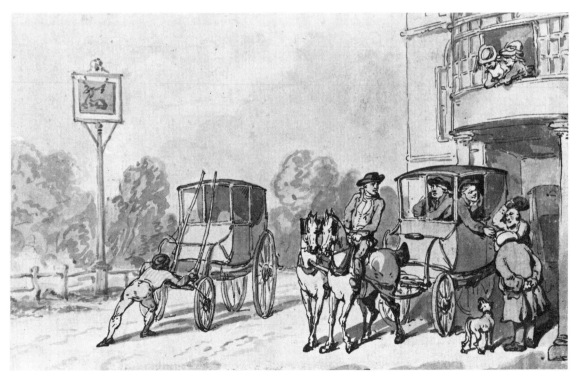

19. THE WHITE HART INN, BAGSHOT

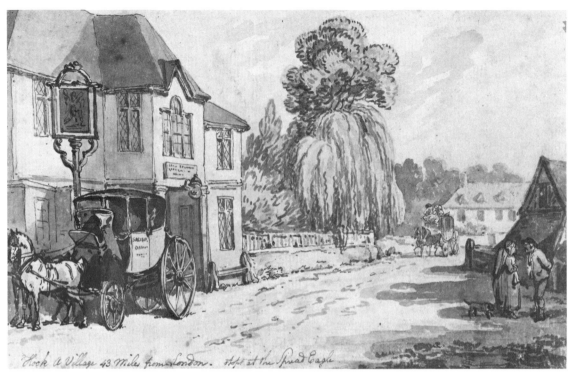

Hook a Village 43 Miles from London. Stopt at the Spread Eagle

20. THE SPREAD EAGLE AT HOOK

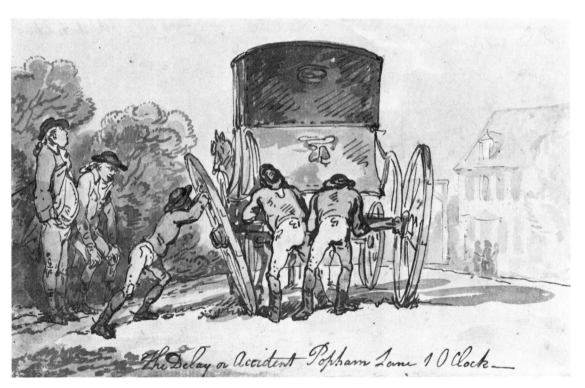

The Delay or Accident Popham Lane 1 OClock

21. THE DELAY AT POPHAM LANE

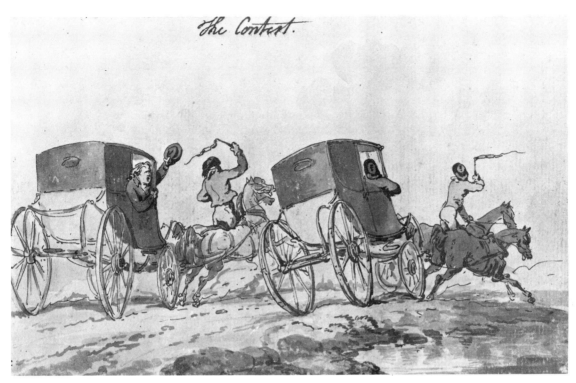

22. THE CONTEST FOR PRECEDENCE OVER THE DOWNS BETWEEN STOCKBRIDGE AND
SALISBURY

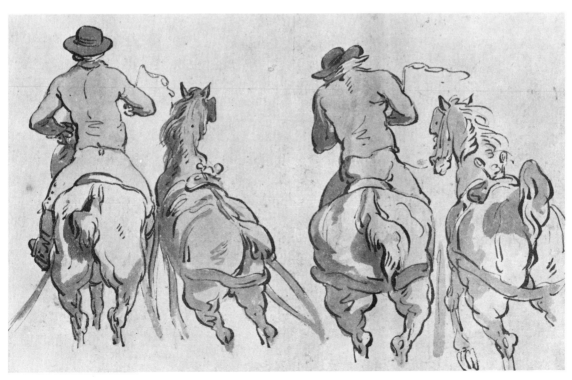

23. HEAD AND TAILPIECE

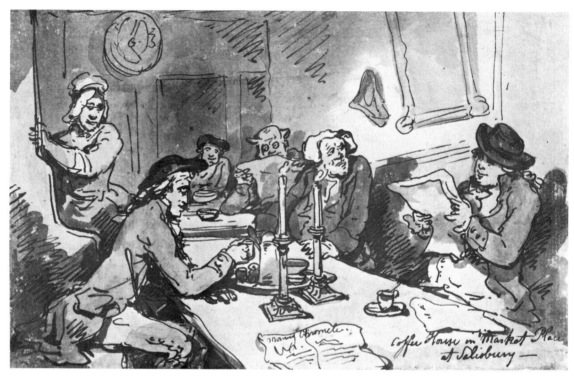

24. COFFEE HOUSE IN SALISBURY MARKET PLACE

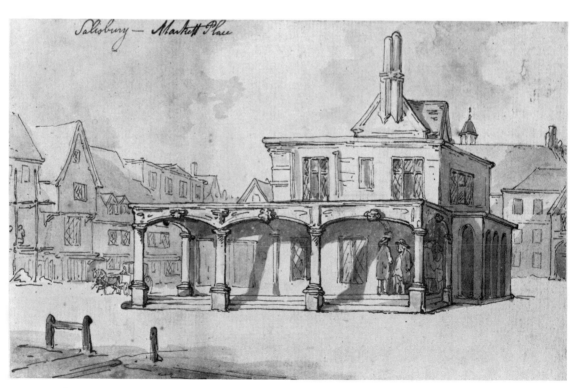

25. SALISBURY MARKET PLACE

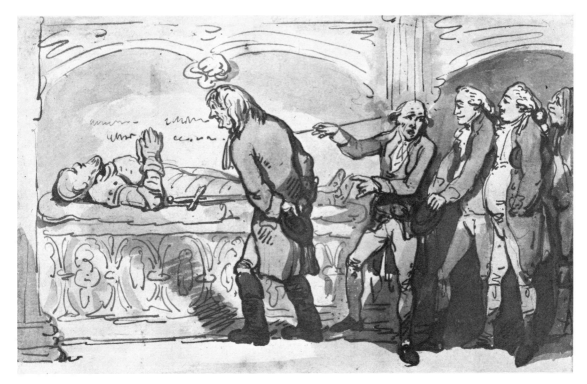

26. A MONUMENT IN SALISBURY CATHEDRAL

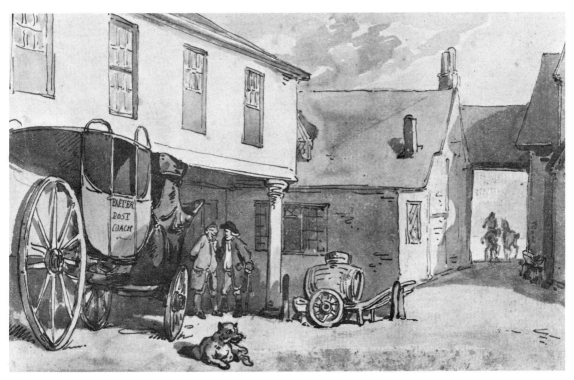

27. THE YARD OF AN INN

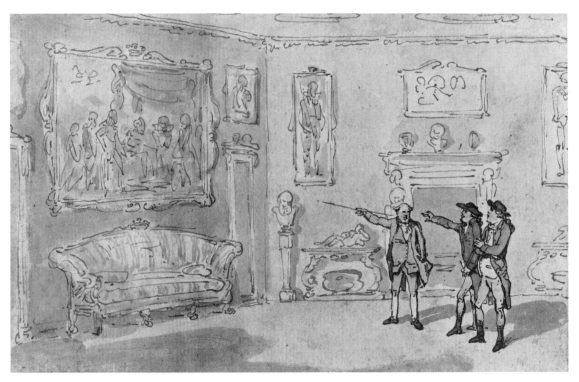

28. THE GRAND ROOM IN WILTON HOUSE

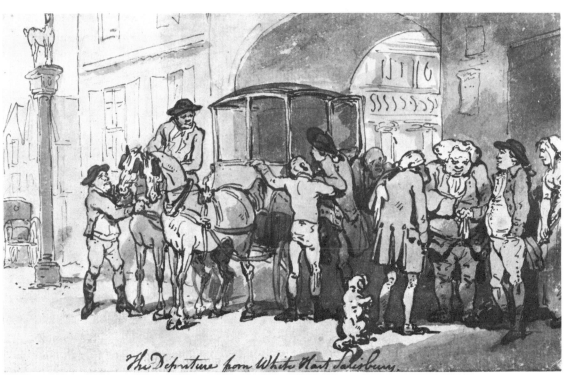

The Departure from White Hart Salisbury.

29. THE DEPARTURE FROM THE WHITE HART, SALISBURY

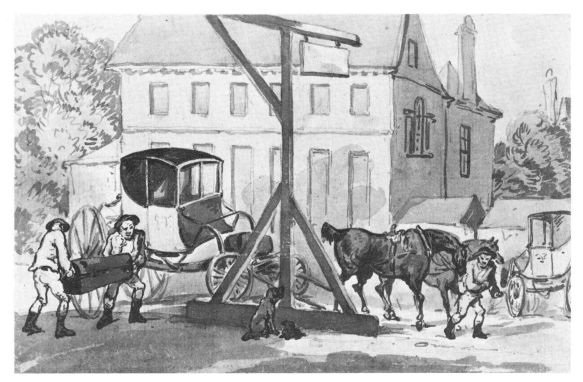

30. ARRIVAL AT AN INN

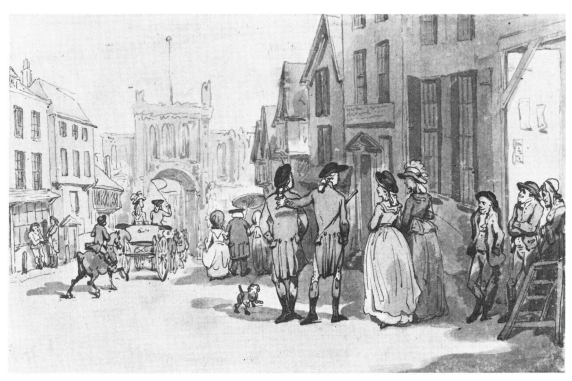

31. THE BAR, SOUTHAMPTON

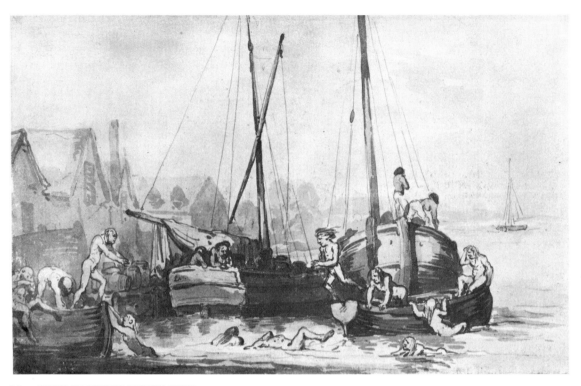

32. VIEW ON SOUTHAMPTON RIVER

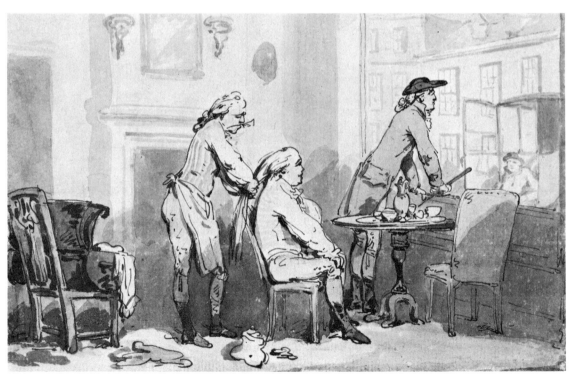

33. THE CHAISE WAITING TO CARRY US TO LYMINGTON

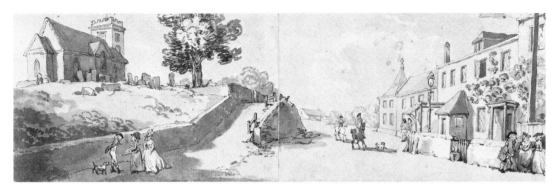

34. THE CHURCH, THE CROWN INN, AND THE DUKE OF GLOUCESTER'S
STABLES AT LYNDHURST

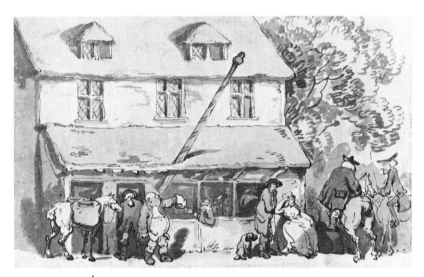

35. A BARBER'S SHOP

36. FIRST INTERVIEW WITH TWO FEMALE FRIENDS ON OUR
ARRIVAL AT LYMINGTON

37. THE YARD OF THE ANGEL INN, LYMINGTON

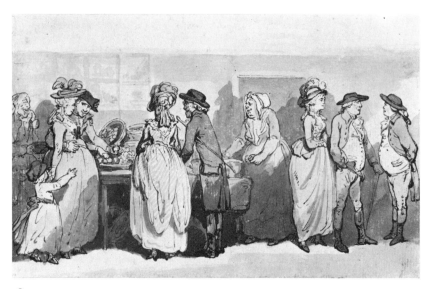

38. FRUIT SHOP AT LYMINGTON—MR WIGSTEAD MAKING FRIENDS

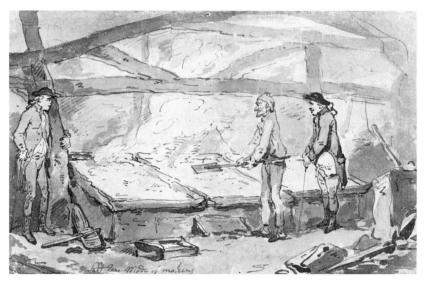

39. INSIDE OF A SALTERN AT LYMINGTON, WITH THE MANNER
OF MAKING SALT

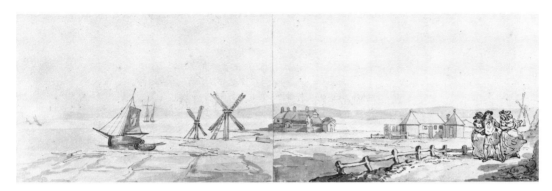

40. MRS BEESTON'S BATHS AT LYMINGTON

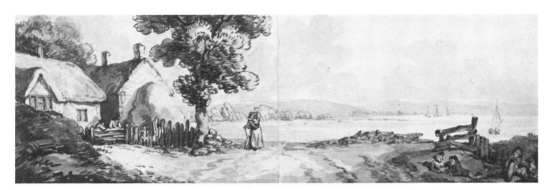

41. A COTTAGE AT LYMINGTON

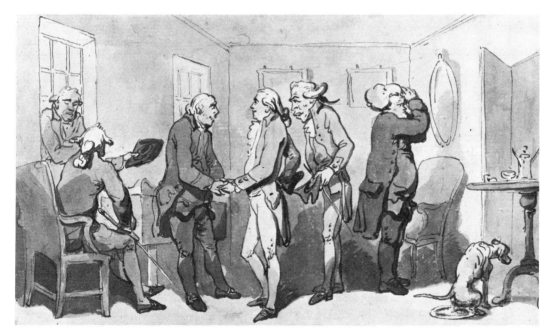

42. FIRST INTERVIEW WITH A FRIEND AT LYMINGTON

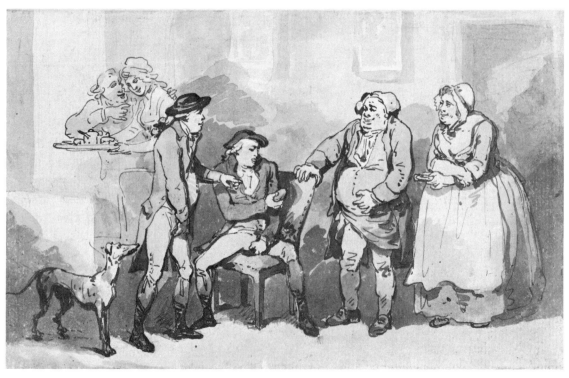

43. THE LANDLORD WHERE WE LODGED AT LYMINGTON COMPLAINING
 OF HIS MISFORTUNES

44. THE ANGEL INN AT LYMINGTON

45. KITCHEN AT THE INN AT LYMINGTON, ON ROAD TO PILESWELL

46. PILESWELL, NEAR LYMINGTON IN HAMPSHIRE—THE SEAT OF ASCANIUS WILLIAM
SENIOR, ESQ^re

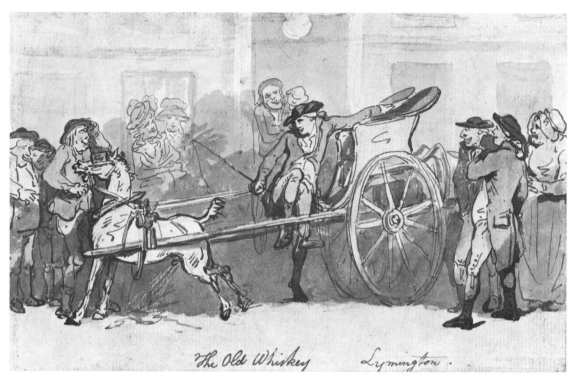

47. THE OLD WHISKEY, LYMINGTON

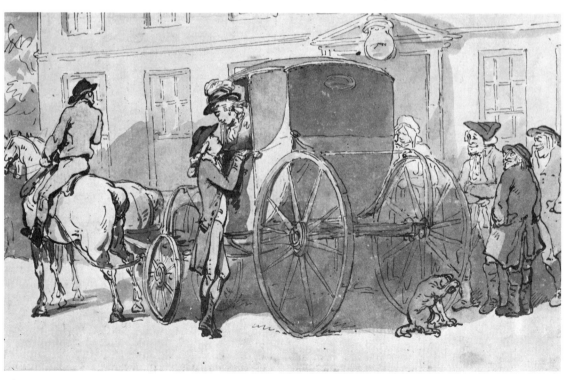

48. ROWLANDSON TALKING WITH A LADY OUTSIDE THE ANGEL, LYMINGTON

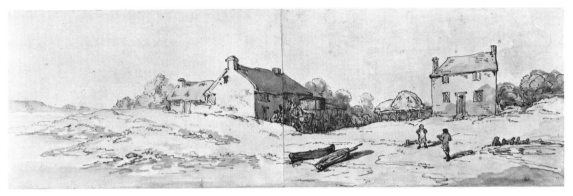

49. PITT'S DEEP, NEAR HURST CASTLE, A LITTLE ALE HOUSE FAMOUS FOR
 SELLING GOOD BRANDY

50. SHIPPING OXEN ON BOARD THE ISLE OF WIGHT PACKET

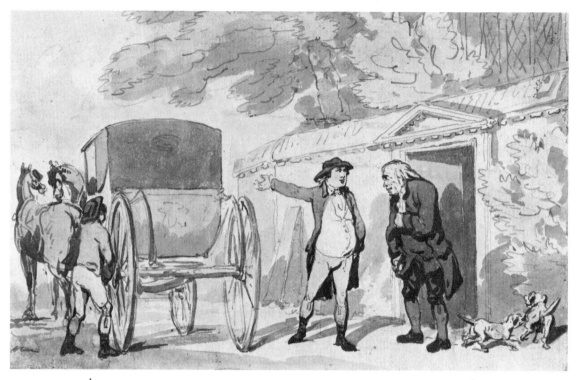

51. WIGSTEAD'S PARTING INTERVIEW WITH HIS LYMINGTON FRIEND

52. LYMINGTON QUAY WITH THE METHOD OF SHIPPING CATTLE FOR THE ISLE OF WIGHT

53. THE PRETTY HOSTESS AND ROWLANDSON—WITH THE EXTRAVAGANT
BILL, AND WIGSTEAD

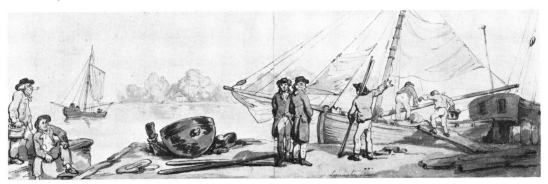

54. LYMINGTON RIVER, NEAR THE QUAY—GOING ON BOARD THE VESSEL TO CARRY US TO
THE ISLE OF WIGHT

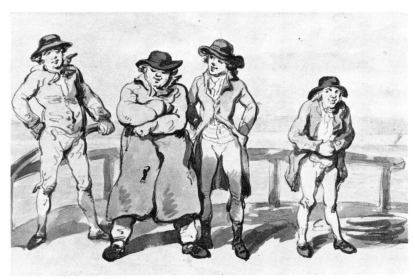

55. LYMINGTON TO THE NEEDLES—ON BOARD THE PACKET

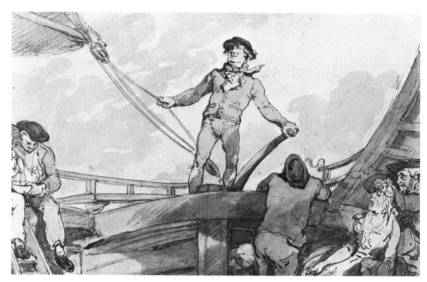

56. THE QUARTER-DECK OF THE VESSEL WHICH CARRIED US TO THE
 NEEDLES—THE WIND BLOWING HARD

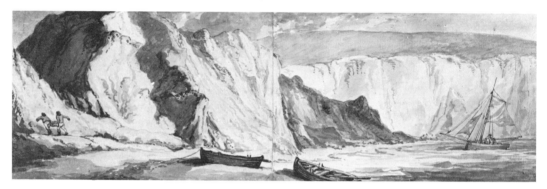

57. SIX MILES FROM YARMOUTH—ALUM BAY

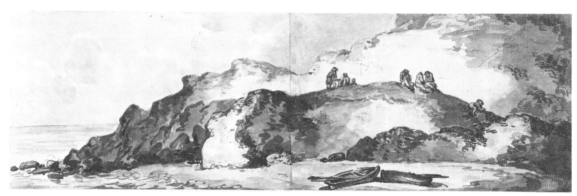

58. PART OF THE ROCKS IN ALUM BAY

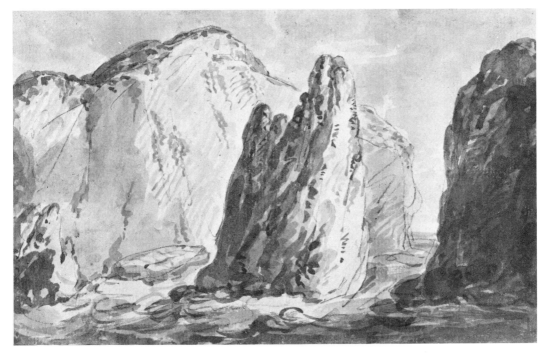

59. THE NEEDLE ROCKS FROM THE SEA

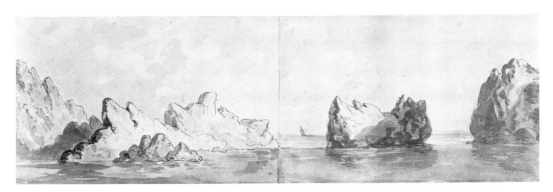

60. THE NEEDLE ROCKS

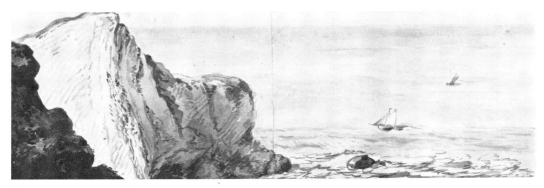

61. ST. CHRISTOPHER'S ROCK

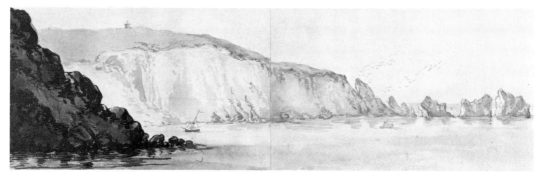

62. THE WESTERN END OF THE ISLE OF WIGHT FROM THE SOLENT

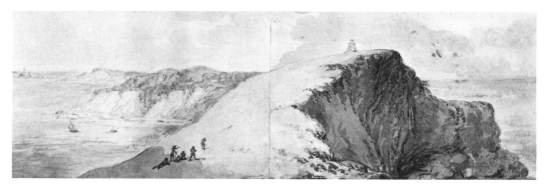

63. THE ISLE OF WIGHT AS SEEN FROM THE BLUFFS ABOVE THE NEEDLES

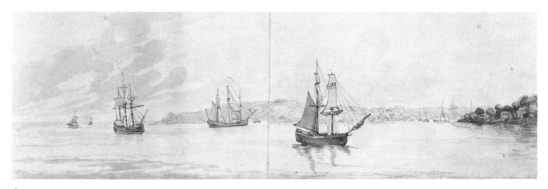

64. A GENERAL VIEW OF THE ISLE OF WIGHT

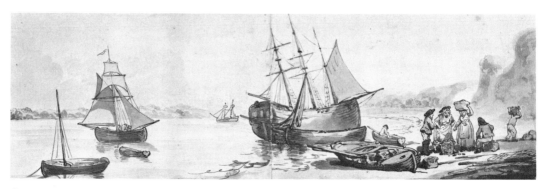

65. COWES HARBOUR IN THE ISLE OF WIGHT

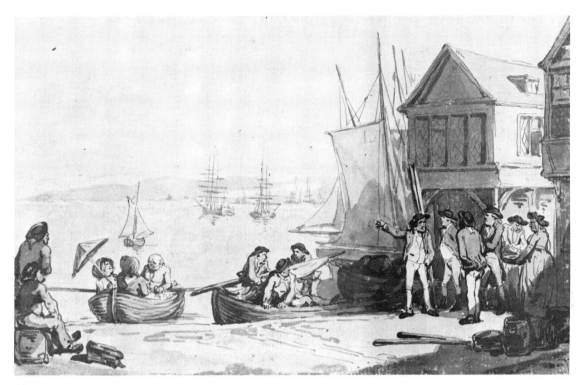

66.　COWES HARBOUR IN THE ISLE OF WIGHT

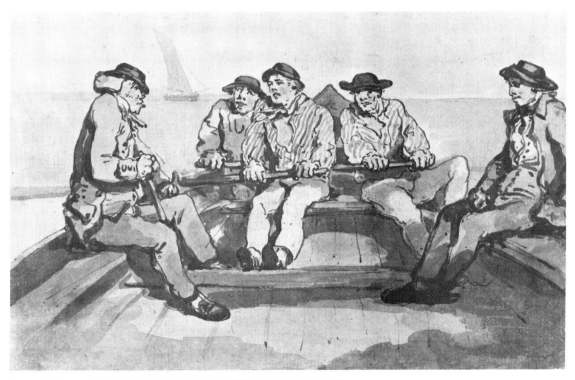

67.　THE BOAT WHICH WE HIRED FROM COWES TO PORTSMOUTH

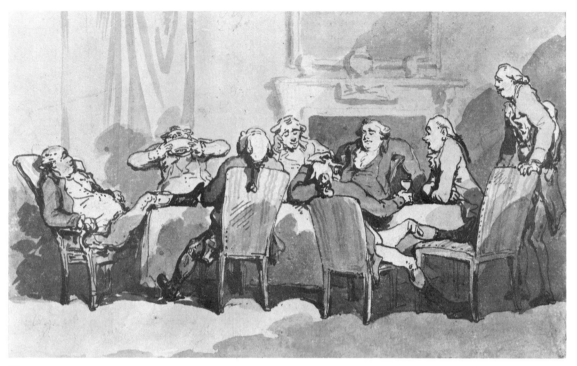

68. AT SUPPER IN PORTSMOUTH ON OUR ARRIVAL FROM COWES, ALL
VERY MUCH FATIGUED

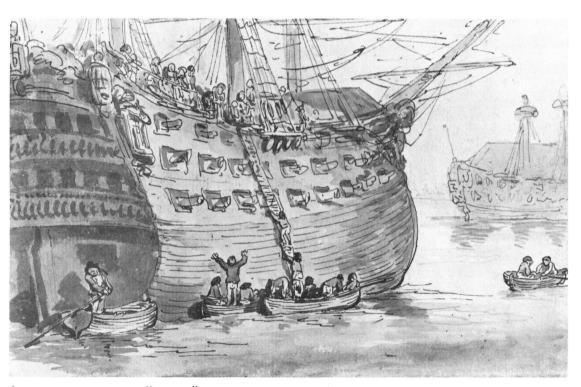

69. GOING ON BOARD THE "HECTOR" OF 74 GUNS, LYING IN PORTSMOUTH HARBOUR

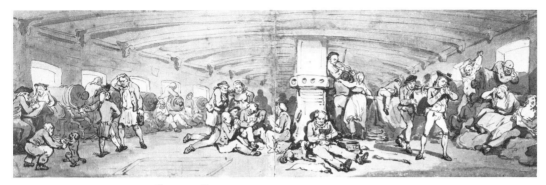

70. MIDDLE DECK OF THE "HECTOR"

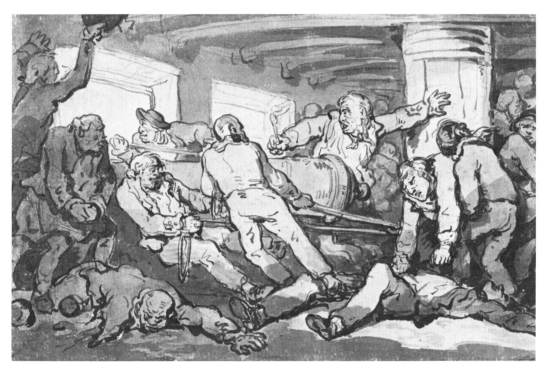

71. THE MANNER OF WORKING THE GUNS ON BOARD A SHIP IN TIME OF ACTION

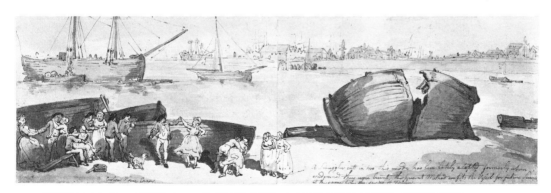

72. CUSTOM HOUSE CORNER, PORTSMOUTH, WITH A SMUGGLING VESSEL CUT IN TWO

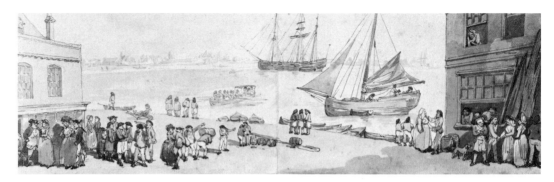

73. PORTSMOUTH POINT WITH A DISTANT VIEW OF GOSPORT

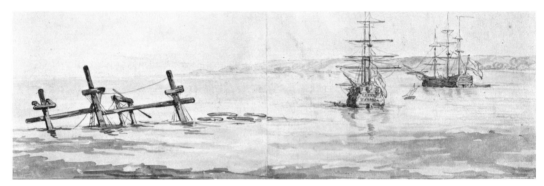

74. SPITHEAD, WITH THE EXACT SITUATION AND APPEARANCE OF THE "ROYAL GEORGE," WRECKED AUGUST 29, 1782

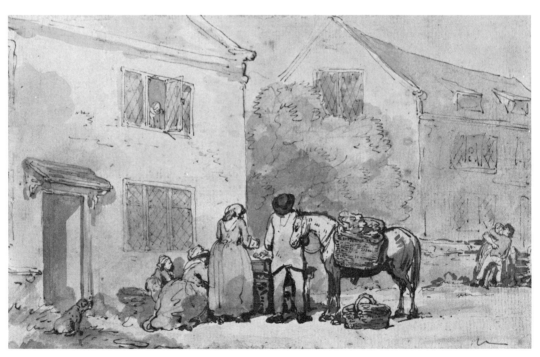

75. COTTAGES, FARNHAM, SURREY

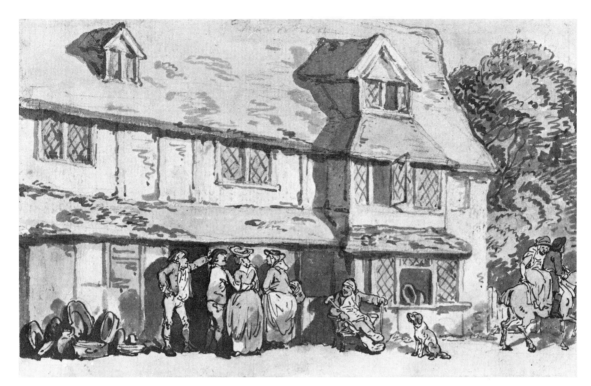

76. AN EARTHENWARE SHOP AT FARNHAM, SURREY

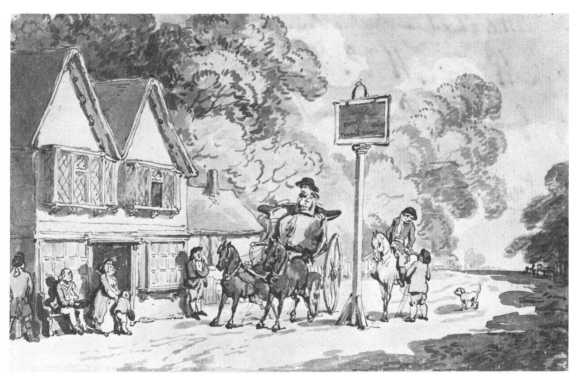

77. THE TUMBLE-DOWN DICK

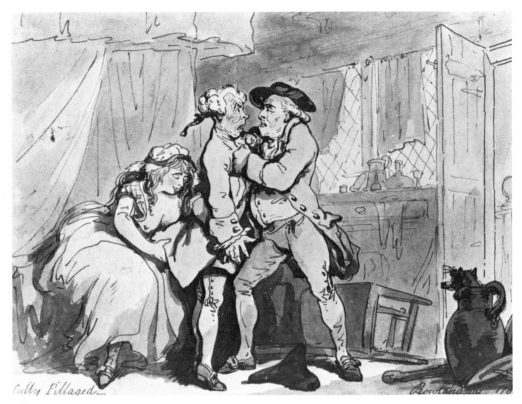

78. A CULLY PILLAGED

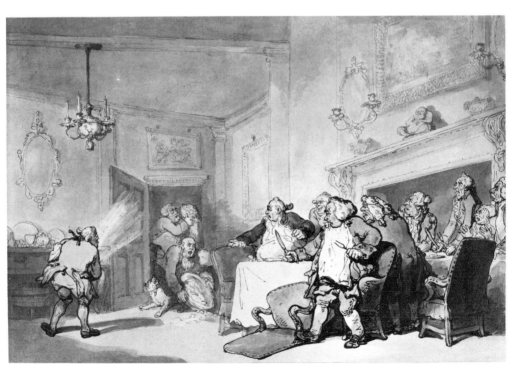

80. THE DISAPPOINTED EPICURES

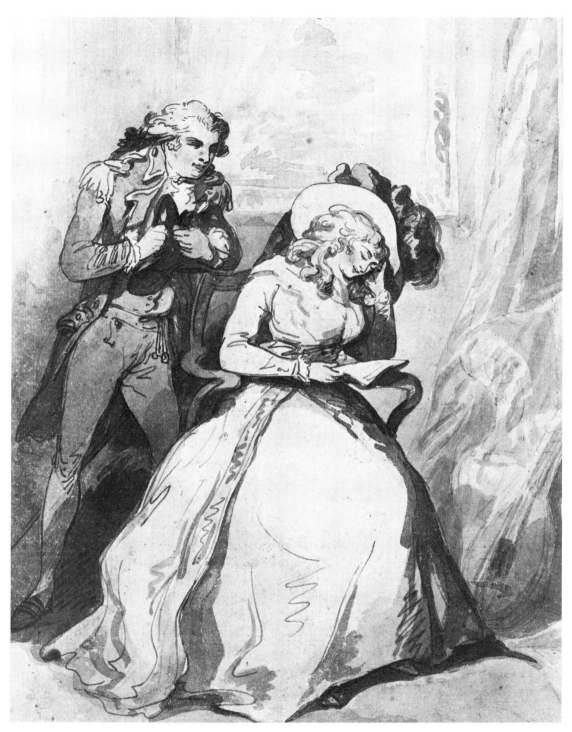

79. THE PANTING LOVER

81. THE BETTING POST

82. THE LIFE CLASS

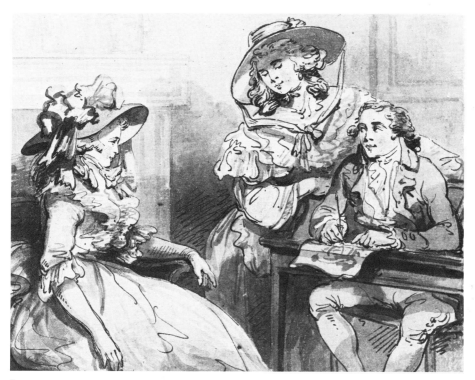

83. ROWLANDSON AND HIS FAIR SITTERS

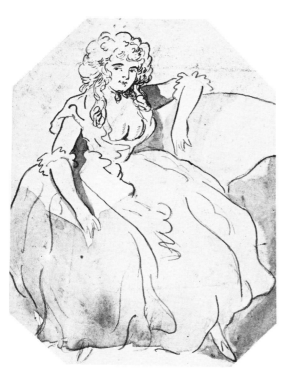

84. YOUNG WOMAN SEATED

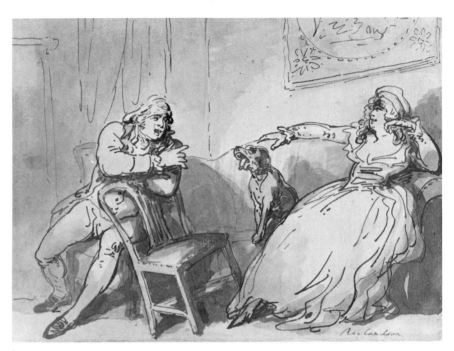

85. A MORNING VISIT

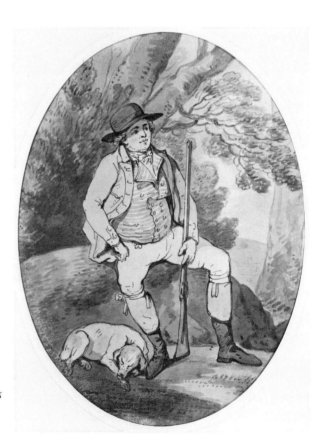

86. PORTRAIT OF A MAN WITH A GUN

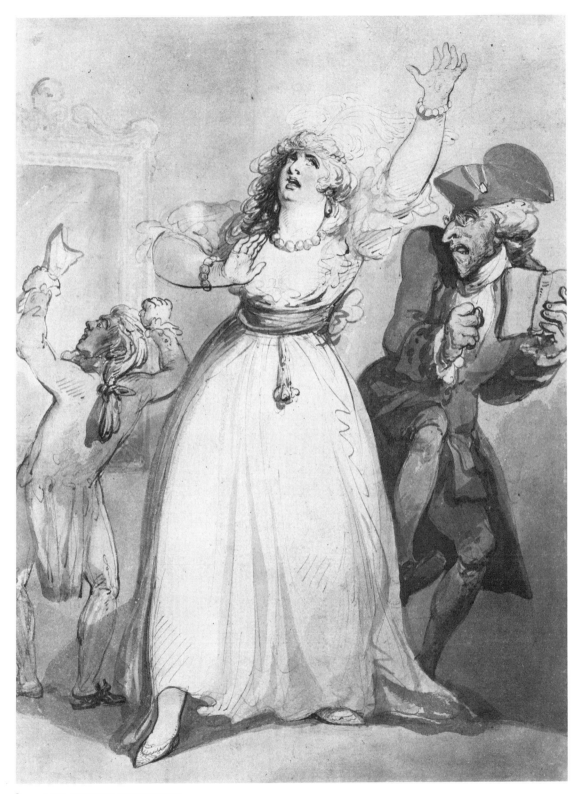

87. MRS. SIDDONS REHEARSING

88. A LADY IN A PHAETON DRAWN BY SIX HORSES

89. A FRENCH HUNT

91. TWO FIGURES ON HORSEBACK
AND A DOG

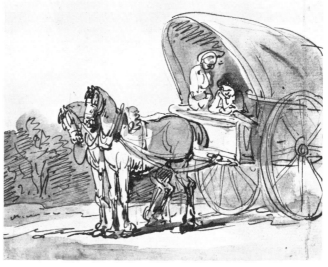

90. A COVERED WAGON, TWO HORSES, AND TWO FIGURES

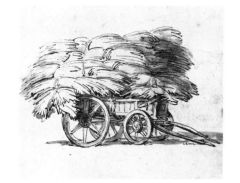

93. A LOADED HAY CART

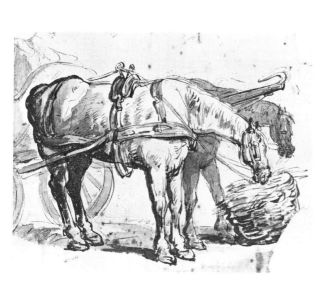

92. A TEAM OF HORSES

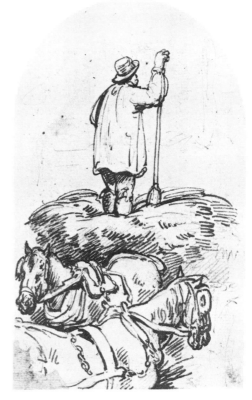

94. A FARMER STANDING ON HAY;
TWO HORSES

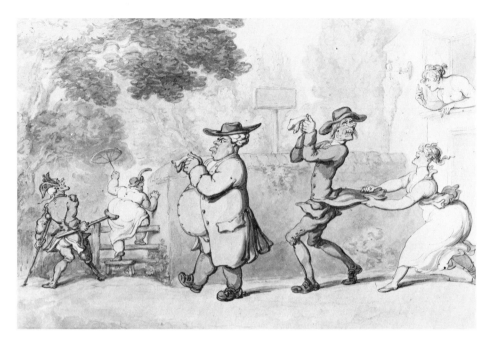

95. LOVE AND WAR

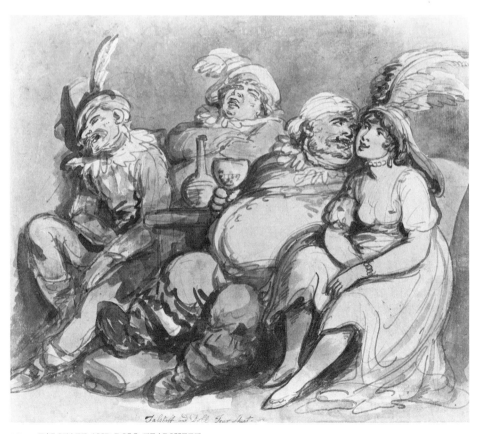

97. FALSTAFF AND DOLL TEARSHEET

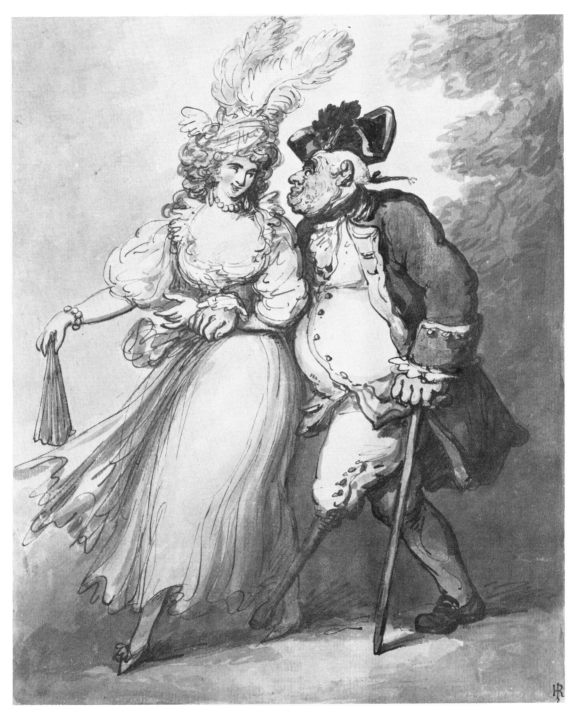

96. A FRENCH FRIGATE TOWING AN ENGLISH MAN O' WAR INTO PORT

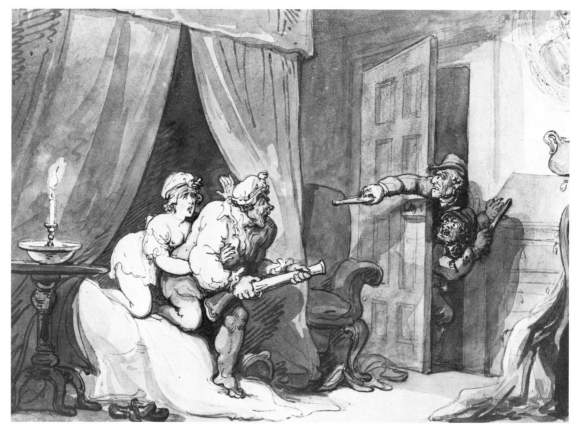

98. HOUSE BREAKERS

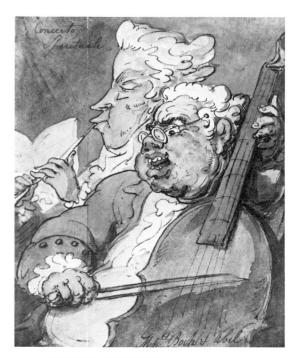

99. CONCERTO SPIRITUALE

100. WEST COWES, LAUNCHING A CUTTER

101. CRUMPETS AND MUFFINS, ALL HOT!

102. EELS, ALL ALIVE!

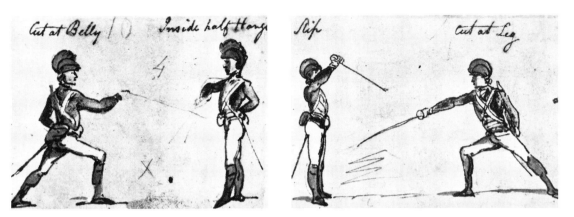

Cut at Belly Inside half Hange Slip Cut at Leg

103. TWO DETAILS FROM HIGHLAND BROAD SWORD

104. SLOANE'S VOLUNTEERS, CHELSEA

105. A GROUP OF TRAVELERS WITH TWO DONKEYS

105. [VERSO]

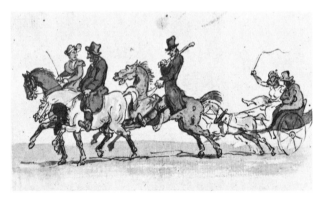

106. THREE FIGURES ON HORSEBACK AND TWO IN A
CARRIAGE

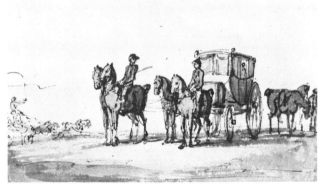

107. A COACH AND FOUR AT REST

107. [VERSO]

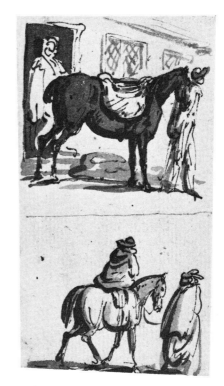

108. TWO SKETCHES WITH FIGURES
AND HORSES

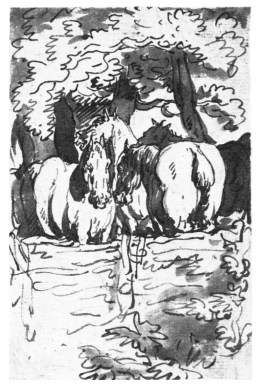

109. FOUR HORSES IN A PADDOCK

109. [VERSO]

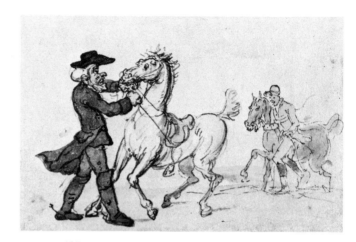

110. A CLERIC WITH AN UNRULY HORSE

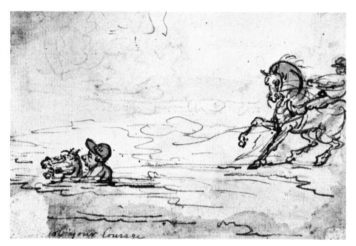

111. FORDING A STREAM

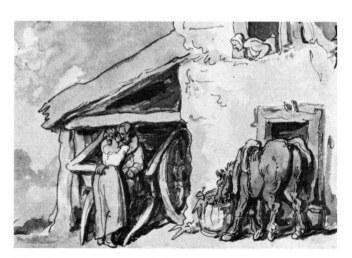

112. A COUPLE EMBRACING OUTSIDE A FARMHOUSE

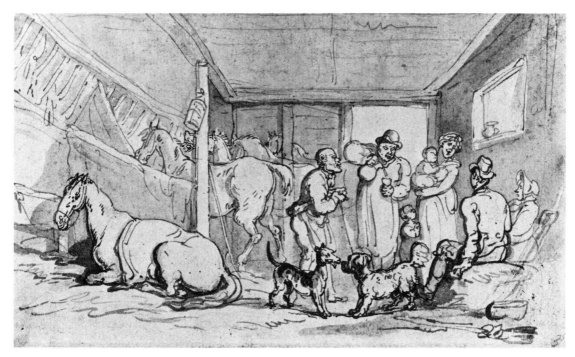

113. FIGURES IN A STABLE INTERIOR

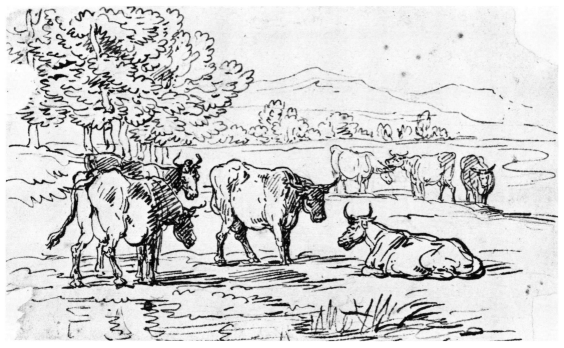

114. SEVEN COWS IN A LANDSCAPE

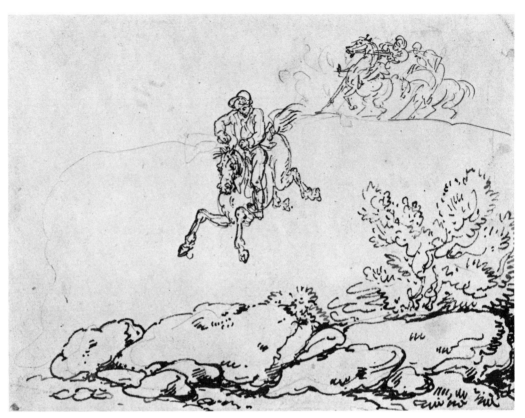

115. DICK NIGHT LEAPING FROM A HEIGHT

116. AN AFFAIR OF HONOUR

117. CONNOISSEURS IN THE STUDIO

118. SOLDIERS RESTING

119. DEATH IN THE RING

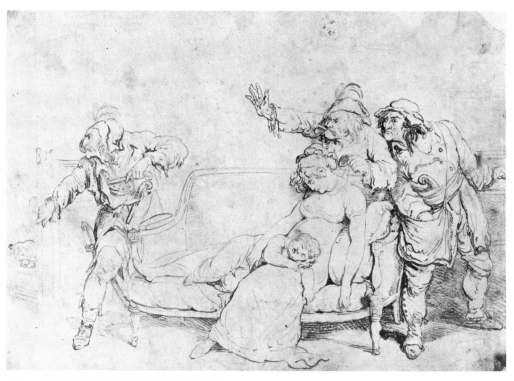

120. DISTURBERS OF DOMESTIC HAPPINESS

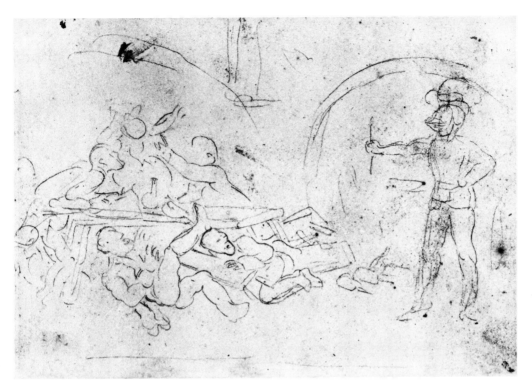

121. A GHOST IN A WINE CELLAR

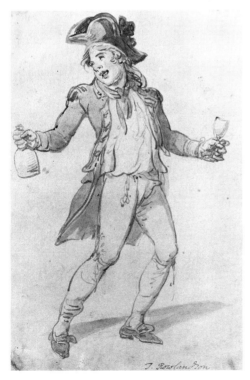

122. A DRUNKEN MIDSHIPMAN

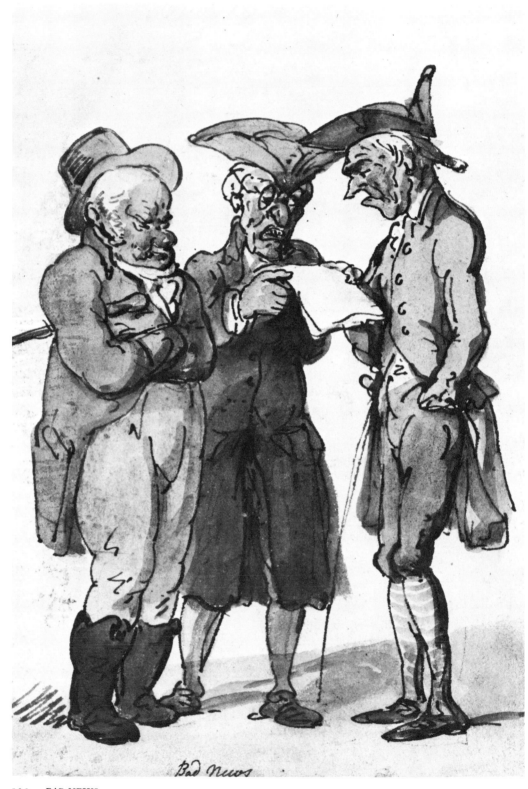

Bad News

123.　BAD NEWS

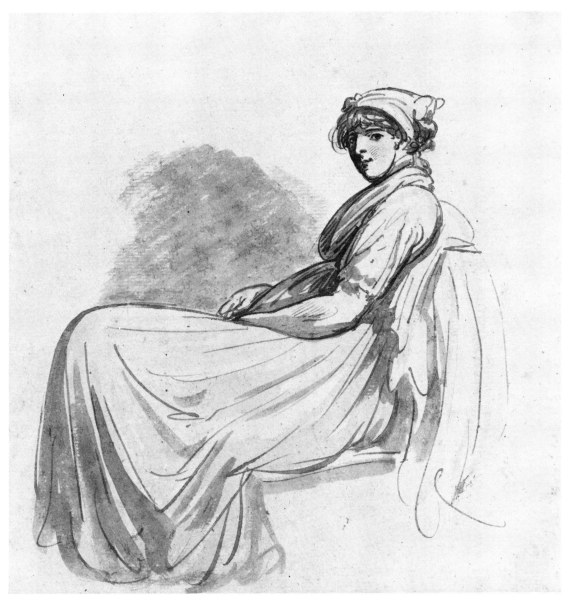

124. SEATED WOMAN

125. A BOXING MATCH

126. STUDIES OF DOGS AND A RABBIT

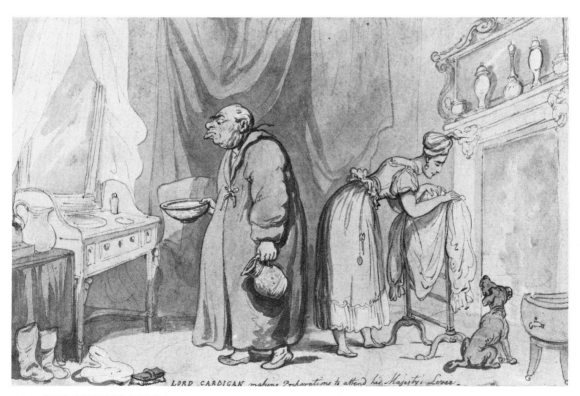

LORD CARDIGAN making Preparations to attend his Majesty's Levee.

127. LORD CARDIGAN AT HOME

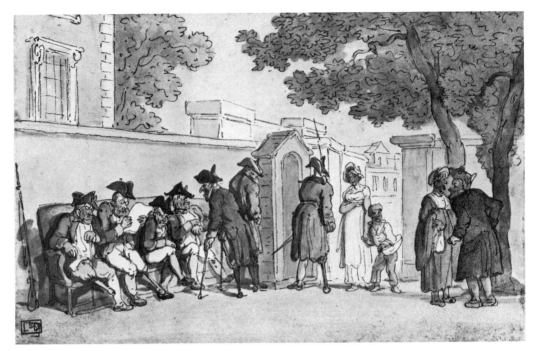

128. CHELSEA PENSIONERS

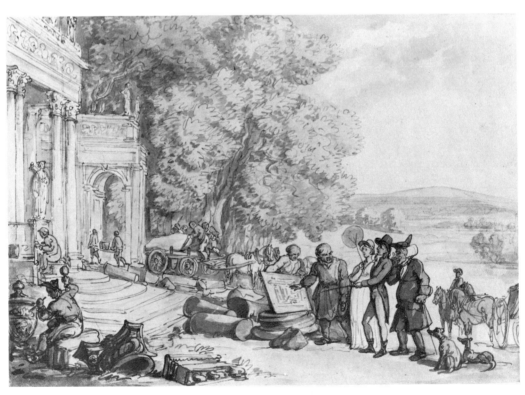

129. A NOBLEMAN IMPROVING HIS ESTATE

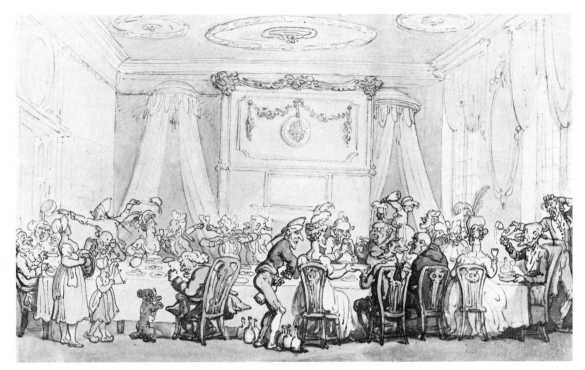

130. A TABLE D'HOTE, OR FRENCH ORDINARY IN PARIS

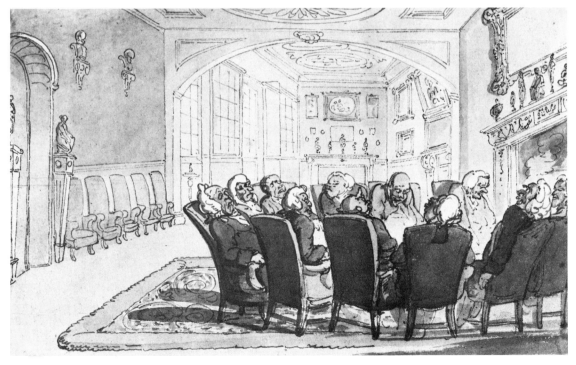

131. A MEETING OF COGNOSCENTI

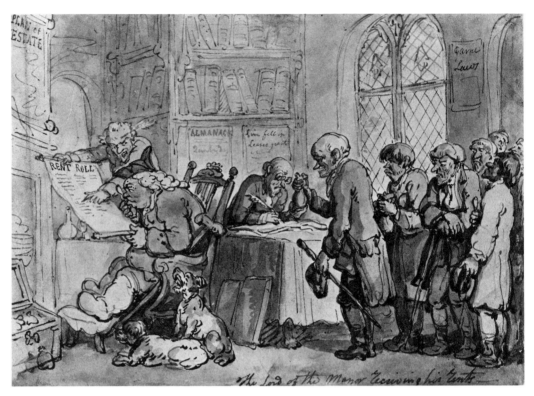

132. THE LORD OF THE MANOR RECEIVING HIS RENTS

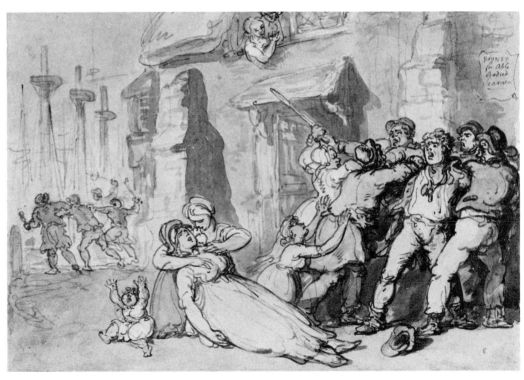

133. THE PRESS GANG

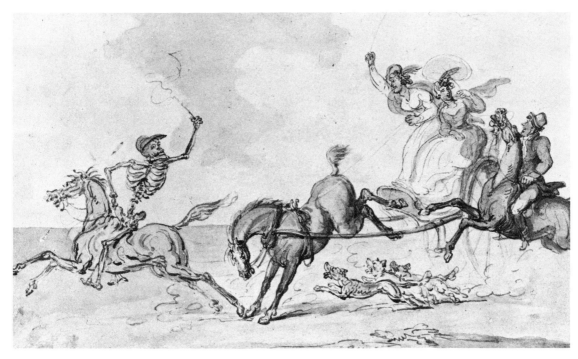

134. ROAD TO RUIN

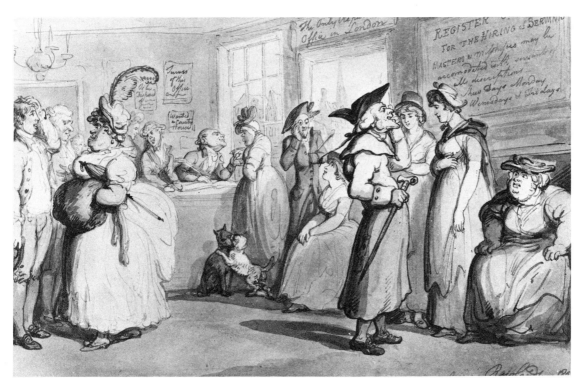

135. THE REGISTRY OFFICE

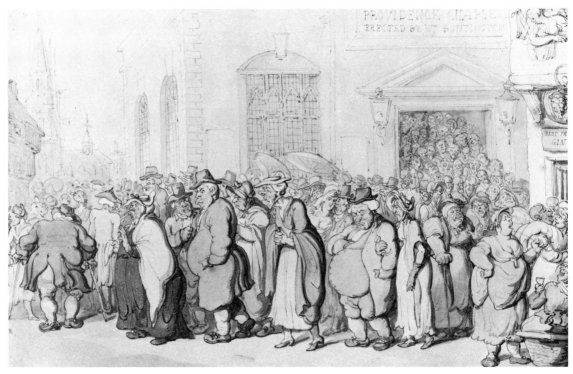

136. PROVIDENCE CHAPEL

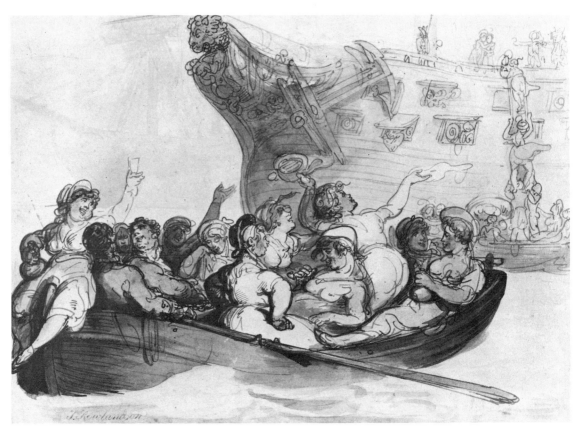

137. SCENE OFF SPITHEAD

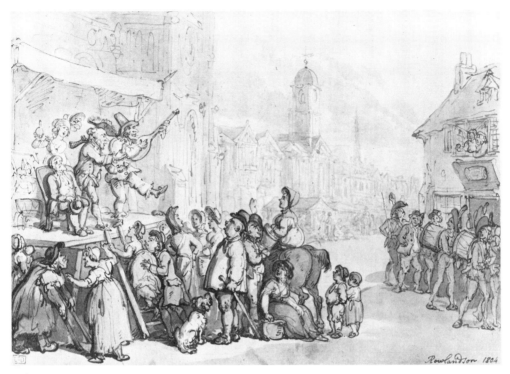

138. THE MOUNTEBANKS

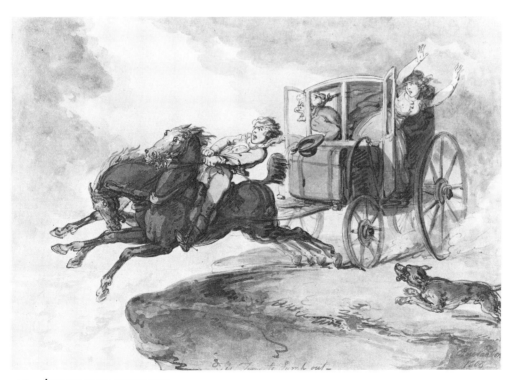

139. 'TIS TIME TO JUMP OUT

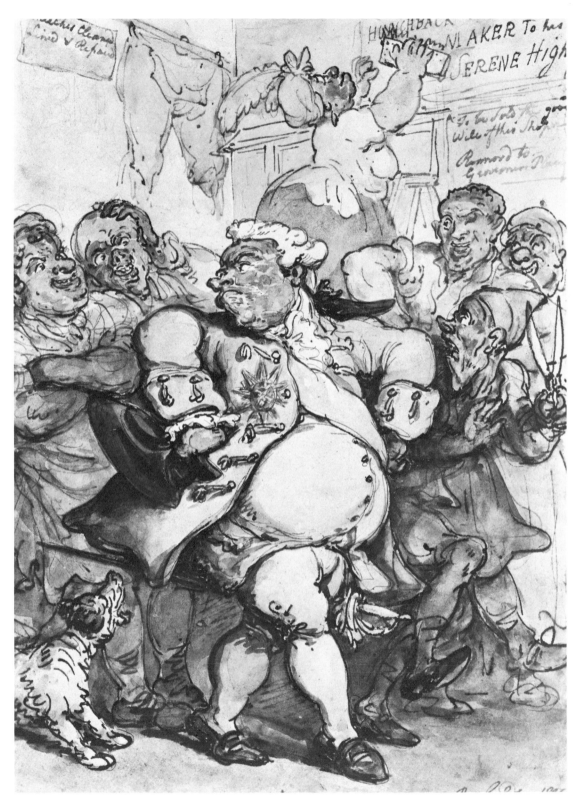

140. RECOVERY OF A DORMANT TITLE

141. TWO HORSEMEN SEEN FROM THE REAR

142. THE SERVANTS' DINNER

143. A PRIZE FIGHT

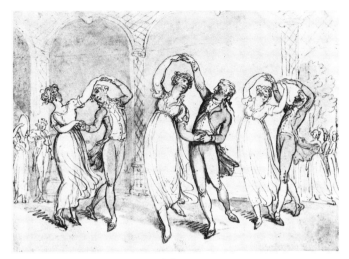

144. THE GERMAN WALTZ (1)

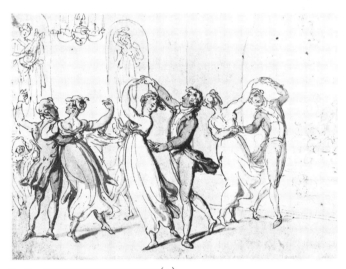

145. THE GERMAN WALTZ (2)

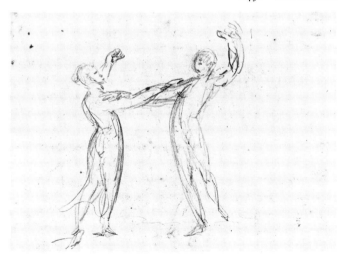

145. [VERSO]

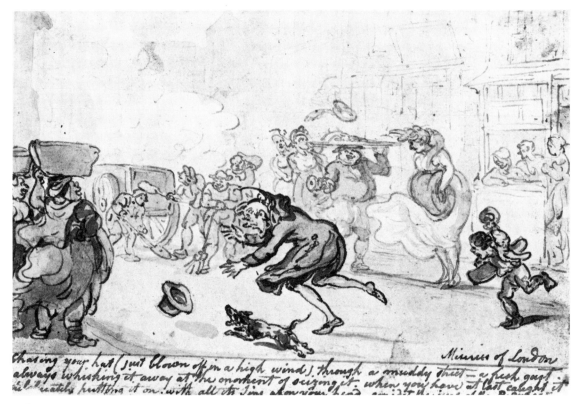

146. CHASING YOUR HAT

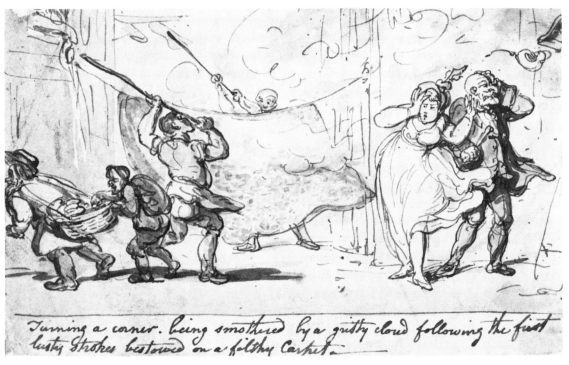

147. BEATING THE CARPET

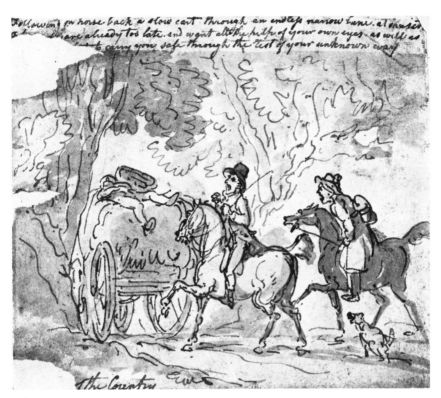

148. FOLLOWING ON HORSEBACK A SLOW CART

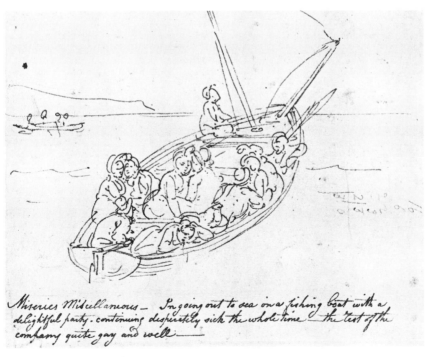

149. MISERY IN A BOAT

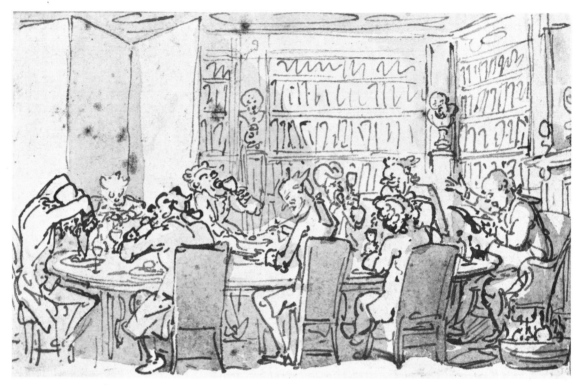

150. FABRICIOUS'S DESCRIPTION OF THE POETS (1)

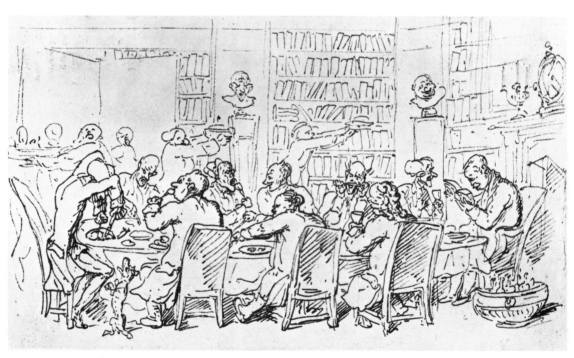

151. FABRICIOUS'S DESCRIPTION OF THE POETS (2)

CURIOSITY CURED.

152. CURIOSITY CURED

153. INTERIOR OF AN EATING HOUSE

154. FOUR HORSES

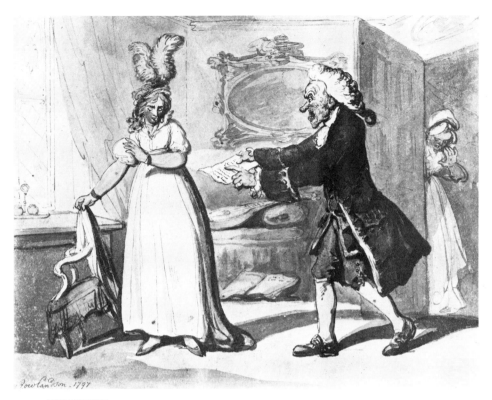

155. THE LETTER

156. SUTTON, NORTHAMPTONSHIRE

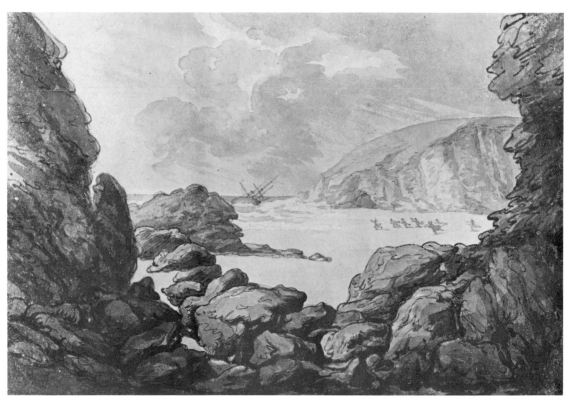

157. COASTAL SCENE WITH SHIPWRECK AND RUNNING FIGURES

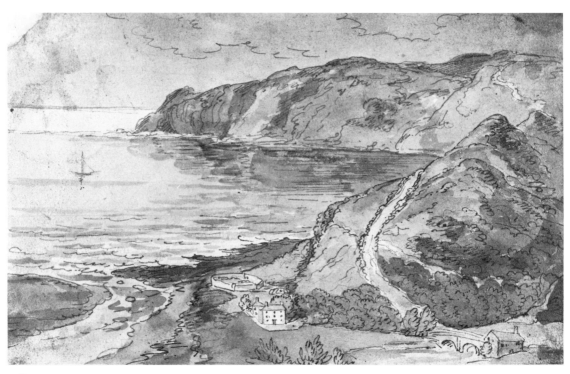

158. COASTAL VIEW FROM A BLUFF, A HOUSE IN CENTER FOREGROUND, BRIDGE AND
HOUSE TO RIGHT

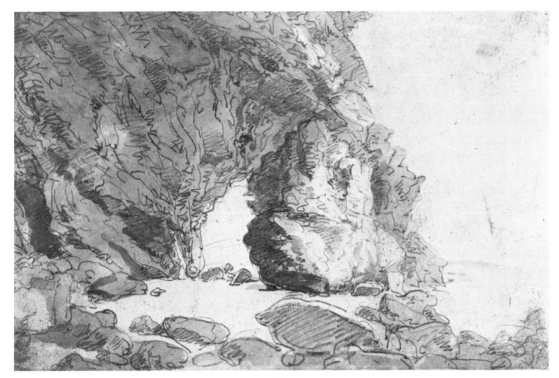

159. COAST SCENE WITH NATURAL ROCK BRIDGE (1)

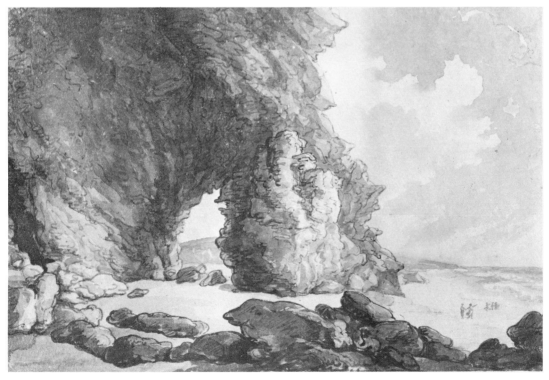

160. COAST SCENE WITH NATURAL ROCK BRIDGE (2)

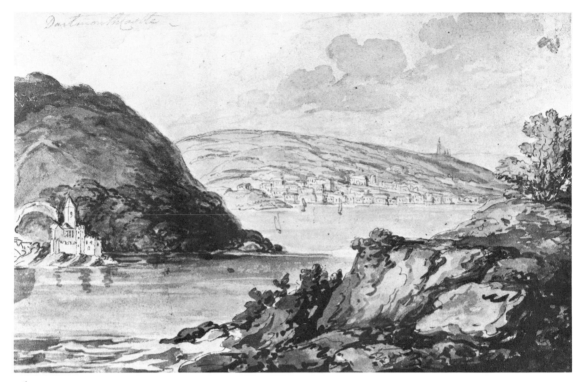

161. DARTMOUTH CASTLE FROM KINGSWEAR

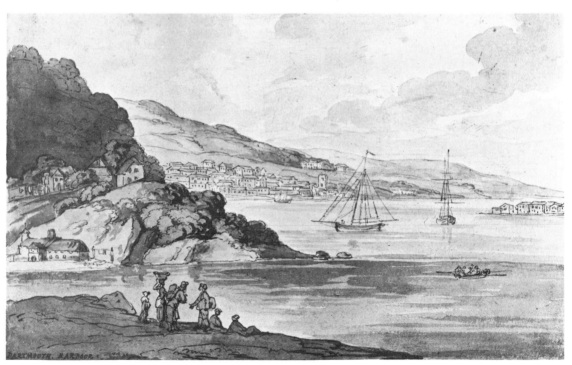

162. DARTMOUTH HARBOR

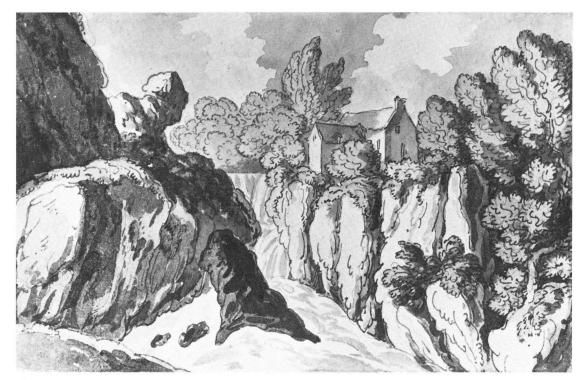

163. HOUSE NEAR A ROCKY GORGE

164. RURAL LANDSCAPE WITH A CHURCH ON A HILL

165. TWO SAILBOATS ON A LAKE, ROCKY BANK TO LEFT

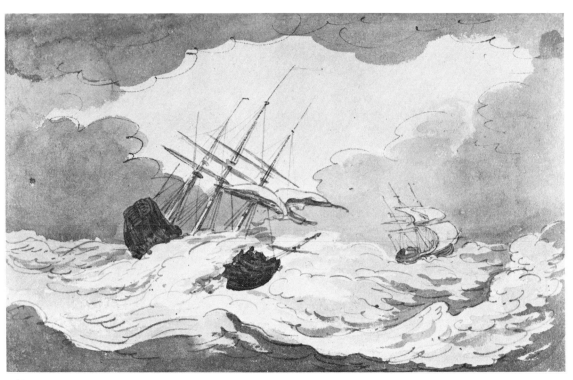

166. TWO SHIPS IN A STORM

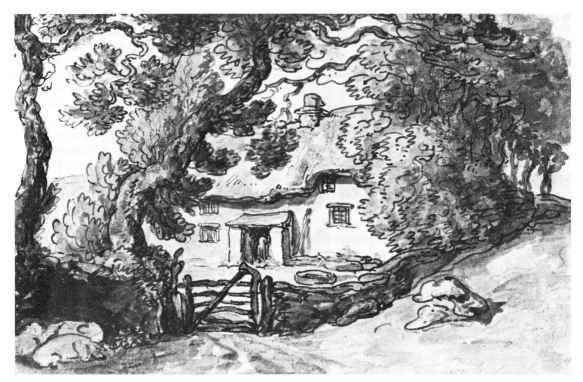

167. COUNTRY COTTAGE WITH GATE AND STONE FENCE

168. RUINS OF A CONVENT IN WILTSHIRE

169. STREAM IN A HILLY LANDSCAPE

170. THE LOGAN ROCK, CORNWALL

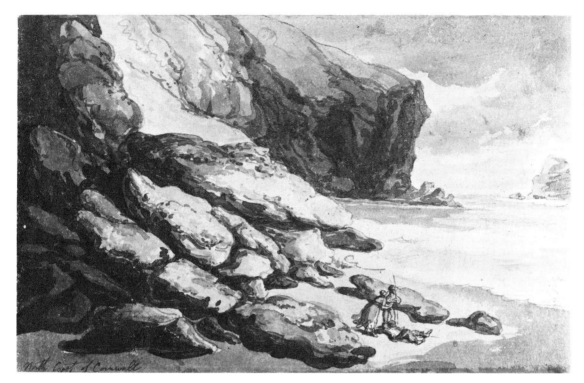

171. NORTH COAST OF CORNWALL

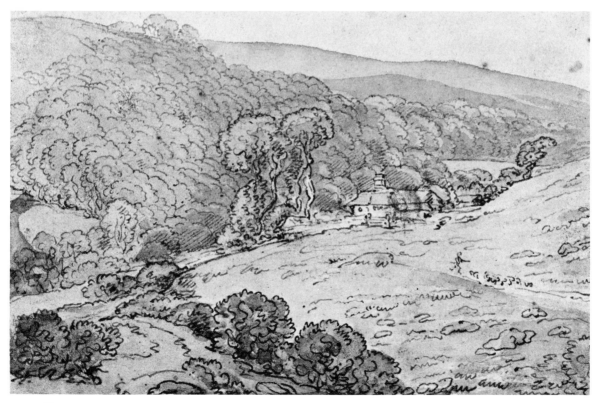

172. FARM IN A HILLY LANDSCAPE

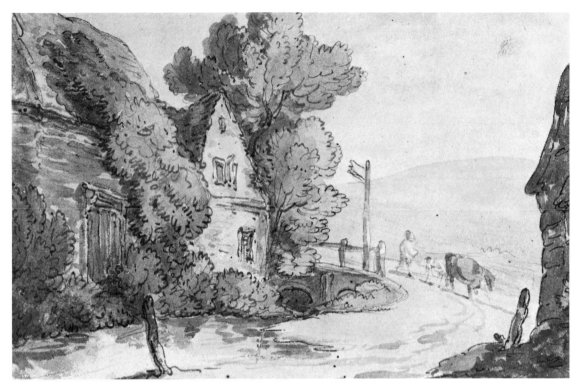

173. COTTAGE NEAR A BRIDGE

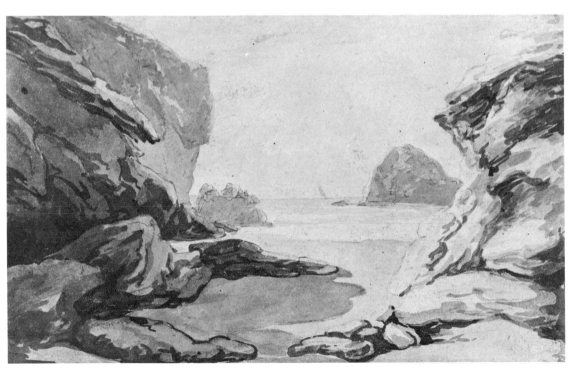

174. A COVE ON A ROCKY SHORELINE

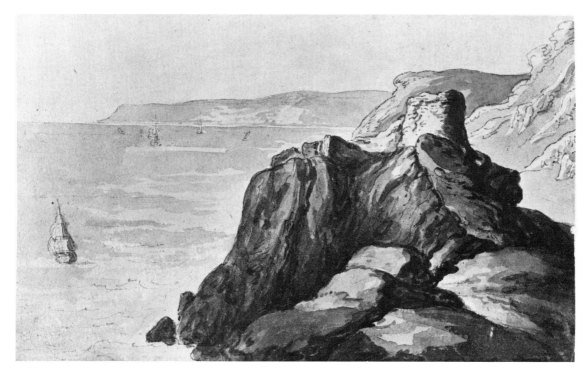

175. A RUINED TOWER ON A SEA COAST

176. DEER BENEATH A LARGE TREE

177. A HUNTER WITH THREE DOGS WALKING THROUGH WOODS

178. COASTAL SCENE WITH CASTLE, HULK, AND MEN FISHING

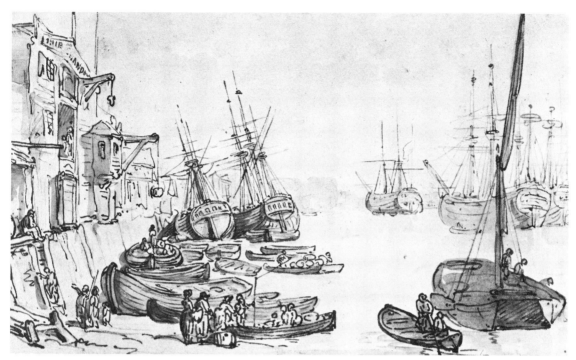

179. THAMES [?] DOCKYARD

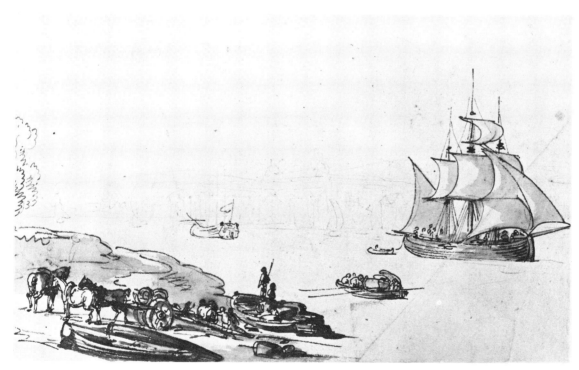

180. RIVER SCENE (GREENWICH?)

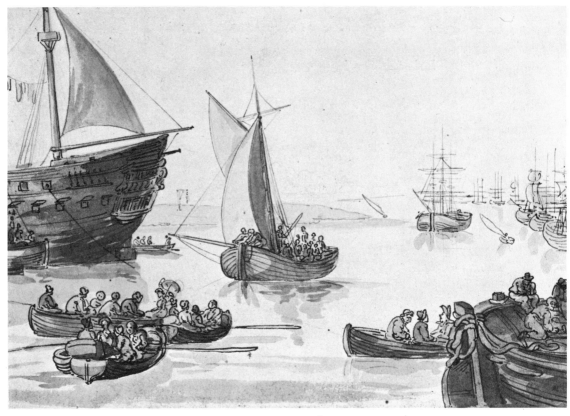

181. HARBOR SCENE WITH MANY FIGURES IN BOATS; MAN O' WAR TO LEFT

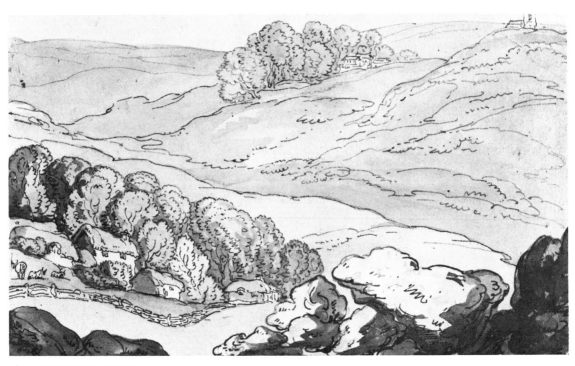

182. BRENT TOR, DEVON

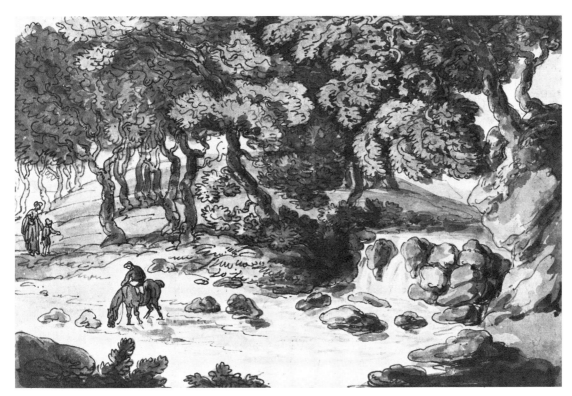

183. CORNISH CASCADE

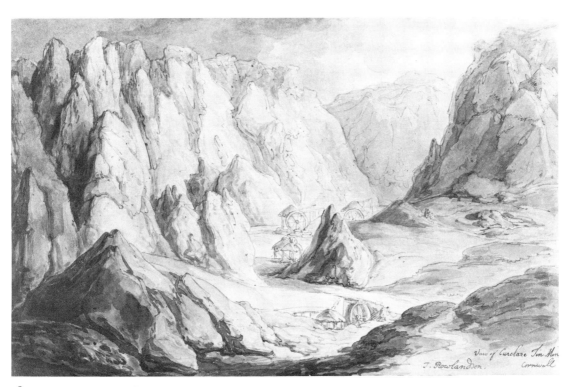

184. CARCLAZE TIN MINE

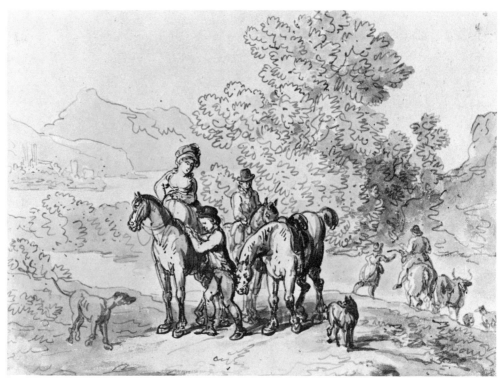

185. FIGURES ON HORSEBACK; A BOY ADJUSTING A LADY'S SADDLE

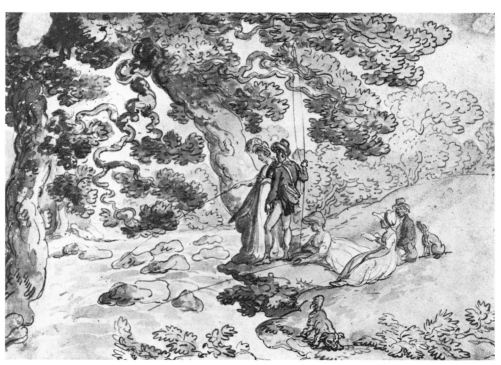

186. A FISHING PARTY

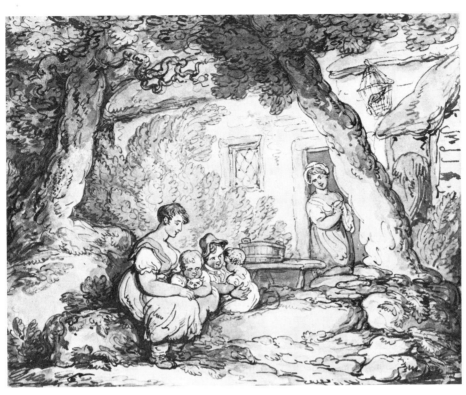

187. THE COTTAGE DOOR

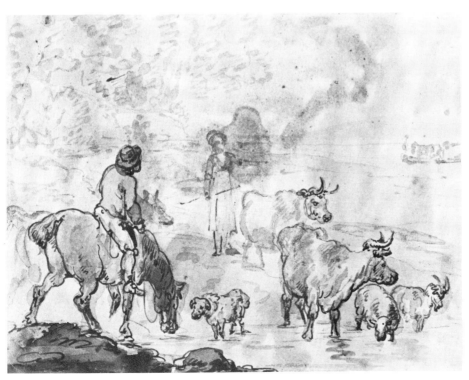

188. CATTLE WITH MOUNTED HERDSMAN AND A GIRL

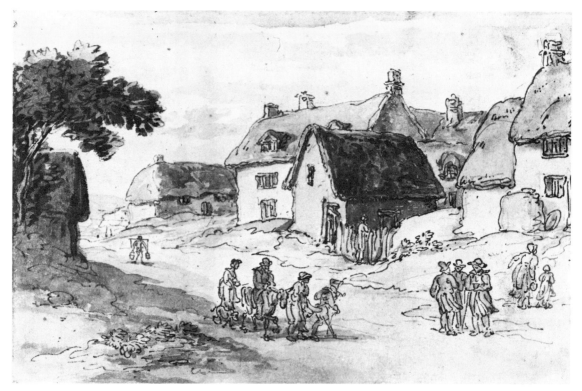

189. VILLAGE STREET SCENE

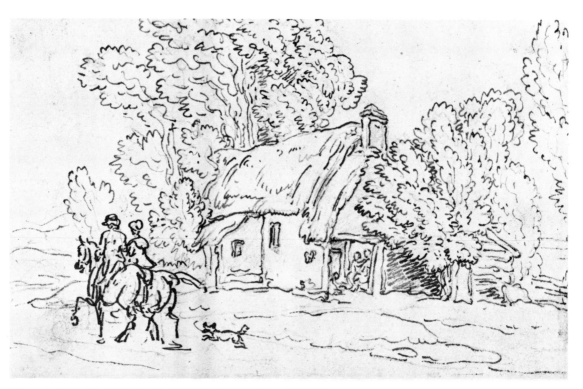

190. A MAN AND WOMAN ON HORSEBACK PASSING A COTTAGE

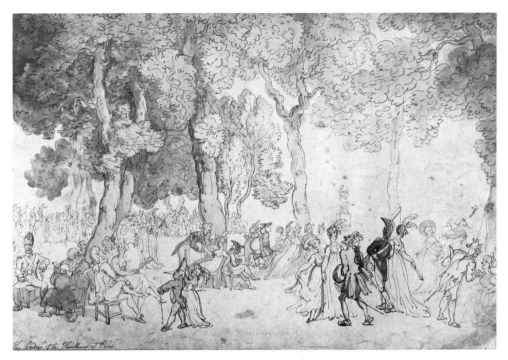

192. THE TUILERIES GARDENS

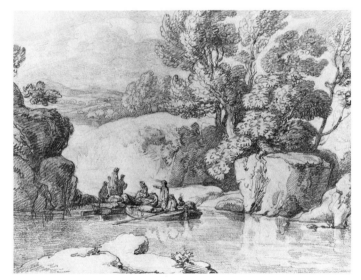

191. RIVER LANDSCAPE WITH FIGURES

193. A JUDGE SEATED IN
 DOCTORS' COMMONS

194. A LECTURE ON HEADS

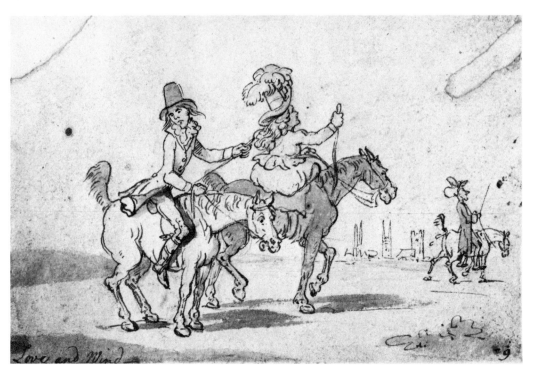

195. LOVE AND WIND

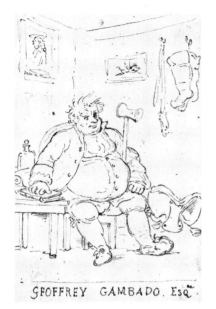

196. GEOFFREY GAMBADO, ESQ.

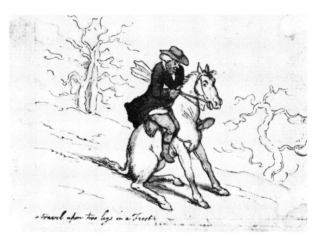

197. HOW TO TRAVEL UPON TWO LEGS IN A FROST

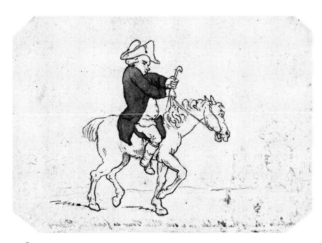

198. MR. GAMBADO SEEING THE WORLD

199. FIRE AT ALBION MILLS, BLACKFRIARS BRIDGE

200. PASS ROOM, BRIDEWELL

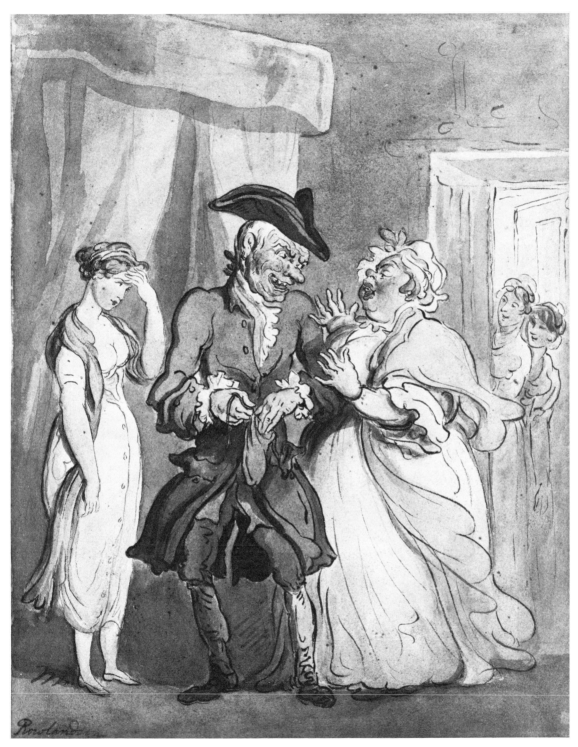

201. INNOCENCE IN DANGER

202. FIGURES WALKING BY A RIVER

203. STREET SCENE

204. PLEASURE BOATS, A HOUSE IN THE BACKGROUND

205. A LARGE BOATING PARTY WITH WATER MUSIC

206. THE PUBLIC LIBRARY, CAMBRIDGE

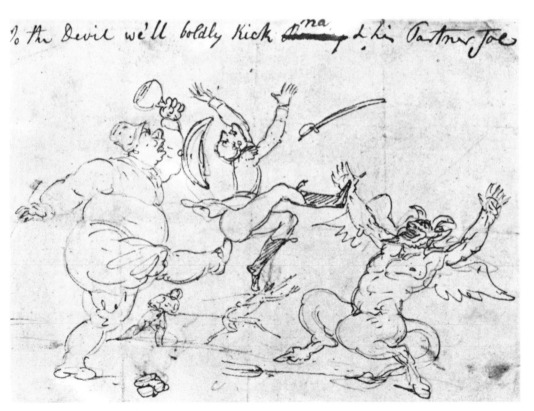

207. TO THE DEVIL WE'LL BOLDLY KICK NAP AND HIS PARTNER JOE

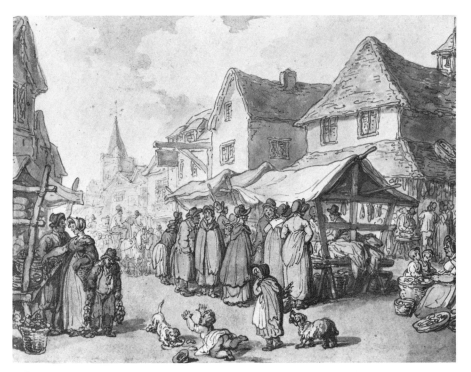

208. A VILLAGE MARKET

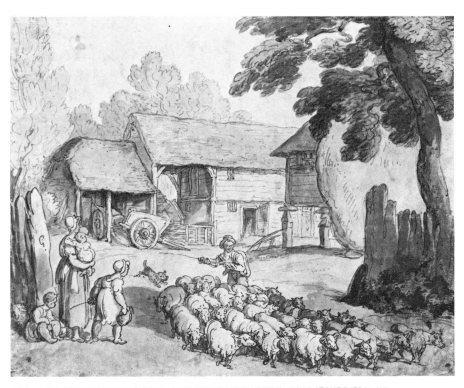

209. A MAN HERDING SHEEP; FIGURES TO THE LEFT; FARMBUILDINGS IN
 THE BACKGROUND

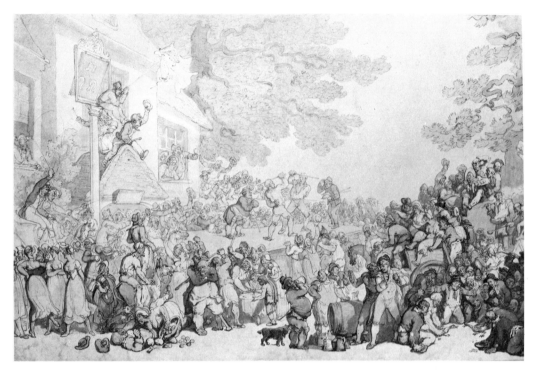

210.　A SINGLE STICK MATCH

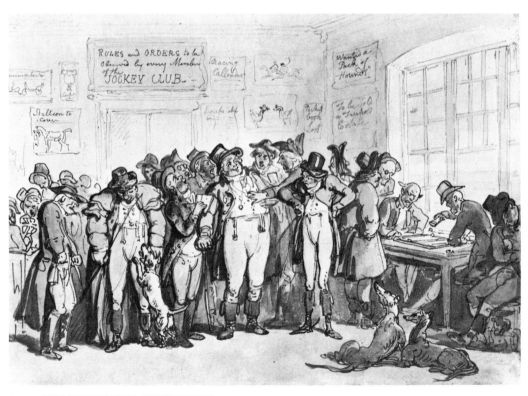

211.　THE JOCKEY CLUB, NEWMARKET

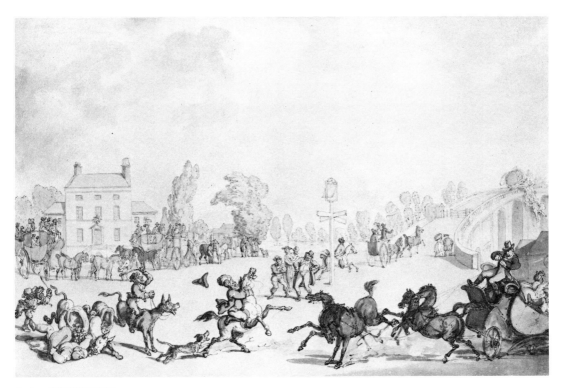

212. KEW BRIDGE

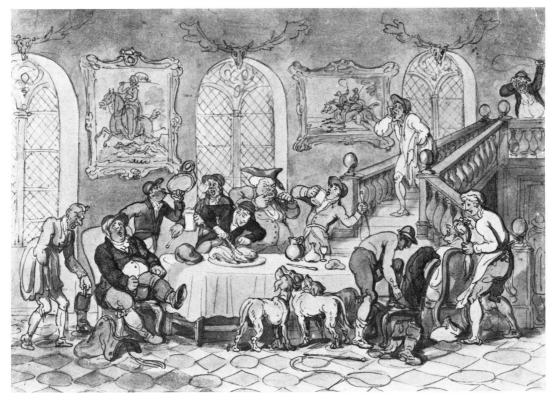

213. THE HUNT BREAKFAST

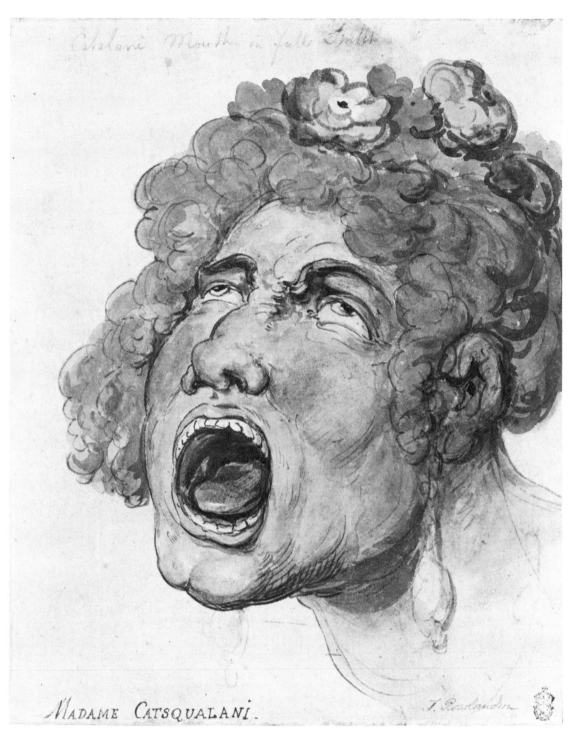

Catalani Mouth in full Gullet

MADAME CATSQUALANI.

T. Rowlandson

214. MADAME CATSQUALANI

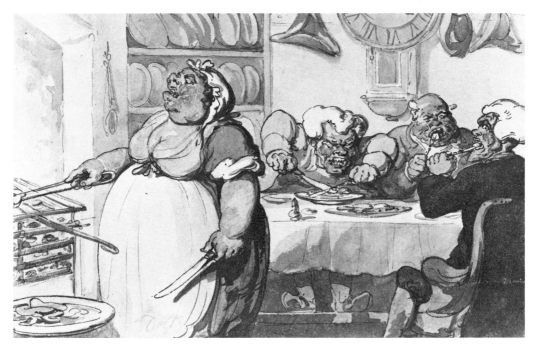

215. THREE MEN AT TABLE AND A COOK

Virtue in Danger or Symptoms of Vice

216. VIRTUE IN DANGER OR SYMPTOMS OF [?]

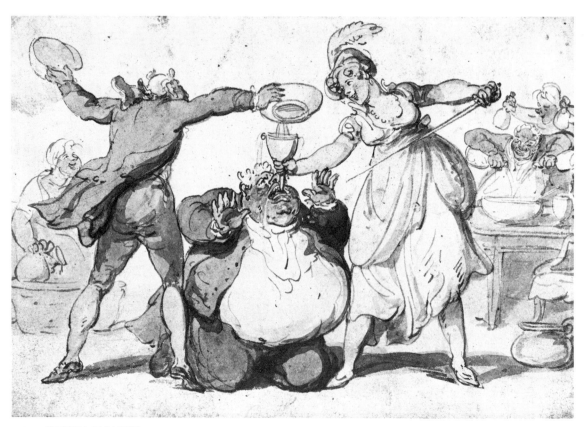

217. TESTING CAPACITY

218. A COACH AND FOUR

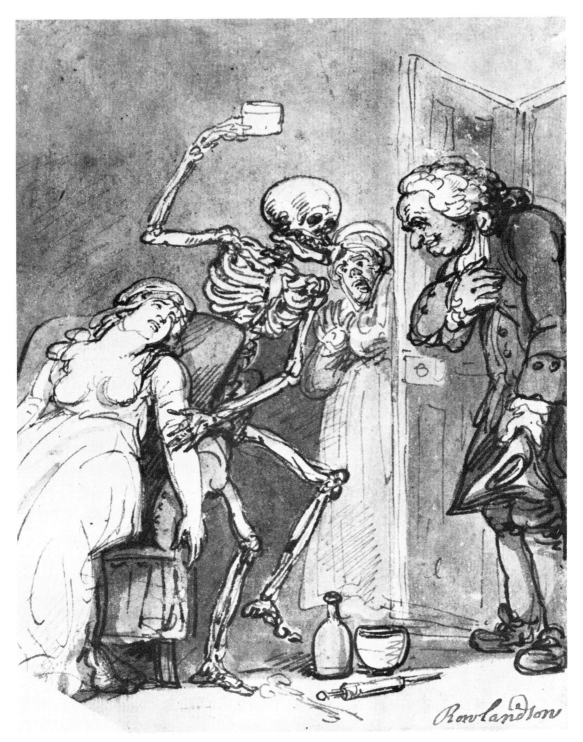

219. THE DOCTOR GREETS DEATH

220. THREE MEN SEATED AROUND A TABLE

A Brace of Fellows of Brazen Nose — Coll —

221. A BRACE OF FELLOWS OF BRAZEN NOSE COLLEGE

222. A COACH PASSING A HOUSE IN THE COUNTRY

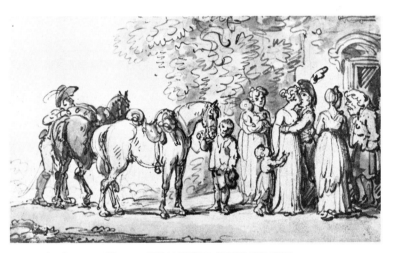

223. A YOUNG SOLDIER TAKING LEAVE OF HIS FAMILY

223. [VERSO]

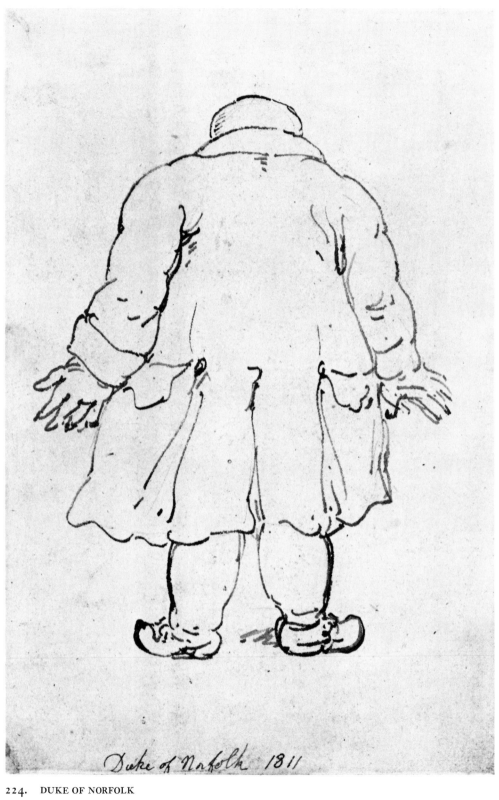

Duke of Norfolk 1811

224. DUKE OF NORFOLK

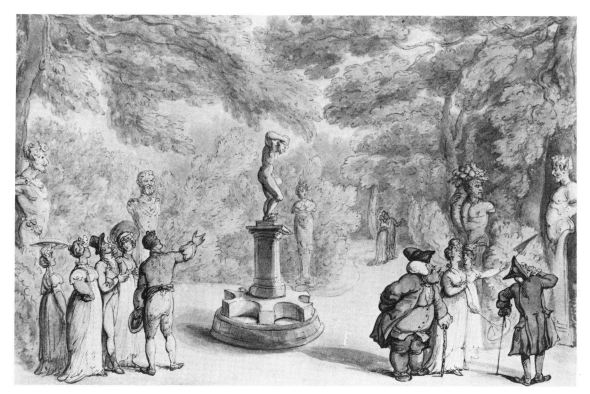

225. STOWE GARDENS (?)

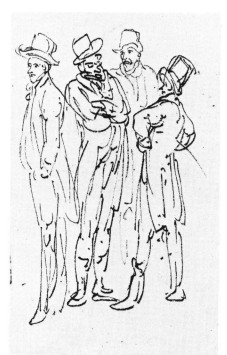

226. FOUR MEN STANDING

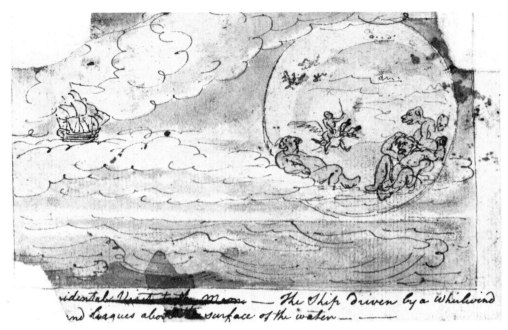

*idental Visit to the Moon — The Ship Driven by a Whirlwind
nd Leagues about the surface of the water —*

227. SHIP DRIVEN BY A WHIRLWIND

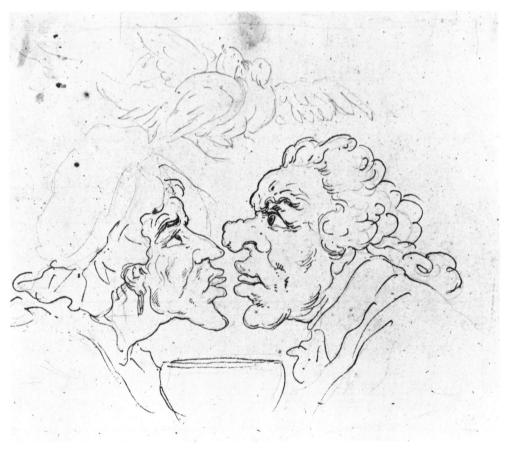

228. MOCK TURTLE

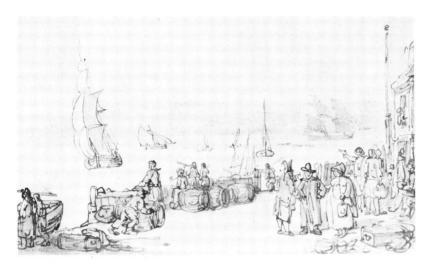

229. PORTSMOUTH AND THE ISLE OF WIGHT

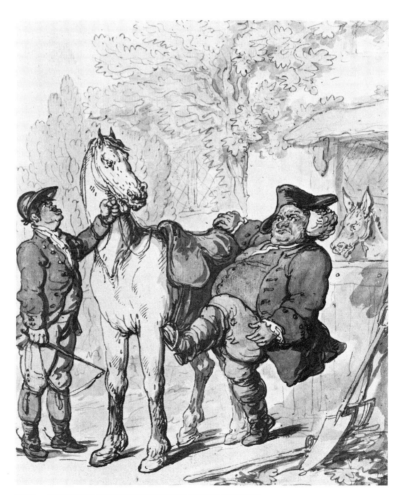

230. LONDON JOCKEY GOING TO NEWMARKET

231. CONVERSATION AT A GATE

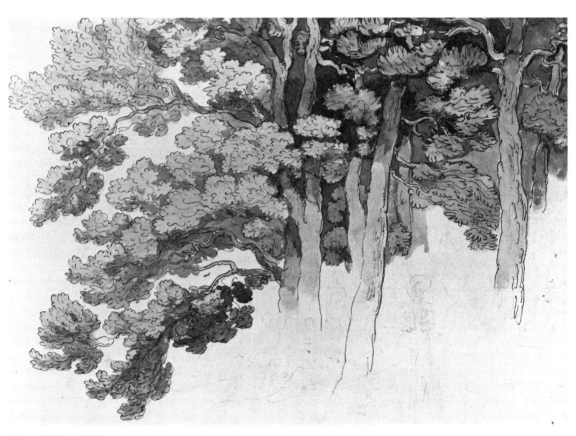

232. TREE STUDY

233. HUNTING SCENE

234. ARRIVAL OF THE COACH AT BATH

235. TATTERSALL'S

236. PIC-A-BACK MUSICIANS

237. SCOTS GREYS AT WATERLOO

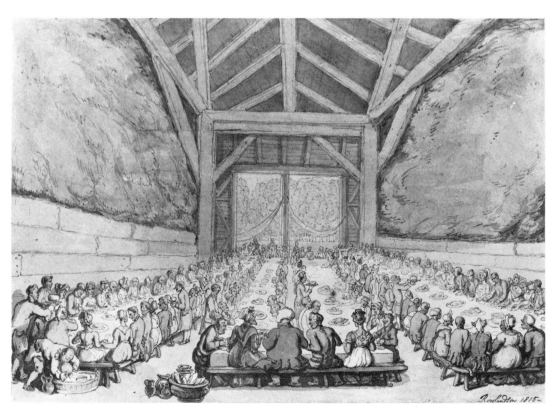

238. A WATERLOO CELEBRATION

239. A BULL LOOSE IN A CROWD

Moll Flackett had run to save her life

240. MOLL FLACKETT

241. A HORSERACE WITH MALE AND FEMALE RIDERS

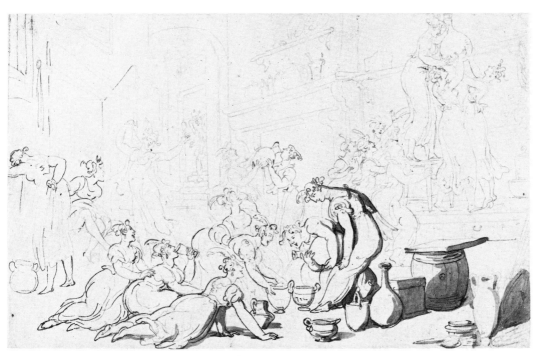

242. A BACCHANALIAN SCENE AT DON LUIGI'S BALL

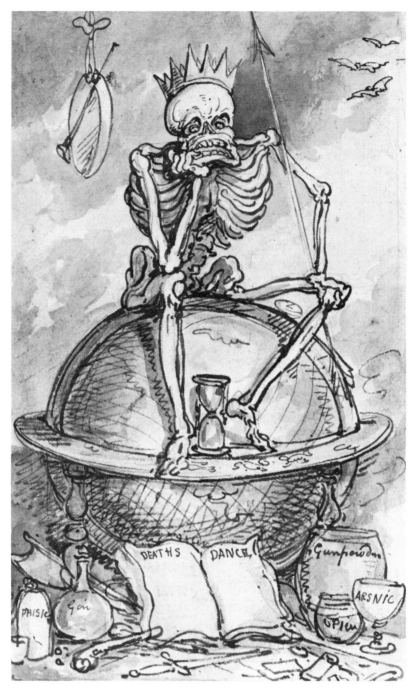

243. DEATH SEATED ON THE GLOBE

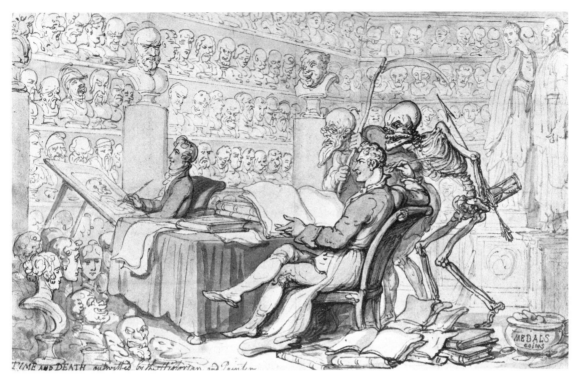

244. TIME AND DEATH

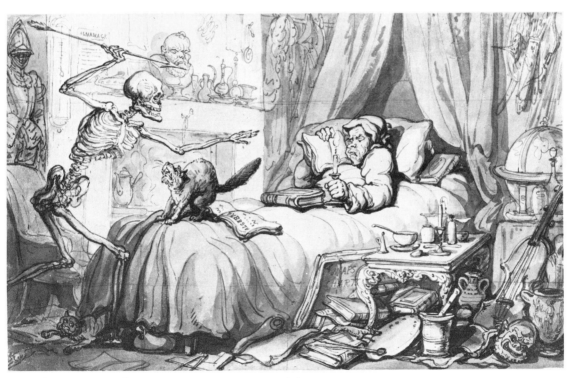

245. THE ANTIQUARY'S LAST WILL AND TESTAMENT (1)

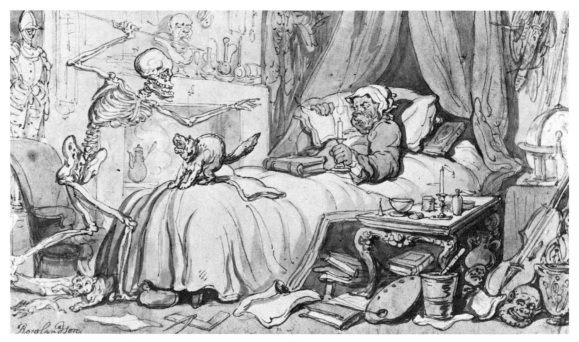

246. THE ANTIQUARY'S LAST WILL AND TESTAMENT (2)

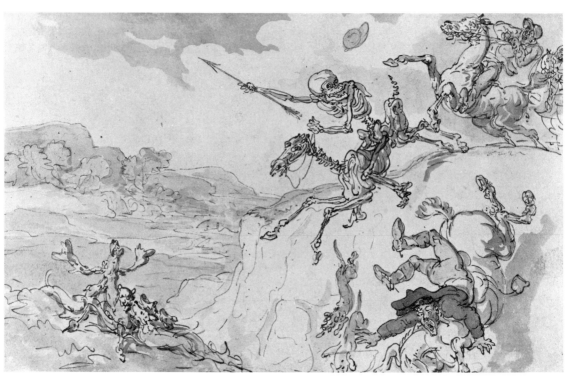

247. THE LAST CHASE (1)

248. THE LAST CHASE (2)

249. THE LAST CHASE (3)

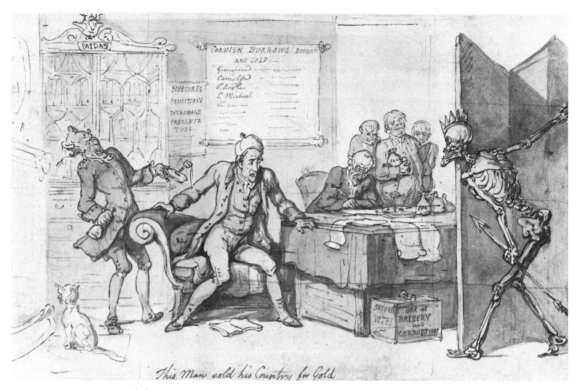

250. THE STATESMAN (1)

251. THE STATESMAN (2)

252. THE STATESMAN (3)

253. TOM HIGGINS

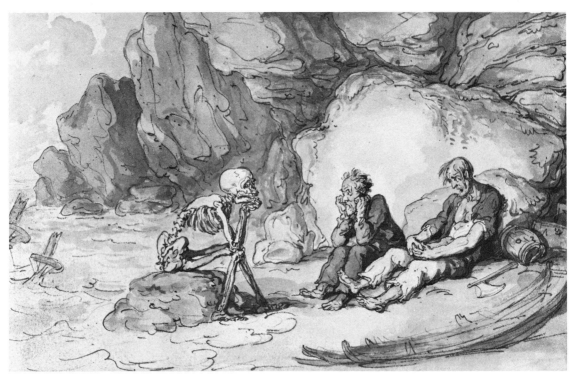

254. THE SHIPWRECK

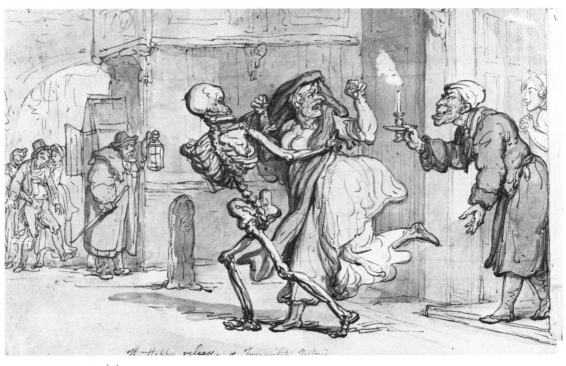

255. THE VIRAGO (1)

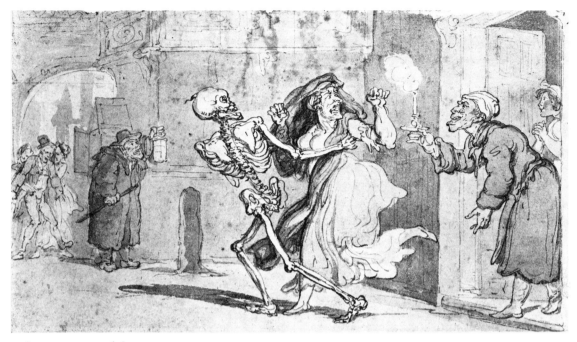

256. THE VIRAGO (2)

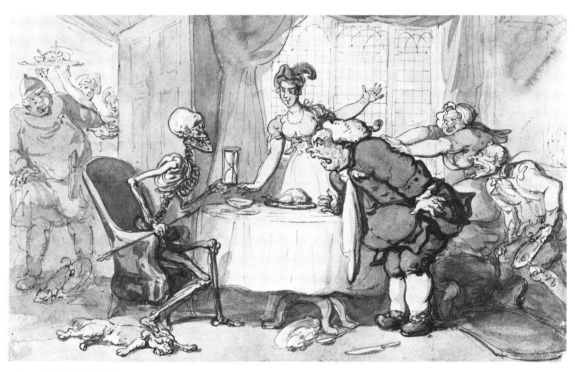

257. THE GLUTTON

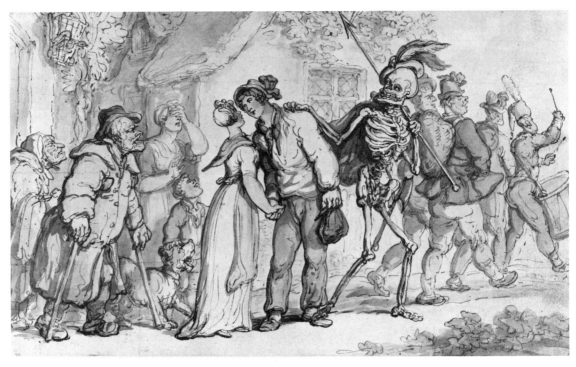

258. THE RECRUIT (1)

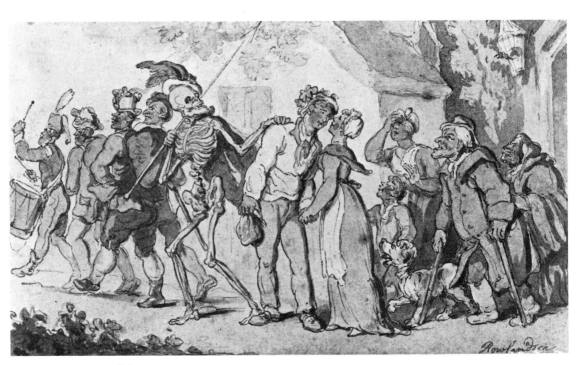

259. THE RECRUIT (2)

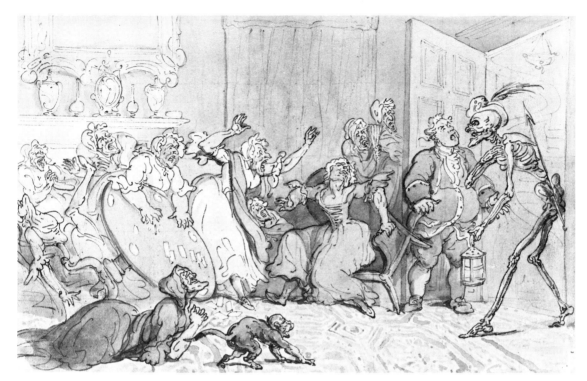

260. THE MAIDEN LADIES (1)

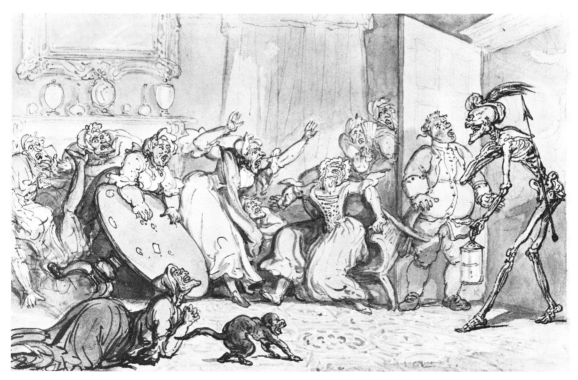

261. THE MAIDEN LADIES (2)

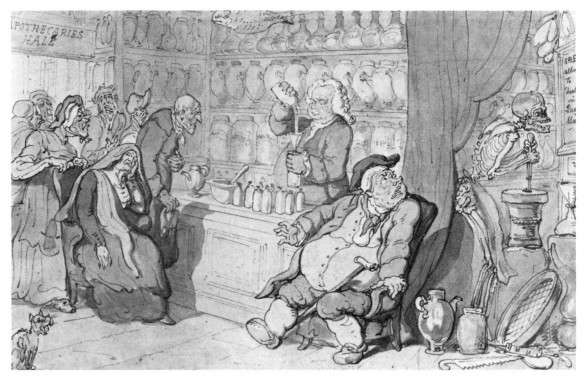

262. THE QUACK DOCTOR

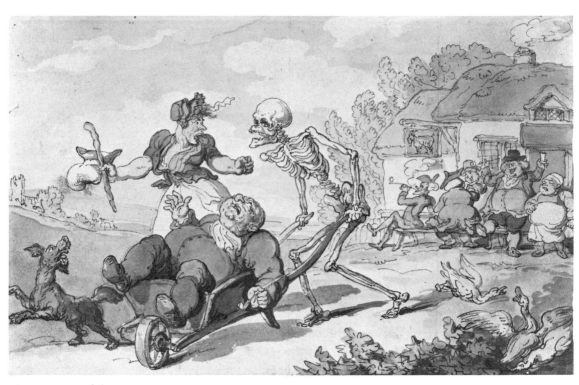

263. THE SOT (1)

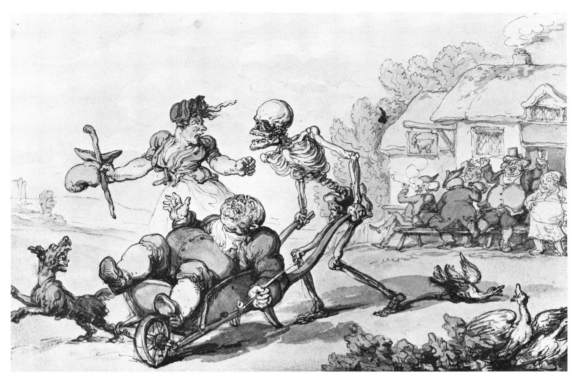

264. THE SOT (2)

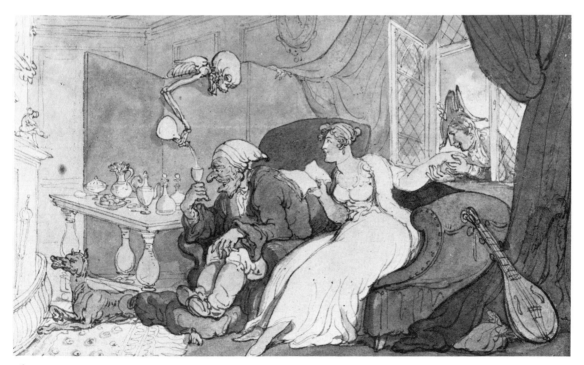

265. THE HONEY MOON

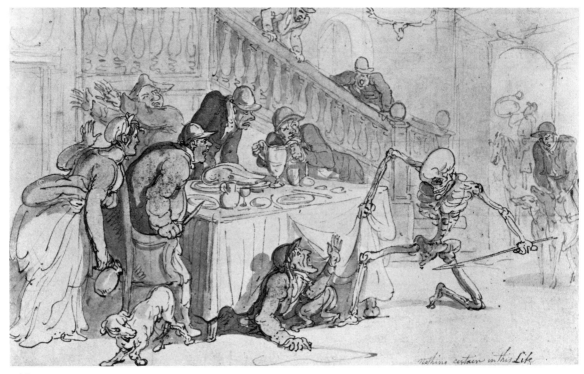

266. THE HUNTER UNKENNELLED

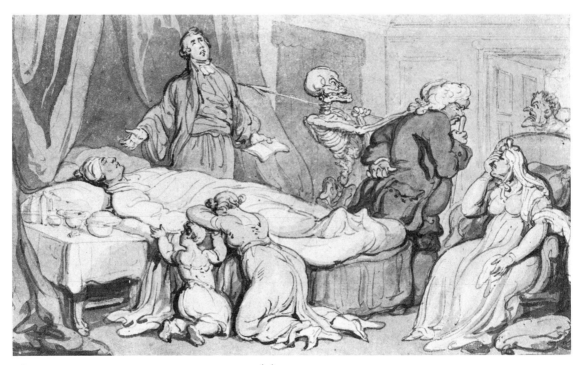

267. THE GOOD MAN, DEATH, AND THE DOCTOR (1)

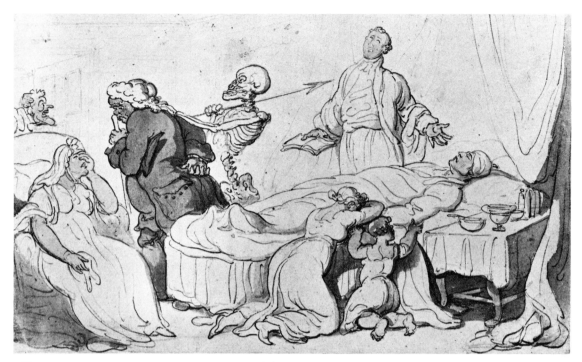

268. THE GOOD MAN, DEATH, AND THE DOCTOR (2)

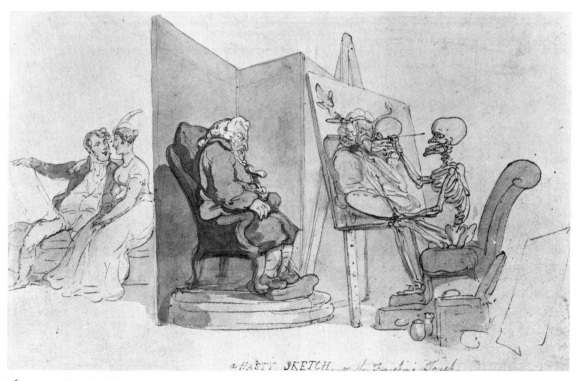

269. DEATH AND THE PORTRAIT

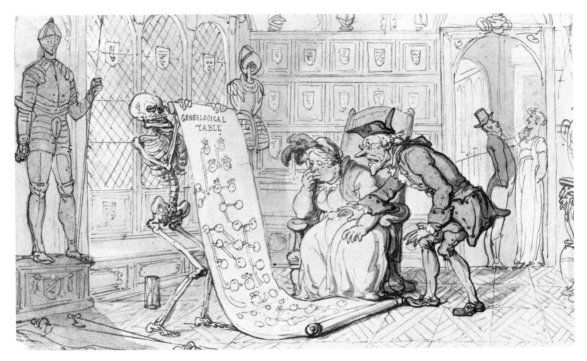

270. THE GENEALOGIST

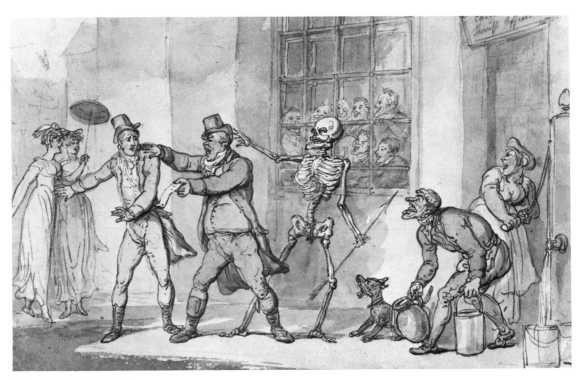

271. THE CATCHPOLE

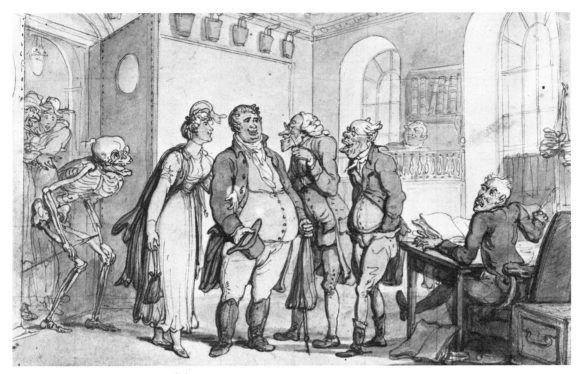

272. THE INSURANCE OFFICE (1)

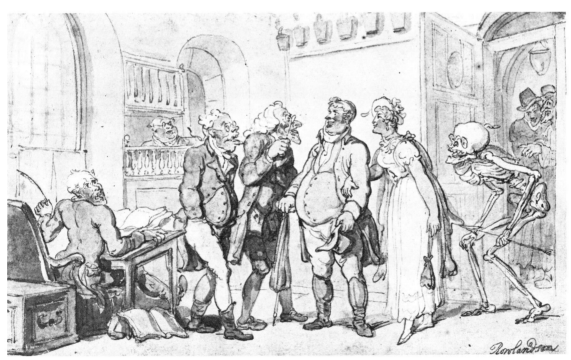

273. THE INSURANCE OFFICE (2)

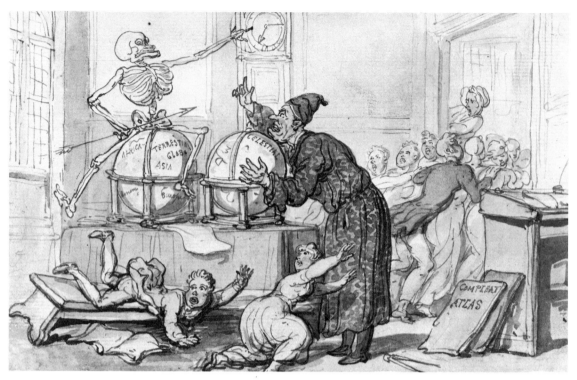

274. THE SCHOOLMASTER

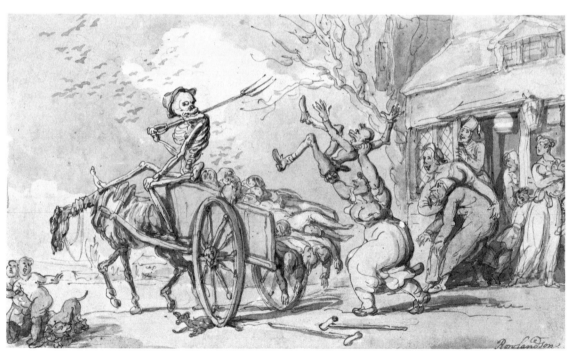

277. TIME & DEATH, AND GOODY BARTON

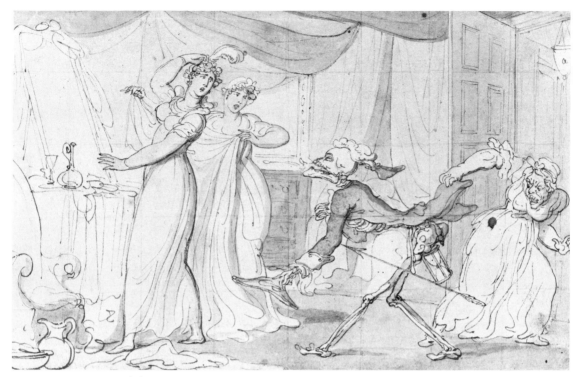

275. THE COQUETTE (1)

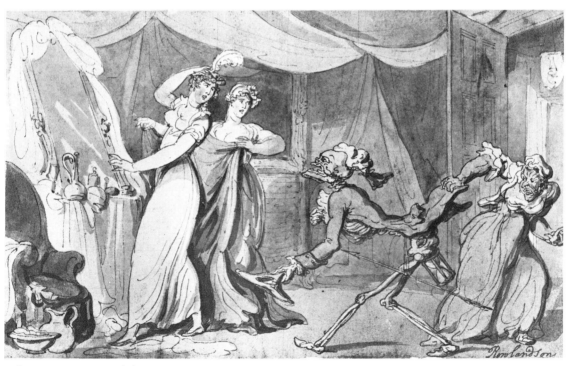

276. THE COQUETTE (2)

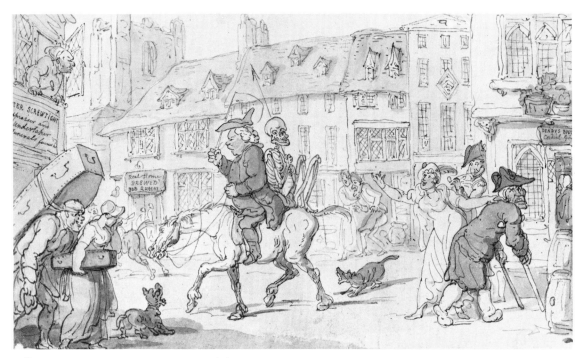

278. THE UNDERTAKER & THE QUACK (1)

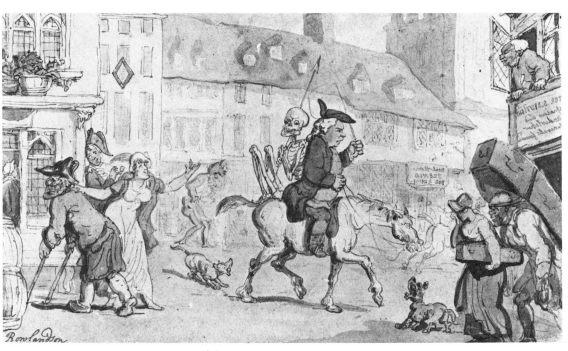

279. THE UNDERTAKER & THE QUACK (2)

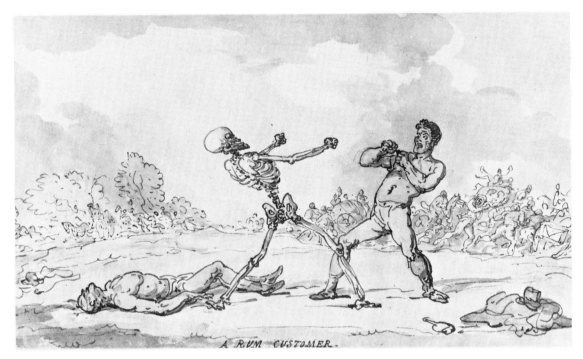

280. THE DEATH BLOW

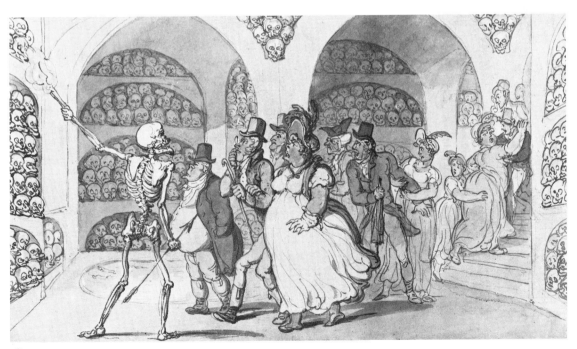

281. THE VISION OF SKULLS

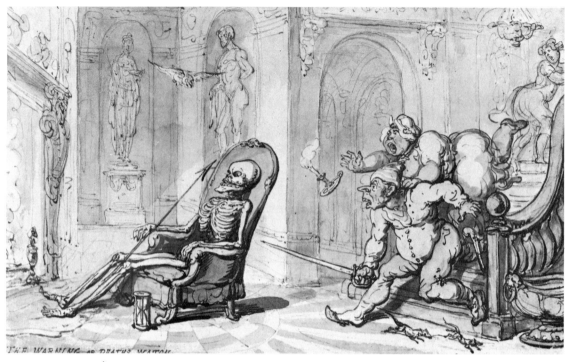

282. THE PORTER'S CHAIR

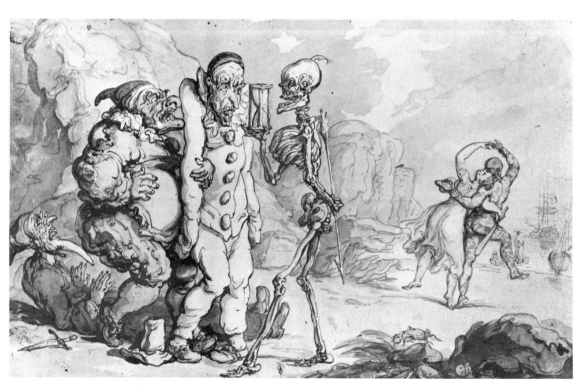

283. THE PANTOMIME (1)

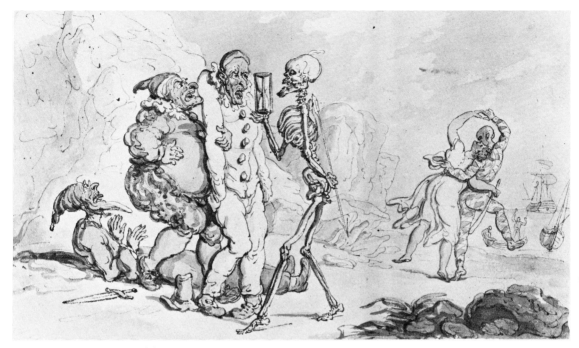

284. THE PANTOMIME (2)

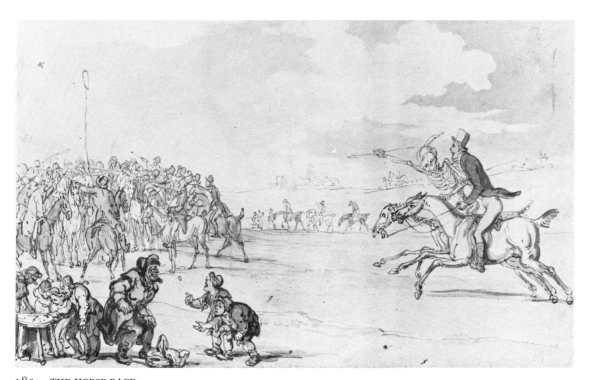

285. THE HORSE RACE

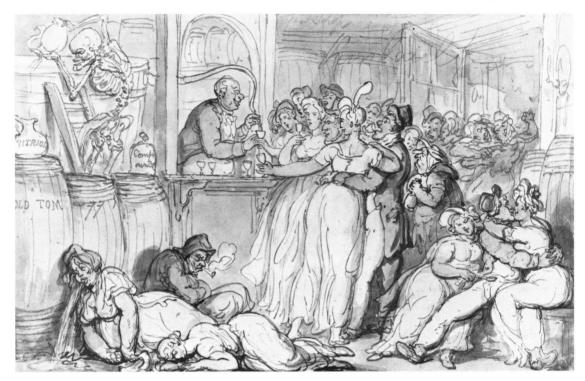

286. THE DRAM SHOP

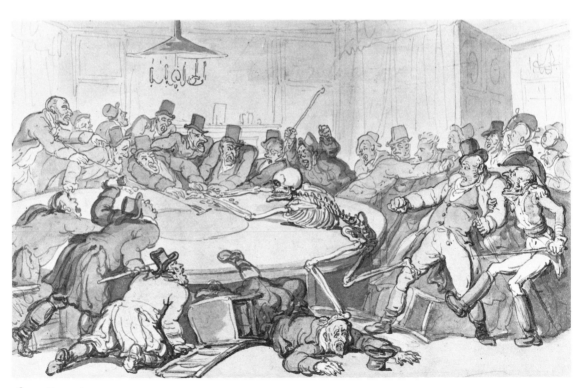

287. THE GAMING TABLE

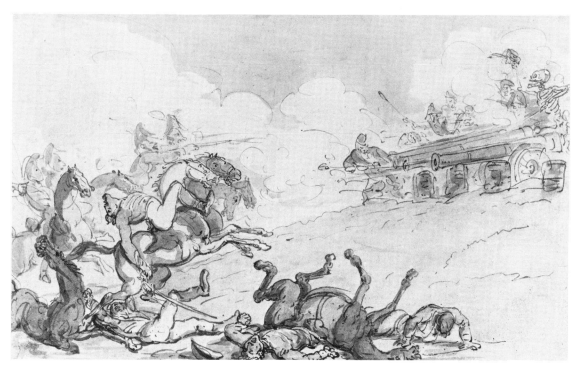

288. THE BATTLE

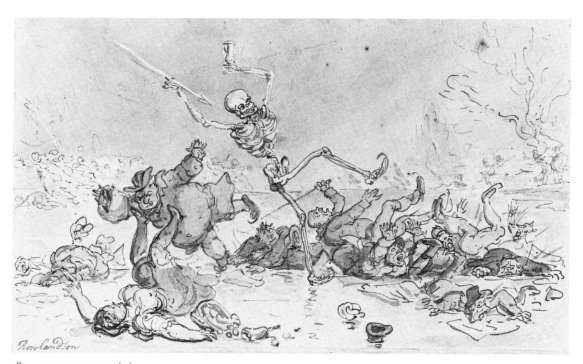

289. THE SKATERS (I)

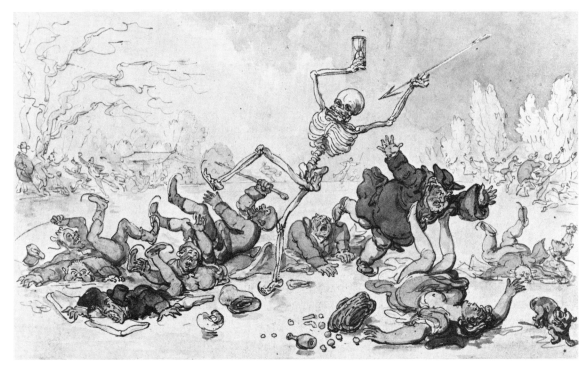

290. THE SKATERS (2)

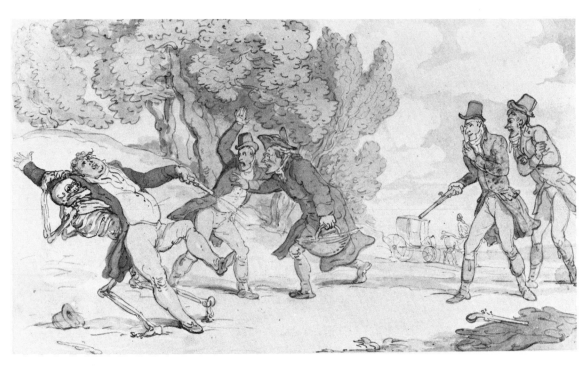

291. THE DUEL

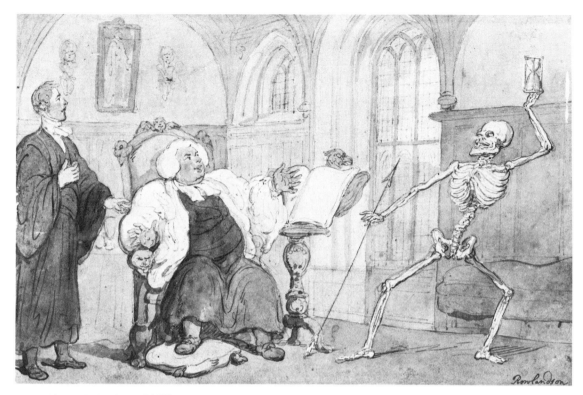

292. THE BISHOP AND DEATH

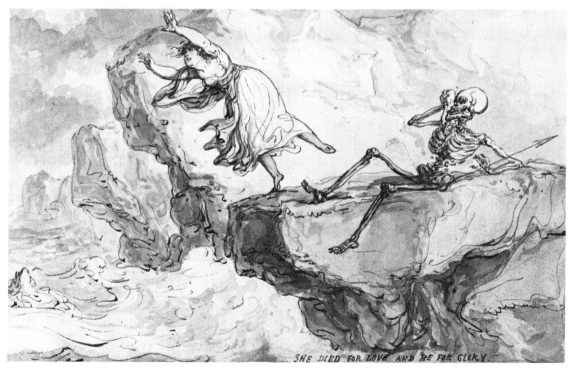

SHE DIED FOR LOVE AND HE FOR GLORY.

293. THE SUICIDE

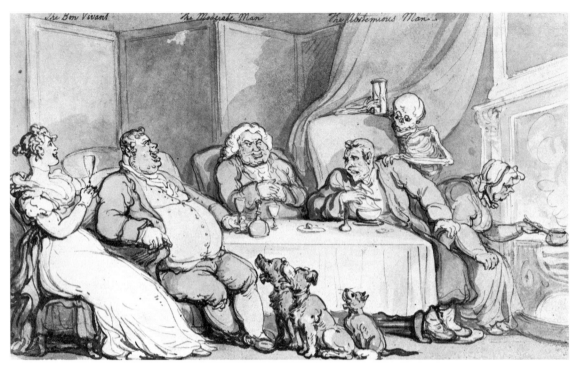

294. CHAMPAGNE, SHERRY, AND WATER GRUEL (1)

295. CHAMPAGNE, SHERRY, AND WATER GRUEL (2)

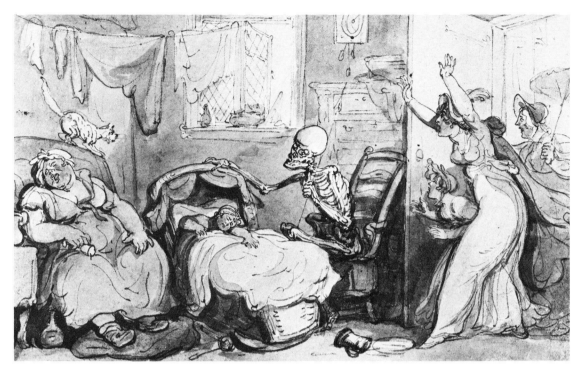

296. THE NURSERY

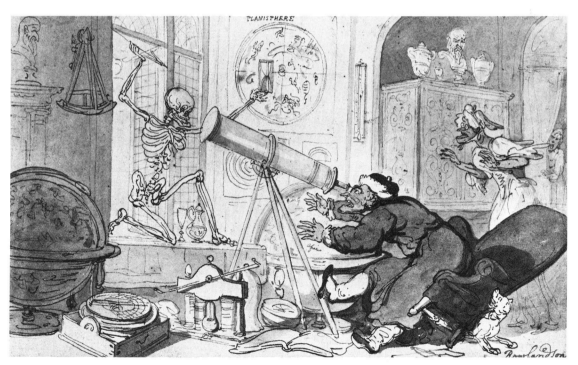

297. THE ASTRONOMER

298. THE FATHER OF THE FAMILY

299. THE FALL OF THE FOUR IN HAND

300. GAFFER GOODMAN

301. THE URCHIN ROBBERS

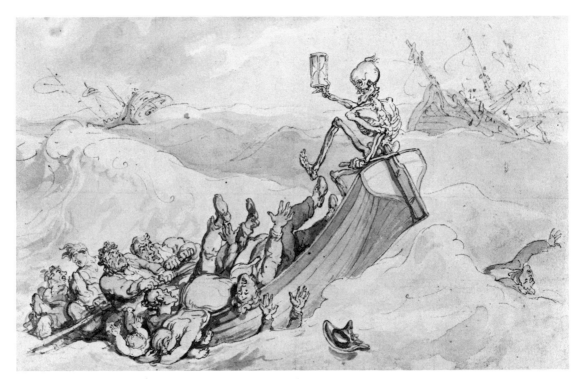

302. DEATH TURNED PILOT

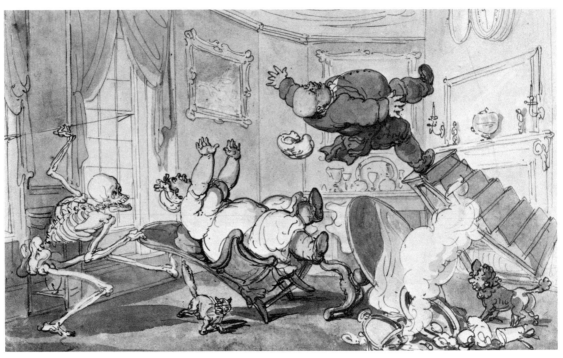

303. THE WINDING UP OF THE CLOCK

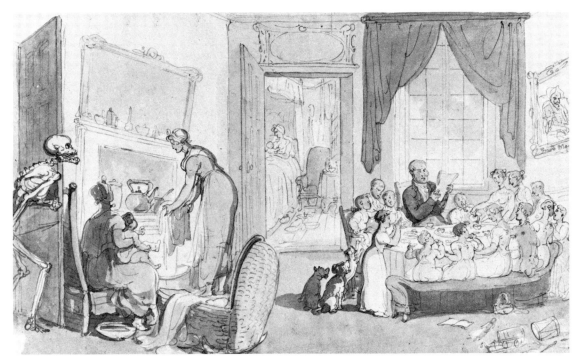

304. THE FAMILY OF CHILDREN

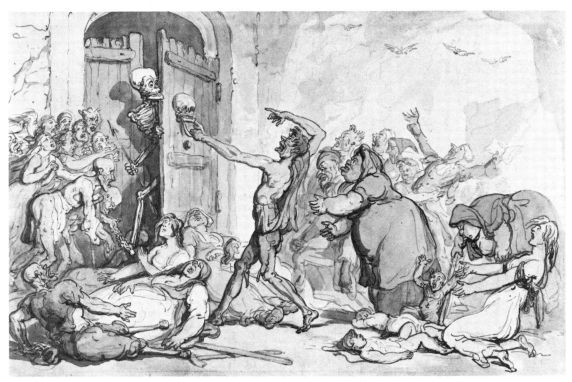

305. DEATH'S DOOR (1)

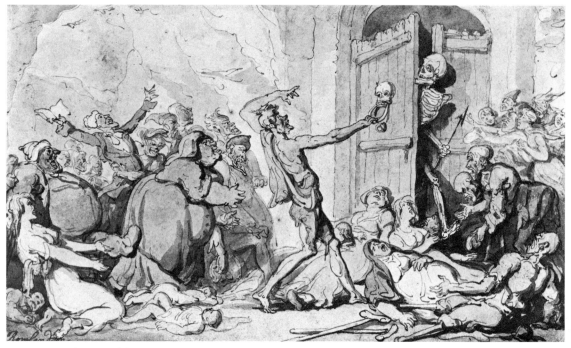

306. DEATH'S DOOR (2)

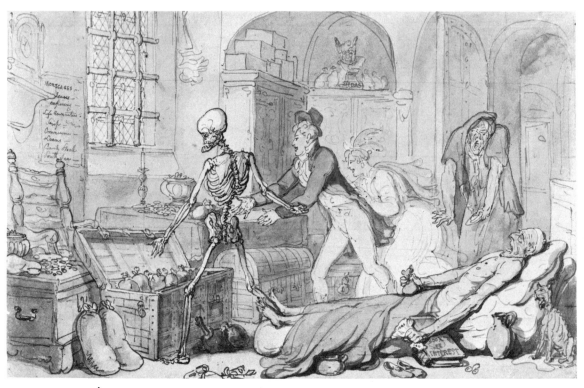

307. THE MISER'S END

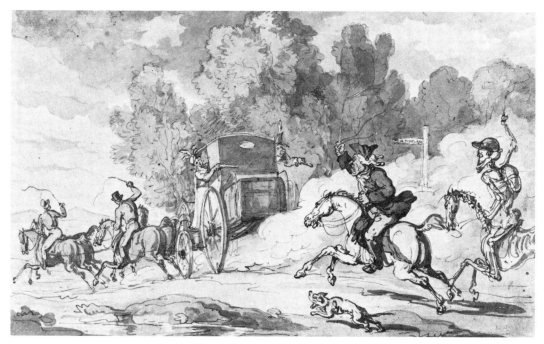

308. GRETNA GREEN

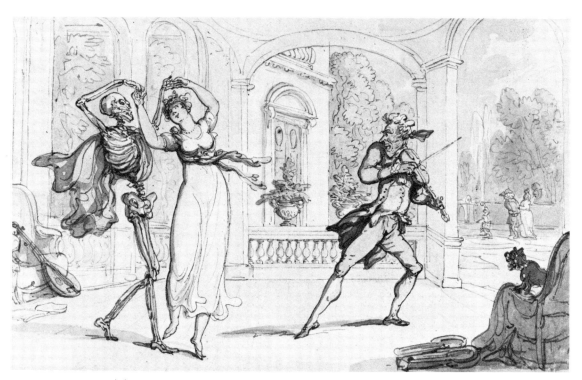

309. THE WALTZ (1)

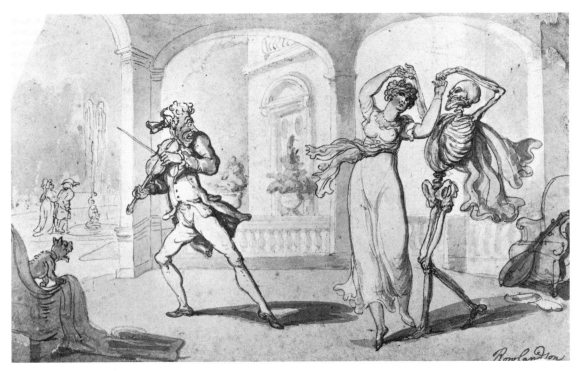

310. THE WALTZ (2)

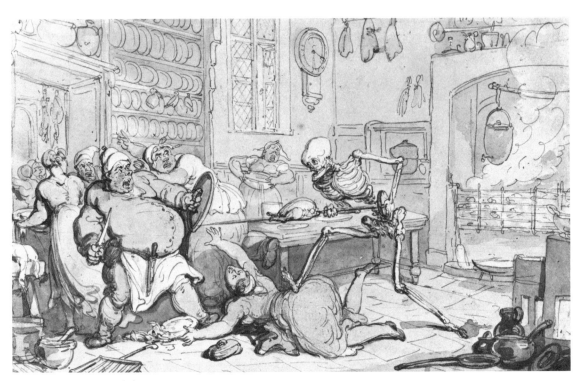

311. THE KITCHEN (1)

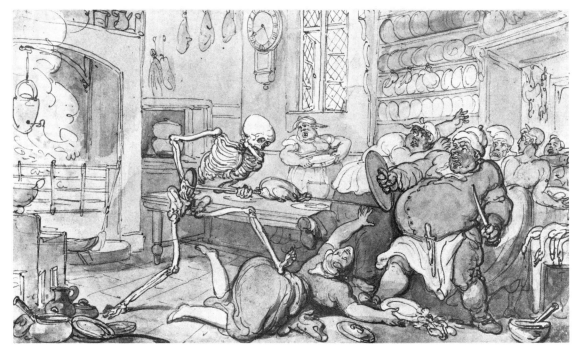

312. THE KITCHEN (2)

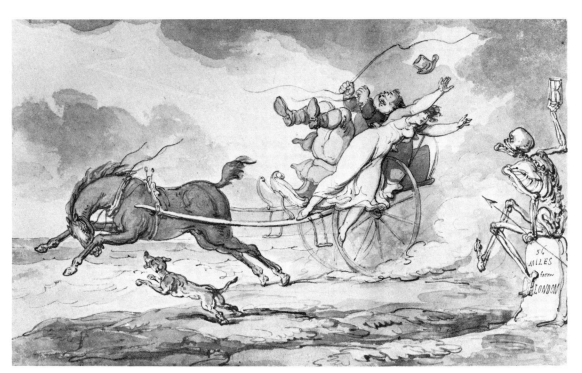

313. THE GIG

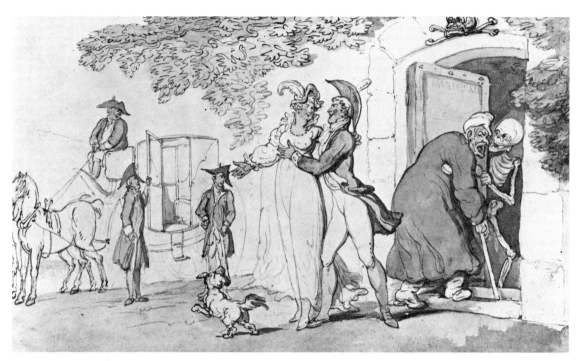

314. THE MAUSOLEUM

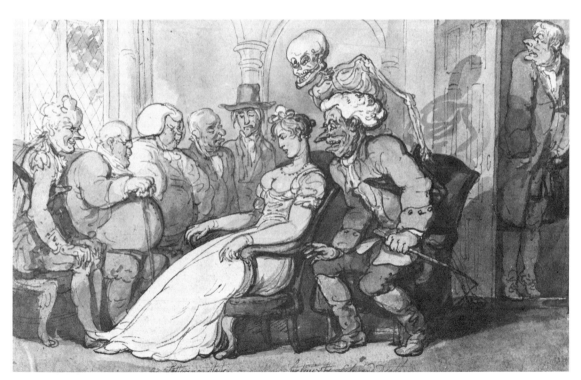

315. THE COURTSHIP

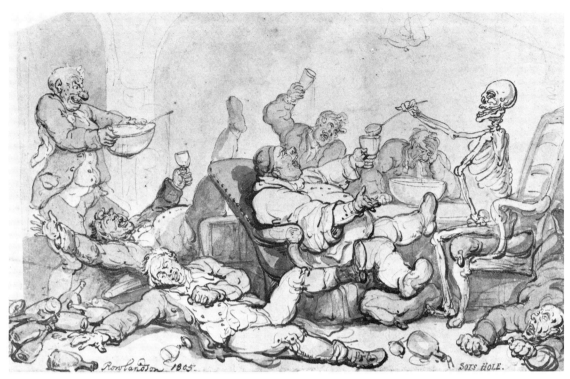

316. THE TOASTMASTER

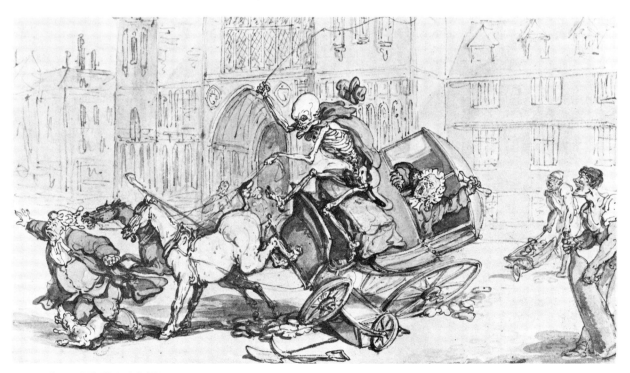

317. THE LAW OVERTHROWN

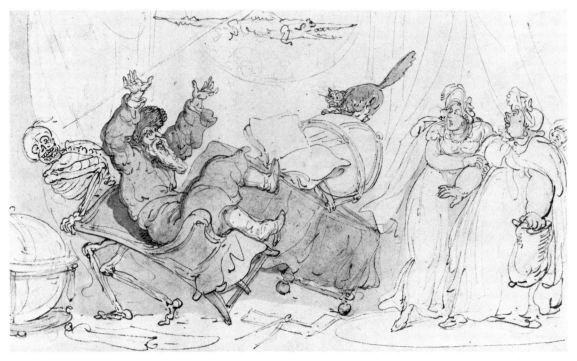

318. THE FORTUNE TELLER

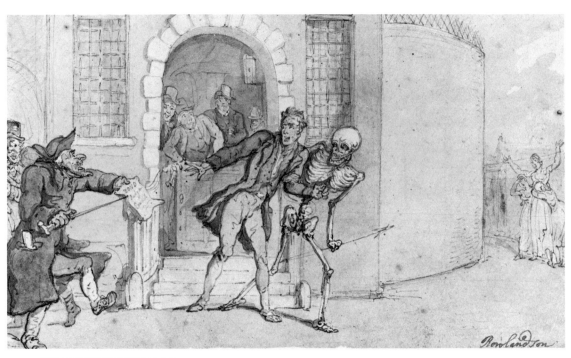

319. THE PRISONER DISCHARGED

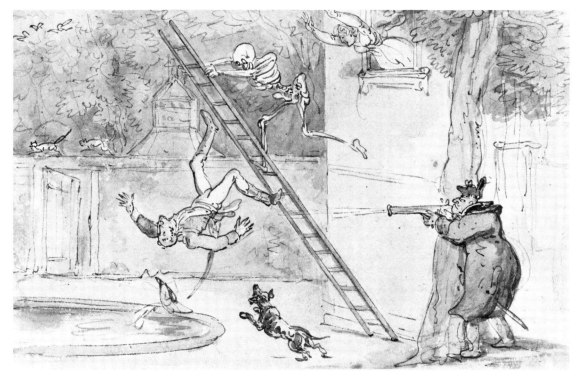

320. THE GALLANT'S DOWNFALL

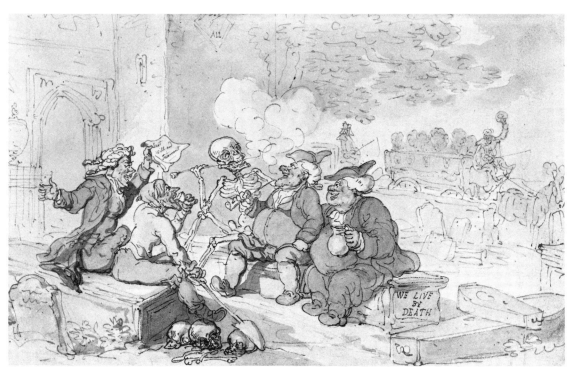

321. THE CHURCHYARD DEBATE

322. THE NEXT HEIR

323. THE CHAMBER WAR

324. DEATH AND THE ANTIQUARIES (1)

325. DEATH AND THE ANTIQUARIES (2)

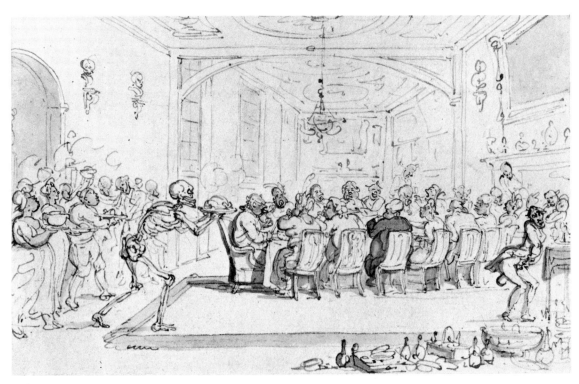

326. THE DAINTY DISH

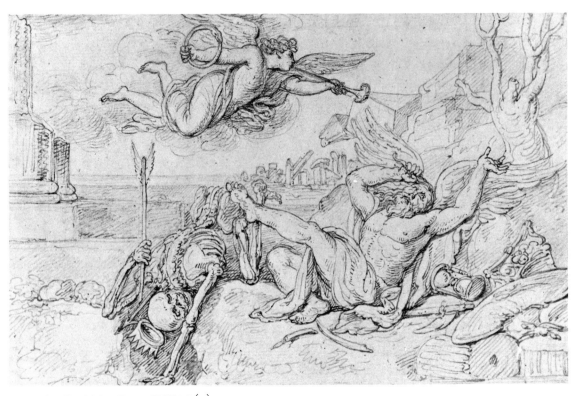

327. TIME, DEATH, AND ETERNITY (1)

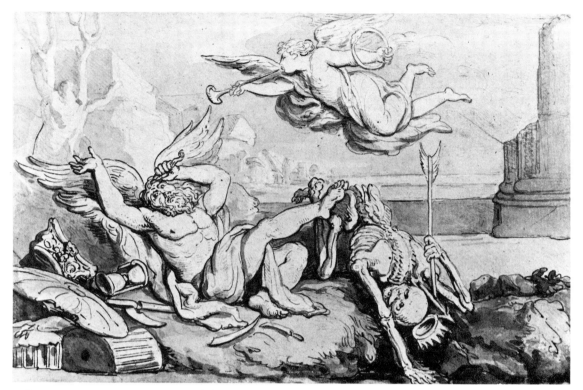

328. TIME, DEATH, AND ETERNITY (2)

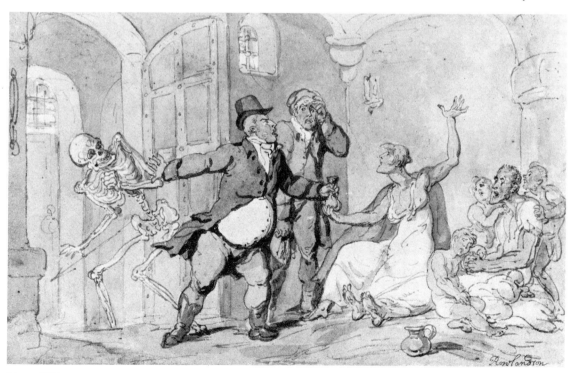

329. THE MAN OF FEELING

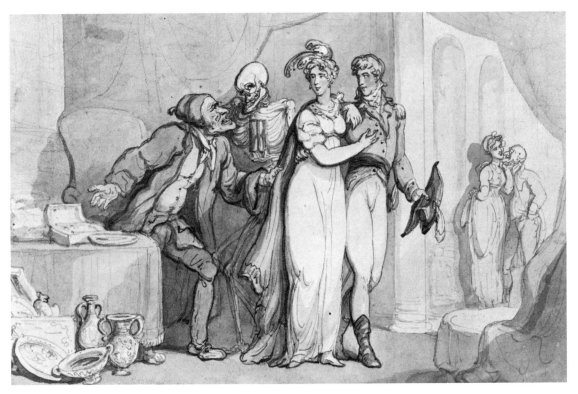

330. THE OLD SUITOR REJECTED

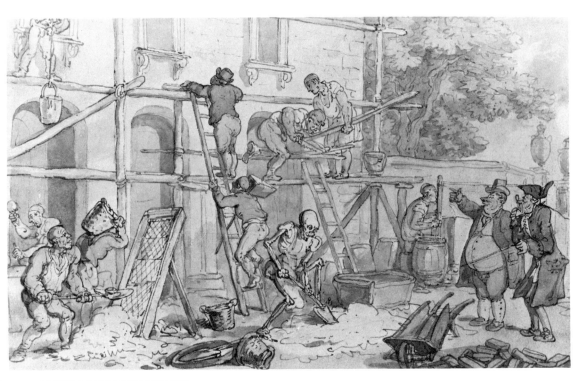

331. DEATH MIXING THE MORTAR

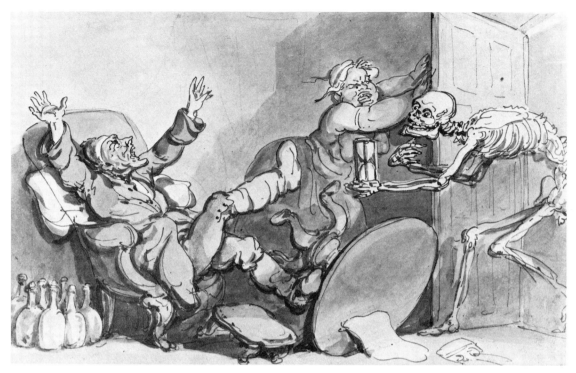

332. DEATH AT THE DOOR

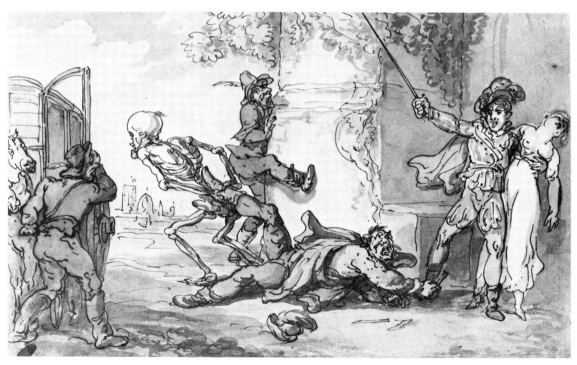

333. THE SWORD DUEL

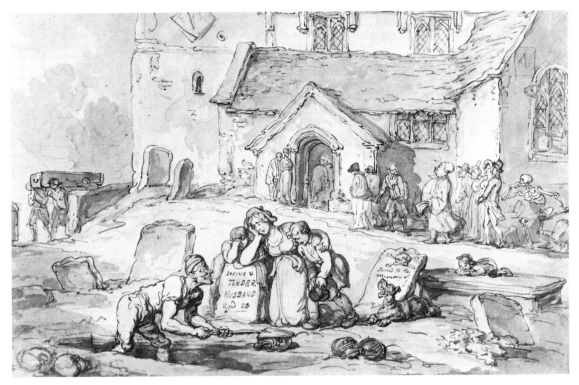

334. THE YOUNG FAMILY MOURNING IN THE CHURCHYARD

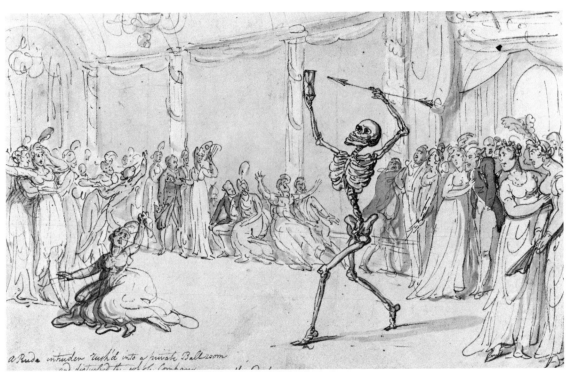

335. DEATH IN A BALLROOM

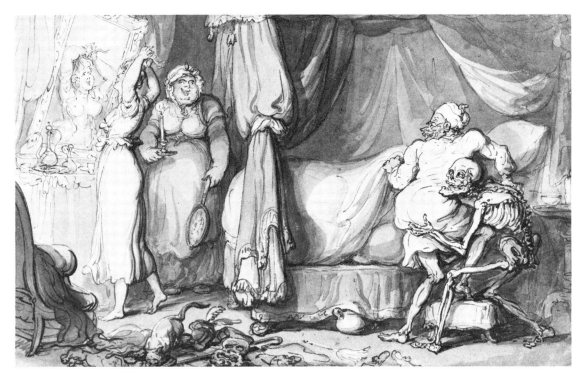

336. DEATH HELPING AN OLD LOVER INTO BED

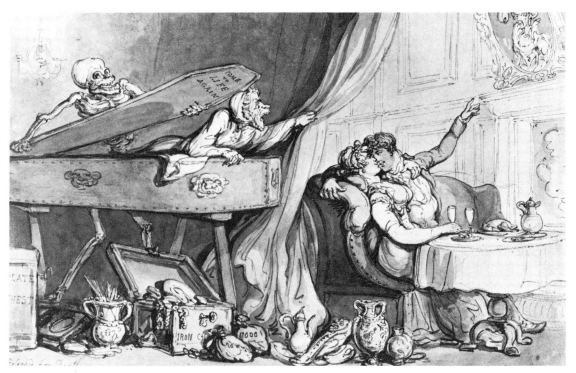

337. RELEASED FROM DEATH

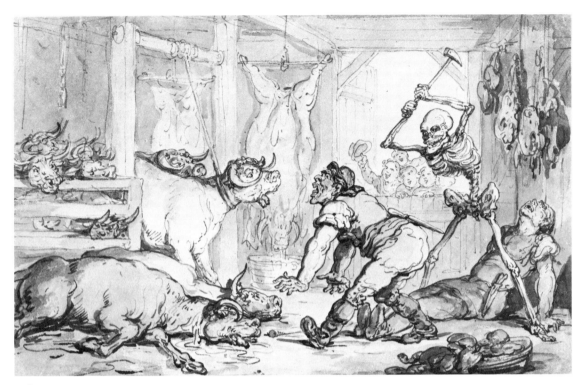

338. DEATH AND THE BUTCHER

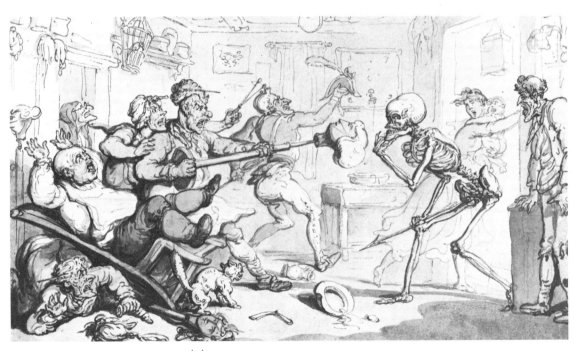

339. DEATH IN THE BARBER SHOP (1)

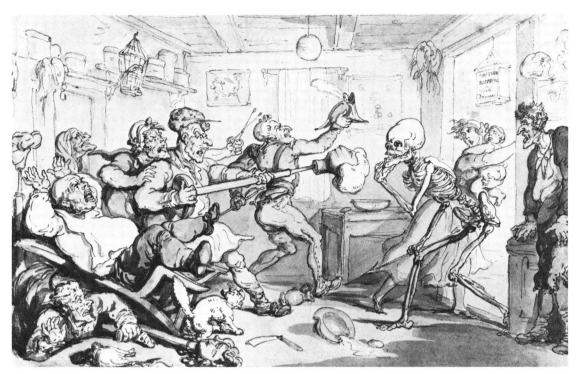

340. THE BARBER SHOP (2)

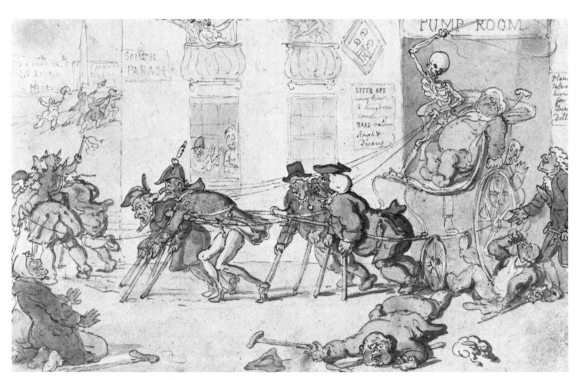

341. THE PUMP ROOM DOOR (1)

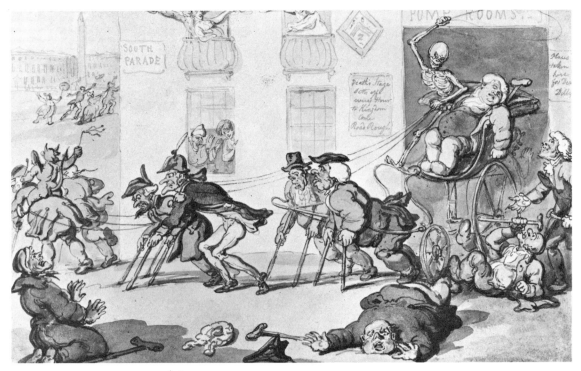

342. THE PUMP ROOM DOOR (2)

343. THE MAN OF LETTERS

344. INTERIOR OF AN INN

345. THE FLOUR MILL

346. MUSICAL CATS

347. A YOUNG WOMAN WITH A GROUP OF ADMIRERS

348. FORCE OF IMAGINATION (1)

349. FORCE OF IMAGINATION (2)

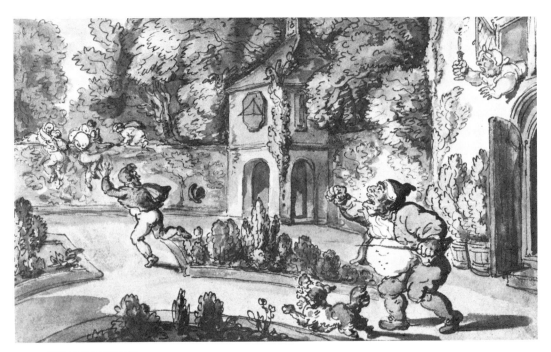

350. THE MARAUDERS

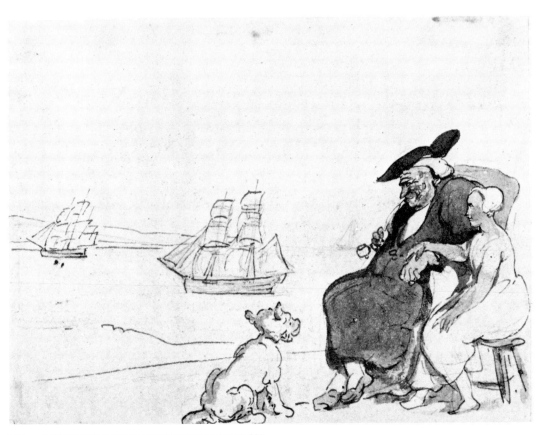

351. A MAN AND A WOMAN WATCHING SHIPPING

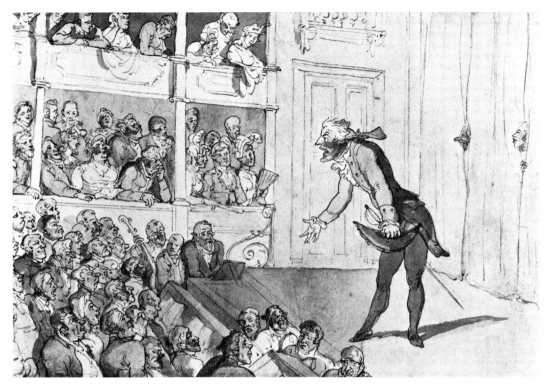

352. THE PROLOGUE

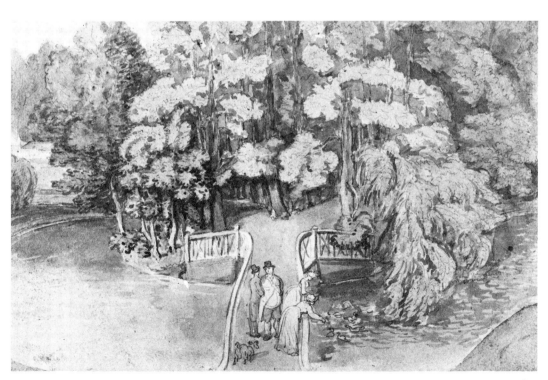

353. FIGURES ON A BRIDGE IN A PARK

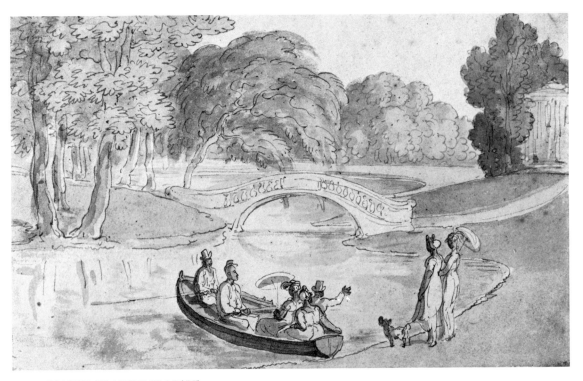

354. BOATING ON A POND IN A PARK

354. [VERSO]

355. A MAN TORTURED OVER A FIRE

356. A MAN HAVING HIS TONGUE CUT

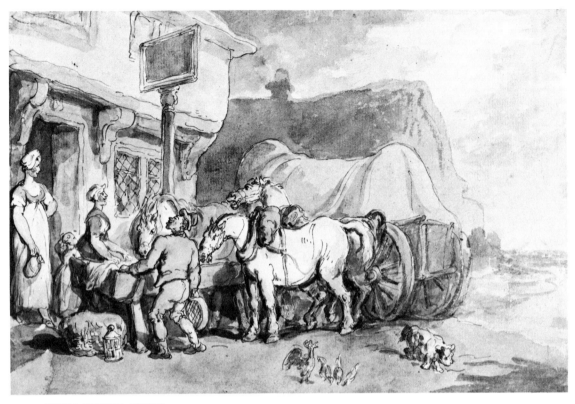

357. SCENE OUTSIDE AN INN

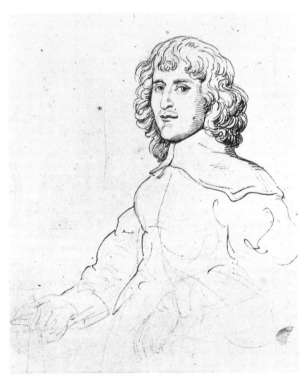

358. COPY AFTER A SEVENTEENTH-CENTURY PORTRAIT

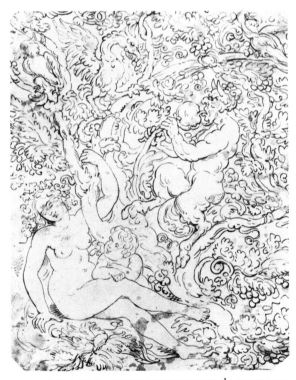

359. COPY AFTER HANS SEBALD BEHAM'S WOODCUT
"VINE PATTERN WITH SATYR FAMILY"

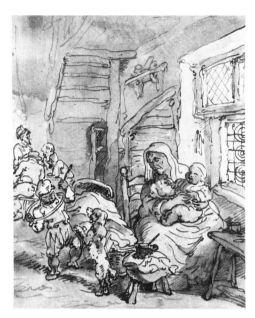

360. INTERIOR IN THE MANNER OF OSTADE

361. NYMPH AND FAUN WITH CHERUBS

362. MYTHOLOGICAL SUBJECT

363. LE DÉLUGE, AFTER CLODION

364. STUDY AFTER GUERIN'S "RETURN OF
MARCUS SEXTUS"

365. WINGED FEMALE FIGURE

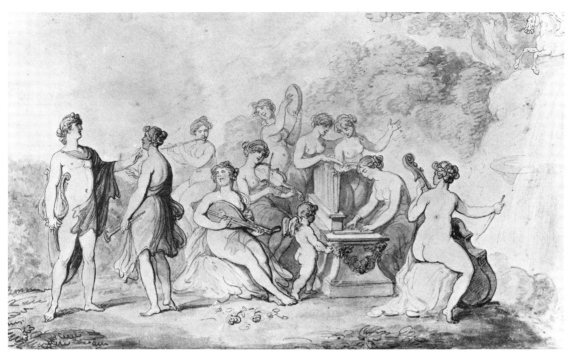

366. APOLLO AND THE MUSES

367. RAPE OF LUCRECE

ΣΩΚΡΑΤΗΣ

368. THE PAINTER

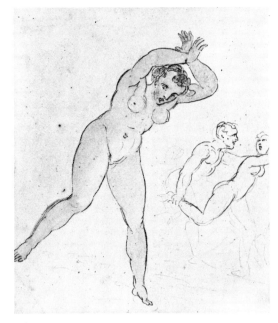

369. RUNNING FEMALE NUDE

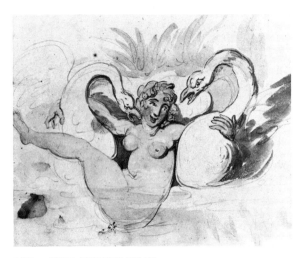

370. LEDA AND THE SWAN

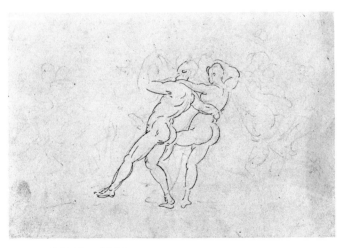

371. DANCING NUDES

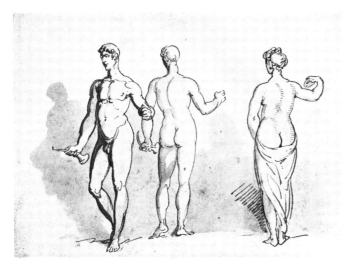

372. THREE CLASSICAL FIGURE STUDIES

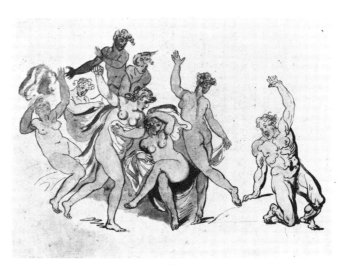

373. DIANA AND ACTAEON (?)

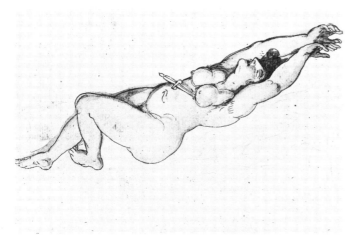

374. A NUDE FIGURE, A DAGGER IN THE HEART

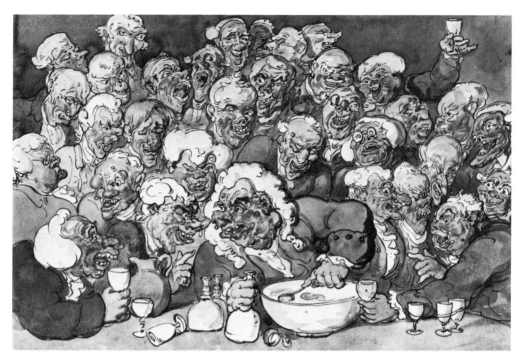

375. THE UGLY CLUB

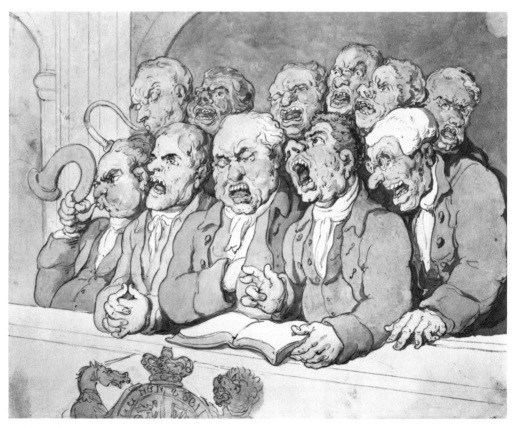

376. THE CHOIR

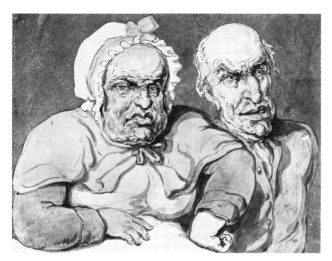

377. TWO PHYSIOGNOMIC STUDIES

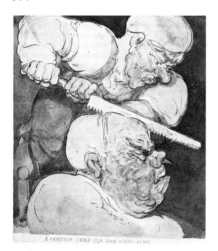

378. A CERTAIN CURE FOR
THE HEADACHE

378. ‧ [VERSO]

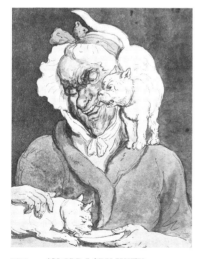

379. AN OLD LADY WITH
TWO CATS

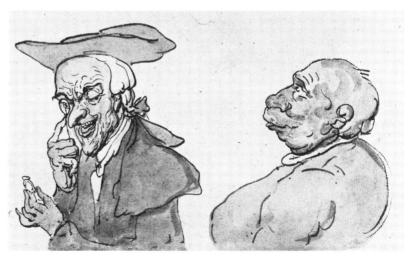

380. TWO PAWN SHOP CHARACTERS

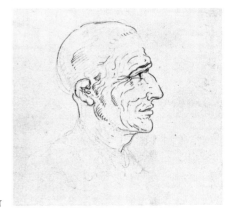

381. HEAD OF A MAN

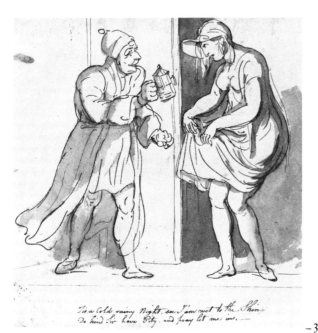

'Tis a Cold rainy Night. see I'am wet to the Skin;
Do kind Sir have Pity. and pray let me in. —

-382. 'TIS A COLD, RAINY NIGHT

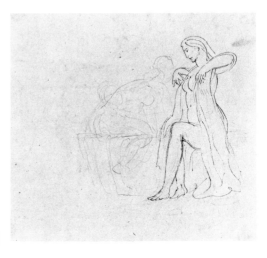

382. [VERSO]

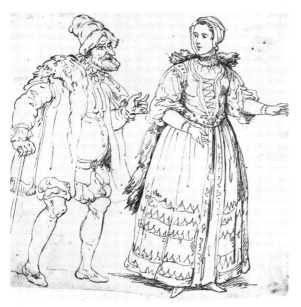

383. COSTUME STUDIES

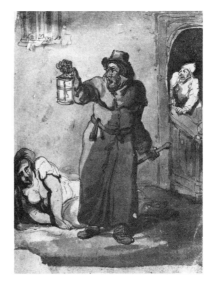

384. THE NIGHT WATCHMAN

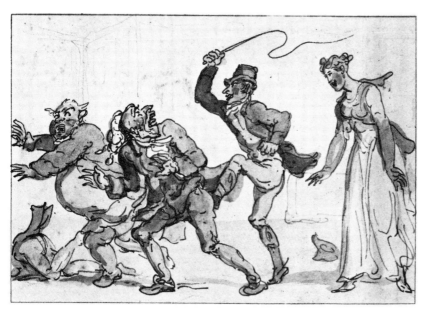

385. CREDITORS EXPELLED

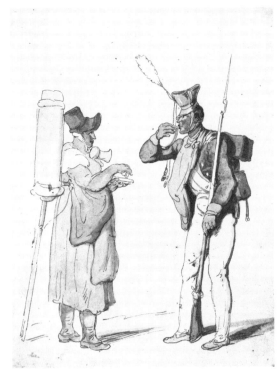

386. LA MARCHANDE DE COCO

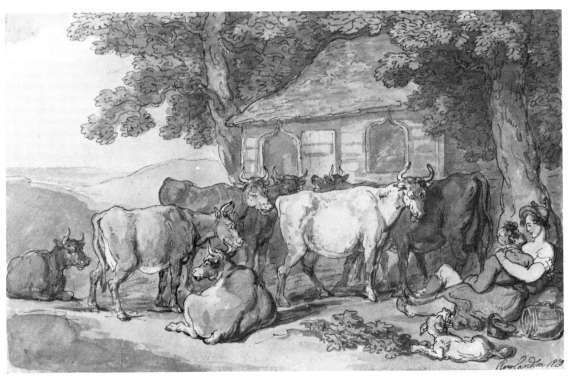

387. THE BUSY COWHERD

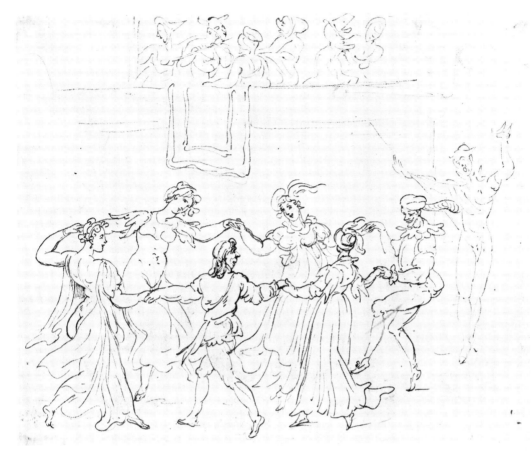

388. A GROUP OF DANCERS

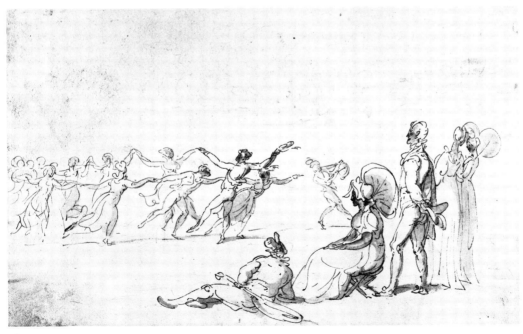

389. ROUND DANCE WITH SPECTATORS

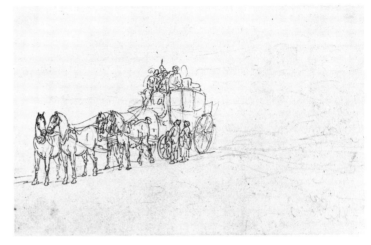

390. A COACH AND FOUR AT A STOP

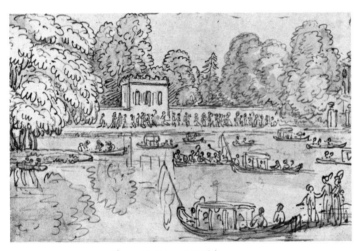

391. RIVER SCENE (HAMPTON COURT?)

391. [VERSO]

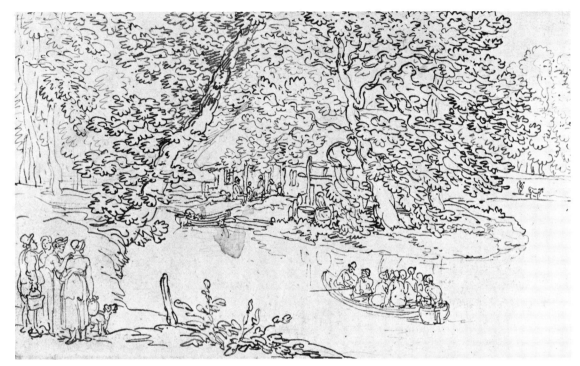

392. A BOATING PARTY NEAR AN ISLAND IN A RIVER

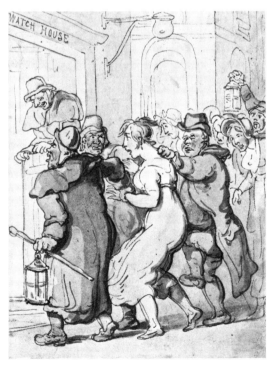

393. A WOMAN ARRESTED

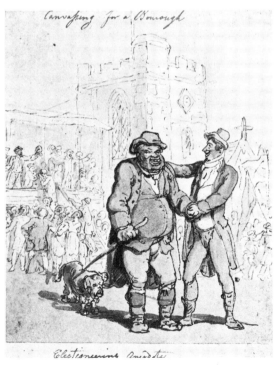

394. CANVASSING FOR A BOROUGH

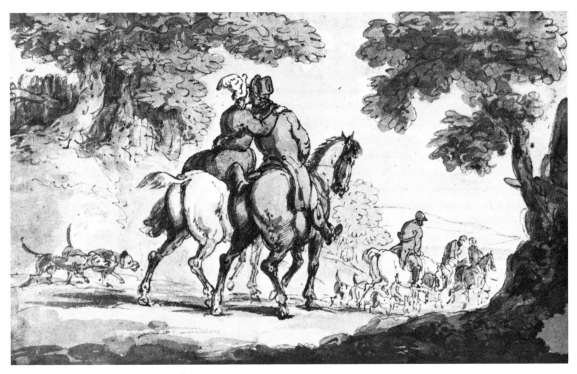

395. RETURN FROM THE HUNT (1)

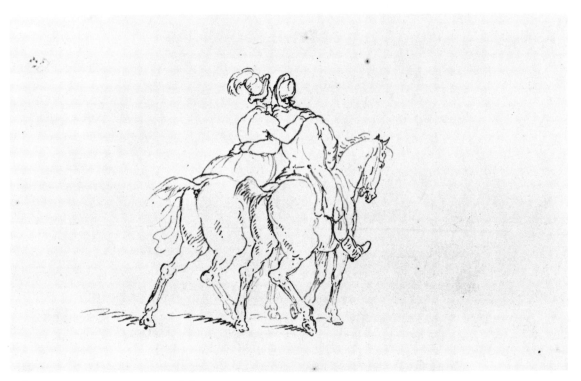

396. RETURN FROM THE HUNT (2)

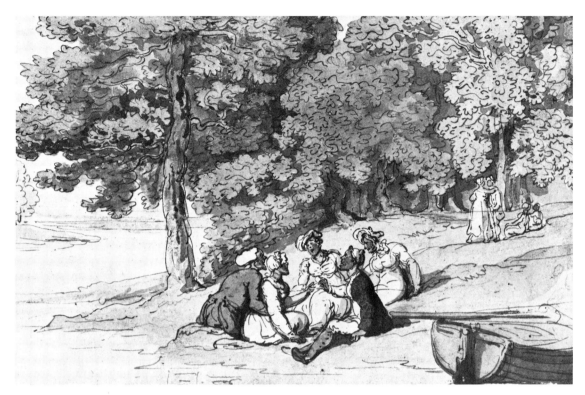

397. PICNIC BY A STREAM

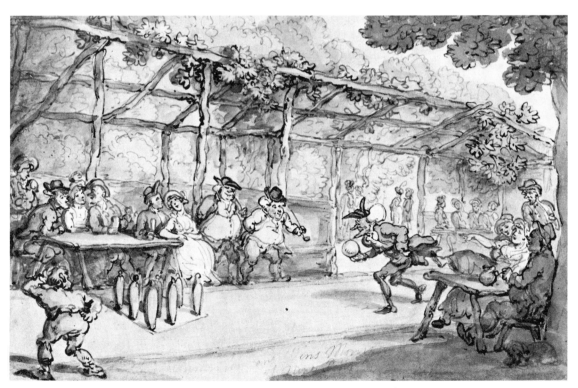

398. DR SYNTAX WINS AT NINE PINS

399. DR SYNTAX KISSING A MULE

400. DR SYNTAX AND THE STRANDED WHALE

401. DR. SYNTAX IN A BOAT WITH TWO WOMEN

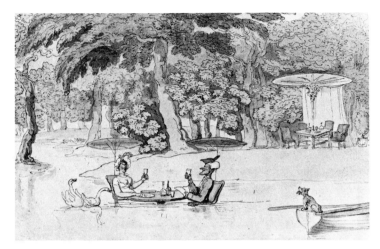

402. DR. SYNTAX DINING IN THE LAKE

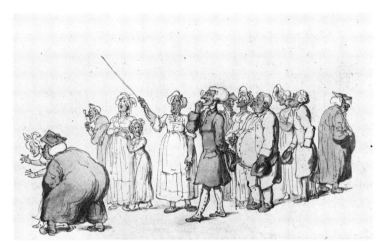

403. DR. SYNTAX ON TOUR

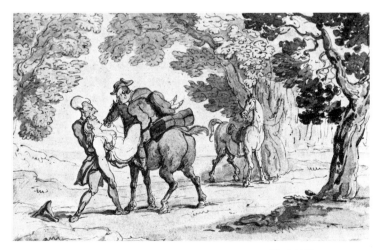

404. DR. SYNTAX AND PAT HELPING AN INJURED WOMAN

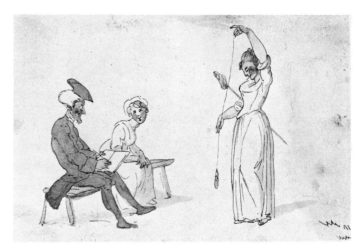

405. DR. SYNTAX SKETCHING A WOMAN SPINNING (1)

406. DR. SYNTAX SKETCHING A LADY SPINNING (2)

407. A BAT LOOSE IN A ROOM

408. DEATH AND THREE FIGURES ON A COUCH

409. COL. WINDHAM AND HIS BUTCHER

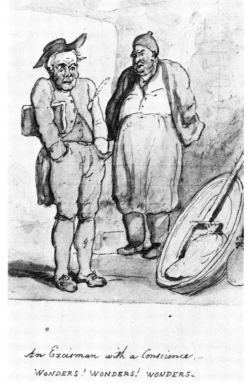

410. AN EXCISEMAN WITH A CONSCIENCE

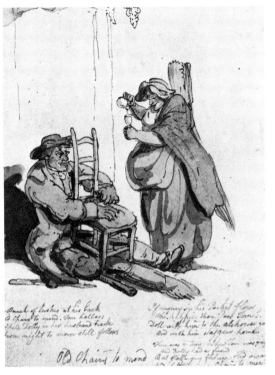

411. OLD CHAIRS TO MEND

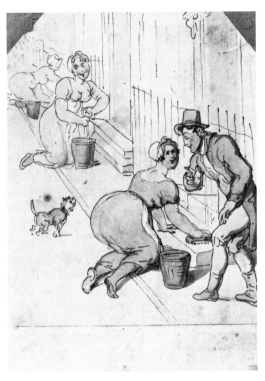

412. SCRUBBING DOORSTEPS

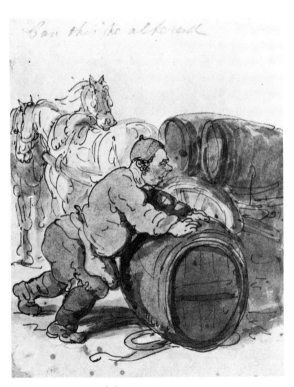

413. DRAYMAN (1)

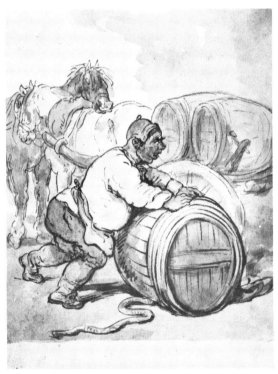

414. DRAYMAN (2)

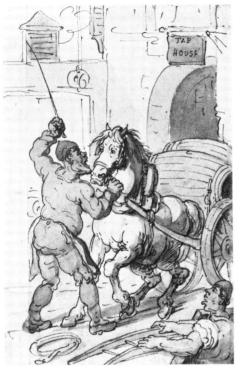

415. DRAYMAN (3)

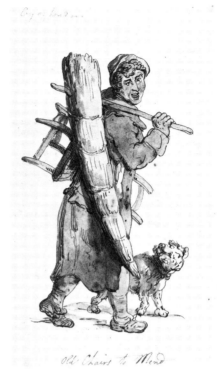

416. OLD CHAIRS TO MEND

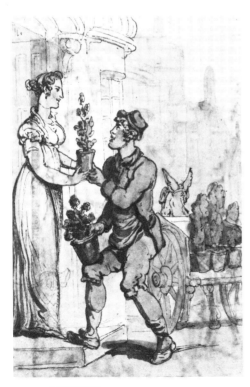

417. GARDENER

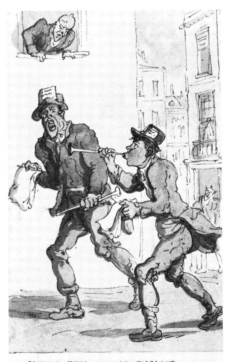

418. GREAT NEWS

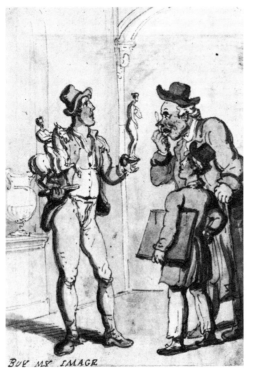

419. BUY MY IMAGE

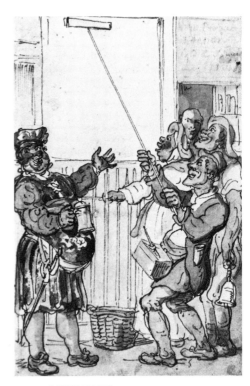

420. MENAGERIE

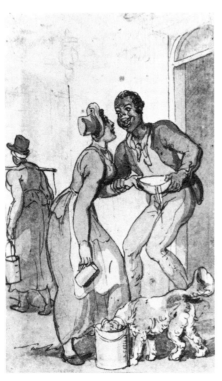

421. MILK

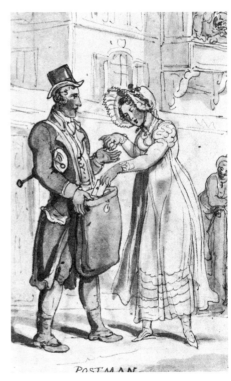

422. POSTMAN

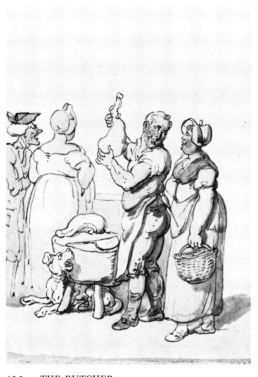

423. THE BUTCHER

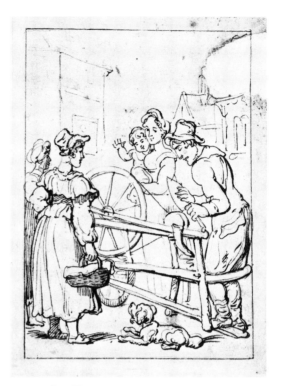

424. THE KNIFE GRINDER

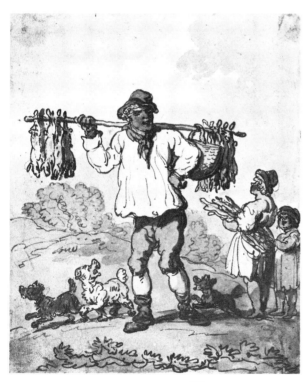

425. A MAN WITH DEAD RABBITS (?)

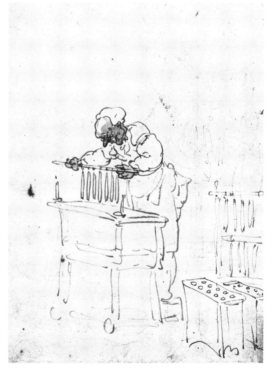

426. A CANDLE MAKER

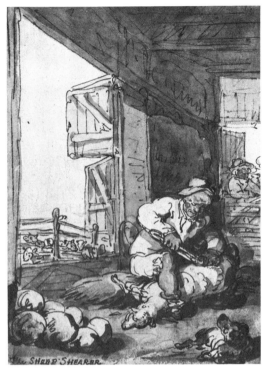

427. THE SHEEP SHEARER

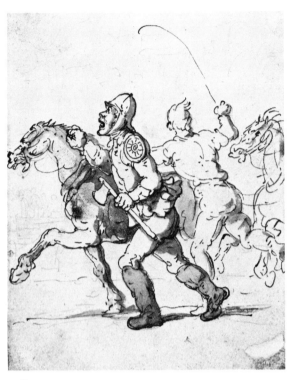

428. FIREMEN

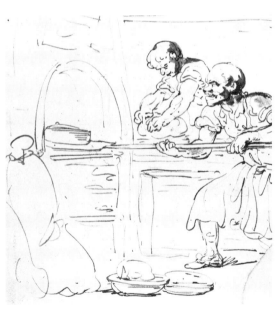

429. BAKERS

429. [VERSO]

430. THE WATERMAN (?)

431. THE GRINDER

432. CARPENTERS

433. THE CORONATION PROCESSION OF GEORGE IV (?)

434. A PRISONER AT AVIGNON

435. ANGERSTEIN'S HOUSE AT BLACKHEATH

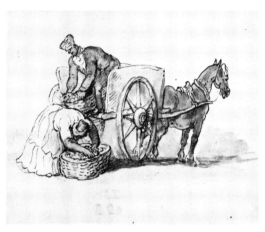

436.　A PROCESSION, AND A ROUND,
　　　THATCHED BUILDING

437.　A MAN AND WOMAN LOADING A CART

438.　DOVE HOUSE, CHARLTON

439.　ST ALFEGE'S, GREENWICH

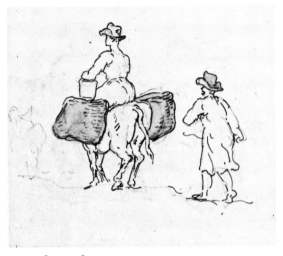

440. A GROUP OF PENSIONERS

440. [VERSO]

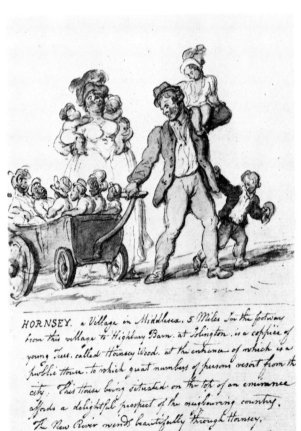

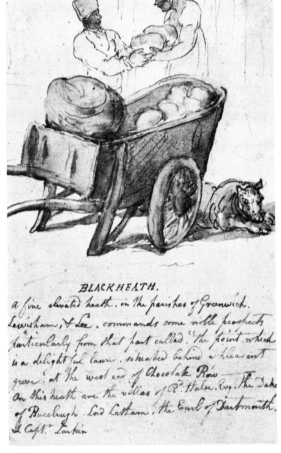

HORNSEY. a Village in Middlesex. 5 Miles In the footway
from this village to Highbury Barn at Islington. is a coppice of
young Trees. called Hornsey Wood. at the entrance of which is a
public House. to which great numbers of persons resort from the
city. This House being situated on the top of an eminence
affords a delightful prospect of the neighbouring country.
The New River winds beautifully through Hornsey,

BLACKHEATH.
a fine elevated heath. in the parishes of Greenwich.
Lewisham, & Lee. commands some noble prospects
particularly from that part called. The Point. which
is a delightful lawn. situated behind a pleasant
grove. at the west end of Chocolate Row.
On this heath are the villas of R Hulse Esq. The Duke
of Buccleugh. Lord Latham. the Earl of Dartmouth.
& Capt. Larkin.

441. HORNSEY

441. [VERSO]

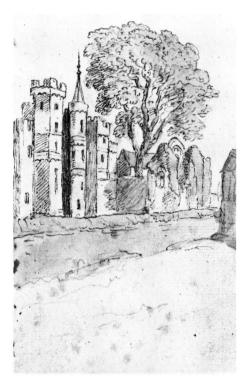

442. VANBRUGH CASTLE

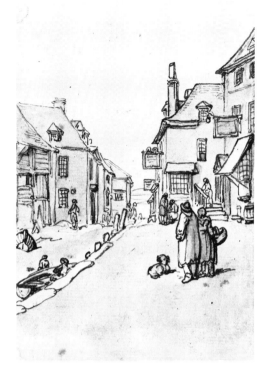

443. STREET SCENE

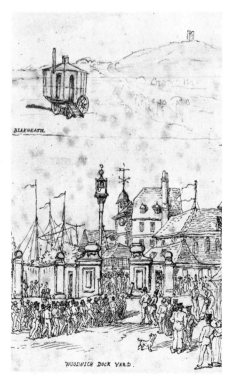

444. BLACKHEATH AND WOOLWICH
DOCK YARD

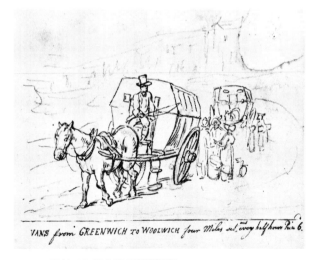

445. VANS FROM GREENWICH

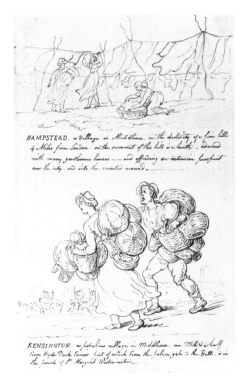

446. HAMPSTEAD AND KENSINGTON

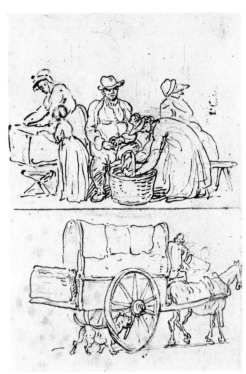

447. GENRE SCENE AND COVERED WAGON

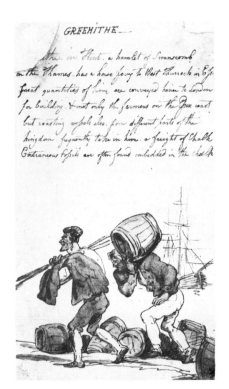

448. GREENHITHE

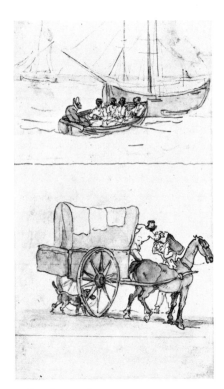

448. [VERSO]

DEPTFORD anciently called West Greenwich
a large town in Kent. 3½. It is remarkable for its
noble Dock. in which a great number of hands is employed

449. DEPTFORD

449. [VERSO]

BLACKWALL.

in Middlesex. (between Poplar) and the mouth of
the river Lea is remarkable for the Ship yard &
wet dock of Ino. Perry Esq. The Dock. which
is the most considerable, private one in Europe
contains. with the water and embankments
near 19 Acres. It can receive 28 Large East
Indiamen. & from 50 to 60 ships of smaller size

450. BLACKWALL

CHISLEHURST a village near Bromley. in Kent 11½ Miles
from London where the celebrated Camden composes the
principle part of his Annals of Queen Elizabeth. This was the
birth place of Sir Nicholas Bacon. Lord Keeper in that reign. and
father of the great Viscount St. Albans. and here also was born
the famous Sr. Franc. Walsingham. In this Park near St. Mary
Cray. is Foggmall the seat of Viscount Sydney. and opposite
Bentia Place. are the Villa & Park of Mr. Twycross

451. CHISLEHURST

452. FARMER GILLETT OF BRIZE-NORTON

WATTON WOOD HALL. *an elegant seat 5 Miles from Hertford. built by S.r The.s Rumbold Bar.t The Park is planted with great taste and a beautiful rivulet called the rib. which runs through it is formed into a spacious canal. with islands for the haunts of Swans. This estate was sold in 1792. to Sir H.C Calthorpe B.*

453. WATTON WOOD HALL

RAINHAM *a village in Essex. 15 Miles from London and 1 from the Thames. where there is a ferry to Erith. the road hence to Purfleet commands an extensive View of the Thames & the Marshes — which are uncommonly fine and are covered with a prodigious numbers of cattle —*

454. RAINHAM

455. A SHIPYARD

456. A WEAVER

457. A MAN STANDING IN FRONT OF
ORIENTAL BUILDINGS

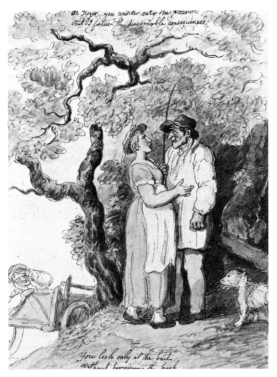

458. AH ROGER!

459. THE DOCTORS PUZZLED

460. A SCHOOLMASTER AND HIS PUPIL STUDYING A TOMB

461. STREET SCENE IN ITALY

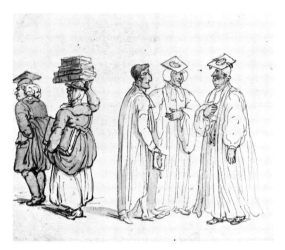

462. QUAE GENUS AT OXFORD

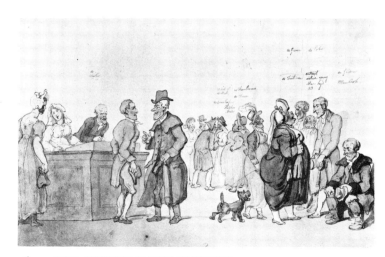

463. QUAE GENUS IN SEARCH OF SERVICE

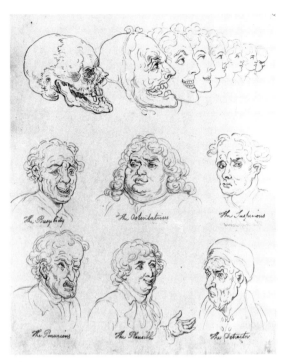

467. MARCUS AURELIUS, AFTER
 THE ANTIQUE

468. LIVIA, AFTER THE ANTIQUE

Paysan ecorchant un dain

469. PEASANT DISEMBOWELING A DEER,
 AFTER THE ANTIQUE

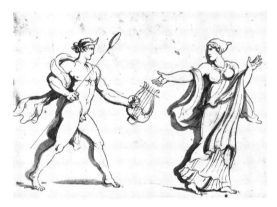

470. TWO RUNNING FIGURES, AFTER
 THE ANTIQUE

471. THREE CLASSICAL VASES

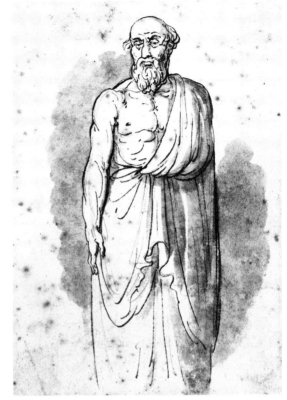

472. ELDERLY MAN IN A TOGA

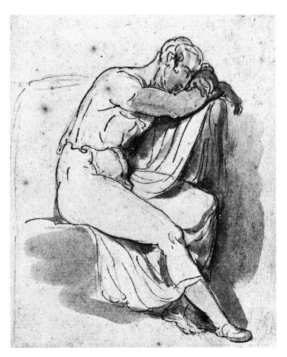

473. MAN SEATED WITH HIS HEAD ON HIS ARM

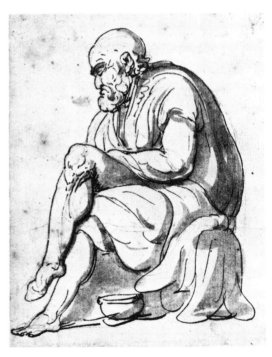

474. ELDERLY MAN SEATED WASHING HIS FEET

475. TWO WOMEN
 CARRYING BASKETS

476. LEAPING A FIVE-BARRED GATE

477. DR. SYNTAX AND THE SKIMMINGTON RIDERS

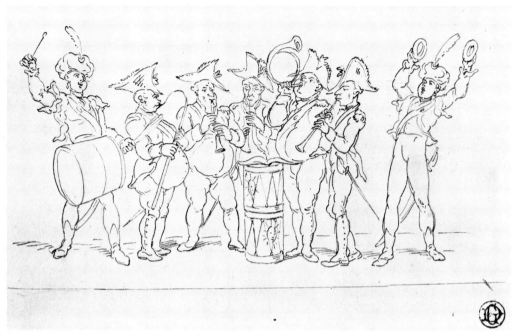

478. THE BAND (1)

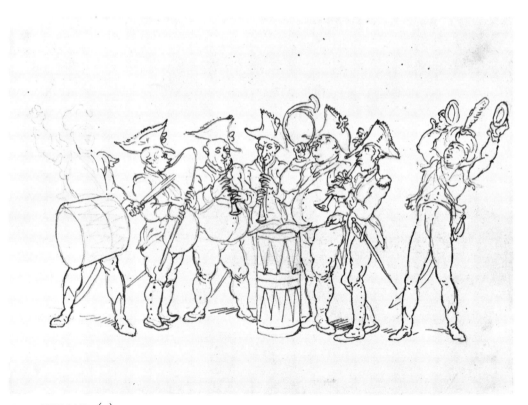

479. THE BAND (2)

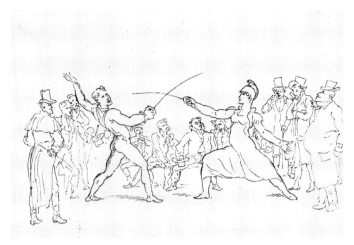

480. MME CULLONI AND M. RENAULT, GRAND ASSÁULT, PARIS

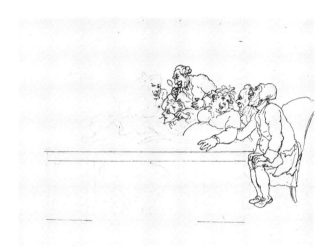

481. THE CARICATURE PORTFOLIO

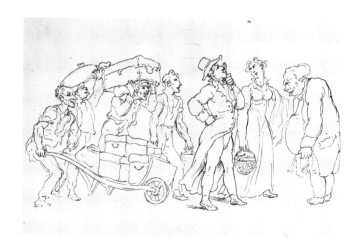

482. TAKING UP NEW LODGINGS

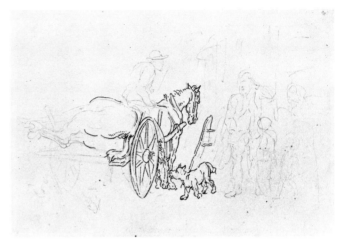

483. THE DEAD HORSE

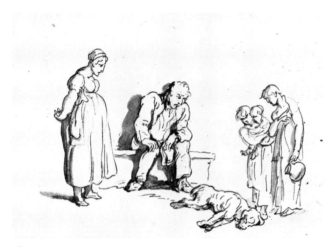

484. THE DEAD DOG

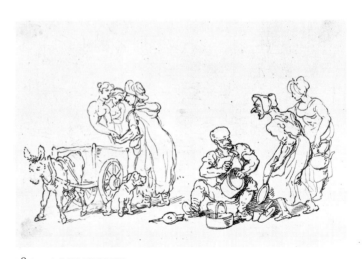

485. A POT MENDER

486. TWO MEN WATCHING THREE MEN DIGGING

487. STABLE SCENE WITH EMBRACING COUPLE, TWO HORSES,
 AND TWO DOGS

488. THE POACHER ARRESTED

489. BAILIFFS OUTWITTED

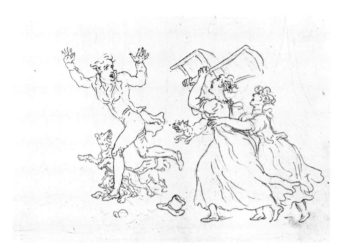

490. HOW TO GET RID OF A TROUBLESOME CUSTOMER

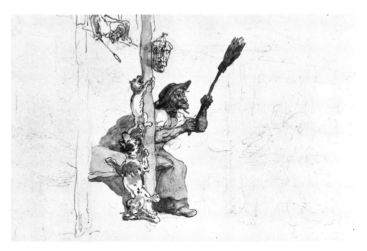

491. AN OLD HAG WITH A BROOM

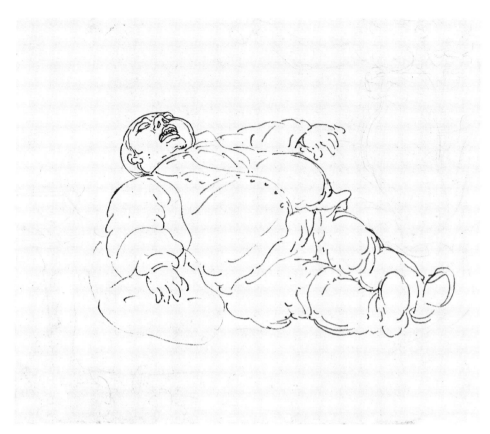

492. A FAT MAN IN A STUPOR

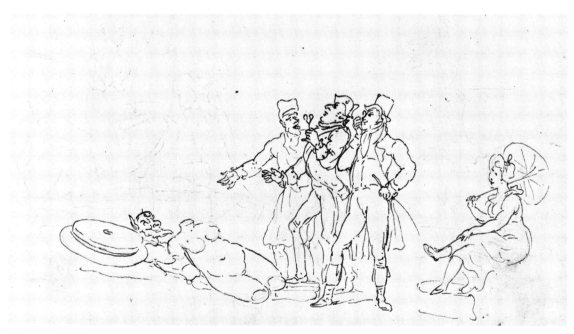

493. A STATUARY YARD

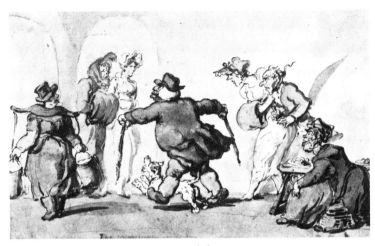

494. WINDY DAY AT TEMPLE BAR (1)

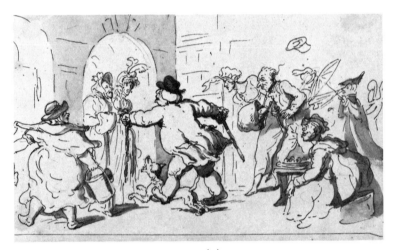

495. A WINDY DAY AT TEMPLE BAR (2)

496. A WINDY DAY AT TEMPLE BAR (3)

497. BLEEDING A FAT WOMAN

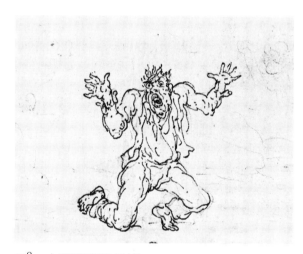

498. A TERRIFIED MAN

499. A BALLOON ASCENT (?)

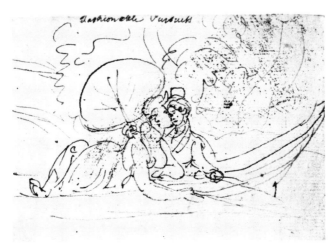

500.　A COUPLE IN A BOAT

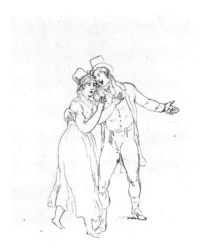

501.　A HAPPY COUPLE

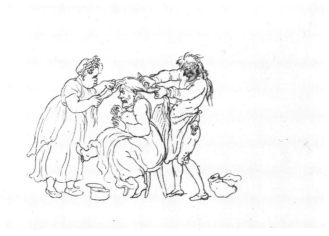

502.　COMBING HAIR

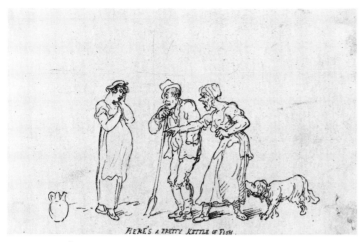

503. HERE'S A PRETTY KETTLE OF FISH

504. FIGURE SKETCH

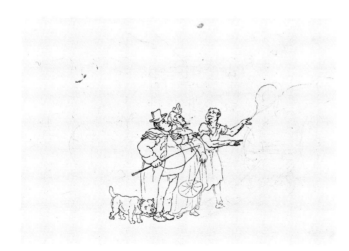

505. INSPECTING A CABRIOLET

506. THE MISERIES OF INTRIGUING

507. ROBBERS CONFRONTED

508. THE FEAST OF ARISTOTLE

509. A WOMAN AND A MONKEY

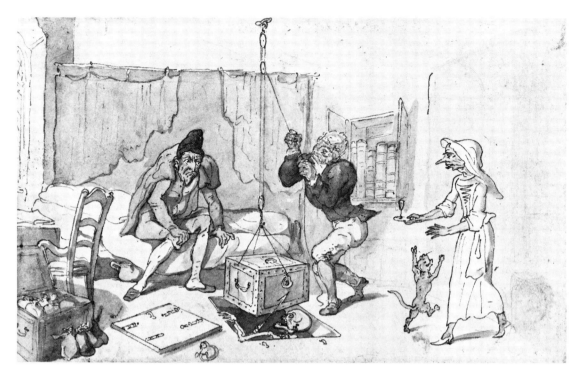

510. DEATH AND THE MISER'S CHEST

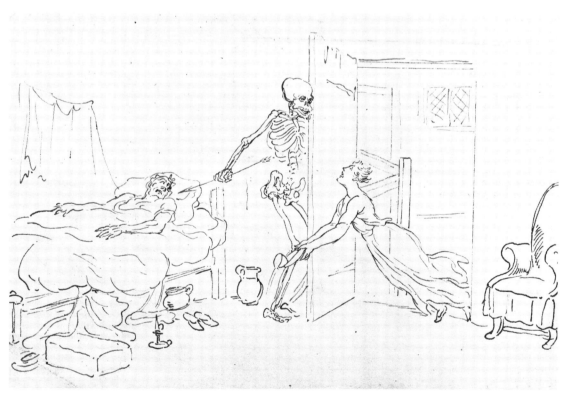

511. DEATH OPENS THE DOOR

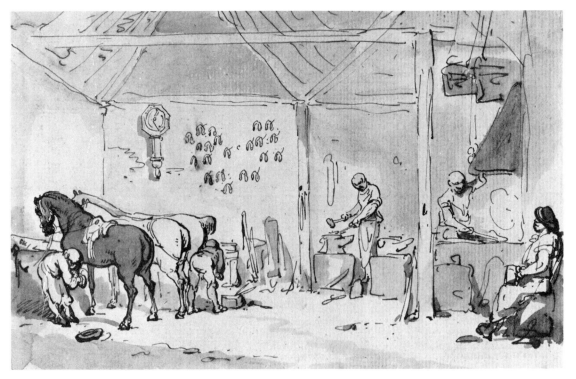

ADDENDA I

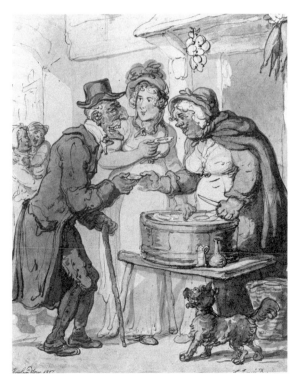

ADDENDA II

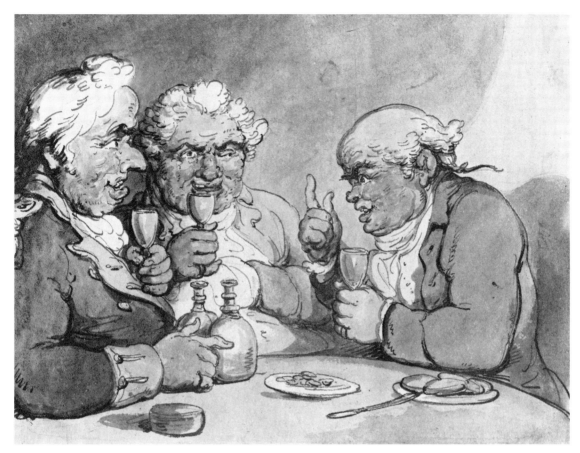

ADDENDA III

Index

INDEX OF WORKS BY ROWLANDSON
CATALOGED OR MENTIONED

Italic numbers refer to pages in the Introduction; all others refer to Catalog entries.

387

GENERAL INDEX

Italic numbers refer to pages in the Introduction; all others refer to Catalog entries.